THE GREAT HOUSES OF LONDON

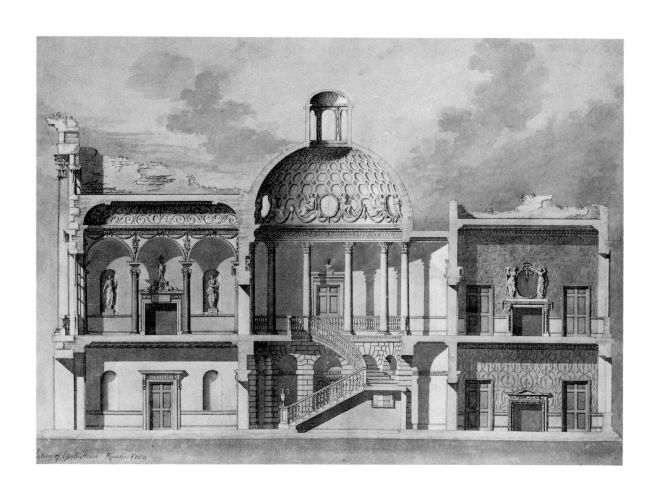

Frontispiece, *the quintessential eighteenth-century London palace. Section drawing of Sir William Chambers's proposal for York House, Pall Mall, for the Duke of York (1760). Matthew Brettingham, who was finally commissioned to design the house, produced a rather more mundane building than is suggested here. The splendour of the rooms of the* piano nobile *surrounding the central staircase and approached from its loggia-like gallery, is typical, but Chambers's dramatically domed and top-lit stair is architecturally more ambitious than usual*

DAVID PEARCE

THE GREAT HOUSES OF LONDON

THE VENDOME PRESS

PUBLISHED BY
THE VENDOME PRESS
1370 AVENUE OF THE AMERICAS
NEW YORK, NY 10019

DISTRIBUTED IN THE U.S. BY
RIZZOLI INTERNATIONAL PUBLICATIONS THROUGH
ST. MARTIN'S PRESS
175 FIFTH AVENUE
NEW YORK, NY 10010

Library of Congress Cataloging-in-Publication Data

Pearce, David, 1937–
 The great houses of London.
 p. cm.
 Originally published: c1986.
 Includes bibliographical references and index.
 ISBN 0-86565-154-X (pbk.)
 1. Mansions - - England - - London. 2 Interior decoration - - England - - London. 3. Lost
architecture - - England - - London. 4. London (England) - - Buildings, structures, etc. I. Title.
NA 7512.4.L6 P4 2001
728.8'09421 - - dc21

 2001026212

Contents

List of Illustrations

The following abbreviations are used in this list:

BAL British Architectural Library; photograph reproduced by courtesy of the Royal Institute of British Architects

BM British Museum; reproduced by courtesy of the Trustees

CL Country Life Magazine; reproduced by permission of Country Life Ltd.

GLC Greater London Council (including Survey of London) reproduced by permission

LON MUS Museum of London; reproduced with the Museum's permission

NMR National Monuments Record; reproduced by permission of the Royal Commission on Historical Monuments (England)

PUB Property of B.T. Batsford Ltd.

Soane Sir John Soane's Museum; reproduced by courtesy of the Trustees

Acknowledgements

Works published by the following architectural historians were of immense value to the author: Howard Colvin, John Cornforth, John Harris, John Schofield and Sir John Summerson. Opportunities to discuss this book with several of them were greatly appreciated. E. Beresford Chancellor's book on the subject published in 1908 (and several others of his writings) provided a starting-point. Even earlier publications, which Chancellor acknowledged, such as those by H. B. Wheatley and E. Walford, provided a mine of information – not all of it could be relied upon, however, especially on architectural matters, in which these writers were little interested.

For those areas covered by the Survey of London there could be no better source, unless it be the Survey team itself, among which Hermione Hobhouse and Victor Belcher were notably kind. The Greater London Council's Historic Buildings historians, led by Ashley Barker and John Earl and including especially in this case Frank Kelsall and John Robinson, were more than generous with their assistance. Mr Kelsall was good enough to read the lengthy original draft and suggest various revisions. At the National Monuments Record Stephen Croade and Patricia Drummond were very patient. Mireille Galinou of the Museum of London was also most helpful in the matter of illustrations. At the Sir John Soane Museum, Dorothy Stroud, lately the Inspectress, was most encouraging as indeed was her successor Margaret Richardson, then at the RIBA's British Architectural Library.

London's mansions having been either demolished or re-used, grateful thanks are due to the following successors in title or occupation: the Duchess of Devonshire, the Earl of Carrington and, at the Clermont Club (44 Berkeley Square) Peter Byrne, at the Oriental (Derby House) the Secretary Mr Rapson, and at 66 Lincoln's Inn Fields (Newcastle House), Sir Matthew Farrer. At Chatsworth, where much Devonshire House material is preserved, the librarian Peter Day and archivist Michael Pearman were generously helpful. While at that great house there was also an invaluable opportunity for a long talk on the subject of London's mansions with the Earl of Stockton.

Finally the author wishes to acknowledge his debt to the following for support and advice: Dulan Barber, Alan Baxter, Sarah Dennison, Mark Donaldson, Christopher Goode, Judy Hillman, Paddy Kitchen, Sylvia Middleton, Geoffrey Palmer, Caroline Ryan, Matthew Saunders, David Sawyer, Nicholas Thompson, John Waite, David Williams and Christopher Zimmerli.

Introduction

This mansion is a very good specimen of masonry, and is built for long endurance ... If a New Zealander, who is to gaze on the deserted site of fallen London in some distant time to come, sees nothing else standing in this neighbourhood, he will certainly find the weather-tinted walls of Dorchester House erect and faithful.

The Builder

The magazine's words of 1854 were to be mocked three-quarters of a century later in another issue which stated that 'Dorchester House in Park Lane is unfortunately about to be pulled down to give place for an hotel.' The private palaces of the nobility had been socially and politically dominant for half a millenium, and second only to churches in architectural and aesthetic significance. As late as 1908 Chancellor could claim that their pictures, furniture and *objets d'art* could 'defy comparison with the chateaux of France, and even with the Venetian *palazzi* in the days of their prosperity'. And further that in many cases 'these old houses remain in the hands of the great families'. Now they are gone; but there are still those who recall the lavish life within them. Such are the Queen Mother, and the Earl of Stockton, who have spoken to the author – in one case briefly, in the other at length – about London's mansions.

Even the term 'palace', which recurs in these pages, may sound odd. It had long currency: in 1672 John Evelyn wrote 'dining at Lord John Berkeley's ... new house, or rather palace'; in 1679 he went 'to see Mr Montague's new palace neere Bloomsbery.' A century later Lord Camelford was thinking of letting 'my palace in Oxford Street'. But when Queen Victoria remarked to her neighbour, the Duchess of Sutherland, 'I have come from my house to your palace', she was making a qualitative comparison between the architecturally effective building now known as Lancaster House and the unsuccessfully enlarged Buckingham House, which had become a royal palace.

A 'palace' is not just a big house, nor in this context a royal or episcopal house, nor even necessarily the residence of an aristocrat – it is a house designed for ceremony, a house of parade, self-consciously formal. It is lifted above the ordinary by its scale, drama and, perhaps, beauty. Such a mansion is to be approached, entered and traversed in a pre-ordained sequence. A gatehouse, courtyard, porch and screens passage comprised the pre-Renaissance pattern; a *porte cochère*, entrance hall, grand stair and galleried landings giving access to state apartments was the nineteenth-century one. The art of architecture, its formal language imposed on such a plan, could lift a modest-sized house to the level of a palace.

The Great Houses of London is an account of buildings and their designers; it is about their owners too. The great town house, more than any other major building type, expressed the tastes and aspirations of a single person, and usually one rich and powerful enough to have his own way. Such a client was not easy for the architect, especially prior to the formalization of the profession in the nineteenth century. When that did happen, and an architect such as George Basevi could be appointed for the overall design of large numbers of grand houses – such as those comprising most of Belgrave Square – the resulting residences lacked the individuality of the aristocrat's private palace, no matter how opulent

the furnishings. Most of the powerful families who created major town houses were free-holders, although there were exceptions, especially on the Grosvenors' Mayfair estate.

The architect was appointed by the noble client to produce a distinguished design and, at least as importantly, to carry out a complex and subtle floor-planning exercise. In Georgian times the life of the aristocracy gradually became more formal, its activities compartmentalized – receiving, sitting, eating, withdrawing, reading, music-making, card-playing, sleeping, dressing, bathing – these were all given separate spaces. Classes of people and types of occasion were graded. In later palaces the family customarily had a suite of rooms for living privately on the ground floor and another for living publicly, when the occasion demanded, on the first. Miracles of organization were achieved by Robert Adam, for example, even in narrow-frontage houses. There were back stairs, passages and jib doors so that servants could appear unobtrusively – like Jeeves, they were supposed to float silently in and out of rooms. For servants who were meant to be seen at times, such as footmen, there were places where they could stand out of the way, yet be ready to come forward when required. The nineteenth century saw households even more inflated and hierarchic, and entertaining grander and more formal. Fifty to 60 servants were present in large town houses. The family expected privacy, not only from them, but also from its younger members and from its guests. Such careful architectural planning was a world away from the medieval courtyard houses which, to a considerable extent, 'just grew' and in which a great deal of the life centred on the single great hall.

Those early mansions were sited in the City, Westminster and the Strand area between them; as the centuries passed the fashionable locations spread north and west. In *Round About Piccadilly and Pall Mall* of 1870, Wheatley wrote of the quarter centred upon St James's Square: 'It has been from its proximity to the court, frequented by the ruling powers in state and general society for about two centuries. In former times society, or the "world", consisted of a small circle of persons who were almost all known to one another, and lived within this district.' Before 1660 'St James's Fields' were just that. The thirteenth-to-nineteenth-century migration by the rich and powerful is reflected in the structure of this book. *The Great Houses of London* starts in the walled City of London, explores suburbs such as Holborn, Bloomsbury, Soho, Piccadilly, St James's, and Marylebone, and ends in Park Lane, from which aristocrats were driven by the noise of motor buses, the demands of hoteliers and the effects of taxes.

The east–west progress broadly parallels the chronological one over six centuries. But there are diversions; apart from describing a number of important houses in a particular location and period, most chapters also present an exposition in aesthetic, architectural, political or town-planning terms. There are some 40 major houses and perhaps a hundred lesser ones. Each chapter recounts the story of a few of these with an emphasis on the theme of the chapter concerned. The conjunction of houses and themes is contingent in that some private palaces could have been discussed under several headings. In the interests of readability, the history of a house, once embarked upon in detail, is carried forward to its conclusion.

I
Houses of the City, the Strand and the Medieval Suburbs

An early thirteenth-century traveller from Westminster to the City of London passed through open country with only a scatter of dwellings, apart from the hamlet at Charing. After struggling along the rutted and muddy Strand he reached the city boundary alongside the impressive walled precinct of the Knights Templar. The chain between the wooden posts marking the limits of the mayor's jurisdiction would not be in position to bar his way at busy times of day; as he continued he noticed a few larger buildings, especially towards the River Thames. There were also orchards and garden plots. Crossing the bridge over the River Fleet and climbing the hill, he entered the city through Lud Gate. In front of him was the massive cathedral dominating a metropolis of 10,000 people.

There was one other structure as large as St Paul's: the Tower of London guarded the city's distant eastern flank. But here down towards the riverside were two much smaller Norman castles, Baynard's and the Tower of Montfichet, both now regarded as grand residences rather than strongholds. Both were to be demolished after 1276, when Robert Fitzwalter gave them to the Blackfriars to extend their monastery. Fitzwalter then built a new Castle Baynard on the river bank east of the monastery. At one time granted to the Earls of Clare, this was in the ownership of Humphrey, Duke of Gloucester when rebuilding was necessary after a fire of 1428. It was here that Edward IV was proclaimed king in 1461, and the castle remained in royal hands, being ambitiously rebuilt by Henry VII. By that time the city, and particularly its western approaches, had been transformed, notably by the replacement of the castle by the courtyard house as a home for the nobility, and the development of the river bank or 'strand' between the two cities with such mansions. One of the earliest references to the 'inn' of the Bishops of Norwich on the riverside east of Durham House was to the repair of its quay in 1237. We know that the papal legate was lodged at Durham House the following year. The Count of Savoy was granted possession of his manor in 1246 by Henry III.

Soon after the end of the thirteenth-century Thameside, between the Fleet river just outside the city wall, and Ivy Lane running from the Strand to the Thames and marking the boundary of Westminster, had been occupied by the palaces, the 'inns', of great men. Most of these were churchmen: the abbots of Tewkesbury, Faversham and Winchcombe, for example, had built houses on the drier ground inland, part of what became the Bridewell site. Next, to the west, was the impressive inn of the Bishop of Salisbury. Then came the even bigger, more institutional complexes of the Whitefriars convent and the Inner, Middle and Outer Temples. Then in turn were the inns of the Bishops of Exeter, Bath, Llandaff, Coventry and Worcester. Beyond the Savoy Palace were the inns of the Bishops of Carlisle, Norwich and Durham.

Of Bishop Richard le Poor's original *Durham*

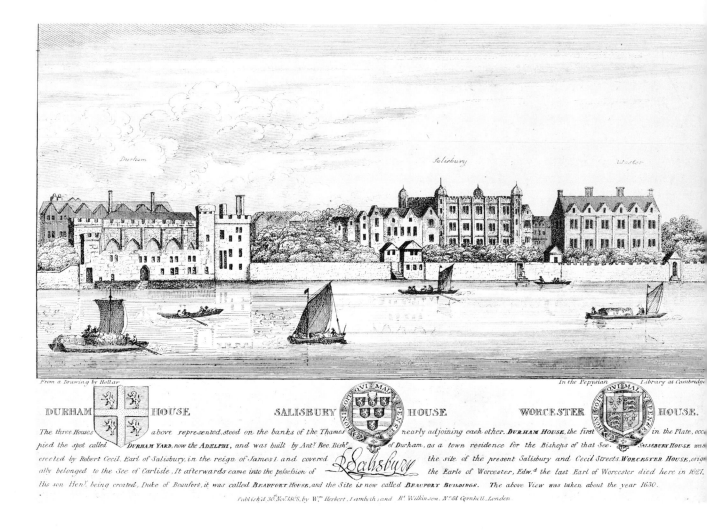

From a Drawing by Hollar *In the Pepysian Library at Cambridge*

DURHAM HOUSE. SALISBURY HOUSE WORCESTER HOUSE.

The three Houses above represented, stood on the banks of the Thames nearly adjoining each other. DURHAM HOUSE, the first in the Plate, occu-pied the spot called DURHAM YARD, now the ADELPHI, and was built by Antᵒ Bec, Bishᵖ of Durham, as a town residence for the Bishops of that See. SALISBURY HOUSE was erected by Robert Cecil, Earl of Salisbury, in the reign of James I. and covered the site of the present Salisbury and Cecil Streets. WORCESTER HOUSE, origin-ally belonged to the See of Carlisle. It afterwards came into the possession of the Earls of Worcester, Edwᵈ the last Earl of Worcester died here in 1627, his son Henᵞ being created, Duke of Beaufort, it was called BEAUFORT HOUSE, and the Site is now called BEAUFORT BUILDINGS. The above View was taken about the year 1630.

Publish'd 30ᵗ Novʳ 1808, by Wᵐ Herbert, Lambeth; and Rᵗ Wilkinson, Nᵒ 58 Cornhill, London.

1 *Durham, Salisbury and Worcester Houses in 1630. A Hollar draw-ing of three Strand palaces in three architectural forms. Durham House, virtually a castle, was first built in the thirteenth century. Worcester House was a many-gabled Elizabethan mansion, whereas Salisbury House – like its early Jacobean contemporary, Northumberland House, further west on the river bank – was more classically symmetrical. Four-square and turretted, this type was an English version of the Re-naissance palace self-consciously dressed in romantic medieval forms*

House little is known, for his inn of about 1230 was rebuilt by an architecturally ambitious prelate, Bishop Bec, at the turn of the century. It must have been regarded as splendid; in 1258 the great baron Simon de Montfort lived there. One day he offered Henry III shelter from a storm, but the King re-plied, 'thunder and lightning I fear much, but by the head of God I fear thee more'. Various map views, typically Norden's of 1593, suggest that Dur-ham House, tall, crenellated, with several towers and turrets, was the most impressive building on the river bank between the Temple and Whitehall.

Wolsey lodged there from 1516 to 1518, and in 1528 while the even grander York Place in White-hall was being rebuilt. In July 1536, the Bishop of Durham conveyed to Henry VIII 'all that his capy-tall messuage ... commonly called Durham Place ...' He was lucky in not being wholly uncompen-sated for his 'gift', the see of Durham receiving Coldharborough (Coldharbour) and other houses in recompense. Edward VI granted the house to his sister Elizabeth 'for life', but by 1553 the Duke of Northumberland had obtained possession. He was there by the time of Edward's death later that year, and arranged Lady Jane Grey's marriage and pro-clamation in the house.

Following that 'brief tragedy', Queen Mary re-turned the house to Tunstall, the same bishop who had conveyed it away. Indeed the comings and goings in this most historic residence were complex. King Philip of Spain stayed during Tunstall's second occupation. That was in 1555; four years later Tun-stall was turfed out again by the new monarch,

Elizabeth, who installed the famous Spanish ambassador, de Quadra. The year after his departure in 1565, the first of a series of favourites was granted the house: the Earl of Leicester. He was followed by Sir Henry Sidney and then in 1572 by the Earl of Essex. For 20 years until his fall and imprisonment in 1603 Sir Walter Raleigh lived at Durham Place.

No doubt in Raleigh's time much refurbishment was carried out. Norden described the house as being 'stately and high, supported with lofty marble pillars'. When dispossessed by James I, who re-installed the Bishop of Durham, Raleigh complained that he had spent £2000 out of his own purse. The then Bishop of Durham had a life hardly less irksome than his predecessor, for in 1604 his house was shorn of its Strand and Ivy Lane frontages by Sir Robert Cecil, who was shortly to become Earl of Salisbury. The garden of neighbouring Salisbury House itself was extended. Little Salisbury House (see page 27) was built on Ivy Lane and, in 1608, Cecil built the New Exchange on the Strand frontage. As if that was not enough, ambassadors continued to be billeted upon the bishops. 'Considering the large cost of repairs necessary for so old a fabric and the small enjoyment to be had of it', the Bishop of Durham was only too glad to agree to Charles I's proposal in 1641 that the house be granted to Philip, fourth Earl of Pembroke, in return for an annual payment of £200.

Pembroke planned a large new palace to be built to designs by John Webb, pupil and relative of Inigo Jones. He was frustrated by the Civil War. Parliamentary troops were quartered there, so Durham House was in a sorry state when repossessed by the fifth Earl at the Restoration. He sold it for development as housing. But not all was demolished. 'The front towards the river long remained a picturesque, and the stables or outhouses an unsightly ruin.'[1] The whole site was cleared of the newer housing and the remnants of the older palace to make way for the Adam brothers' Adelphi in 1769–70.

The Bishop of Norwich's inn was constructed, as has been noted, some time before 1237. Henry VIII obtained possession of it in the same year as its neighbour. There he installed his brother-in-law, Charles Brandon, Duke of Suffolk, at the same time providing the bishop with another house in Cannon Row, Westminster. The Duke surrendered the house to Queen Mary who granted it to the Archbishop of York in 1556. Two years later at Mary's death *York House* – as it was henceforward known – was given up to Nicholas Bacon, together with the Great Seal of England. For the next 70 years the house was in lease to successive Lords Keeper of that seal. Of this, one of London's most distinguished palaces, little architectural history is recorded. There is, however, no lack of political colour. The Earl of Essex attempted to gain possession of York Place in 1588, apparently successfully. A few years later he attempted similarly on the kingdom and he failed. His trials were in York Place in 1597 and again in 1600; he was condemned to death. Sir Francis Bacon, born in the house in 1561, succeeded as Lord Keeper in York Place in 1617. He was soon in disgrace, quite possibly as a result of the plotting against him by the king's favourite, George Villiers, Duke of Buckingham. Dismissed following his House of Lords trial for corruption in 1621, Bacon pleaded, 'York House is the house wherein my father died, and wherein I first breathed, and there will I yield my last breath, if so please God and the King will give me leave.'[2] The King did not do so. Bacon was allowed to return to London only after promising to give up York Place to Buckingham, which was probably the object of the whole exercise.

The extent of Buckingham's rebuilding is a subject on which authorities differ. He was usually short of funds. It is clear that Sir Balthazar Gerbier, who was in the Duke's service in various artistic capacities between 1616 and 1628, carried out repairs and decorations. He reported that the 'cabinet de Marbre' was being paved in about 1626, and that he was about to whiten the vaults.[3] Later he mentioned that King Charles I was 'graciously pleased to vouch he had seen in Anno 1628 (close to the Gate of York House, in a Roome not above 35 foot square) as much as could be represented (as to Sceans) in the great Banquetting Room of Whitehall.'[4] That 'Roome' was probably a gallery constructed in timber by Gerbier for the Duke. A contemporary spoke of walls 'covered with huge panes of glasse'; he meant mirrors, an expensive luxury then.

The French ambassador, attending a lavish reception on 8 October 1626, spoke of the Duke's residence as 'extremely fine ... the most richly fitted

up than any other I saw'. That same Maréchal de Basompierre also remarked in his dispatches about the ballets, the beautiful music and theatrical displays which accompanied supper. We would think of these entertainments as masques and recall, rather sadly, that Inigo Jones expended much of his genius, and the court much of its resources, on such ephemera. The art collections proved to be ephemeral too, being dispersed as far afield as Russia after the Parliamentary victory. The core of Buckingham's collection was that from Rubens's own house in Antwerp, which he had bought for a hundred thousand florins. This included statues, gems and other classical antiques, but above all a supreme collection of paintings: 19 by Titian, 17 by Tintoretto, 21 by Bassano, 18 by Veronese, three by Raphael, three by Leonardo and 13 by Rubens himself. Gerbier could well write to his employer, and not without a little reflected glory, that '... out of all the amateurs, and princes, and Kings, there is no one who has collected in forty years as many pictures as your Excellency has collected in five'.[5]

There were other riches too: 'the garden will be renowned so long as John de Bologna's "Cain and Abel" stand there, a piece of wondrous art and workmanship'.[6] But it was the Water Gate that survived to occasion wonder. Executed by Nicholas Stone, it was much studied and admired in the eighteenth century as a work of Inigo Jones. Most probably it was designed by Sir Balthazar Gerbier who used as a model the Fontaine de Médicis at the Luxembourg.[7] That gate in Paris was twice mentioned in Gerbiers' writings; furthermore Jones never saw it, whereas Gerbier had opportunity to do so on a trip to Paris in 1625.

The Duke did not live in York House, using it only for state entertainings. His London home was Wallingford House, where his son the second Duke was born in 1627. Buckingham was assassinated the following year – it was just as well that he had lived intensely. His widow went to live at York House. (Wallingford House, where the office of Lord High Admiral had become established, continued in that role and was eventually rebuilt as the Admiralty.) The dowager Duchess married the Earl of Antrim in 1635. They were evicted from York House during the Civil War, when it was presented to General Fairfax. In 1657, however, the general's daughter and heir was thoughtfully married to the second

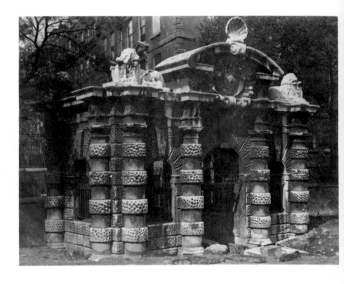

2 *York House, Watergate, built 1626. The only remains of the ducal palace, now marooned 150 yards from the river. In the centre of the broken pediment are the Villiers arms. Shown here in romantic decay before the restoration of the 1950s*

Duke of Buckingham. Cromwell agreed to Buckingham's living in the house so long as he did not leave it without permission. Being as headstrong as his father, Buckingham did so and found himself in the Tower. This contretemps was survived; at the Restoration all the Villiers properties were returned.

By this time York House was in a poor state however; indeed five years earlier Evelyn had noted in his diary: 'I went to see York House and gardens, belonging to the former greate Buckingham, but now much ruin'd thro' neglect.'[8] This may have resulted from its being let out to various ambassadors, including the Spanish and the Russian. For, although alleged to be the richest man in England, Buckingham spent beyond his means. In 1672 he raised £30,000 by selling York House and its gardens to building 'undertakers' Eldyn, Higgs and Hill. He specified that his name and title should be commemorated in George Street, Villiers Street, Duke Street, Of Alley and Buckingham Street.

The third of the thirteenth-century riverside palaces with which we deal was by far the shortest-lived. At his death in 1268, the Count of Savoy left some of the property to his niece, Eleanor of Provence, Henry III's Queen, but the bulk of the *Manor of the Savoy* was bequeathed to the monastery of St Bernard, of Montjoux, Savoie. In 1270 Eleanor bought it back for 300 marks, quite expen-

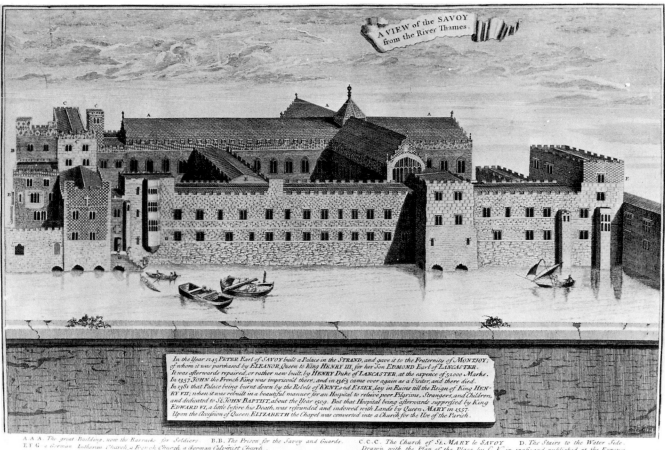

3 *The Palace of the Savoy, drawn by Vertue in 1736. The complex was largely reconstructed by Henry VII, but some of the lower sections of the riverside blocks have survived from the thirteenth century*

sively, since her husband had originally granted it for an annual rental of three barbed arrows. She gave it to her second son Edmund, Earl of Lancaster. In 1279 Alexander III of Scotland lodged there with Edmund 'Crouchback'.

The manor descended in turn to the Duke's two sons, Thomas and Henry; the latter caused a paved way to be constructed in front of the Savoy 'hostiel'. The next Earl and first Duke, Henry's son, also named Henry, added further properties to the estate in the period 1347–50. He was a powerful magnate and as a military commander his fame was second only to that of the Black Prince. With the rich booty from the capture of Bergerac in 1345 he 'repaired or rather new built' the Savoy. The sum expended was vast, variously described as 50,000 marks or £35,000, equivalent to perhaps ten millions today. The result was unequalled among the palaces of England. There are no pictorial records, but some idea can be gained from accounts of the building at the time of its destruction a generation later. A complex round at least two courtyards, it extended from the Strand to the river. This was not so great a distance as it became after later embankments, the medieval Thames being about twice as wide as the modern river. There were imposing gates to the street, probably with a turreted gatehouse, as well as river gates. Much of the building and certainly its external walls would have been of stone. Many of its roofs were thatched, the common material at the time. Probable exceptions would have been the great hall and the chapel, with lead roofs. Associated with those key elements were the cloisters; more distant were stables and pleasure gardens. Beyond them was a vegetable garden surrounded by a hedge, and a fish pond. Like a large country manor house, the Savoy would have been self-sufficient for day-to-day supplies; it had a bakehouse, brewery, laundry, blacksmith and dairy.

In 1357 King John of France was conducted to

the Savoy by his captor at the battle of Poitiers, the Black Prince. He was confined until 1360. In 1361 the Savoy was inherited by John of Gaunt, through his wife, Blanche, the Duke of Lancaster's daughter. Among their household of 150 knights was Geoffrey Chaucer. He had married Philipa Swynford, John of Gaunt's sister-in-law, in the palace chapel. In the early 1360s the French king was once again living in the Savoy, having returned voluntarily to England after his son had broken parole. He died there in 1365.

The Savoy Palace was a casualty of Wat Tyler's revolt which threatened the capital and indeed the kingdom; the building was sacked on 13 June 1381. John of Gaunt escaped, but his physician and serjeant-at-arms were killed. Most of the building was burned, together with its many treasures. It was reported that such were the ideals of the Peasants Revolt, that those who looted the wine cellars, or tried to make off with valuables, were themselves consigned to the flames or left by their peers to die in the collapsing cellars.

The palace was not fully rebuilt, but some re-use took place. Stephen Lote, who succeeded his partner Henry Yevele as Master Mason to the Crown in 1400, had carried out works at the Savoy for John of Gaunt in 1393-4.[9] Between 1404 and 1405 the Strand wall was rebuilt. Nonetheless, the history of the Savoy as a residence was over. Seventy years later Simeon's tower on the west side of the site was still standing, together with the great gate and the water gate – it was used as a prison during the fifteenth and sixteenth centuries. Much of the site was derelict until Henry VII, in an uncharacteristic act of charity, founded a 'common hospital' with 100 beds for the lodging of poor folk. He further endowed it in his will of 31 March 1509. Then there were no less than three chapels; today one of them remains and is known as the Savoy Chapel. The hospital was suppressed in 1553, re-endowed in 1556 and struggled on in increasing squalor until 1702, when it was finally dissolved. Other parts of the large site were variously used for an orphanage, barracks, a prison and tenement housing.

In its heyday the palace of the Savoy was a court-yard house 'writ large'. No complete medieval house of that type exists in London now. The nearest extant example is Penshurst Place, in Kent. The pattern was standard in its essentials. Approach was

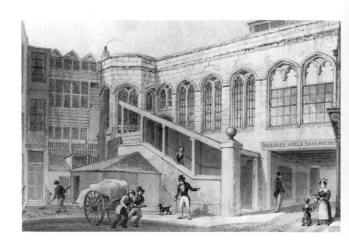

4 *Crosby Place, Bishopsgate. Nineteenth-century view of the hall, engulfed in commerce*

by a gatehouse in the street wall, which controlled entry into a court. The main range with the great hall would usually be opposite, with service buildings completing the other sides. The visitor crossed the court and entered the hall indirectly via a screens passage which separated it from the kitchens, buttery and pantries. The other end of the hall was the 'prestige' end; a high table on a dais was probably flooded with light from an oriel window. Beyond that was a stair to the family's private chambers which increased in size, number and luxury as the centuries passed. Certainly by 1350 there would have been a private dining room with its own hooded chimney on an outer wall. The family would usually eat here, rather than in the great hall with its smoky central open fire of the type that can still be seen at Penshurst. The door at the further end of the screens passage often led to another, more intimate court and to gardens and orchards beyond that.

Construction was predominantly of stone, with oak panelling, doors and roofs. Bricks had been imported from the Low Countries in the fourteenth century but were seldom used in quantity until the mid-fifteenth. The walls of Sir John Crosby's mansion in Bishopsgate, built in 1466, were of ashlar stone but the vaulting of the undercroft was in brickwork. *Crosby Place* was an appropriate setting for the semi-royal court of the Duke of Gloucester, who indeed had himself proclaimed Richard III there. It is mentioned three times in Shakespeare's

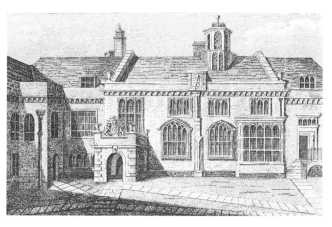

6 *The Charterhouse, north of the city near Aldersgate Street. A Carthusian monastry of c. 1370, built in part by the master mason, Henry Yevele. Converted into a residence after 1545 and, in 1611, into a school. Despite the later porch and lantern, here is a typical late medieval hall*

5 *Crosby Place, Bishopsgate. The fine bay window had a vaulted ceiling, seen complete with its added chimney, in illustration 4*

play. Later occupants included Sir Thomas More, before his removal to Chelsea. At the end of the sixteenth century Sir John Spencer 'made great reparations', having recently purchased what Stow's Survey described as 'This house ... very large and beautiful, and the highest at that time in London.' In the following three centuries, however, Crosby Place became successively a non-conformist meeting house, a company office, a wine merchant's warehouse and then a restaurant before partial demolition.

The hall of Crosby Place survives, as does another smaller hall just to the west of the City, *Barnard's Inn*. The latter was built in Holborn in the early fifteenth century by the Dean of Lincoln and be-

queathed by him to become an Inn or College for lawyers. Complete with original stone walls and timber roof with a louvre for smoke, it is probably the earliest surviving fragment of a medieval city mansion and, remarkably, is still used as a dining hall.[10] Barnard's Inn hall has been much restored, so has that of the *Charterhouse*, a former Carthusian priory north of Smithfield. Nonetheless here again some idea can be obtained of the courtyard and hall, with the cloister which was not exclusive to ecclesiastical buildings. It was converted into a town mansion by Sir Edward North after the Dissolution.

The late-thirteenth-century chapel of St Ethelreda in Ely Place, all that remains of the Bishop of Ely's London palace, represents another constituent element of the greater houses. Like most large medieval urban buildings it had a crypt or undercroft; several such cellars survived long after the buildings above had vanished, and sometimes they became filled with rubble as ground levels rose. A number of fine undercrofts in the City were discovered during nineteenth-century redevelopment, but were not preserved. One such was identified as late as 1980 in Philpot Lane. Transformed into the kitchen of a restaurant, with its brick vaulting and four-centred stone arches of about 1500 disguised by layers of plaster and paint, it just escaped demolition. A slightly later and finer example, the wine cellar of York Place, Cardinal Wolsey's Whitehall palace,

was also nearly destroyed in a 1940s government building project.

For examples of palatial gatehouses in London it is necessary to turn to buildings which were hardly 'private': namely Lambeth Palace built by Bishop Morton in 1495 and St James's Palace built for Henry VIII 40 years later. Both are of fine Tudor brickwork with stone dressings. This impressive form survived into the sixteenth and even early seventeenth centuries in such non-gothic structures as Somerset and Northumberland houses. Ecclesiastical palaces are essentially outside the scope of this account, but since most of the bishop's houses or 'inns' were later taken over by noblemen, their architectural importance cannot be ignored.

Most of the great monastic complexes were adapted for lay domestic use. For example, the Marquis of Winchester created his mansion out of part of the precinct of the Austin Friars near Broad Street.[11] Holy Trinity Aldgate went to Lord Audley, Blackfriars passed to Sir Thomas Cawarden,[12] the Charterhouse to Sir Edward, later Lord, North, the leper hospital of St Giles to Lord Dudley. The leper hospital of St James was retained by Henry VIII and became St James's Palace. Converted monastic precincts produced courtyard mansions of irregular form, unsatisfactory in that the former purpose centred on a now-redundant building, the church. At Austin Friars Paulet gave the western part of the church to the Dutch community, and its use for worship ensured survival up to the Second World War. Most of the churches were destroyed.

London, until the reign of Elizabeth, was still essentially the Roman 'square mile'. Most of the population of 20,000 in 1380 lived within the walls.[13] The original form of local government relates to the largest type of town house 'which was in all essential respects the same as a country manor house'.[14] Within the city walls land was divided according to the same manorial system as in rural areas. 'The wards of the City have grown out of manors with their surrounding cottages, and the parishes at least to some extent out of the chapels of manor houses.'[15]

By 1530 the population in the City itself had nearly doubled to about 35,000; the available land was densely built over. London as a whole housed about 50,000. By 1605 this had grown dramatically to 225,000, of whom 75,000 were within the City.

Building densities were remarkable, streets narrow with jettied houses practically meeting at higher levels. With open drains and a virtually permanent pall of smoke from coal and charcoal fires, it was not surprising that, although suburban development spread both east and west, it was mainly in the latter direction, that of the prevailing winds, that the rich and powerful chose to migrate.

The only river crossing was London Bridge. Roads were bad; a complaint of 1532 spoke of the 'pits and sloughs' in the Strand.[16] There were also footpads. So the usual form of transport to the Tower, to Southwark, and *en route* to Kent and the Continent for all who could afford it, was by barge. Map views, including the earliest by 'Agas' of about 1565, show the Thames full of boats, including in that case the royal barge. No wonder the riverside palaces between Temple and Charing Cross, all with their own water gates, found their way into the hands of the most puissant nobility. Not that the powerful had quite evacuated the City by the sixteenth century. It 'was still the home of great men', says Pevsner, who quotes research showing that in 1595 there were 121 families living there who also possessed country seats.[17] Derby House in Baynard's Ward was retained by the Earl until 1555, when he donated it to the College of Arms. By that time his new mansion in Cannon Row, Westminster, was nearing completion. Even today there are reminders: Warwick Square is the site of the courtyard of Warwick the Kingmaker's house. The home of the de la Poles, Dukes of Suffolk, is commemorated in Suffolk Lane and more obscurely in the nearby Duck's – that is Duke's – Foot Lane.

Some corruptions are so thorough as to almost defy translation – thus Bucklersbury, originally 'Bokerelesburi', named after the wealthy thirteenth-century family of Bokerel or Bukerel, whose manor this was. Another surviving manorial name is that of the Blemund family, thus 'Bloomsbury'. At the aristocratic level, London was a city of many mansions similarly named but belonging to different families who had borne the same title in various centuries; in certain cases different members of the same family had given their name, or one family had moved from place to place. Thus, apart from the Suffolk House of the de la Pole family, there was the rather later Suffolk House in

Georgius Vertue Londini delineavit et sculpsit anno MDCCXXXIX.

Southwark, built by Charles Brandon, Duke of Suffolk. Later still, Suffolk House at Charing Cross was in the Howard family from 1617 to 1646, before becoming Northumberland House under a new owner, Algernon Percy. There had been other Percy mansions too; the Earl of Northumberland's house in Seething Lane had already become a gaming house when Stow writes of it in the 1590s. The Earl's son, famed as 'Hotspur', had also owned a mansion not far away, at the corner of Aldersgate Street and Bull and Mouth Street. This building was splendid enough for later occupation by Henry IV's Queen, and was known for a time as the Queen's Wardrobe. It too went down in the world, later becoming a printing works and a tavern. Of York and of Montagu houses there were each some half-dozen in different locations.

Only two significant houses have borne the name *Devonshire House*, and they were both Cavendish

7 *Gresham College was established soon after Sir Thomas Gresham's death in the courtyard house he built in 1566. The Green Court was largely arcaded and had more of the character of a Renaissance palace than the rather forbidding exterior suggested*

homes. Devonshire Square, Bishopsgate, was named after the earlier Devonshire House, one of the grandest in the City. It was built by a lawyer, Jasper Fisher, probably in the 1560s. Large and beautiful, with extensive gardens, it had apparently stretched its builder's finances and became known as 'Fisher's Folly'. It was occupied among others by Sir Roger Manners, and later the Earl of Oxford who entertained Queen Elizabeth there. In the following reign owners included the Earl of Argylle and then the Marquis of Hamilton, before purchase by the second Earl of Devonshire in about 1625. Devonshire House, as it was by now called,

remained in the Cavendish family throughout the seventeenth century.

Another splendid City residence was that of Sir Richard Whittington. Thrice Lord Mayor, born well-to-do, he rose to be a merchant prince. He supported three successive English kings with loans, and left a fortune equivalent to the wealth of a medium-sized kingdom. Unfortunately not a wrack remains of any of his colleges, libraries or alms-houses, nor even of his vast public lavatory. Nor do we have any reliable record of his own house in College Hill, though typically there are several seventeenth-, eighteenth- and nineteenth-century views of 'Whittington's Palace', all in a style of architecture at least a century too late.

A later merchant prince and benefactor, Sir Thomas Gresham, built a house which became *Gresham College* after the death of Sir Thomas's widow in 1596, survived for nearly two centuries and was well recorded, at least as to the externals. According to Stow it was 'built of brick and timber, and the most spacious of all there about'. The chief court-yard was at least partly arcaded with plain Tuscan columns and semi-circular arches possibly inspired by those at Somerset House a few years earlier.

Gresham's house escaped the Fire of London; most mansions did not. One such had been bought in 1334 by Sir John Pulteney and was usually called 'Coldharbour' but sometimes 'Pulteney's Inn'. This is not to be confused with his Pountney Lane House, called the *Manor of the Rose*.[19] Why this plutocrat required two impressive dwellings in such proximity is unclear. It was apparently for the Manor that Pulteney obtained a royal licence to crenellate, that is to fortify, in 1341. Its tower is visible in the 'Agas' map of about 1550, which also shows Coldharbour with stairs and a landing stage. Perhaps the river-bank house with facilities for storing and handling goods was his commercial headquarters, and paralleled Sir Thomas Gresham's extensive ware-house and business premises adjacent to his Bishops-gate/Broad Street mansion.

After Pulteney's death in 1349, Coldharbour passed through several hands including those of the Crown. In 1485 Richard III granted it to the newly founded College of Heralds. Naturally this grant was revoked by his successful rival Henry VII, who rewarded George Talbot, fourth Earl of Shrewsbury with the mansion.[20] The history of the house then

View in Passage.

8 *The Manor of the Rose, Laurence Pountney Hill. The undercroft of one of Sir John Pulteney's fourteenth-century mansions. Sketches published by* The Standard *newspaper in 1894 when there was an abortive campaign to dissuade the developers from demolition*

is obscure; it appears to have been alienated from the Talbots after the fourth Earl's death in 1541, but granted again to the fifth Earl in 1553. At about that time there must have been extensive changes. A view in the Guildhall Library shows a lofty five-gabled, four-storey block on a substantial river wall, a much more impressive building than that of 1550. Shortly before the end of the century, however, the sixth Earl 'took it down, and in place thereof built a great number of small tenements, letten out'.[21] The Manor of the Rose also passed through aristocratic hands. In Stow's *Survey* of 1598 it was said to be 'an house sometime belonging to the Duke of

Buckingham, wherein the said school is kept' [i.e. the Merchant Taylors' School]. There was a sequel in 1894 when a vaulted undercroft was discovered during building operations; despite protests it was destroyed. Of the City Mansion of the Earls of Abergavenny there is only documentary evidence: 'At the north end of Ave Mary Lane, is one great house builded of stone and timber, of old time pertaining to John, Duke of Britaine ... Since that it is called Pembrook's Inn ... as belonging to the Earls of Pembroke ... It is now called *Burgaveny House*, and belongeth to the late Lord of Burgaveny.'[22] This house was later (1611) purchased by the Stationers Company, destroyed in the Great Fire and rebuilt in 1670.

Only one City Street, Aldersgate, was considered an appropriate setting for the houses of the nobility after the Great Fire. Howell in *Londinopolis* had written:

> This street resembleth an Italian Street more than any other in London, by reason of the spaciousness and uniformity of buildings, and straightness thereof, with the convenient distance of the houses; on both sides whereof there are divers fair ones, as Peter House, the palace now and mansion of the most noble Marquess of Dorchester. Then is there the Earl of Thanet's house, with the Moon and Sun taverns, very fair structures.[23]

Peter or *Petre House* was the residence of the Lords Petre from 1550 to 1639. During the Commonwealth it was used as a Parliamentary prison for, among others, Richard Lovelace the poet. Before the Restoration Henry Pierrepont, Marquis of Dorchester, was in occupation – but not for long, for in 1666 the see of London bought the building for the bishop whose house near St Paul's had been destroyed. Henceforward it was called London House.

On the opposite, that is the eastern side of the street, only about 60 feet from its northern termination at the Barbican stood Thanet House, later *Shaftesbury House*. A courtyard plan, with extensive gardens behind, this was the London base of the Tuftons, Earls of Thanet. In the early 1640s it acquired a new, classical, street front.

Anthony Ashley Cooper, Earl of Shaftesbury, was the tenant from 1676 until his death in 1682, but the building was known as Shaftesbury House for two centuries. The philosopher Locke stayed with his intellectual friend in Aldersgate Street from his return from the Continent in May 1679, a time when Shaftesbury was chief minister of the Crown.

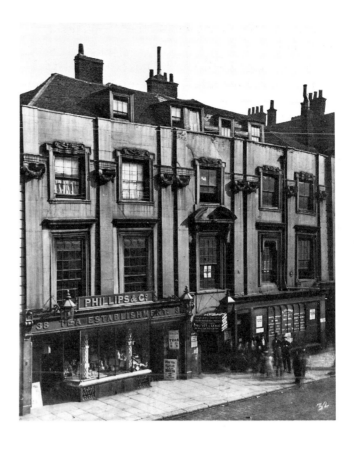

9 *Shaftesbury (ex Thanet) House, Aldersgate Street. The artisan classical front to a former courtyard house. Ionic pilasters decorated with garlands at the volutes, commonly attributed to Inigo Jones because of certain similarities with Lindsey House, Lincoln's Inn Fields, also of the 1640s*

The house had reverted to the Tuftons by 1708 but, as Seymour wrote in 1736, 'the politeness of the town is far removed from hence'.[24] By 1720 the building was an inn; by 1734 it was a mere tavern and then between 1750 and 1771 the London Lying-in Hospital. It survived in various commercial uses until 1882.

A near neighbour on Aldersgate was *Lauderdale House*, the town residence of the duke whose name represented the L in the famous CABAL Ministry. His career bore similarities with Shaftesbury's, and was ended by death at roughly the same time. His house, however, differed, being brick-faced and set back from the street. It was probably altogether more old-fashioned.

Of the Aldersgate residence of the Nevilles, Earls of Westmoreland, all that is known is that Pennant regarded it as 'a magnificent pile'. By his time it had degenerated into tenements. Demolished in

1760, it was long commemorated in 'Westmorland Buildings'.

Nearby again was *Bridgewater House*, Barbican. Originally known as the Garter House, and so shown on the 'Agas' map, this was built by Thomas Wriothesley, who was Garter King of Arms in 1504. At the end of the century it became the town house of the Earls of Bridgewater. A fire destroyed the mansion in 1687, two of the earl's children dying in the blaze.

The great days of Strand palaces were in the reigns of Elizabeth, James I and Charles I. Houses bearing similar names were built on different sites, especially by members of the Russell and Cecil families. There were also owners rejoicing in titles, for example Salisbury and Worcester, common to the bishops whose inns had previously occupied sites in the locality. So familiar names recur. One such was the sixteenth-century *Exeter House*, quite unrelated to the Bishop of Exeter's Inn next the Temple in the fourteenth century. This house was built on 'four messuages', that is holdings, on the Strand opposite the Savoy. Originally belonging to the manor of the Savoy, later the property of the parson of St Martin in the Fields, it then 'by composition came to Sir Thomas Palmer, Knight, in the reign of Edward VI, who began to build the same of brick and timber very large and spacious; but of later time it hath been far more beautifully increased by the late Sir William Cicile, Baron of Burghley'.[25] Stow fails to mention that Palmer had lost his head in 1553.

This house was one of the more splendid of town residences. It was four-square, presumably with an inner courtyard, certainly with turrets at each corner. An elaborate example of Tudor brickwork, it was 'curiouslye bewtified with rare devises'.[26] Burghley kept a household of 80. Elizabeth I, having given the place to one of her chief servants, visited him there on several occasions. The name was variously Cecil or Burghley House; the position was not clarified by the fact that another house for Lord Burghley's son, Sir Robert Cecil, was built alongside it to the east – naturally that was also called Cecil House.

A further change in name occurred after Lord Burghley died in 1598. His son Thomas, who succeeded, was created Earl of Exeter in 1605. He does not appear to have enjoyed exclusive use of the residence, for in 1617 Lady Hatton rented it. In 1623, shortly after the death of the first Earl, part of Henrietta Maria's suite lodged there prior to her marriage to Prince Charles. She returned briefly, as his widow, after the Restoration in 1660. A few years later the house was back in private occupation, that of the first Earl of Shaftesbury, whose second wife was daughter of the third Earl of Exeter. In 1671 his grandson, the future third Earl was born there. He was to be a philosopher like his tutor John Locke. The mansion was demolished in 1676. The site was developed as Exeter and Burleigh Streets, as well as Exeter Change.

Wimbledon House was also known as Cecil House on occasion. Another significant mansion of the Burghley clan, it was erected on part of the Exeter House property by a grandson of Lord Burghley. Sir Edward Cecil (d. 1638) was the first and last Baron Putney and Viscount Wimbledon. He was a client of Inigo Jones. Perhaps that architect did not design the house as a whole, but there is evidence from a 1619 Smythson drawing of a balcony, that he worked there. 'The Pergular at Coronall Sissel's House in the Strande' it is labelled, and matches an untitled drawing by Jones himself.[27]

Wimbledon House survived as a prominent Strand landmark until 1782, far longer than many of its better-known neighbours. One such neighbour was *Worcester House*. Land immediately to the west of the Savoy had, in the Middle Ages, been occupied by the town house of the Bishops of Carlisle. In 1539 John Russell, first Earl of Bedford, obtained the property. The 'Agas' map of 1560, and indeed Faithorne and Newcourt's view a century later, both indicate a relatively modest and compact house, but of several storeys and gables, built as a solid pile. Its gardens stretched to the river.

The house was left by the second Earl in 1585 to his grand-daughters. Another site on the north side of the Strand, hitherto used for stables, went to his grandson, Edward, who became the third Earl. There a second Bedford House was built for him the following year. Meanwhile his sister, Anne, in whom the earlier house had been vested, married Henry Somerset, Lord Herbert, who later succeeded as Earl of Worcester. Thus the house acquired the name by which it was subsequently known. It should not be confused with the medieval Bishop of Worcester's Inn to the east of the Savoy,

or with the Worcester House also on the river, but, as shown on the 'Agas' map, at Garlickhithe in the City.

Worcester House was forfeited to Parliament during the Civil War; it was used to store confiscated goods and as the seat of various committees and commissions. In 1657 the Worcester family were back and in 1660 the then Marquis of Worcester made a great show of offering the place, rent-free, to Lord Clarendon only 12 days after the Restoration.[28] In fact the Chancellor paid £500 a year, even though Worcester House was 'not in so good reparation'. Here, only three months later, the wedding took place of Clarendon's daughter, Anne Hyde, to the Duke of York, the king's brother. During the Chancellor's six-year tenancy, Worcester House was the setting for much public and official life. As early as 20 August 1660, Pepys mentions a conference 'betwixt the Episcopal and Nonconformist Divines' taking place in the great hall.

Clarendon later moved to Berkshire House, St James, while his new mansion in Piccadilly was being made ready. Worcester House does not seem to have been a residence after 1666. It was again used for various official functions before demolition in about 1680. The family retained the property after redevelopment as Beaufort Buildings – the third Marquis having been created Duke of Beaufort in 1682, the year he bought a house in Chelsea.

Next to Worcester House on the west was *Salisbury House*, an impressive pile, as shown on Faithorne and Newcourt's 1658 view. Its origins were early in the reign of Henry VIII, when Thomas, Lord Dacre built himself a house in 'Carlisle Rents'; his granddaughter married Lord William Howard who rebuilt the house. Virtually nothing is known of these, the first two mansions on the site.

It was Robert, the younger son of Elizabeth's great minister Lord Burghley, who was responsible for a palace designed to reflect his new style as Earl of Salisbury. Following his father's death in 1598 and the passing of the family property on the north side of the Strand to the elder brother Thomas, shortly to be Earl of Exeter, Sir Robert Cecil, as he still was, bought Lord Dacre's former house. He also bought other parcels of land south of the street, and part of Durham House garden, and further extended his site by moving Ivy Lane westwards. The building of Salisbury House was supervised by

Simon Basil, Surveyor of the Works to the Queen. Indeed the aged Elizabeth visited the part-finished building in 1602. Work continued until 1610.

At this time Little Salisbury House was also created to the west of the main building, whether originally a subdivision or built separately is not clear. Little Salisbury House, 'which was used to be let out to persons of quality', being also a large house,[29] was tenanted by among others the third Earl of Devonshire, father of the first Duke. The Earl provided a home there for his former tutor, the philosopher Thomas Hobbes. In 1672 the third Earl of Salisbury converted the 'Little' house into an 'Exchange' of shops, the seventeenth-century version of an indoor shopping arcade. Salisbury House itself was demolished in 1694 by the guardians of the fifth Earl. Cecil Street was created. The whole of the Salisbury estate on the Strand was sold in 1888; most is now occupied by Shell Mex House.

Allusion has been made to the second *Bedford House*, built for the young third Earl of Bedford in 1586. It was on a piece of land quaintly called Friars Pyes which had been acquired by the first Earl in 1541. The older Bedford House having gone to the female grandchildren, his aunt and guardian the Countess of Warwick initiated the construction of a new house in 1586. Its gardens occupied part of the former convent garden which was later to lend its name to London's first piazza. The mansion was of increasingly irregular plan as further ranges were added. An inventory of 1643, when Parliament took over, speaks of 23 hearths, but by 1673 the then earl was taxed for 60 hearths. Hollar's view of some years earlier had shown Bedford House covering a considerable site area.

On the Strand front was a 100-foot-long, two-storey, timber-framed range with great gates in an arched opening at the east end. Three evenly spaced oriel windows lit the 'gallery next the Strand' and a turret room. An ogee-roofed stair tower rose behind this block at the west end. The courtyard wing on this side was also timber-framed, and appeared to lead to a great hall. To the north again was another courtyard with two-storey buildings round three sides; beyond that was a further northern wing which terminated one end of Maiden Lane. The whole complex was completed by service and stable blocks, a large formal garden and a 'wilderness' with trees.

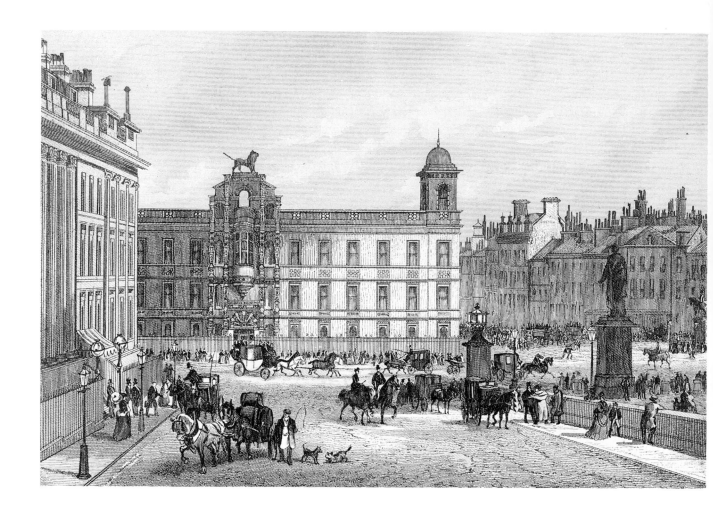

10 *Northumberland House, an engraving of c. 1870, showing the dominant position of this palace on the south-east side of the recently formed Trafalgar Square. Soon it would be swept away by municipal vandals. The flamboyant central gatehouse looked back to the style of Robert Smythson at Wollaton Hall in the 1580s. The corner turrets had been lowered by one storey in the eighteenth century, the Percy lion was added in that period; and the rest of the front 'Georgianized'*

Strype wrote of 'a large but old-built house, having a great yard before it for the reception of coaches: with a spacious garden, having a terrace walk adjoining to the brick wall next the garden'.[30] There was a series of building works after the Restoration and a 'new building for the Earle of Bedford' was completed to the design of Capt. Richard Ryder as late as 1682. But the days of this Bedford House was limited; the Russells moved out soon after the death of the fifth Earl and first Duke in 1700. The young successor moved somewhat westwards to live with his mother at Southampton House, Bloomsbury, which in due course became the third Bedford House. The Strand mansion was demolished in 1705–6; it was replaced by South-

ampton and Tavistock Streets and Tavistock Row.

Further west the Hungerford family were in possession of a large site stretching from the Strand to the river. The first mansion was built by Sir Walter Hungerford in 1422, three years before he was created baron. The next couple of generations of this unattractive tribe met violent ends, and in 1469 their property was confiscated. *Hungerford House* was granted to Ann, widow of Humphrey Stafford, Duke of Buckingham. She re-married and lived there until 1479. Henry VII had a way of reversing his predecessor's decisions, and at least part of the estate was restored. Sir William Hungerford maintained the family's reputation for nastiness, unless history has maligned him, and Sir Walter Hungerford was beheaded in 1540. However, the estates were once more returned by Queen Mary.

On the parliamentary side in the Civil War, the then head of the house is said to have 'carried out his duties with unpleasant zeal'. After the Restoration the Hungerfords – not surprisingly – failed to prosper. The last of the line, Sir Edward, having

wasted his substance in foolish extravagances, decided to retrieve them by speculation. The mansion having burnt down in 1669, he built Hungerford Market on the site. Completed in 1682, it never succeeded in its aim of rivalling nearby Covent Garden. Rebuilt and enlarged by Charles Fowler in 1833, it was later replaced by Charing Cross railway station. The railway bridge there is still known by the name 'Hungerford'.

At the junction of the Strand and Whitehall was a small hamlet called Charing. A number of modest properties there were demolished in about 1605 when Henry Howard, first Earl of Northampton, began assembling a large site for a mansion. Among the accomplishments of an Elizabethan courtier was the abilities to make music, write verse and draw 'plattes' or plans. Henry Howard was certainly capable of the last – he was largely responsible for the building of Audley End for his nephew the first Earl of Suffolk. The new London house was of courtyard form, with corner towers. Northampton House (later known as *Northumberland House*) shared with Audley End a 'repertoire of Anglo-Flemish ornament'.[31] There was another important shared factor, the presence as surveyor of Bernard Janssen, originally from Amsterdam. Craftsmen from the Low Countries were certainly also involved, and prominent among them Gerald Christmas.

These men were responsible for creating a monument. Its large scale, its key position, the eminence of its owners, caused the house to be regarded as part of the fabric of the capital, like Westminster Hall or the Tower. Thus Canaletto painted it; and thus even the hypercritical James Ralph is uncharacteristically subdued: 'Northumberland House is very much in the Gothic taste; and, of course, cannot be supposed very elegant and beautiful; and yet there is a grandeur and majesty in it, that strikes every spectator with a veneration for it; this owing entirely to the simplicity of its parts, the greatness of its extent and the romantic air of the towers at the angles.'[32]

Regular externally, the central court was 81 feet square and the street front 162 feet long. On the south side of the court was a great hall placed asymmetrically, a medieval feature. The open arcade, however, must have seemed modern at the time. Bays and oriels were disposed in a balanced way, but they related only vaguely to the spaces behind.

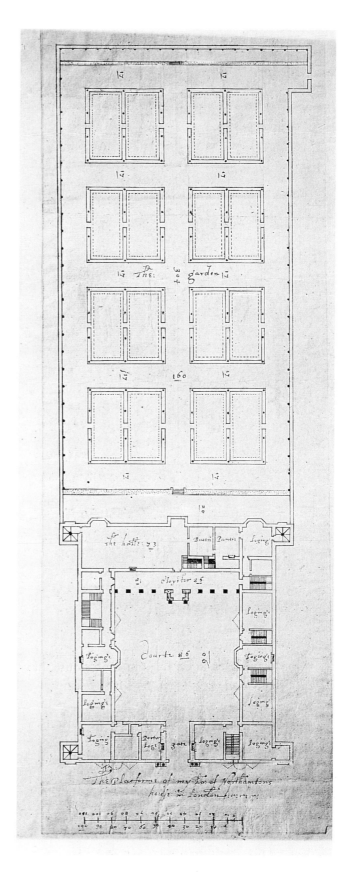

11 '*The Platforme of my Lord of Northampton's house in London*' was how John Smythson labelled his 1618/19 drawing of the plan of this regularized courtyard house of 1605–9, with its formal garden to the south

The rooms round the court were not organized in any grand or sequential fashion. They constituted, with their separate doors and stairs, lodging for members of the household. It was like a college. Yet the whole thing was tricked up in what passed in Jacobean times for classical ornament.

The Strand front was most ambitious: three storeys of brickwork with stone dressings and the central feature, an exotic reinterpretation of the medieval gatehouse was a three-bay, four-stage carved stone frontispiece. A wide entrance arch, with a tall mullioned oriel window over, was framed on either side by pairs of heavily carved and tapered pilasters, with arched niches between them. To describe the 'extreme impurity' of the decoration we can do no better than rely on Summerson who characterized the style as 'essentially a version of Italian Mannerism brought to a pitch of stylization beyond that to which Rosso brought it at Fontainebleau ... more outrageous than the strapwork of de Vries...'[33] The front was topped by a high parapet with alternating solid and fretwork panels.

Henry Howard, who had been out of favour in Elizabeth's reign because of his sympathies with Catholicism and with Mary, Queen of Scots, was naturally favoured by the latter's son, James. Made a Privy Councillor and an earl in 1604, the year before he started his great house, Northampton only occupied it for some half-dozen years. At his death in 1614 he was succeeded by his nephew, the first Earl of Suffolk, who himself died in the London house a dozen years later. Theophilus, the second Earl, was succeeded by his son in 1640, but two years later the house effectively passed from the Howard family.

Elizabeth, second daughter of the second Earl, married Algernon Percy, tenth Earl of Northumberland. The marriage settlement involved the transfer of what was henceforward known as Northumberland House to Percy, upon payment of £15,000 to his wife's family. A man of moderation and tact, unlike his forebears as portrayed by Shakespeare, Percy managed to keep in with Parliament during the Commonwealth and with the king at the Restoration. During the years 1657-60 significant alterations by John Webb relocated the main living accommodation from the Strand front to the garden side. Rooms facing south-east, towards the river and away from the noise of the street, must have been more pleasant. Drawings by Webb for chimneypieces for both the dining room and the withdrawing room exist at the RIBA; and there is an account at Alnwick Castle from Edward Marshall for masons' works which included £200 for 'great stone stairs' from the dining room down to the terrace.[34]

The tenth Earl's immediate successors were content with the house. In 1670 the eleventh Earl died leaving the place to his three-year-old daughter Elizabeth, thus ending the direct male Percy line. She made unfortunate marriages: as virtually a child to Lord Ogle, who shortly died, and then a year later in 1681 to Thomas Thynne who also soon died. Thynne was murdered in the Haymarket by a jealous admirer of Elizabeth, Count Koningsmarck, an event recorded graphically on the victim's Westminster Abbey memorial. Lady Elizabeth was soon wed again, this time to Charles Seymour, the 'proud' Duke of Somerset. She died in 1722, he in 1748, having remarried. Their son, Earl of Northumberland in a new creation, had no male children. He was shortly succeeded by his son-in-law, Sir Hugh Smithson, who was later raised to Duke of Northumberland.

Meanwhile Northumberland House was being altered radically. Two projecting wings were being built on the garden side which involved the final removal of the towers there. They extended over 100 feet and contained a ballroom and a picture gallery. The latter was particularly splendid with a heavy modillioned cornice and decorated frieze below a coved and panelled ceiling, all in a late Palladian style. Walpole wrote of a 'sumptuous chamber, ... might have been in better taste'.[35] The architect was Daniel Garrett, who was also responsible for the almost total reconstruction of the Strand front in 1748-50, topped by the famous Percy lion. This cast lead figure is now at the Northumberlands' London suburban mansion, Syon House. Garrett died early in 1753, and much of his work was taken over by James Paine, who completed the gallery in 1757. In the mid-1760s, the walls facing the courtyard were re-faced in stone by Robert Mylne; the open arcade disappeared in the process. Mylne may also have been the architect who extended the wings, and altered the great stair on the garden side.[36]

Lord and Lady Northumberland, as they were

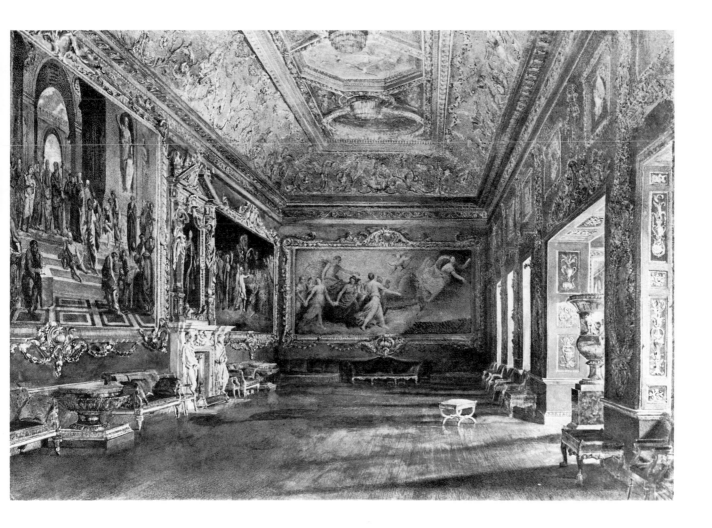

known until 1766, were immensely rich – he from a great-grandfather's haberdashery fortune, she from ancient estates. They were also handsome, cultivated and capable. She helped her son win an election campaign, against Wilkes, for the Westminster seat. She was Lady of the Bedchamber to Queen Charlotte, whose retinue her own outnumbered, according to Walpole.[37] She was also a connoisseur of art and a leader in decorative fashions. He was businesslike and held a number of important public offices as well as running the family properties efficiently. He was lavish in building works at all three major residences: Alnwick, Syon and Northumberland House. His natural son was James Smithson (b. 1765) who founded the Smithsonian Institute in Washington. The Northumberlands were enthusiastic hosts. They were also for a quarter-century among Robert Adam's most important clients.

Adam was commissioned in 1770 to redecorate the state rooms in the south range. In particular he

12 *Northumberland House. The picture gallery of c. 1750 was 106 feet long – an early and sumptuous example of the type of apartment which was added to or incorporated in most mansions in the next century and a half*

designed for the Duke and Duchess one of his most brilliant and daring interiors, the glass drawing room; 'it was a creation suited to the Duke's expensive taste and to the glittering entertainments for which Northumberland House was famous'.[38] Unfortunately the Duchess died in 1776, only a year after the work was completed. The drawing room measured 36 feet by 22 feet; it had eight large pier glasses or mirrors, while the rest of the wall surface was panelled with richly shimmering red and green glass, framed and overlain with the delicate neoclassical motifs of Adam's middle period. Nothing was understated; the ceiling design was among the architect's richest, with motifs akin to his Etruscan mode and paintings perhaps by Angelica Kauffmann. There was little space for paintings on the

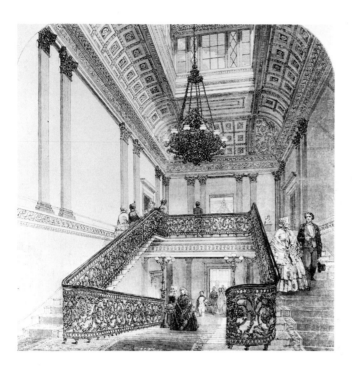

13 *Northumberland House. The grand marble staircase engraved in 1851 when the house was open to the public in connection with the Great Exhibition*

walls, but ample room for Adam's settees, chairs and pier tables. On top of the latter were numerous candelabra to light and reflect the scene. The notable marble and composition chimneypiece is now in the green drawing room at Syon House.

Two other major alterations affected Northumberland House during its remaining century of existence. On 15 March 1780 fire broke out at the east end of the second storey of the Strand front, destroying the first and second floors. It was rebuilt much as before, except that the towers were reduced by one storey. The other change was necessitated by structural weakness in the south façade. In 1819 Thomas Cundy rebuilt the wall five feet south of the old one and with seven bays instead of nine. The grand first-floor apartments were altered, including the glass drawing room which lost a window and gained considerable width. As part of this work, which continued until 1824, Cundy also built a new grand staircase. This was the feature most admired in the later days of the house. The guide book produced at the time of the Great Exhibition of 1851, when the fourth Duke opened the house, spoke of the 'Magnificent staircase ... without exception the most splendid feature of the building'.

The picture collection, some of which has now found its way into national galleries, was also remarkable. It included such masterpieces as Titian's 'Cornaro Family', as well as its share of copies. In 1874 these and other of the contents were to find their way into other Percy homes, especially the new London residence at 2 Grosvenor Place. For years the survival of such a venerable pile had seemed like an affront to the forward-looking men of the railway age, and from the 1830s the spirit of glamour had undeniably departed from the house. It was especially neglected under the fourth Duke, a scholar recluse. The old palace was a little isolated after Trafalgar Square had been created in front of it and the Embankment behind. Nonetheless the sixth Duke resisted pressure to sell to the Metropolitan Board of Works in 1866. A few years later he was forced to give way; the house and grounds were sold for £500,000. A quite useless road, Northumberland Avenue, lined with uninteresting hotels was constructed in the place of 'this great historical house, commenced by a Howard, continued by a Percy, and completed by a Seymour',[39] and this despite a fierce conservation campaign, one of the first. Fragments of the glass drawing room have been re-assembled at the Victoria and Albert Museum.

Of the three great houses east of the Savoy, two were in their time as important as Northumberland House; that time was from the mid-sixteenth to the mid-seventeeth centuries. They were Somerset and Arundel houses. The first ceased to be a truly private palace a few years after completion, when it was taken over by the Crown, becoming a home for princessses and queens. The fascinating aspect of *Somerset House* is that it was the first Renaissance palace in England. Built before the reign of Elizabeth, it was more classical in design, that is closer to early sixteenth-century Italian and French interpretations of Roman architecture, than was the Earl of Northampton's house which was built after Elizabeth's death. Stylistically Somerset House was hugely important; as James Ralph wrote of it in 1734 'the only fabrick ... which deviates ever so slightly from the Gothick, and imitates ever so remotely the manner of the ancients. Here are columns, arches and cornice ...'.[40]

The site, immediately to the east of the Savoy, was one of the largest of any London house of any

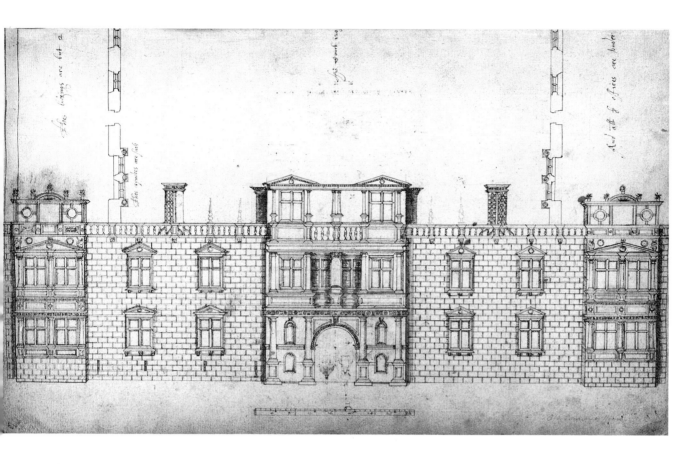

14 *Somerset House, the Strand front of* c. *1550, the first Renaissance palace in England. What would have been the medieval gatehouse has been transmuted under the influence of Serlio (whose third volume was* published *in 1540) into a Roman triumphal arch – though with Tudor oriels pushing their way in*

15 *Somerset House seen from the river. A fairly accurate impression of the Elizabethan ranges, which had reverted to a more traditional style.* The mural in the former Cecil Hotel (opened 1886) relied on a painting by Cornelis Bol of 1660

period. It had a depth from north to south of 500 feet and a river frontage of 600 feet. Assembled in a short period by the Lord Protector Somerset, it consisted of some half-dozen former properties, mostly ecclesiastical. Chief among them were the church of St Mary-le-Strand, the Inns of the Bishops of Worcester and Llandaff, and an Inn of Chancery, then called Chester Place. That last had been granted by Henry VIII in 1539 to Somerset, then the Earl of Hertford. According to Stow it had been 'first builded by Walter Longton, Bishop of Chester, Treasurer of England, in the reign of Edward the First'.[41] Somerset was living there at the death of Henry VIII in January 1547. Confirmed as Lord Protector two months later – Edward VI was but a child of nine – he set about rebuilding. Somerset, who had been an admirable servant of the Crown since his sister Jane Seymour had become Queen, was that ideal of the time, 'an extreme blend of high idealism and sharp practice',[42] but he proved incapable of decisive administration when in sole charge. Following the suppression of Kett's rebellion by others, he lost power in 1549, and his head in 1552. Probably a great part of his palace had been completed by then, for great resources had been deployed. The Chief resource was stone. This had either to be brought laboriously and expensively over long distances, often from Normandy, or to be obtained from demolished buildings. Great play was made at Somerset's trial of his destruction of the Priory Church of St John Clerkenwell and also the cloister and charnel house of St Paul's cathedral for the purpose. The summary removal of thousands of human remains caused most offence. Somerset, as a Calvinist, would have regarded the buildings merely as relics of superstition.

The eighteenth-century author Pennant refers to one John of Padua as 'Devizer of his Majesty's buildings'; he was suggested as designer for Henry VIII's flamboyant palace of Nonsuch. This shadowy figure has also been suggested as 'architect' of Somerset House. Pevsner toys with the idea, because of the difficulty in determining how quite recent Italian motifs found their way to the Strand. But the most likely route was via France. Somerset's extremely capable steward, John Thynne, was almost certainly in charge of the works, and he had visited France in 1547. His enthusiasm for building

16 *Somerset House. The great court had been substantially completed in the Protector's time and was arcaded with Tuscan columns. An engraving of 1777 shows the building just prior to demolition*

was to be illustrated a little later at Longleat. He was assisted by Robert Lawes, as clerk of works and, at least as far as the main gateway was concerned, by Nicholas Cave, who was Henry VIII's master mason at Nonsuch.[43] Isaac Caus designed the 'great fountain'.

The palace they produced was an amazing mixture of new and old ideas. The plan was late medieval: gatehouse, courtyard, great hall asymmetrically placed in a range on its far side. The elevations were revolutionary: with a Roman triumphal arch disguising the entrance portal, with pilastered end-pavilions and columned bays in the courtyard, with widely spaced windows surmounted by pediments, with an arcaded loggia on the far side of the court (like Gresham's house of 1560 and Northumberland House 50 years later), with balustrades rather than pitched roofs visible on the Strand front. The frankly Tudor features which found their way on to the elevations look like dotty instrusions; such were the narrow oriels squeezed in between the pilasters above the Strand gate and the chimneys – though the latter were enriched with carvings derived from Serlio. Almost nothing is known of the interior, except that in 1557 a carved screen which had been prepared for the hall was set up in nearby St Bride's church.

After Somerset's execution his house passed to the Crown, given to Princess Elizabeth in exchange for Durham House. She used it only occasionally and on her accession in 1558 returned part to the Pro

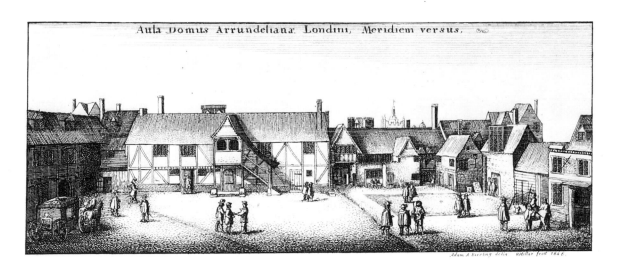

Aula Domus Arrundeliana Londini, Meridiem versus.

17 *Arundel House, Strand. Probably always an agglomeration of buildings, many dating from the times of the Bishops of Bath and Wells, this engraving was based on one of a series of drawings by Hollar of* *1646, which excluded any views of the additions which for once – were by Inigo Jones*

tector's son. Under Elizabeth, Somerset House grew into a shapeless complex of courts, yards and gardens, an extensive but still comparatively small version of her 20-acre palace of Whitehall. The architectural style at this time was traditional, even reactionary. The uses were official, for meetings of Council, and as ambassadorial residences. Later the palace was a residence for Stuart queens. Inigo Jones redecorated some interiors, built a splendid chapel for Henrietta Maria in 1632, and in 1638 produced an ambitious scheme for re-building. The Civil War prevented any major works. Jones died in Somerset House in 1652.

After the Restoration Henrietta Maria returned and a palazzo-like New Gallery was built (1661–62) by John Webb in the centre of the south range. In Catherine of Braganza's time the palace was a lively social and artistic centre. After her departure for Portugal in 1693 successive Queens consort took little interest in the place, which became an increasingly unfashionable and neglected warren of grace-and-favour homes. When in 1775 Queen Charlotte rejected it as a residence in favour of Buckingham House, its fate was sealed. Demolition followed and between 1776 and 1786 Sir William Chambers built the present Somerset House (see page 87).

Only a little less extensive than the Somerset House site was that of its easterly neighbour, *Arundel House*. Indeed the river frontage at 700 feet was greater, though its north–south depth was less. The main court was situated midway between the Strand and the Thames with no frontage, apart from a narrow access road, to the former. There were also extensive outbuildings and gardens as well as an elegant wing which extended at right-angles down to the river's edge. This was a sculpture gallery built or altered by Inigo Jones. Otherwise this mansion consisted in large part of the converted remains of a medieval building.

In 1539, when Hertford was granted Chester Place, the much larger house of the Bishop of Bath and Wells was given to the Earl of Southampton. Three years later he died; the property reverted and was granted to Thomas Seymour, the Protector's brother. On his execution on 1549, the property was sold to the twelfth Earl of Arundel for £41 6s 8d, 'with several other messuages, tenements and lands adjoining'.[44] There is no explanation for this oft-quoted figure. The Earl died in 1580. His grandson and successor Philip Howard perished 15 years later, in the Tower of London, where he had been tried for high treason. In 1607 both the house and the earldom of Arundel were restored to the family in the person of Thomas Howard. The Arundel Marbles, England's first great art collection, was assembled by this Earl from 1615 onwards. Eventually it included 37 statues, 128 busts and 250 inscribed marbles, 'exclusive of sarcophagi, altars, gems, fragments, and what he had paid for, but could never obtain permission to remove from Rome'.[45] Thomas Howard was also a patron and a

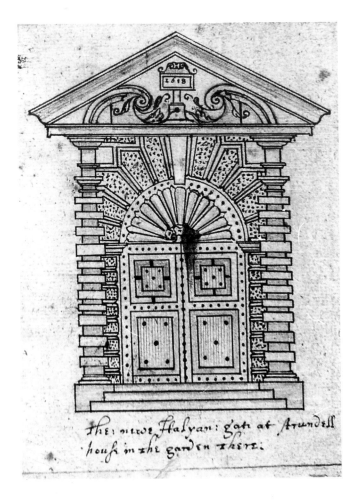

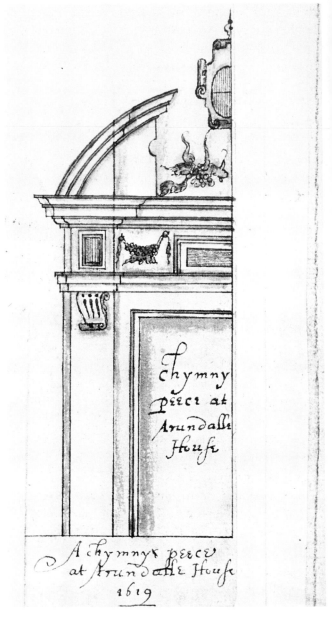

18 *Arundel House. The quality of the Jones designs may be gauged from drawings by John Smythson – though they were inaccurate in detail*
(*a*) *'Italyan gate ... in the garden ...'*
(*b*) *'A chymny peece'*

picture collector. Wenceslaus Hollar was invited to England and, given an apartment in Arundel House in 1636, he engraved his famous London views from the roof.

The Duc de Sully, French ambassador in the reign of James I, wrote that Arundel House was 'one of the finest and most commodious houses of any in London, from its great number of apartments on the same floor'; and that 'the views from the extensive gardens, up and down the river, were remarkably fine'.[46] Thomas Howard died abroad in 1646, and much of his collection was dispersed during the Civil War, when the house was used as a barracks.

In 1660 Arundel House was restored to Thomas Howards' grandson, Henry, sixth Duke of Norfolk. This nobleman was more interested in science than the arts. The remaining marbles were donated to Oxford University, the library to the Royal Society. He toyed with the idea of rebuilding the palace and had Wren produce a design. Nothing came of this plan and, when the Duke died in 1677, it provided the opportunity for his brother and successor to demolish for housing development.

'... a large but ugly house,' said Pepys in 1669 of *Essex House*, on the edge of the City. The site, once the outer Temple of the Knights Templar, was leased to the Bishop of Exeter in 1313. Henry VIII

granted the property to William, Lord Paget, an able Secretary of State. Paget's career also touched those of his Seymour neighbours – he helped Somerset to put aside Henry VIII's will. Unlike them Paget died in his bed, in 1563.

Robert Dudley, the favourite of Henry's daughter Elizabeth, was the next owner. This man, son of the evil Northumberland who had schemed to place Jane Grey on the throne, fascinated the Queen in the early years of her reign. Members of the older nobility called him 'the gypsy' and were nervous that the Queen might marry him.

Under Dudley, who was Earl of Leicester, the house was rebuilt. Ogilby's detailed map shows a compact and irregular courtyard just behind the Strand, and very spacious formal gardens down to the river. In one corner there appears to be a gazebo, and a simple landing stage, rather than water gate. Ogilby's birds-eye view seems to have been drawn a little later; published in 1677 it shows the land behind Essex stairs as being covered with dense new buildings, pierced by the tall arch at the end of Essex Street, fragments of which survive today. These were the work of Nicholas Barbon the speculative builder, who had bought the estate in 1674.

The history of the mansion in the intervening century had not been without incident. Leicester died in 1588; he was succeeded by his stepson, Robert Devereux, Earl of Essex, not only in property but in the Queen's affections. In February 1601, having offended the Queen, Essex contrived a most ineffectual plot. The result was that he was beseiged in Essex House, forced to surrender his pathetic forces and later beheaded. His title and estates were restored to his son, also Robert, as early as 1603. He let half of the house to the Earl of Hertford in 1639. Most of the property was redeveloped by Barbon, who bought it in 1674.

A quarter-mile north-west of the new Essex Street development was Drury Lane, which during the sixteenth and seventeenth centuries had lost is rural air and become an aristocratic street. The most durable of its mansions, *Craven House*, was on the site of a Tudor manor house built by Sir William Drury and that had been raised on the foundations of an older house. Sir William died in 1579, a Knight of the Garter and well esteemed by Queen Elizabeth. Less is known of his descendants, apart from a grand-daughter, Elizabeth, whose early death was

mourned in John Donne's poem 'The Anniversarie'. Donne was a friend of the family, the then Sir Robert Drury having furnished him with 'an useful apartment in his own large house in Drury Lane'.[47]

Early in the seventeenth century the house passed to Sir William Craven, for whom it was rebuilt in 1620, possibly by Balthazar Gerbier. Whoever designed Craven House, there is no doubt that it was the London home of one of the most attractive and romantic of seventeenth-century noblemen, William, first Earl of Craven, who died there in 1697. He was not only a brave and successful soldier, he was also a popular hero in that he stayed in town during the plague and helped to organize relief. Above all he was renowned as 'the gallant lover', the protector, supporter, subsidizer and possibly the secret husband of the unfortunate Queen of Bohemia. Daughter of James I and mother of Prince Rupert, she had returned to England in 1661, following her nephew's restoration. She stayed for six months in Craven House, or possibly next door, in any case at Craven's expense, before moving to Leicester House a week or two before her death.

The Drury Lane House was apparently extensively rebuilt after fire damage in about 1690; this time the architect was said to have been Captain William Winde.[48] Again not impossible: several letters by Winde refer to work for Lord Craven in Drury Lane and elsewhere.[49] The house was of five storeys, eleven bays wide; the first and second floors were embellished with Doric and Ionic pilasters respectively. The bold, modillioned cornice and steep roof do call to mind Winde's Powis House. It was later converted to tenements. 'The cellars still remain, though blocked up,' wrote Wheatley in 1891.[50]

When Drury Lane was still little more than a track leading through fields from the Strand to the hamlet of St Giles, suburbs nearer the City were long established. The Bishops of Salisbury had first built their London inn outside Ludgate in the twelfth century. Later it was virtually absorbed into the nearby royal palace of Bridewell. Towards the end of the fifteenth century, and especially after Henry VIII started building lavishly, it may well have looked as if this, rather than Whitehall, might become the major royal precinct. Salisbury House was possessed by the Crown, occupied by Henry's

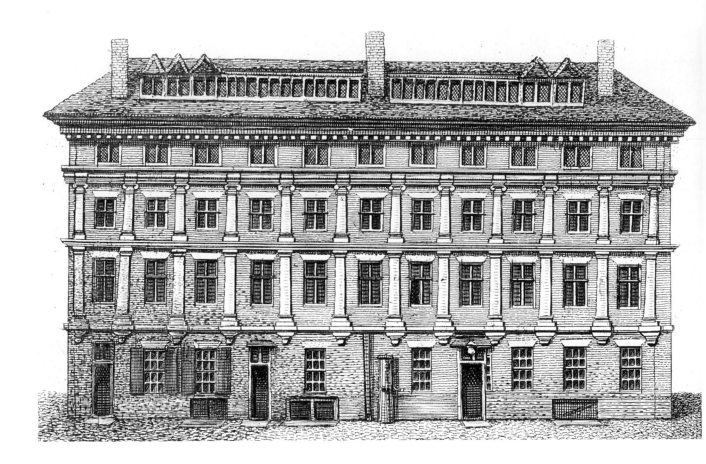

19 *Craven House, Drury Lane. Sir William Drury's manor house had been rebuilt after the Restoration for the gallant Earl of Craven, lover of the Winter Queen. By 1800 it had long been converted into tenements*

son Prince Arthur and, later, by various foreign envoys. But in 1553 Bridewell was given to the City authorities; a decade or so later a century of occupation as a private palace began for Salisbury House. Sir Richard Sackville was the purchaser in 1564.

Sackville's son, Thomas, is best remembered as a poet. He was created Earl of Dorset in 1603, on the accession of James I. The mansion became known as *Dorset House*. The second Earl was something of a wit. One day in 1610 Lord Herbert of Cherbury, a vain gossip if ever there was one, was invited to Dorset House where Richard, Earl of Dorset, 'bringing me into his gallery, and showing me many pictures, . . . at last brought me to a frame covered with green taffeta, and asked me who I thought was there, and therewithal presently withdrawing the curtain showed me mine own picture'.[51]

The Sackvilles continued to live in the house, but at least parts of it were let out to others. Among them was Lord Keeper Bacon in 1617. Was it irony when he wrote to Buckingham from 'Dorset House which puts me in mind to thank your Lordship for your care of me touching York House'?[52] Edward, the fourth Earl, apparently stayed in Dorset House even after the execution of Charles I, surprising in that many loyalist aristocrats had followed his son into exile. The Sackvilles had formerly been regarded as loyal; the last procession of the Cavalcade of the Order of the Garter had taken place from Dorset House on 13 May 1635.

After the Restoration the Marquis of Newcastle lived in part of the now permanently divided Dorset House. To judge by the bird's-eye sketch on the 'Agas' map drawn in about 1560, such a division would not have been physically difficult. We see a many-gabled building, hard up against the outer wall of the principal courtyard of Bridewell Palace. The house was consumed in the flames of the Great Fire. It is commemorated today by Dorset Rise and Salisbury Square.

Let us imagine Thomas Sackville paying a call in

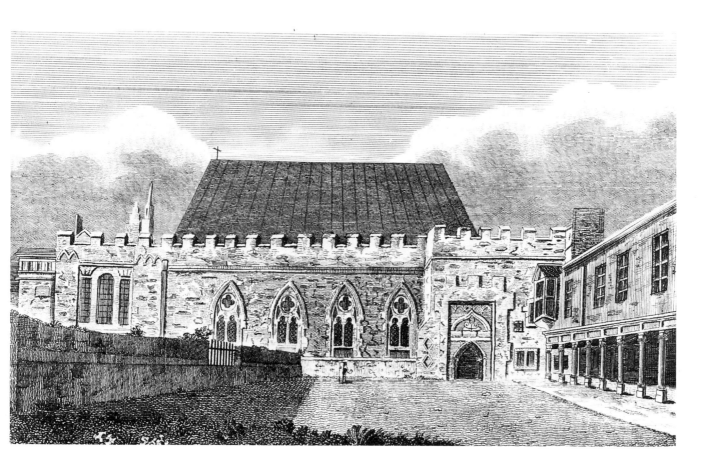

20 *Ely Place, Holborn. Thirteenth-century great hall with later arcade and wing on the right and remains of range on left. The engraving published after demolition shows the complex of buildings in decay*

1576 on the most distinguished newcomer to the locality, Sir Christopher Hatton, a fellow courtier who although a few years younger, had captivated Elizabeth by his brilliance and risen very high. (Sackville was to be Lord Treasurer only in 1599, eight years after Hatton's death.) Hatton had obtained almost complete possession of a great mansion by the (then) rather outdated method of leaning heavily on the bishop whose property it was, with the encouragement of the monarch.

Leaving his house via Salisbury Court, the little public square in front of it, crossing Fleet Street and avoiding the mêlée around the water conduit at the junction, Sackville would have continued north up Shoe Lane which was only in part built up with small houses separated by large gardens and orchards. Near the top of the lane on the left he passed *Bangor Inn*, the then modern residence of the bishop, though on a site owned by the diocese for over two centuries.[53] Next Sackville passed the Parish church of St Andrew on the left and Holborn Manor House on the right; then he crossed the main road, veering a little to the left through the Great Gateway and into the first courtyard of one of London's largest

private palaces, *Ely Place*, which gained in impressiveness by being on a slight hill.

Until the late thirteenth century the Bishops of Ely, one of England's grander sees, had lodgings near the river on part of the property of the Knights Templar. There was a quarrel, and by 1290 the then bishop had established himself in a town house on the north side of Holborn, in an almost rural situation. At his death in that year he bequeathed a messuage and nine tenements adjoining to the see. Land was added by his successor bishops, one in particular acquiring a vineyard, kitchen garden and orchard. Six centuries later there is still a Hatton Garden and a Vine Street. More remarkably there is a chapel of the late thirteenth century called St Ethelreda in the private street still called Ely Place.

The building of the Bishop of Ely's 'hostel' – yet another generic term – took a century. John de Kirkeby had completed the essentials. There was a

large courtyard with a hall facing it, the latter measuring 72 feet by 32 feet and 30 feet high, and the chapel, smaller in plan but loftier, being built on an 'undercroft' which was more or less at ground level. Behind the hall was a cloister. The palace was habitable enough for the fourteen-year-old Phillippa of Hainault to spend Christmas there in 1327 before her marriage to Edward III.

As with all the episcopal mansions royal 'guests' were common. 'Old John of Gaunt' as Shakespeare called him, lived at Ely Place from the time that the Savoy was sacked by Wat Tyler's rebels in 1381, until his death in 1399. It was at Ely Place that the bard imagined Gaunt rhapsodizing about 'This royal throne of Kings, this sceptred isle ...'. It was also, apparently, during the sojourn of 'time-honoured Lancaster' that Bishop Thomas de Arundel constructed, or possibly re-constructed, a 'gatehouse or front' to Holborn, before his translation to the see of York in 1388.

Lay intrusions into the Bishop's domain did not cease with the Duke of Lancaster's death. The catering facilities must have been impressive; in 1531 five days of banqueting attended by Henry VIII and Catherine of Aragon consumed 100 sheep, 51 cows, 91 pigs, 24 oxen, 720 chickens, 444 pigeons, 168 swans and over 4000 larks.[54] In 1547 Ely Place was at the disposal of the Earl of Sussex, and two years later the Earl of Warwick. Such occupations became so well established that in 1576 Bishop Cox had little choice but to oblige Queen Elizabeth and lease the gatehouse, most of the front courtyard and all 14 acres of gardens and orchard to her favourite, the Lord Chancellor, Sir Christopher Hatton. The term was 21 years, the rent a red rose, ten loads of hay and ten pounds per annum.

The Bishop's persistence in maintaining a foothold is admirable. He managed to secure for himself and his successors the right to walk in the gardens and to gather twenty bushels of roses annually. Hatton was determined to build a house in those gardens, at which the Bishop had the temerity to protest even to the Queen. Adopting Hatton's wishes as her own, she is said to have sent a persuasive missive which is worth quoting. Even if a forgery, as is usually averred, it catches the temper of the Virgin Queen: 'Proud Prelate, you know what you were before I made you what you are; if you do not immediately comply with my request, by

God! I will unfrock you.' During the 1580s Hatton built his stately mansion with funds loaned by the doting monarch. Bishop Cox was not obliged to witness its occupation, departing this life in 1581.

The see was vacant until 1598. That was long after Hatton's death, in debt and some disgrace, in 1591. Although the next bishop managed to establish tenure of the reduced Ely House, he was expected to continue to make it available for such important state visitors as the Spanish Ambassador, Gondomar, in 1619. There was much unrest at the chapel being used by the Spanish Jesuits. This use was obstructed by Lady Hatton, the rich widow of Sir Christopher's successor, who also refused Gondomar 'benefit of her back gate to go abroad into the fields'.[55] But since 'this strange lady' had also fallen out with her second husband, the renowned lawyer Sir Edward Coke, and refused him entry by the front door, no one was much surprised. They quarrelled fiercely over the custody of their daughter, a considerable heiress whom the Duke of Buckingham was determined to marry to his brother, Sir John Villiers. Coke supported this and, more importantly, so did the King. But when the wedding did take place Coke was excluded from the celebrations at Hatton House by his wife. King James enjoyed the feast withall, knighting four of Lady Hatton's friends on the spot.

In 1622 Ely Place was granted to the Duke of Lennox, who was at about the same time created Duke of Richmond, apparently to reconcile him to the recent raising to the same rank of the 'upstart' Buckingham. The double Duke did not long enjoy his tenure, being laid in state there in 1624. His widow attempted to lease Hatton House as well as occupying Ely Place. Apparently Lady Hatton favoured the deal at first. But the two proud women fell out. Lady Hatton thus lost the chance of a vast rent of £1500 a year, a sum which indicates the spendour of the mansion. She lived there until her death in 1648.

Meanwhile Ely Place was re-possessed by Bishop Matthew Wren, who was Christopher's uncle. He had some legal success in attempts to assert the see's rights over Hatton House as well, but all was lost when he was sent to prison in 1640. Ely House was used as both hospital and prison during the Civil War, and was in so dilapidated a state by 1659 that portions were demolished. Nevertheless Matthew

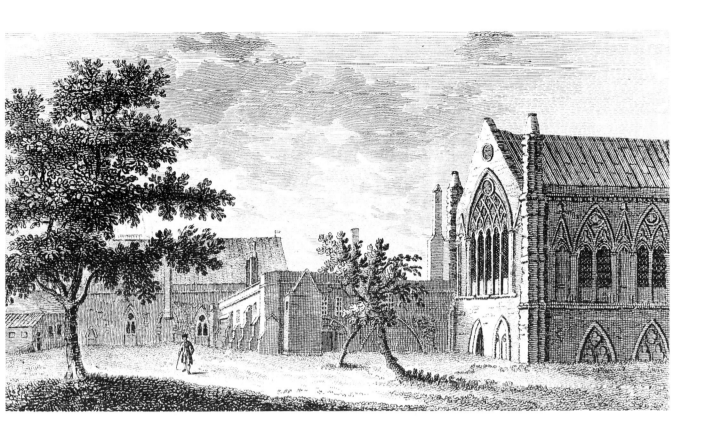

Wren was repossessed of both bishopric and house with the restoration of Charles II.

Ely House continued to be the London residence of the bishops but was increasingly allowed to decay. Dodsley's description of 1761 is instructive: 'the city mansion of the Bishop of Ely [which stands] on a large piece of ground. Before it is a spacious court, and behind it a garden of considerable extent; but it is so ill kept that it scarcely de-

21 *Ely Place, Holborn. The rear of the hall is seen on the left, the Bishop's cloister (centre) was on the line of the present Ely Place. St Ethelreda's chapel (foreground) is a survival. Pevsner speaks of 'interesting tracery patterns showing the evenness of the Geometrical just on the point of disintegrating into the illogicalities of the coming Dec style'*

served the name. The buildings are very old; and consist of a large hall, several spacious rooms, and a good chapel.'[56]

II
The Movement West

Two crucial events of the 1660s, the Restoration of the Monarchy and the Great Fire, resulted in the transformation of London. A city of wood, rubble and plaster become one of brick and stone; a medieval city became a classical one; and the centre of gravity of metropolitan functions, with the partial exception of commerce and trade, moved irrevocably north and west in a series of building booms. The City, as such, was not depopulated, but almost none of the aristocracy now lived there, nor were they to inhabit the Strand for very long.

The population growth of London was seen as positively alarming. Failure of Acts of Parliament in the reigns of both Elizabeth and James I to stem it did not discourage further legislation both before and after the Restoration. The building of new houses was prohibited and immigrants to the City were banned. In 1632 a squire from Sussex 'and moreover a batchelor', as Wheatley remarks,[1] was fined £1000 for staying in town too long. The London of Charles II at over a quarter million was seventeen times larger than Bristol or Norwich.

As always the authorities had to bend to ineluctible pressures, and 'as a means to frustrate the covetous and greedy endeavors of such persons as daylie seeks to fill upp that small remainder of Ayre in those parts with unnecessary and unprofitable Buildings' they gave permission for some planned development.[2] This was in Lincoln's Inn Fields where the 'ayre' was eventually protected by allowing a Mr Newton to erect 32 houses, on the condition that the main field should 'hereafter be open and unbuilt'.

Licences to build were more commonly granted to noblemen. For example the urbanization of Leicester Fields (later Square) followed the building of Leicester House in the 1630s by Robert Sidney, the second Earl. At about the same time the fourth Earl of Bedford obtained a licence to build to the north of his mansion's garden wall houses 'fitt for the habitacions of Gentlemen and men of ability'.[4] His architect, Inigo Jones, designed London's first and finest 'piazza' which did indeed attract fashionable society for a period.

Pressure for the construction of grand residences came from an increase in the size of the aristocracy itself. James I invented a new order of baronetcies, by which he raised £90,000 to pay for an Irish Army. More important, he increased the peerage from 59 to about a hundred; through the good offices of Buckingham in particular, there was a useful market.[3] Charles I was somewhat more restrained in this respect, and the Civil War took its toll. After the Restoration Charles II was generous to the men who had accompanied him in exile. Also favoured were the women who accompanied him in bed; he made Duchesses of most of them and Dukes of their bastards.

The nobility returning from the Continent in 1660 wanted a new kind of house. In particular they had admired French 'hôtels', which were separated from the street by a paved courtyard and

flanked on either side by service wings. At last the conservative English were prepared to desert the basically medieval courtyard house.

Renaissance architecture required the services of the specialized designer. The age of the architect, for which the career of Inigo Jones was but a rehearsal, had arrived. What might be called the proto-renaissance at Somerset House had been side-stepped in the romantic reaction born of self-confident Elizabethan nationhood. Nor had Jones's correct classicism prevailed widely. A flood of Flemish craftsmen had been determined to interpret Italian copy books and French examples in their own way, covering their work with straps and grotesques. But now there were to be practitioners like Webb, May, Wren and Pratt, who understood what classical architecture was about. Some of them had even been to Italy. There was also a second rank of man such as Gerbier, Hooke and Winde, who could produce respectable work.

Geographic factors had an influence on location. London's prevailing winds are from the west, so that the increasingly foul smoke from ever more coal-burning fires usually dispersed eastwards. In any case the land to the east of the city was mostly lower-lying, even marshy, while that to the north-west tended to rise. An open outlook and space for town gardens were the prerogatives of the wealthy. As the city grew even the rich were obliged to move to its boundaries to obtain the large sites they desired for their mansions. Again and again noblemen were scorned by their less far-sighted peers for building inconveniently far 'out of town', whether it was Holborn, Piccadilly, Manchester Square, Hyde Park Corner or Portman Square. They always replied that they enjoyed the healthy air and having no development beyond them.

As they decamped westwards, they profited by selling their former mansions to a new kind of developer. In Restoration times the most notorious – for these men were seldom liked – was Nicholas Barbon. The royal parks effectively halted the migration west except along the river. Here the Grosvenors took over the Earl of Peterborough's house on Millbank where they could enjoy the rural pleasures of duck-shooting. Belgravia was largely marshland until the nineteenth century.

Upper-class houses, including several detached mansions, were built north of 'the road to Oxford'

in the eighteenth century, but the expansion of the metropolis soon put paid to the idea that space, outlook and fresh air could be secured by building a mansion on the edge of town. At least two of the greatest nineteenth-century palaces, Bridgewater and Stafford (Lancaster) Houses, were the result of rebuilding on the site of earlier mansions which had the advantage of sites overlooking parks.

So the period after the Restoration saw different materials, plans, styles and fashionable locations. Houses were closed down and sold for development in the Strand area, as sites had been abandoned in the City after the Great Fire. The 'movement West' – to Piccadilly and St James's, the new quarter populated by much of the ruling class – was not without a few diversions. Under the Stuarts the north-west fringe of the City and Clerkenwell, parts of Holborn and Bloomsbury, Covent Garden and Lincoln's Inn Fields, were all fashionable. Still further west the 'ton' settled briefly at Leicester Square and Soho Square, and more permanently in Pall Mall. This chapter describes houses exemplifying the changes in area and in architecture. One part of town only briefly fashionable was 'North and slightly uphill from the City and Smithfield, on fertile meadow land watered by abundant springs and the Fleet river ... Clerkenwell grew up as a hamlet serving the twelfth-century monastic foundations, St Mary's Nunnery and the Priory of St John of Jerusalem.'[5] Among the Tudor nobility who built houses on these former monastic properties were the Dukes of Newcastle and the Earls of Northampton and of Ailesbury, as well as the Challoners and Berkeleys. Two interesting mansions were Newcastle House and Ailesbury House.

The Cavendish family acquired at least parts of the nunnery, the cloister of which survived in their garden into the 1770s. The outstanding character connected with *Newcastle House* was William Cavendish, created Duke of Newcastle at the Restoration, who lived 'in great state' in Clerkenwell.[6] It is difficult to believe that he liked the gloomy old mansion – 'a sombre, monotonous brick structure, having its upper storey adorned with stone pilasters,' declared *Old and New London*, which went on to say that the east and west wings enclosed a large courtyard in front. Newcastle was a man responsible for some of the most imaginative buildings in England, the employer of both John and Huntingdon

Smythson. 'Like all his family he was a great builder, adding to both Bolsover and Welbeck, building a house at Ogle in Northumberland and, after the Restoration, the great castle on the cliff at Nottingham.'[7] Newcastle was 'the munificent patron of men of genius',[8] a man 'of whom it is impossible not to be fond, so gentle was he, so generous, so brave, so tolerant, so easy'.[7] He was so charming that his creditors in Antwerp 'swore he should not want if they could help it'. His was a different character to that of his tough grandmother, Bess of Hardwick; but then she had established the family wealth that he enjoyed. It would appear that little of that wealth was expended on the London house which remained in the family till the death of his granddaughter in 1743. Known as the Mad Duchess, she had married the second Duke of Albemarle and after him Ralph, first Duke of Montagu. The latter, aware of her wealth as the Cavendish heiress, was willing to pander to her determination to marry nothing less than a monarch. But having convinced her that he was Emperor of China, he had her locked up first in Montagu, then Newcastle House for the remainder of her 96 years. After that the house was divided and let as tenements and workshops. In 1793 it was demolished together with most of the monastic remains. Newcastle Place was built on the site. Part of the cloister foundations were uncovered in the 1970s, then largely destroyed.

Ailesbury House was the London mansion of the Bruces, Earls of Ailesbury. Its grounds, which extended about 500 feet south of Clerkenwell Green, had been those of the Knights of St John and, according to Wheatley, had descended to the Bruces from the Cecil family. Little is known of the building, which passed to other hands after 1706. Its most famous occupant was Robert Bruce, created first Earl in 1665. Deputy Earl Marshal, he had been one of the twelve commoners deputed to invite Charles II to return.

Houses in Holborn were of architectural interest in early Stuart times: this is witnessed in drawings made by John Smythson on his 1618 visit. Of these only Fulke Greville's was palatial. Greville, Lord Brooke, 'servant to Queen Elizabeth, counsellor to King James, and friend to Sir Philip Sidney', was assassinated at *Brooke House* in 1628. Stow writes of his mansion as having been 'of late for the most part new built' by the Earl of Bath, that is, it replaced an earlier building.

The 'Holborn gable' sketched by Smythson on several house fronts, including that of Lord Brooke, was later than Stow's 1598 Survey. In fact it was on a three-bay additon of *c*. 1615 to a five-bay house of *c*. 1580. Above the top-storey cornice was a gable with scrolled sides rising to a pediment. As Sir John Summerson points out, it looks to have been of more classical than Netherlandish derivation, and may have been inspired by illustrations in Serlio's *Libro Extraordinario*. Furthermore, that it was a creation of Inigo Jones 'is not impossible'.[11] After Fulke Greville's death the house was occupied by the French Ambassador. Other official uses included, in 1668, the meeting of the 'Brooke House Committee' which had been set up by Parliament to enquire into certain expenditures of Charles II.

Warwick Court, north of Chancery Lane, is practically the only evidence remaining of *Warwick House* apart from written records of, for example, Lady Warwick's death there in 1646. Pepys dined there in 1660 with Lords Sandwich, Fiennes, and Berkeley, Sir Dudley North and the Earl of Manchester, the last-named apparently being the host. William, Lord Russell, on his way to execution for his alleged involvement in the Rye House plot, passed the house and remarked to the bishop accompanying him that the house was shut up; he wondered if Lord Clare was out of town. This anecdote in *Old and New London* suggests that the former Warwick House still existed in 1683, that it was in the ownership of Lord Clare and that the latter was, apparently, showing a mark of respect.

Lincoln's Inn Fields were originally two 'waste common fields' used by students at the Inn, and also as a place for public executions. In the 1630s, development was finally allowed. A large building in the north-west corner was known as Carlisle House, then Powis House and finally *Newcastle House*. Built for the 'earle of Carlile' in 1641–2, it was the last in what had already become a fashionable square.

James Hay, second Earl of Carlisle died in 1660, and the title became extinct in that line. Carlisle House, contemporary correspondence suggests, had been bought by Sir George Savile as early as 1656. This statesman, orator and writer, better known as Marquis of Halifax (he was created Viscount in

1668, Earl in 1679 and Marquis in 1682), was devoid of party prejudice and motivated by national interest. Thus he was unfairly called a 'trimmer'. He died in 1695 but had by then been settled for over twenty years in Halifax House, St James's Square. Carlisle House was re-named when purchased by Lord Powis in 1672. This peer, the leader of the Roman Catholic nobility in the reigns of Charles II and James II, had an eventful career. Imprisoned in the Tower in 1678, he was released in 1684. That was also the year his house burnt down. Powis House was rebuilt, but when barely complete was nearly destroyed again, this time by the mob when James II fell in 1688. The following year Lord Powis, a close adherent of the last Stuart king, fled to St Germain and was attainted in his absence. His property was forfeit to the Crown.

The mansion was the work of the remarkable soldier-turned-architect, Captain William Winde (d. 1722). The design was traditional, especially when compared to Buckingham House of 1702–5 with its curved colonnades and wings enclosing a courtyard. Here on a restricted urban site only a lofty single block could be accommodated. It is remarkable that the attractions of a location, so soon to be deserted by the fashionable world, were sufficient to justify the expense of so large a house.

The main entrance is approached via steep steps so that the floor below is only a semi-basement; beneath that is another. The very high first floor has a generous chamber floor above it and two floors of attics in the steeply pitched roof. So Winde achieved no less than seven floors which, with two rear wings, amounted to a great deal of space. The elevation is of five bays, the centre three projecting, with stone quoins and band courses to a brick building with a boldly projecting, enriched and modillioned cornice developing into a pediment over the centre.

Powis House was appropriated for Lords Keeper of the Great Seal in 1692. Sir John Somers, who was appointed Lord Keeper in 1693, was one of the more distinguished politicians to grace that office. During his time, in 1694, the Great Seal was affixed to the Charter of the Bank of England in what later became the Peacock Room. A patron of literature, a friend of Addison, Steele and Congreve, he was not universally popular. There was an attempt at impeachment in 1700; it failed, but Lord Somers,

22 *Newcastle House, Lincoln's Inn Fields. Captain William Winde squeezed seven floors – including an attic, garrets, a basement and semi-basement – as well as wings behind the main block, onto this restricted site. Built 1685 for James II's courtier, later altered for George II's future prime minister, it was an exemplar for brick and stone manor houses all over England*

as he was by then, was dismissed. His successor lost office in 1705. By name Sir Nathan Wright, he had the misfortune to come to the attention of Sarah, Duchess of Marlborough who described him as 'a man despised of all parties, of no use to the Crown, and whose weak and wretched conduct in the Court of Chancery had almost brought his very office into contempt'.[12]

In May 1705 the second Lord Powis sold the house for £7500 to John Holles, first Duke of Newcastle. This indicates that the Powis family had been at least partially restored to their estates. In fact Lord Powis gave Newcastle a deed of indemnity in case the 'attainder should be unreversed'.[13] That reversal finally took place in 1722. Meanwhile Lord Powis had built his splendid new house in Great Ormond Street.

The Duke of Newcastle himself was immensely

rich. As Earl of Clare, he had married Margaret Cavendish, co-heiress of Henry, second Duke of Newcastle. The 'Mad Duchess' who died in the other Newcastle House, in Clerkenwell, was the other. Besides a large portion of the Cavendish fortune which he acquired in 1691, John Holles succeeded three years later to the estates of the third Lord Holles, one of the wealthiest men in the kingdom. It was left only to create him Duke of Newcastle, which was done in 1695. He died in 1711, leaving his estates to his nephew, Thomas Pelham Holles, who was made Duke of Newcastle in his turn in 1715 as a reward for his opposition to the Pretender.

This Duke had the means to be a potentate, but not all the abilities of a politician. He was both, but did little more in national policy terms than muddle through. Made Secretary of State by Walpole in 1724, he held office for most of the next thirty years. 'We have one minister that does everything with the same seeming ease and tranquility as if he was doing nothing. We have another that does nothing in the same hurry and agitation as if he did everything,' said Lord Hervey in 1735,[14] referring to Walpole and Newcastle. The former fell in 1742; the latter was a tenacious opportunist and on the death of his younger brother Henry Pelham in 1754, he became Prime Minister for the first of two periods. He finally resigned office in 1762.

During all this long period Newcastle held court in his Lincoln's Inn Fields house; large, shambling and amiable, he kept people waiting endlessly. The story is told of one poor supplicant, 'Long Sir Thomas Robinson', who spent many hours in ante-room and hall paying attention to a pet monkey and admiring a clock. One day he called, but was refused entry by an exasperated servant who declared, 'Sir, his Grace has gone out, the clock stands and the monkey is dead.'[15]

The Duke died in 1768, which date effectively marks the end of aristocratic occupation. His widow sold Newcastle House to Henry Kendall, a banker, for £8400. The sale included the site of No. 65 next door which the Duke had bought in 1758 to provide an approach to his stables. Kendall built a house for himself on that site, divided Newcastle House itself into two, eventually let the northern half and sold the southern portion to James Wallace, later to be Attorney General. In 1790 Wallace's son sold his

house, then numbered 66, to James Farrer. This distinguished firm of solicitors is there still. In 1904 the creation of Kingsway obliged them to sell the rear wing of No. 66; at the same time they bought No. 67 and re-united the house. Sir Edwin Lutyens's rebuilding of the outside walls was, as Pevsner remarks, 'tactfully and tastefully done',[16] allowing an impression of the original design whilst being clearly the product of the 1930s. Much the same may be said of the handsomely reconstructed entrance hall with stone-flagged floor and oak stairs.

Of early features in the house it is difficult to distinguish between those designed by Winde in about 1686 and those of some twenty years later. In the first category the most likely inclusions are one or two boldly carved marble chimneypieces. The rectilinear leaded lights to basement windows in No. 66 also have a later-seventeenth-century character but are probably Lutyens replacements. There is also much plasterwork, as well as some doors and doorcases of that character, particularly at the entrance floor level of No. 66. Heavily modillioned cornices in the front, or 'Peacock', room are surely 1705 at the latest. Indeed the three principal rooms of the south part of the house were still basically of the Newcastle period until the demolition of the Library at the rear in 1904. In that room, as well as in the Peacock room and the drawing room above it, additional plaster friezes and other detail were added in a vaguely Adam style presumably at the time of the division into two in the early 1770s.

The only other house in Lincoln's Inn Fields with a claim to have been a private palace is also the one surviving building of the original pre-Civil War development of the square. As such and as the precursor of the unified terrace design, where individual houses are subsumed into a larger entity with a giant order and continuous cornice, *Lindsey House* is 'perhaps, historically, the most important single house in London'.[17] Nicholas Stone is the most likely designer, both on stylistic grounds and because it was built for a friend of his, Sir David Cunningham. In any case ownership was soon in the hands of Robert Bertie, Earl of Lindsey. 'A handsome building of the Ionic order and strong and beautiful court gate, consisting of six fine spacious brick piers with curious iron work between them, and on the piers are placed very large and

23 *Lindsey House, Lincoln's Inn Fields. A model for eighteenth-century terraces, it was built in 1640 and, therefore, inevitably attributed to Inigo Jones. First-floor windows are boldly pedimented, the centre one only being curved and broken to emphasize the entrance. Divided and stuccoed in the mid-eighteenth-century, it is all that is left of the original square, though none of the interior is of that time. Note the splendid brick gateposts*

beautiful vases.[18] The Ionic order of the elevation is visible, but stone columns no longer contrast with brickwork. The latter, having been stuccoed to look like masonry, has recently been repainted to look like brickwork!

The fourth Earl of Lindsey was created Duke of Ancaster, so the building was then known as Ancaster House. Later sold to another duke, the 'Proud Duke of Somerset', it was however divided into two in around 1759, which is probably the date of the exterior stucco.

If, notwithstanding its undoubted architectural importance, Lord Lindsey's Lincoln's Inn Fields house was only questionably of palatial status, the second *Powis House*, that built by William Herbert, second Marquis, in Great Ormond Street was a very grand house. This was especially so in the form best known to posterity, that illustrated in *Vitruvius Britannicus*. Colen Campbell's engraving shows the front as rebuilt in 1714 after a fire, the front door suitably surmounted by a phoenix. How close this corresponds to the mansion built less than 20 years

earlier is impossible to say. Nor is it entirely clear when Lord Powis first let that house for use as the French Embassy. It is known, however, that on 26 January 1713 '... the French Ambassador, Duc d'Aumont, sent Lord Treasurer word that his house was burnt to the ground. It took fire in the upper rooms, while he was at dinner with Monteleon, the Spanish Ambassador and other persons.... I believe it was the carelessness of his rascally French servants.' Thus reported Jonathan Swift, with just a trace of xenophobia.[19]

The house was insured, but the dignity of the King of France required that he, rather than a 'Fire-office', pay for the neglect of the servants of his representative. The identity of the architect of the new house is unknown, but may have emanated from the same source as the funds. Nine fairly narrow bays extended to a 104-foot frontage with the merest suggestion of centre and end wings being achieved by two architectural devices. The first is by a slight projection of the single end bays and the centre three; the second is that these bays and not the intervening ones are emphasized by pilasters. The latter consist of a giant fluted Corinthian order to the two principal floors and a plain panelled one above, the statues on their plinths continuing the vertical lines. The staircase walls were painted by the Venetian, Giacomo Amiconi.

In 1737 the Earl of Hardwicke was the occupant; he was later appointed Lord Chancellor, but continued to reside in Great Ormond Street. The house was once again an embassy between 1764 and 1783, this time of Spain. Demolished before the end of the century, Powis House had had its admirers, including Walpole who in 1764 spoke of it as being made 'magnificent' by the Spanish Ambassador.[20]

English taste had for the moment turned to a more theatrical baroque represented by Thomas Archer's *Monmouth House*. Soho Square had captured the loyalty of the *haut monde* only briefly. Perhaps the fate of its most famous inhabitant, James Scott, Duke of Monmouth, cast a blight. The name 'Soho' is said to have derived from his hunting cry. That seems unlikely since it had previously attached to Soho Fields which were granted by Charles II to the Earl of St Albans. Development was part of the great expansion of the capital following the restoration of the 'merry monarch'. Indeed the new *place* was briefly called 'King's Square'.

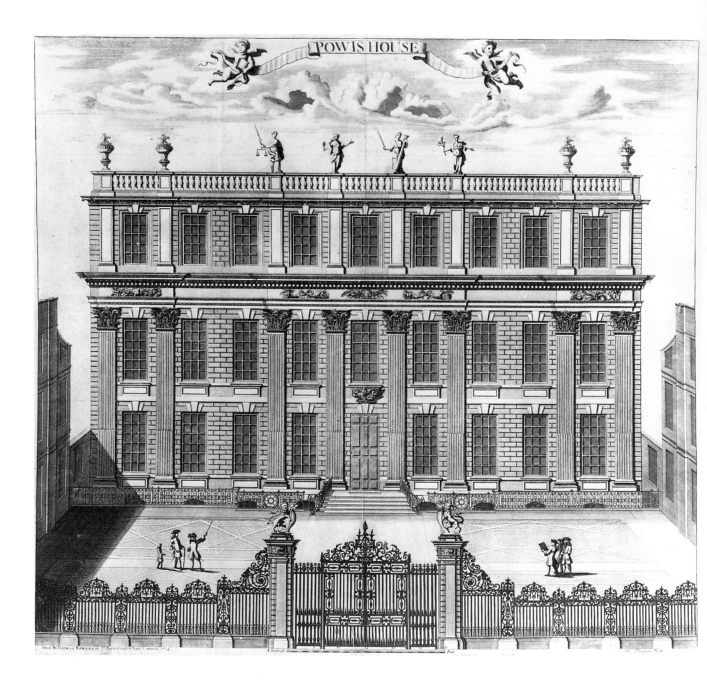

24 *Powis House, Great Ormond Street. A sophisticated three-storey design of 1713 raised on an arched basement, surmounted by a parapet with urns and statues. The designer may have been French, the occupant at the time of the fire which destroyed Lord Powis's original mansion being the French ambassador. Note the phoenix over the entrance and the delicately carved frieze of palms, horns of plenty and musical instruments*

The Earl of St Albans, who lived elsewhere – his was the house in the south-east corner of St James's Square which became Norfolk House – leased part of the land in Soho to a brewer, who in turn passed it on, having increased the value by obtaining a royal licence to build. The enterprising builders, Frith and Thomas, in partnership with two other investors, developed the large site on the south of the square to James, Duke of Monmouth. The eldest of Charles II's illegitimate sons looked to have a glittering future. His London palace was to be on a suitable scale.

The ground had a frontage of 76 feet and a depth of 280 feet. In addition there was a strip along the east side of Frith Street intended for stabling and coach-houses. The agreement of 17 February 1682 stipulated that Frith and Thomas would build the Duke 'a fair messuage'. This they set about, and Monmouth was already in occupation of part of the building intermittently during 1683 and 1684. The first year was that of the Rye House Plot to murder

the King and during much of the second he saw fit to be in the Netherlands, having been banished from the Court. Indeed, Monmouth only returned thence in June 1685, to engage in his rebellion. Following its failure, his estates were forfeited to the Crown, likewise his life.

The situation was financially disastrous for various craftsmen and suppliers, the mortgagee (a Mr Hinton), and the Duchess. Monmouth's widow herself eventually resolved matters in 1698 by buying the lease for £1750 with the agreement of the rest of the creditors. She re-sold the still unfinished property for £3000 in 1717 to Sir James Bateman. A wealthy merchant, Bateman was Lord Mayor of London as well as Sub-Governor of the South Sea Company. He seems to have re-fronted the property before his death in November 1718. A letter by a John Ozell to Bateman's son, William, who was on the Grand Tour, spoke of 'costly embellishments ... not to mention the furnishing and adorning [of] this Palace which, though begun for the Duke of Monmouth, was preordained for the mansion of Sir James Bateman.' He also spoke of 'Plans and Schemes' at that time.[21]

That the architect was the wealthy amateur, Thomas Archer, is highly likely, both on stylistic grounds and because he had a family connection. Elements of the design such as the downward-tapering pilasters on the upper storey look archaic, almost Jacobean, in illustrations. Perhaps the house was impressive, though Ralph's typically acerbic comment would suggest not. The 'lower order could boast of beauties ever so exquisite, the upper is so Gothique and absurd, that it would destroy them all', he wrote in 1734. The giant Corinthian pilasters of the ground and first floors were very much of the day and can be seen in John Price's unexecuted design of 1720 for the Duke of Chandos, which also had tapering and fluted pilasters as well as a recessed centre. But no other building fully shared the 'huge broken pediments on the skyline in the manner of the Villa Aldobrandini at Frascati'[22] except Archer's Roehampton House.

Thomas Archer was well off, well connected, and an amateur architect in that he did not live on the income from the buildings he designed for his friends. He travelled for four years, 1691–1695, and his 'restless' designs were clearly influenced by the Roman Baroque school, especially 'the sinister and

25 *Monmouth House, Soho Square. Incomplete at the death of the Duke, this mannerist front was added c. 1718. The recessed centre divides a giant pediment and is, in turn, crowned by a pediment of its own. 'So striking it positively attributes itself to Thomas Archer' says* the Survey of London. *Like other views this was based on sketches for the Crowle Pennant of 1764*

unbridled style of Francesco Borromini – the *enfant terrible* of Italian architecture and the man whom, in a very few years English architects were to regard much as a good schoolboy regards a prostitute'.[23]

William Bateman completed the house in 1719–20, married Anne Spencer, grand-daughter of Sarah Duchess of Marlborough in the latter year, and was created Viscount Bateman. He erected splendid wrought iron gates embellished with his crest to close the courtyard in front of his house. The second Viscount also lived in Soho Square till 1756. The house was then let to the eighth Earl of Winchelsea. A series of tenants included the French and then the Russian ambassadors in the 1760s. The fashionable world having quite deserted the area, demolition was decided on in 1773.

The fullest account of the house is given in a *Life of Nollekens* by J.T. Smith. These two visited while demolition was under way.

There were eight rooms on the ground floor; the principal one was a dining room towards the south, the carved and gilt panels of which had contained whole length pictures. At the corner of the ornamental ceiling which was of plaster, and over the chimney piece, the Duke of Monmouth's arms were displayed.... The staircase was of oak, the steps very low, and the landing floors tessellated with wood of light and dark colours, similar to those now remaining on the staircase of Lord Russell's house ..., [of 1716–7]. The principal room on the first floor ... was lined with blue satin, superbly decorated with pheasants and other birds in gold ...[24]

This lengthy reminiscence does not mention Sir James Thornhill's paintings on the staircase walls which were commissioned by Sir James Bateman and for which Thornhill's sketches still exist.

In the south-eastern corner of Soho Square, *Carlisle House* was the town residence of the Howard family. In 1685, Edward Howard, second Earl of Carlisle of that creation, built a large mansion – though hardly one consonant in grandeur with Castle Howard, the family seat near York. A fairly plain brick house, it had back buildings alongside Sutton Street leading to the stables on Hog Lane. That inauspiciously named thoroughfare became the nineteenth-century Charing Cross Road.

The Howard family abandoned Soho Square fairly early in its decline from fashion. Their lease from the Duke of Portland (Soho Square was then part of that family's estate) was sold in 1753 to a firm of upholsterers. Carlisle House saw, however, a few more years of gracious living, being let to a series of tenants including the Ambassador of Naples. Indeed there were days of slightly suspect glamour under the next tenant, Theresa Cornelys. Courtesan, opera singer, actress, this lady attracted the *beau monde* to her public entertainments. For some reason or other, a consortium of her creditors who took over after her bankruptcy in 1772 were unable to equal her entertainments. The property was demolished in 1791. This house is not to be confused with the large one at the end of Carlisle Street which also bore the name 'Carlisle House'.

Number 20 Soho Square was occupied by Thomas Belasyse from 1683 to 1700. After his creation as first Earl Fauconberg in 1689, his mansion took that title too. It was a substantial building with a frontage of 64 feet. The descendants of the Earl's marriage to Mary, daughter of Oliver Cromwell, lived in *Fauconberg House* till 1753, when Arthur Onslow, Speaker of the House of Commons, took over.

In 1761 a powerful Scottish connection commenced with the occupation of the fourth Duke of Argyle and following him, in 1770, a Scottish lawyer and owner of West Indian sugar plantations, John Grant. The latter commissioned his fellow countryman, Robert Adam, to remodel the façade and to re-plan and decorate the interior. Adam's 'fashionable dress' for the house concealed the original irregular windows behind a typically rusticated ground floor supporting a giant order of Ionic pilasters to the two upper floors. It was mostly done in Adam's own 'Liardet's Stone Paste'. There was a decorated stone frieze and a modillioned cornice beneath a balustrade.

Grant's means were stretched by what was in any case a poor investment, for already Soho Square had been deserted by the 'ton'. His executors sold the house to a hotel owner. The building thus began an inexorable decline. The pattern was one more familiar further east in the City where once-fashionable mansions were appropriated for commerce. It became a tavern, and was later taken over by musical instrument makers. In 1858 it became a pickle factory and warehouse for Messrs Crosse and Blackwell until demolished in 1924.

The houses on the north side of Piccadilly were built before those in Soho Square and were of a totally different character, essentially that of country houses. Riding along Piccadilly in 1665 Samuel Pepys remarked on three mansions being built, Lord Berkeley's, Lord Chancellor Clarendon's and Sir John Denham's. The last was shortly to be bought by Lord Burlington and survives, though buried inside later buildings. Berkeley House was burnt down half a century later, but was rebuilt as Devonshire House and only demolished in 1924. The building between those two and more interesting than either, *Clarendon House*, was 'the best contriv'd, the most usefull, gracefull and magnificent house in England', according to John Evelyn. 'If it is not a solecism to give a palace so vulgar a name, I have never seen a nobler pile.'[25] The unanimous praise has been echoed by modern writers, including John Summerson: 'Clarendon House was among the first great classical houses to be built in London and easily the most striking of them. It was imitated far and wide...'[26] Where it was not imitated was nearby, that is in London. Such success and wealth as Clarendon's, especially when so os-

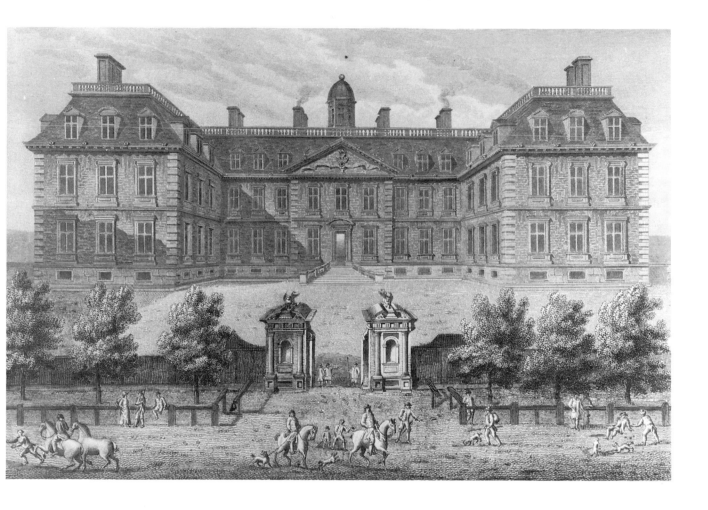

tentatiously flaunted as by the building of a palace in the capital of a country wherein its owner is still holding public office, gives rise to envy. The great and ill-used, if somewhat vain, Edward Hyde was destroyed by it. His house 'rose in splendour, was occupied in sorrow and misgiving, and became a thing of the past, within the short space of a single decade.'[27] British aristocracy, with rare exceptions, took the lesson to heart.

The site obtained by Lord Clarendon in August 1664 was large; as so often the case it was a royal grant. In modern terms it stretched from Swallow Street nearly to Berkeley Street. The house itself faced down St James's Street, its perfect symmetry almost seeming to deride the rambling palace down the hill. Facing a large courtyard was the nine-bay main block with the slightly projecting three-bay centre surmounted by a pediment which, as was then the custom, developed out of the heavily bracketed projecting cornice. Much more remarkable was the scale and extent of the side wings extending towards the street; they were in no sense

26 *Clarendon House, Piccadilly. The greatest house of its time was built in 1664–7 for the greatest politician. 'The finest pile I ever did see in my life' (Pepys) – it was swept away by developers in 1683*

minor appendages to the central block but continuations of it at right-angles. The whole 'H-shaped' house was of double-pile form, again a significant innovation affecting houses of all types except the smallest in the late seventeenth century. 'Double-pile' means that the house is at least two rooms deep and would usually have a double gable with a 'valley gutter' between. Here the roof rose to a balustraded flat.

Clarendon House was the greatest work of an architect only known to have produced four large houses as his total output, Sir Roger Pratt (1620–85); a gentleman and a lawyer who took up architecture as a secondary interest. Unlike that other enthusiast for the subject, John Evelyn, with whom he was 'co-habitant' in Rome in 1645, Pratt put into practice the lessons of his Continental tours and of his studies of Palladio, Scamozzi and Serlio. In

doing so he became a pioneer in English domestic architecture. Of Clarendon House's plan we know little, but can assume much from Pratt's earlier masterpiece Coleshill, which was tragically destroyed by fire in 1952. Here in 1650–62 and at Horseheath (1663–5) Pratt disposed all the elements which appeared in 1664–7 at Clarendon House in their 'most fully developed and refined form'.[28] Horseheath was demolished in 1777; it is known to have had the same pedimented frontispiece. Otherwise, apart from the large wings of the Piccadilly house, the three were similar in having two floors of almost equal height on a raised basement. Coleshill certainly and Horseheath probably shared the following features too: steeply pitched roofs and large dormers with alternating triangular and segmental pediments, a wider spacing between the three middle windows than elsewhere, a central octagonal domed lantern lighting a large central staircase hall, a small, blank, bracketed, segmental pediment over the main entrance approached by a straight flight of steps with curved balustrades, alternating long and short rusticated quoins to the corners, and massive panelled chimneys.

The other key point about these houses and the scores built in imitation of them up to 1715 was that they were 'astylar', that is they had no giant orders – in fact no orders at all. Summerson encapsulates the type as being derived from Inigo Jones, i.e. English, but modified by knowledge of such Dutch buildings as the Mauritshuis at the Hague. In particular the plan of Coleshill and presumably of Clarendon House was first seen in essence at Jones's Queen's House at Greenwich with its double-pile of rooms either side of a central corridor and with its staircase hall and great parlour on the entrance floor and the great dining room above it.

Clarendon House probably cost about £40,000, its furniture, pictures and plate more on top. The misfortunes of the Plague and Great Fire had not induced tolerance. As early as 14 June 1667 Pepys was recording in his diary 'that some rude people have been ... at my Lord Clarendon's where they cut down the trees before his house, and broke his windows; and a gibbet either set up before or painted upon his gate...' Later that year he was impeached. Evelyn's diary paints a sad picture of the last day in England of a statesman abandoned to his fate by Charles II, as was the way with the Stuarts. 'December 9, 1667 – to visit the late Lord Chancellor. I found him in his garden at his new built palace, sitting in his gowt wheelchair... After some while deploring his condition to me, I took my leave. Next morning I heard he was gon.' He died in France in 1674, by which time he had completed his 'History of the Rebellion', the profits from which later funded the Clarendon Building at Oxford.

Evelyn, in a letter to Pepys, probably following a visit to Clarendon's son Lord Cornbury in 1668, lists the pictures in the house – or rather the portraits – for if there was any other sort of picture they are not mentioned. That and the fact that the artists are nowhere named says much about the civilized Englishman's taste in paintings at the time. To do Lord Cornbury justice he was an historian and the subjects of his portraits were 'famous and learned Englishmen' such as the Duke of Buckingham, Raleigh, Sidney, Leicester, many other aristocrats, the royal family, archbishops, 'witts, poets, philosophers'. Macaulay dubbed them 'The masterpieces of Vandyck which had once been the property of ruined Cavaliers', housed in the 'palace which reared its long and stately front opposite to the humbler residence of our Kings'.[29]

Clarendon House was sold to Christopher Monk, the second and last Duke of Albemarle, for £26,000 in 1675. Eight years later it was demolished by Sir Thomas Bond as head of a syndicate of developers who had bought it from the extravagant and then indigent Duke. Bond Street, Dover Street and Albemarle Street are on the site. 'I walked to survey the sad demolition of Clarendon House, that costly and only sumptuous palace of the late Lord Chancellor Hyde, where I had often been so cheerful with him, and sometimes so sad...' wrote Evelyn on 18 September 1683. Let him have the last word.

Buckingham House in St James's Park, built by William Winde for John Sheffield, Duke of Buckingham in 1703–5 was also an important architectural prototype for much of the eighteenth century's country houses. Winde was generally unoriginal. His first country house, Combe Abbey for Lord Craven, was based on Clarendon House; Powis House, Lincoln's Inn Fields, was a loftier version of the then-standard mansion type. Buckingham House, with its dominant central block marked in the centre with a giant Corinthian order, and with

27 *Buckingham House, St James's Park. Built on the site of Arlington House, seen here – perhaps somewhat imaginatively – in 1700, three years before demolition. The* New View of London *described it as having been 'a graceful palace, very commodiously situated . . .'. In fact it was the most attractive setting in London*

a courtyard enclosed by subsidiary wings linked to the main block by curved colonnades, took after May's Berkeley House in Piccadilly. What was new was the urbanity achieved by the replacement of a hipped roof by a flat-topped extra storey which, with its balustrade and statues could well have been the model for Powis House, Great Ormond Street ten years later. What made this more striking was the setting, the most isolated of any discussed in these pages.

The first substantial house on the site was that attached to James I's Mulberry Gardens – a failed silkworm project. Part of the property, including the house, was bought by Lord Goring in about 1630. Goring House was tenanted for some of the Commonwealth period by Speaker Lenthal. Returning in 1660 Lord Goring refurbished the house but he died shortly thereafter and his son sold the house to the future Lord Arlington of CABAL ministry fame. Both mansion and grounds were then enlarged to include almost all of the former Mulberry Gardens. But the house was consumed by fire in 1674 together with 'the best and most princely furniture that any subject had in England'.[30] Lord Arlington rebuilt the house which passed at his death in 1685 to his daughter. She was the Duchess of Grafton, having married a son of Charles II and the notorious Lady Castlemaine.

Arlington House was sold in 1702 for £13,000 to John Sheffield who was created Duke of Buckinghamshire the following year. He pulled down the existing mansion and by 1705 was in occupation of the new building 'conducted' by Captain William Winde. There is a suggestion in the *King's Works* that William Talman may also have been the designer.[31] In any case this is the red-brick building later engulfed in the copious Bath stone of Buckingham Palace. The cost was £7000, to which has to be added £1000 for the impressive stone staircase with its ironwork by Tijou and its paintings of *Dido and Aeneas* by Laguerre.

The money was well spent if Macky's description is anything to go by:

> Buckingham House is one of the great beauties of London, both by reason of its situation and its building ... fronting the Mall ... behind it is a fine garden, a noble terrace (from whence, as well as from the apartments you have a most delicious prospect), and a little park with a pretty canal. The courtyard which fronts the park is spacious ... in the middle is a round basin of water, lined with freestone, with the figures of Neptune and the Tritons in a water work. The staircase is large and nobly painted; and in the hall before you ascend the stairs is a very fine statue of Cain slaying Abel in marble. The apartments indeed are very noble, the furniture rich, and many very good pictures.[32]

This is not the end. Macky goes on to describe the statues at roof level, inscriptions on the elevations – that facing the garden being the unoriginal 'Rus in Urbe' – and says that from that garden nothing but open country can be seen.

A good impression of the interior comes from the pen of the Duke himself. Passing his 'great basin', mounting to a terrace we enter a large Hall, 'paved with white stones mixed with a dark-coloured marble; the walls of it covered with a set of pictures done in the school of Raphael'. On the right is a parlour, 33 feet by 39 feet, with a 15 foot niche for a 'Bufette'; this is beyond an arch and has 'Pilasters of divers colours' and a ceiling painted by Ricci. Finally, the Duke returns to the rural theme saying that outside his library window 'is a little wilderness full of blackbirds and nightingales'.[33]

These descriptions say as much about the education, interests and sentiments of the day as they do about the building. There is an informed enthusiasm for classical architecture, painting and sculpture. Despite Marlborough's recent wars there is the influence of French taste for courts, 'waterworks', murals, even buffets. There is an appreciation of spaciousness, both within and without. The

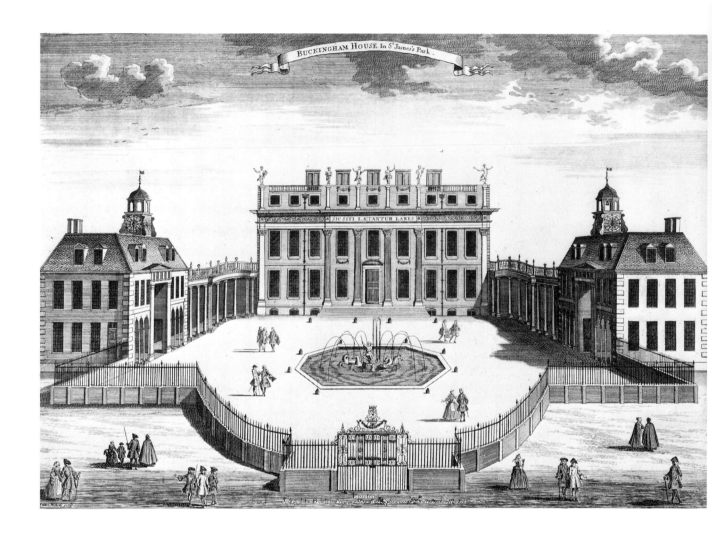

28 *Buckingham House. William Winde built this grander replacement for the Duke of Buckingham c. 1704. Although in red brick, its flat-topped, urban character may have influenced such rather later buildings as Powis House. The style of the service blocks is nearer to the then more prevalent English Baroque of Wren. Parts survived within the stonework of Nash's royal palace*

romantic appreciation of nature, not in the raw as at the end of the century but as an artful counter-point to classical architecture, is notable.

'Spacious' was also one of James Ralph's more favoured terms. His 1734 entry on Buckingham House is lengthy. He carps about the proportions not being 'absolutely perfect', the windows being too large and numerous, the decorations being 'poor and trivial', the colonnades being stuck on to the house 'without any plea for its connexion', the wings so joined being miserable in themselves and 'no ways akin to the house they belong to'. At least in the last he is being conservative but he also surely has a point, for the wings, no doubt because they

were seen as service ranges, are very much of seventeenth-century type with two storeys below overhanging eaves, pitched roofs, dormers and lan-terns. But even Ralph, after all this criticism, has the cool nerve to add that, 'Upon the whole, it must be confessed, it has the appearance of taste and design, and if it is not perfect, there are few houses that are more so.'

James Ralph had to suppress his Burlingtonian prejudice for fewer and smaller windows and other Palladian proprieties, and admire the setting. He applauds the late Duke of Buckingham 'for chusing his ground so well'. For it gives him the advantage of 'a triple vista along the Mall, the air of Constitution-hill, the prospect of Chelsea-fields, ter-minated by the hills of Surrey, and a most delightful view of the canal, with the landscape on either side, and the Banquetting-house at Whitehall. . .'[34]

It is in that direction that our attention will soon turn, when it no longer would be quite so eccentric to go further west and build a residence in

Chelsea-fields! The Duke died in 1721, leaving the house to his third wife. She left a life interest in the place to Lord Hervey who did not, however, take possession. Buckingham House was eventually sold to George III by the Duke's illegitimate son, Sir Charles Sheffield in 1762.

Whitehall mansions are discussed in other chapters; however, the essentially ecclesiastical centre of Westminster did also attract a number of the nobility seeking sites for houses, and of these the outstanding example was yet another attributed to Inigo Jones. In the case of *Ashburnham House* there was more justification than usual at least in stylistic terms. His assistant was most likely John Webb, not only because so accomplished a design built before 1662 narrows the field, but furthermore the Earl of Ashburnham told Batty Langley that it was Webb. The suggestion by Chancellor and others that at least the famous staircase was constructed by Webb, to designs by Jones, which the Civil War prevented being implemented, is not absurd.

The house was built on the site of the Prior's Lodging and incorporates fourteenth-century rubble walls in the hall and chamfered beams in the former kitchen. 'The best example in London of a progressive and stately midC17 house'[35] was built by William Ashburnham who was rewarded for his loyalty to Charles I by being appointed Cofferer of the Household to Charles II. In 1679 the property passed to a relative, John Ashburnham, created Baron a decade later. The third Baron, raised to first Earl Ashburnham in 1730, sold the house to the Crown at about the same time. The intention was to accommodate the Cotton Library of manuscripts hitherto deposited in Essex Street. Unfortunately a fire in 1731 destroyed over a hundred volumes and damaged almost as many.

What remains of the original red brick building is occupied by Westminster School; that consists of the west wing which contains the staircase and drawing room, both with fine plasterwork and heavily carved doorcases. The other wing, demolished in 1739 for the building of two prebendal residences, was reinstated in its essentials in 1930. The staircase is of the square type in a large open

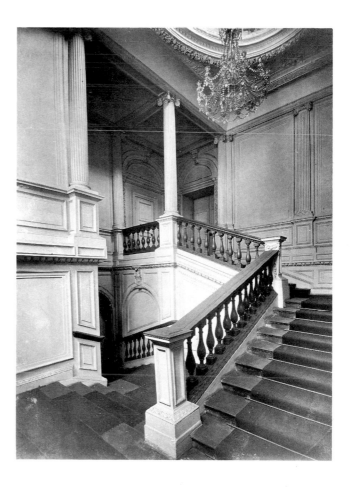

29 *Ashburnham House, Westminster. Although not built till after the Civil War, this fine stair may have been designed by Inigo Jones. Attached Ionic pilasters, columns, attached and detached, robust but finely carved balusters are all handled with great assurance. Above is a rich cornice, shallow dome and the top lighting which was to become usual for such compartments*

well, which is lit by a domed oval lantern. It is an extremely skilful exercise, especially in the manner that unequal numbers of steps and several landings cope elegantly with awkward storey heights. The whole house, in plan and section, is rendered irregular by the re-use of old fabric. The elevation is of a half-storey, full-storey and then another half. In the five-bay centre is a plain rusticated surround to the entrance door. This description makes Ashburnham House sound like a clearer seventeenth-century statement than its actual appearance, among rebuildings and additions, allows.

III
The Augustan Ideal

'Something there is more needful than expense. And something previous even to taste, 'tis sense.' Thus wrote Alexander Pope in his *Essay on Taste*, addressed to Lord Burlington.[1] His meaning was precise: 'You show us Rome was glorious not profuse.' Nor was this Augustan reticence, this aristocratic disdain for vulgar display, merely an aesthetic preference. It was also a widely shared moral imperative. James Ralph, the architect best known for his *Critical Review*, published in 1734, three years after Pope's essay, prefaced that book with an essay on taste. Ralph shared the Palladian enthusiasms of Lord Burlington and his poet friend. For Ralph 'A good taste is the heightener of every science, and the polish of every virtue ...' 'Truth and beauty' he goes on to say 'include all excellance'.[2]

The private palaces described in this chapter are direct products of a coherent set of values, conveniently labelled 'taste'. An assured aristocracy neither needs nor wishes to make displays of wealth or power. For the first time aesthetics is the motivator. It is governed by a fundamental attitude about the moral dignity of restraint and the vulgarity of excess. Mid-eighteenth-century excursions into such 'excess' – the *rocaille* decoration of Chesterfield and Norfolk houses, Adam's garish glass drawing room at Northumberland House, even his employment of Gothic and Chinese motifs – were conscious reactions against what was at that later time seen as the pedantry of the Burlingtonians.

Changes in architectural taste do not occur overnight. Two late Baroque houses (Marlborough and Powis) were illustrated by Colen Campbell in the first volume of *Vitruvius Britannicus* published in 1715. This book, and the two later volumes, each containing 100 plates, were crucial propaganda for the new, more 'correct' classicism of the Palladians and for Campbell's own work. Despite favouring 'Antique Simplicity' over the 'affected and licentious' forms of the baroque, he did not entirely exclude the old school. In his preface he could not 'but reflect upon the happiness of the British Nation, that all abounds with so many learned and ingenious gentlemen, as Sir Christopher Wren, Sir William Bruce, Sir John Vanbrugh, Mr Archer, Mr Wren, Mr Winne, Mr Talman, Mr Hawksmore, Mr James & c, who have all greatly contributed to adorn our island with their curious labours and are daily embellishing it more'.[3]

Twenty years later Ralph slighted the achievements of all the above named 'for want of elegance and discernment in the execution'. He felt that there were few 'fine pieces of architecture' in sight; 'they are generally hid in holes and corners'.[4] He complained further that 'our structures' were heavy, and that they were 'rather incumbered than adorned'. There were two points here: firstly that what he sought in terms of spaciousness and vistas was lacking, that there was very little formal urban design; secondly that he disliked the giant orders, heavy carving and exuberant modelling of the Wren

school. Ralph's hero was Lord Burlington, to whom he dedicated his 1734 book, saying that the way to avoid 'Folly in building ... is to consult the models your lordship has obliged the publick with, and then they will learn that beauty is first founded in simplicity, and harmony; and magnificence in propriety of ornament, and nobleness of imagination.' Partisanship was the fiercer because of the links between politics, patronage and taste. There was, as John Harris has described, a struggle between two establishments, the old ones based on the Court, the Office of Works and its architects, the new one 'in a high pressure take-over bid on the Jones-Campbell-Burlington platform ...'[5]

The latter triumphed and four rather different West End houses illustrate that triumph: Burlington's own, nearby Devonshire House by his friend William Kent; Queensberry House, Burlington Gardens by Giacomo Leoni; and General Wade's

30 *Typical staircase mural of 1720–30, showing eight figures looking over a balustrade, probably by a follower of Laguerre. Both people and architecture are realistically and confidently painted. This was discovered in 1909 at 44 Grosvenor Square, covered with panelling, rediscovered in 1961, now in the Victoria and Albert Museum*

House in Great (now Old) Burlington Street also designed by the Earl himself. The matter of the authorship of Burlington House itself is a complex one; the client shared responsibility with Gibbs, Campbell, possibly Leoni and certainly William Kent, though the last was only responsible for parts of the interior.

Devonshire House, though large in scale and judicious in proportion was an undemonstrative brick building with some of the qualities of north Italian estate buildings seen in Inigo Jones's St Paul's Church, Covent Garden. Burlington House was a

stone palazzo of a sophistication new in London, with a large courtyard and colonnaded wall separating it from the street. Queensberry House was a smaller palazzo right on the street, as if in an Italian town. General Wade's house, smaller again, a town villa of almost Platonic perfection directly based on a drawing by Palladio, was the first classical house in England to use the Doric order for the *piano nobile*. Wade's house was especially palatial in its aristocratic disdain for practicality. Ralph thought it perfect, 'intirely chaste and simple'. Even the client tolerated the inconvenience. As Lord Chesterfield gibed: 'to be sure [General Wade] could not live in it, but intended to take the house over against it to look at it.'[6] Here is truly patrician architecture; aesthetics were its impulse. Taste, as understood by a handful of conoscenti, was the only criterion it allowed.

The 1720s and 1730s were the most productive of Lord Burlington's life; his influence predominated up to 1750. He was referred to as 'the noble Maecenas of the Arts' by Vertue, and 'the genius of the age' by Thomas Herring.[7] Two major mid-eighteenth-century houses illustrate Burlington's influence and, at the same time, the growing reaction against that influence. The exterior of Chesterfield House, begun in 1747 by Isaac Ware, was not devoid of Palladian formal elements nor restraint. The whole effect is a little thin compared with Devonshire House, with which it had plan similarities and a common material, brick. Spencer House was of stone, yet compared with the Augustan weight of Devonshire House, looked positively flighty and unsure of itself sitting insubstantially on its grotto-like rusticated base. Both these palatial houses had interiors of the utmost richness, the first including unusual essays in the rococo, the second with strong overtones of Greek neo-classicism.

Lord Chesterfield, as his writings adduce, was quite capable of resisting dictation on aesthetics – among other things. His architect was not; so powerful still was the Burlington propaganda that Ware 'recanted' his Chesterfield House work, for all the world like a revisionist returning to the party line.

The influence of Lord Burlington has been emphasized here because it was extraordinarily potent in the field of aristocratic town-house building and because, unlike that of Jones, Wren and Adam in their different ways, it is capable of being under-

estimated. As a summary that of James Lees Milne is difficult to improve upon: Burlington's influence, he writes, 'finally dispelled the baroque from England and prevented general acceptance of the rococo. The one never reached full maturity: the other was retarded at birth. Burlington succeeded in making the architecture of Wren, Vanbrugh and Archer look uncouth to his contemporaries, and Lord Chesterfield's *rocaille* decoration ... ridiculous.'[8]

He had first started altering his own house in 1712; aged only eighteen he was not seriously interested in architecture, not having undertaken even his first and less formative trip to Italy. The baroque of Wren and his followers still held sway. It would thus be appropriate to commence the detailed examination of houses in this chapter with a precursor, an example of exactly what the Palladians rejected: *Marlborough House*. This was one of the last private palaces of Queen Anne's reign; it was built by one of her closest friends. Wren's Marlborough House was a self-assured essay in his English renaissance brick and stone style. Handsome and robust, it was, as Macky wrote, 'in every way answerable to the grandeur of its master'.[9] Certainly it looked old-fashioned and provincial to those with the new Italian tastes, but Ralph's diatribe about it being overloaded with ornament is the product of prejudice.[10] It had no orders, columns or pediments, just two lofty storeys on a basement, surmounted by a cornice and a continuous balustrade. The storey-height window over the main entrance was supported by carved stone scrolls. The door was approached by the kind of generously wide and shallow steps the Duchess was to lament the lack of at Bedford House. Every window had a plain stone apron below, and between the two windows in the projecting end bays on both main fronts were niches. These, together with bold and regular stone quoins, were all the house offered in the way of adornments. Wren did intend a little more bravura – urns and a central motif of carved trophies above the balustrade. Statues, also no doubt martial in character, were intended for the niches. Sarah probably cancelled these frills. Before the completion of the house she had decided that 'the poor old man' was being put upon by the contractors and dispensed with Wren's services.

Little of the quality of the original palace can be appreciated today. Marlborough House is a sorry

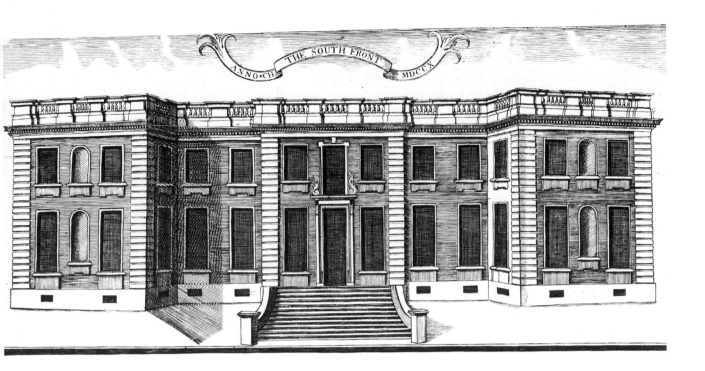

sight, less as a result of the modern institutional use as Commonwealth Secretariat, more the effects of additions to cope with large aristocratic households in the 1770s and 1870s.

Marlborough House was in tune with the Duchess's image of herself as 'Mrs Freeman' the 'frank, open' companion of 'Mrs Morley', otherwise known as Queen Anne. She said she wanted 'it plain and cheap'. The house was also a product of her scorn for the architectural pretension epitomized in the splendidly theatrical Blenheim Palace, erected by the nation in homage to her warrior husband. It cost £50,000, however.

The house was built between June 1709, when Sarah laid the foundation stone, and midsummer three years later. The ground leased from the Queen was on the eastern fringe of St James's; it was very much a product of Sarah's wish to be near the Court. 'I have no great opinion of this project,' said her husband, still conducting his last campaigns against France while his political enemies at home were plotting his destruction. By the time the house was completed he had been dismissed; the Marlboroughs were obliged to give up their apartments in St James's Palace. This was a minor consequence of a quarrel between two middle-aged women which had major effects in contributing to the fall of a government, and the ending of a war

31 Marlborough House, Pall Mall. The original south front is uncluttered by the first of a series of additions after 1770. Wren's design is robust and assertive, like his client, Sarah, Duchess of Marlborough. She thought the builders (Edward Strong and Henry Bankes) were taking advantage of the aged architect and sacked them. 'My Father has laboured as far as his health and time would permit him,' wrote Wren's son

with a treaty which greatly enlarged the British Empire.

After the Duke's death in 1722 the Duchess remained a power in the land, largely through sheer force of personality. She disposed of a huge fortune, of an incisive but acerbic tongue, and of various offspring in marriage. Two of Sarah's grand-daughters married dukes and, as will be seen at Bedford House, she saw it as her duty to direct their households too. She rubbed along well enough with 'neighbour George' (George II), for she lived much of her declining years in the Pall Mall mansion which she came to regard as 'the strongest and best house that ever was built'. Sarah constantly tried to improve its setting. She leased more land to enlarge the garden and tried to buy houses on Pall Mall which restricted the entrance gates. In the latter manoeuvre Sir Robert Walpole, one of her many enemies, deliberately thwarted her. At her death in 1744, there being no surviving son, the titles and estates devolved by special remainder through her daughter.[11]

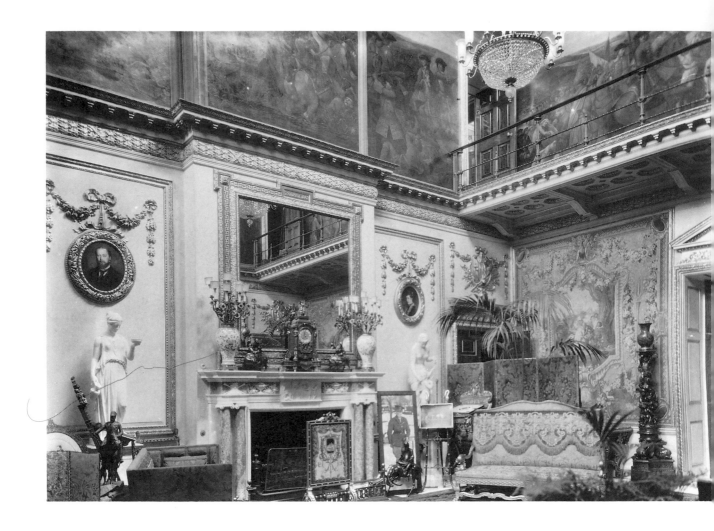

32 *Marlborough House. The entrance saloon when the mansion was still in use as a home – albeit by the widowed Queen Alexandra – in 1923. Above the cornice and gallery are Laguerre's murals of the battle of Blenheim, the Duke of Marlborough's most famous victory*

Whatever its aesthetic merits Marlborough House was widely acknowledged to be awkwardly planned – even by contemporary standards the route from the basement kitchens to the dining room was extended. The interior was intended to be austerely impressive, but also light and airy. This was on the insistence of Duchess Sarah, who scorned the Palladians' niggardly provision of windows. Entry was direct into the two-storey saloon, which extended the full height of the house. This was a common feature of the period; it nearly always led to later plan modifications. When this happened at Marlborough House the room itself was not destroyed; a *porte-cochère* and entrance vestibule were prefaced to it.

At first-floor level in this saloon is one of the great features of Marlborough House, Laguerre's murals of the battle of Blenheim, painted about 1714. More notable artistically is the ceiling painting by the Italian, Orazio Gentileschi. He had painted murals for the Duke of Buckingham at York House and his work for Charles I had included this large work for the ceiling of the hall of the Queen's House at Greenwich. When moved to Marlborough House in Sarah's time, it was ruthlessly reduced in size. Nonetheless it strikes a welcome contrast with all the martial subjects there. The central panel shows Peace, surrounded by the Liberal Arts and Virtues; the Nine Muses fill the borders, and Music, Sculpture, Architecture and Painting the corners.

The first significant alterations to Marlborough House were carried out for the fourth Duke by William Chambers in 1771–4. Apart from internal changes, the important addition of an attic started the long process of turning the palace into a shapeless agglomeration. This upper floor was replaced in a further enlargement in the nineteenth century.

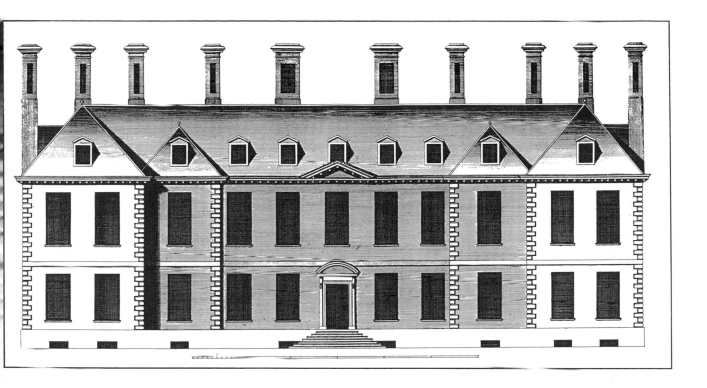

But by then this was no longer a private palace, the remainder of the lease being purchased by the Crown at the death of the fourth Duke in 1817.

The importance of *Burlington House* derives from the Palladian form it assumed in the 1720s, but its origins predated Marlborough House by nearly half-a-century. Its site was part of that large tract of land granted by Charles II to Clarendon in August 1664 – as was the site of Berkeley House to the west. The easternmost seven acres were made over to Sir John Denham and Sir William Pulteney the day after the king's grant. These gentlemen then sub-divided the site, Pulteney taking a 100-foot strip to the east, Denham a similar strip to the west, the centre part to be held in common. It did not work out like that; a central dividing wall was erected and Denham proceeded to build himself a mansion on his half.

Sir John Denham (1615–69) was a poet and also Surveyor General of the King's Works; he was as Evelyn said, a better poet than architect. Nor was he successful in marriage, his second in May 1665 was to the 'lovely Margaret Brook' who shortly became mistress to the Duke of York. The following year Denham went mad; his wife fell mentally ill – thought to be poisoned – and the unfinished house in its three-and-half acres was sold. Much of the proceeds were applied to Sir John's debts. The pur-

33 *Burlington House, Piccadilly. The entrance front of 1665; architectural drawings of elevations have a way of dignifying quite ordinary façades. The basic form, with its weak centre, is that which was refaced for Lord Burlington and still exists today. It was never really satisfactory. This is a plate from Campbell's* Vitruvius Britannicus

chaser was Richard Boyle, first Earl of Burlington, second Earl of Cork, a friend of Lord Clarendon. They were connected by the marriage of their respective daughter and son. Burlington proceeded to complete the house, employing Hugh May, then the Paymaster of the King's Works, who had recently built Berkeley and assisted with Clarendon House.

There is no firm evidence as to responsibility for the original design of 'Denham House', as it was briefly known.[12] 'Mr Denham may, as most gentry, have some knowledge of the theory of architecture, he can have none of the practice, but must employ another' said John Webb who had expected to succeed to the Surveyorship held by Jones, whose deputy he had been.[13] Now he was Denham's deputy and may have helped with the practical side of the Piccadilly mansion. The plan was traditional and was probably laid down by the Surveyor himself.

With a recessed centre it harked back to the Tudor and Jacobean 'H' form, a red-brick, double-pile, hipped-roof mansion with modillioned

cornice, stone quoins and pedimented dormers. The forecourt, flanked by lower service buildings, was separated from the street by a high wall. It had, as Lord Burlington said, 'no building beyond it', that is to the north.

Completion of the wings, the boundary wall and the interior of the main block itself was delayed, as was that of Clarendon House, by the shortage of labour and materials needed to rebuild the City after the Great Fire and to equip the Navy for the Dutch War. Interior decorations, deliberately imitating the advanced taste at Clarendon House, were sufficiently complete for the family to take possession in April 1668. As the *Survey of London* informs us, it was rated that year for 41 hearths compared with 39 for Sir John Clarges' house next door to the east, 57 for Berkeley House and a hundred for Lord Clarendon's.

The double-pile block was 80 feet by 50 feet with single-pile transverse (i.e. north-south) wings projecting 3 feet from the garden front and 13 feet towards the street. The raised terrace between the front wings has survived through all subsequent re-facings and additions, though today there is a ramp up to it for those visiting the Royal Academy in wheelchairs! At this level was the 12-foot-high 'ground' floor, above it the 15-foot principal storey, and above that only garrets. The internal arrangement seems to have suffered in clarity, especially regarding the position of the main stair, when altered in mid-construction to suit the new owner. Burlington, a pious man, made a prominent feature of his chapel, which occupied two-thirds of the east wing.

Burlington House passed from the second Earl, who died young, to his ten-year-old son in 1704. The third Earl was under the guardianship of his mother, advised by a group of distinguished noblemen, till 1715. Then he returned from his first, year-long, Italian visit and Colen Campbell's *Vitruvius Britannicus* was published. Alterations to the house had been initiated by the guardians. An interior scheme including wall paintings chiefly by Sebastiano Ricci, had been carried out by 1713, and external additions by James Gibbs started in 1715. All was late baroque in approach until Campbell himself was appointed in 1717 or 1718. The ousting of Gibbs, 'a disciple of the affected and licentious Fontana'[15], in favour of an architect fol-

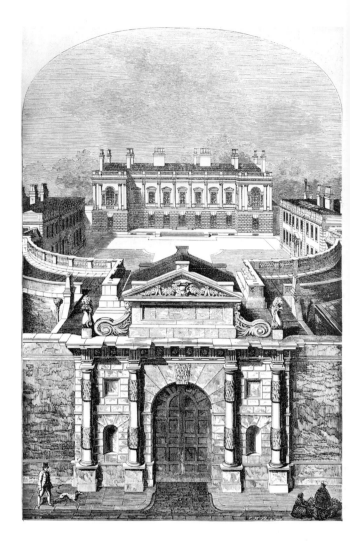

34 *Burlington House. The whole ensemble is seen in this* Builder *illustration of 1854 just prior to demolition of all the fore-buildings, including the famous curved colonnades, and the addition of extra storeys to the main block. Although the perspective gives undue prominence to Campbell's august gateway, it can be seen that the mansion itself fails to dominate*

lowing a dogmatically Palladian path was an important moment in English architecture. Campbell made his designs for the front of the house in 1717 and for the great gate in 1718. Burlington's second trip to Italy, when he went specifically to study the works of Palladio, buy his books and collect his drawings, was in the late summer and autumn of 1719. His conversion to Palladianism was probably helped along by the publication of Campbell's first volume in 1715 and Leoni's edition of *Palladio* in 1716. Being dissatisfied with the Gibbs design – for that architect must have produced an overall scheme for the re-fronting of the mansion as well as

rebuilding the east block and creating the circular colonnade – Burlington was casting about for a replacement.

Intending from the beginning to mask the homely brick mansion behind an imposing stone facade – otherwise why would he have agreed to the use of stone for the stables? – Burlington found what he sought in Campbell's designs, which were themselves clearly of the school of Inigo Jones. Campbell spoke of the Whitehall Banqueting Hall as being 'the first structure in the world'. It exemplified the use of Ionic columns, as on the first floor at Burlington House. The rusticated ground floor can be seen at the Queen's House, Greenwich. The Burlington House window surrounds were made like those at the Great Gallery of Somerset House.

Burlington returned from Rome with more than one copy of Palladio's *Libro dell'Architectura* and an intention to design 'correctly', that is in a manner conformable to Vitruvius; a manner of which he would have considered Jones an outstanding exponent. He found only preliminary mason's work for the new front under way. The reason was shortage of funds, which was probably why he never attempted to alter the north front. It did not prevent his putting William Kent to work to help transform the interior. Burlington had met this bluff Yorkshireman on his first Italian visit; a few years older than the almost over-refined aristocrat. Kent had qualities of exuberance and imagination which appealed. Overlooking his gross personal habits and his negligible formal education, the Earl was magnetized by what he saw as genius. A friendship, extraordinarily warm for that between two such different men, lasted almost up to Kent's death 30 years later. That it was at least partly the power of personality is suggested by the fact that Burlington first championed Kent as a supreme history painter, the art he was practising when they met in Rome and that for which he now obtained a Court appointment in preference to the more talented Thornhill. Kent's first architectural works appeared when he was almost 40.

The north Italian palazzo which appeared in Piccadilly in 1720 impressed by its novelty and its austere classicism. As an aesthetic whole it was not a total success. Truly Palladian, with a monumentally scaled *piano nobile* on a rusticated lower storey, it echoes the plan of the earlier mansion behind the

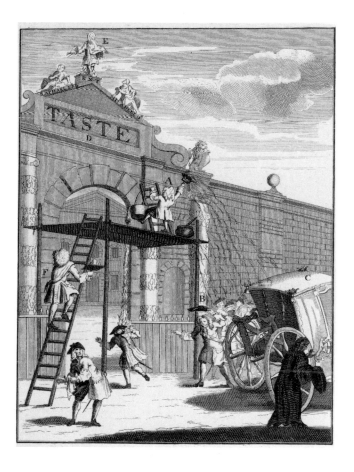

35 *'The Man of Taste' from William Hogarth's series*, Masquerades and Operas, Burlington Gate. *Lord Burlington, beloved of so many artists, earned Hogarth's enmity by securing a royal commission for Kent in place of the more gifted painter Thornhill, Hogarth's father-in-law. Here Burlington carries a hod up to Pope, who is white-washing the statue of Kent – raised on the pediment above Raphael and Michelangelo – and splashing the Duke of Chandos in the process*

new stonework. Height was increased by raising the roof. It consisted, as before, of a recessed seven-bay centre, with narrow, slightly advanced end wings, but now the main feature of the centre was the line of six evenly spaced three-quarter columns. The end bays had large Venetian windows. A projecting band course provided a plinth for the columns and for the pedestal which broke forward under each of the outer windows. The three centre windows had balustraded pedestals, like the Banqueting House. The ground-floor windows were heavily keystoned; those above in the main block had alternating triangular and segmental pediments with scroll console supports. Campbell intended there to be urns and statues on the balustrade in front of the leaded flat roof. As at Marlborough House, they

were not executed. In all its elements the Burlington House façade was very fine, but it didn't add up to a composition which could dominate a courtyard composed of such disparate elements. The criticism levelled at many Campbell/Burlington/Kent compositions is already justified in the first – 'a curiously pedantic feeling for the separateness of each component' in 'restless though logically related elevations'.[16]

Perhaps Gibbs would have made a better job of cladding the old mansion; certainly his creation of the semicircular Doric colonnade was hugely admired. Unique in England, its form must have been suggested by the similarly curved walls connecting the old wings to the front wall. 'One of the finest pieces of architecture' said Sir William Chambers and Horace Walpole, who, not knowing of its existence, did not notice it when he arrived for a ball but, 'looking out of the windows to see the sunrise, I was surprised with the vision of the colonnade that fronted me. It seemed one of those edifices in Fairy tales that are raised by genii in a night-time.'[16]

Campbell's triumphal archway of a gate was also praised; 'the grand entrance is august and beautiful, and by covering the house entirely from the eye, gives pleasure and surprise at the opening of the whole front . . .'[17] This from James Ralph was hypocrisy; he was fiercely critical of other walls less ponderous than this 28-foot one. But then Ralph was an admirer of Burlington.

Burlington's influence was enhanced by his powers of friendship and patronage – he could combine the two – and by the writings and achievements of those friends, among whom were Pope, Swift and Handel. There were enemies; he slighted the painter Sir James Thornhill and so earned the scorn of Thornhill's son-in-law Hogarth, for example. But these were few, for he was a good-natured man. He also developed into an important architect on his own account and was responsible for the adoption of much of the vocabulary of mid-eighteenth-century building. The language can be traced to Palladio: coffered vaults and semi-domes, a low window-to-wall ratio, a preference for a single principal storey, the use of Venetian windows and of the Venetian lunette with mullions, a liking for the temple form and a dislike of the giant order.

Many of these features can be seen today at Bur-

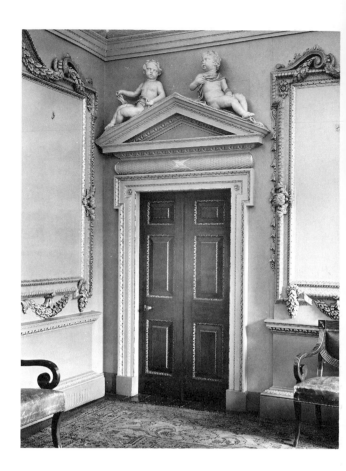

36 *Burlington House. The first-floor front reception rooms survive from the 1720s palazzo. In the saloon the seated boys on the doorcase pediment are by James Richards*

lington House. The three principal rooms on the first floor front are outstanding examples of early Georgian interiors in London. They are essentially Campbell's work; for example the saloon doorways with carvings of seated boys on their pediments are much like those at Marble Hill, which were also carved by James Richards.[18] The saloon ceiling was Kent's. The east room was created out of Burlington's staircase apartment by Ware in 1816–17, but its coved ceiling was of *c.*1720. The four splendid paintings by Sebastiano Ricci, formerly on the staircase, are now dispersed: 'Olympus' to the ceiling of the Council room, 'Bacchus and Ariadne' to that of the assembly room, 'Diana and attendants' and 'The Triumph of Galatea' to the present staircase. Some later alterations were by the Earl himself, notably the creation of an elliptical library on the ground floor of the east wing.

But Lord Burlington, as one of the country's great noblemen, could not see himself as an architect, or

be seen as one, despite the fact that the subject was his ruling passion. Income from vast, though in his time somewhat diminished, estates in England and Ireland had to be augmented by developing some of the London property. Nor could someone created, at his coming-of-age, Lord High Treasurer of Ireland and Lord Lieutenant of the East and West Ridings of Yorkshire, ignore public office. The Yorkshire appointment was certainly taken seriously; at that period the post involved administration. Although a prominent Whig from 1713 to 1733, Burlington had little serious interest in political office. When Walpole brought in his Excise Bill in 1733 he went not unwillingly into opposition with Bathurst, Chesterfield and Cobham. He seemed to lose interest in metropolitan life at that time. The best pictures were sent from Burlington House to the mansion at Chiswick to which in the years 1723–9 he had attached his exquisite villa. He was seldom in town in the 1740s, though the Piccadilly mansion was kept in repair.

Lord Burlington died at Chiswick in 1753. He had no male heir, and his property passed via his daughter to her husband Lord Hartington. Thus not only did what Burlington had called 'the only town residence really fit for a British nobleman'[19] pass to the Cavendish family, which already possessed the substantial Devonshire House next door, but also his collection of drawings by Palladio, Jones and Webb. Some of these are at Chatsworth, but the majority are on permanent loan to the RIBA.

Propositions for sale and development of the site were seriously considered, but in 1771 the house was let to the Duke of Devonshire's brother-in-law, the third Duke of Portland. At this time Portland, a minister in the government, employed Carr of York (1723–1807) to carry out alterations, especially to the dining room. This was a happy choice since John Carr was essentially a Palladian architect. He had been an admirer of Lord Burlington since coming into contact with him in connection with the building of Kirby Hall in c. 1750. Portland was Prime Minister in 1783; then the rate books named Devonshire's younger brother, Lord George Cavendish, as living there. By 1807 when he was Prime Minister once again, Portland was back in residence. There had been a remarkable political re-alignment, so that Burlington House, a Whig

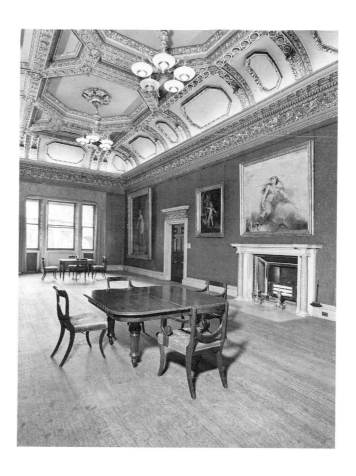

37 *Burlington House, the east room. Now the Reynolds room, with a splendid coved ceiling probably by Campbell*

centre during Portland's first occupation was now a Tory meeting place. War was the spur.

After the Duke's death in 1809, there was further talk of demolition; this was shelved when Lord George Cavendish took up residence once more in 1811. These were again interesting times for the house: for five years the Elgin marbles were found a home in a building in the garden; the Cavendish paintings were removed to Devonshire House. Lord George brought Burlington House for £70,000 in 1815 and appointed Samuel Ware to carry out extensive rebuilding. Ware was another architect with strong Palladian sympathies, and in some areas it is difficult to separate the original Campbell/Burlington fabric from his. During 1815–17 he re-faced the north front, raised the attic storey, converted the stable block to the west of the forecourt into a residence for a member of the family, created new stables on the east side in the angle behind the colonnade and re-sited the staircase to the position at the

centre of the north front where it was probably
intended to be in 1665. To enlarge the stair com-
partment Ware added a projecting centre-piece to
the north front. At a cost of £50,000 the house was
greatly improved in terms of convenience and
barely injured aesthetically.

In 1819 the Burlington Arcade was erected, a
successful venture which helped to refill the Cav-
endish coffers. Created Earl of Burlington in 1831,
a neat move by the new King William IV, Lord
George died three years later. The property went
first to the widow, then in 1835 to the youngest son,
the title to the grandson. Again in this period
schemes for redevelopment were examined. But in
1854 a dreadful fate befell Burlington House; it was
sold for £140,000 to the government. The site in
front, the garden at the rear and, worst of all, the
top of the mansion were covered with new build-
ings. This work by an assortment of architects –
Sydney Smirke, R. R. Banks, E. M. Barry and
James Pennethorne (the last, incidentally, commit-
ted similar rape at Stafford and Marlborough
Houses) – need not be detailed here. Much of Lon-
don University, the Royal Academy and six learned
societies were accommodated. Smirke's RA galleries
did least harm. Among the losses was the unique
circular colonnade, transferred to Battersea Park for
re-erection; it was pulverized by the LCC in about
1900, for the lack of £3000.

The demand for residences for noblemen and
gentlemen had been only temporarily satisfied by
the selling off of much of the grounds of Berkeley
House and the total redevelopment of the Claren-
don House site in the 1680s. The Palladian Earl, a
profligate patron and builder, was able to release
much of the Burlington House land for building,
thereby producing both capital and income. Several
streets bore his name – Cork, Burlington and Clif-
ford. Two fine mansions were erected, Queensberry
House under his eye and that for General Wade to
his design.

Although Lord Burlington did not obtain lease-
hold control of the whole 'Ten Acre' estate north of
the Burlington House gardens till 1732,[20] develop-
ment of the western part of it had begun in 1718.
One of the first lessees was John Bligh, later Lord
Darnley, whose site was on the southern edge be-
tween Saville Street (now Row) and Great (now
Old) Burlington Street. Here a house was built to

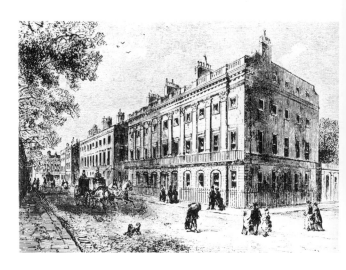

38 *Queensberry House, Burlington Gardens. As its address suggests,
it was on part of the former grounds of the Earl's mansion. The garden
wall of which can be seen on the left. Built 1721–3 to designs by Leoni
as a Palladian street house, rather than villa or palazzo. Extended in
1785 for the Earl of Uxbridge. Now occupied by the Royal Bank of
Scotland*

designs by Giacomo Leoni in 1721–3. In 1722, how-
ever, Bligh's wife died – she had been a great-
grand-daughter of the first Earl of Clarendon. Now
a cousin, another Clarendon descendant, the Du-
chess of Queensberry and her husband took over
the house, henceforth known as *Queensberry House.*
The young duke was himself a cousin of Lord Bur-
lington – relationships played a considerable role in
the development of this area.

The site was a north-south rectangle; the
double-pile house filled the whole 70-foot width, but
only about half of the 104-foot depth, allowing a
large courtyard to the north. Some of the main
storage rooms and kitchens were under that court,
ventilated by a narrow area on the east side. The
house was three storeys high, with a good outlook
to the south over the gardens of Burlington House.
But at street level the wall of that garden made the
situation look cramped. The only fault that Ralph
found was that 'it is badly situated over against a
dead-wall, and in a lane that is unworthy of so
grand a building'.[21] The design, though its order
was Composite – part Ionic, part Corinthian – was
reminiscent of Lindsey House, Lincoln's Inn, which
was thought of as a Jones work. The street front,
which had seven equally spaced windows and six
pilasters between them on the upper floors, was of

brick with stone dressings. Among the latter was a band course at first-floor level providing a plinth for the pilasters and a deep entablature above them. This consisted of a moulded architrave, a plain frieze and a modillioned cornice, above which was a parapet wall of brick with stone dies over the pilasters. The upper-level windows were dressed with moulded architraves also in stone. The ground floor was left as plain brickwork through shortage of funds much to Leoni's disappointment. Lord Burlington himself designed a gate to the courtyard in 1723 – there are drawings in the RIBA collection. The *Survey of London* quotes the building agreement between Queensberry and Witt, the builder, which *inter alia* lays down that the entrance hall is 'to be done in such a manner as the Earl of Burlington's Hall is already done', and that the stair compartment was to be plastered for painting – presumably by a history painter.[22]

In 1732 Queensberry purchased, subject to the Burlington interest expiring in 1809, the freehold of the site and also of a strip to the east abutting Savile Street. The early days of their residence, when the young Duke and Duchess had to spend periods in the country to avoid creditor tradesmen, evolved into a long period of prosperity. In all they spent a glittering half-century in the house. The couple had spent years caring for the poet John Gay, who lived much of his time in Queensberry House and died there in 1732. 'Kitty, Beautiful and Young', as Catherine was dubbed by Prior, had a vivacity which was to turn to wild eccentricity in her old age. She died 'of a surfeit of strawberries' in 1777, a year before her husband.

The house was inherited by 'Old Q', the fourth Duke, who didn't care for it much. So in 1785 it passed to the recently created Earl of Uxbridge, who proceeded to major alterations and extensions designed by John Vardy, son of the architect of Spencer House. It was this architect's only known work and was skilfully done.[23] By 1789 the building had been extended eastwards 30 feet to the Saville Row frontage. A north wing fronting Old Burlington Street was also added, including a new entrance hall. The original design of the house was generally continued, and such elements as the old stair was retained, though its compartment was heightened to allow top-lighting. A large music room was created on the first floor of the north wing; various openings were made and partitions removed to create a splendid *en-suite* range of first floor reception rooms extending to the new bays on the east. The stone cladding of the main elevation was completed.

Lord Uxbridge died in 1812. His son is best known for having commanded the cavalry at Waterloo where he lost a leg and gained a marquisate. His lifestyle required the mortgaging of 'Uxbridge House' as it was by now called. Nevertheless the Marquis of Anglesey held on till his death in 1854. The following year the house was sold to the Bank of England for its West End branch. In 1930 it passed to the Royal Bank of Scotland. Conversion for commercial purposes has, fortunately, left part of the house at the western end unspoilt.

Queensberry House was innovative and successful. Burlington's 1723 *House for General Wade* was regarded as being in important respects, which excluded practicalities, perfect: '... in Cork Street is a structure which, though small, is one of the best things among the modern, or lately erected buildings. Let me add, it is the only fabric in miniature I ever saw, where decorations were perfectly proportioned to the space they were to fill.'[24] This was Ralph's verdict on the palazzo, which survived till 1935; damaged, altered and engulfed in a larger structure. There are plans and an elevation in *Vitruvius Britannicus* and also three drawings by Flitcroft at the RIBA, which differ in several respects from Campbell's.

Henry Flitcroft (1697–1769) an engaging character was another Burlington protégé, who assisted the Earl here and elsewhere. A carpenter, he was working at Burlington House when he fell from a scaffold and broke his leg. The Earl arranged for him to be looked after and at this time noticed his drawing talents. Appointed an assistant to Burlington in 1720, he was later found a post in the Office of Works. He became a successful architect and builder, was chosen as Sherriff of London and Middlesex in 1745, and died extremely well-to-do.

The genesis of the design was a drawing by Palladio in the Earl's possession.[25] It was for a five-bay town villa with an arched ground floor and a noble first floor with superimposed Doric pilasters and a pyramidal roof. Doric, used here for the first time in England for a *piano nobile*, was judged particularly suitable for a military man's house. A slightly wider

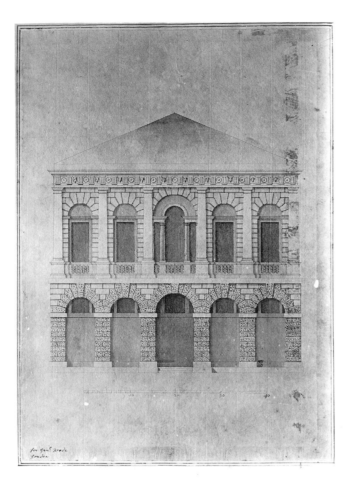

39 *General Wade's House, Great (now Old) Burlington Street was certainly not envisaged as part of the street development which soon engulfed it. Lord Burlington's design was almost entirely in rusticated stonework. Here is the original drawing of the Cork Street front*

centre bay on each floor accommodated an entrance door below and a Venetian window above.

In plan General Wade's house was two rooms deep and similarly disposed on each floor. Facing Great Burlington Street was a hall, 12 feet by 18 feet, flanked on either side by rooms 18 feet square. The western range of rooms comprised a saloon, 30 feet wide and 20 feet deep which left space for only two very small chambers on either side, one of which contained a stair. Before the building of the east side of Cork Street the site was open to the west; afterwards the principal elevation was concealed. Even the less important front to Great Burlington Street was masked when the palazzo was incorporated into the highly respectable Burlington Hotel. This was patronized by such Victorian heroes as Florence Nightingale and Cecil Rhodes. Wheatley, writing in 1870, seemed to think

that the palace he illustrated in *Round About Picca-dilly*[26] was already gone.

General, later Field-Marshall, Wade was one of the Burlington circle. A subscriber to *Vitruvius Britannicus*, and to the publication of poems by the Queensberry's friend Gay, he was also being involved in another of the earl's creations, the Royal Academy of Music. He was an art collector, with major works by Claude and Rubens among others. Indeed his single specific requirement for his new house was wall space to hang a large Rubens cartoon, 'Meleager and Atlanta'. Burlington's plan included so many 'correspondent doors' (said Horace Walpole) that there was nowhere for it and the Marshall sold the picture 'to my father, it is now at Houghton'. In the same letter Walpole had opined that, 'It is worse contrived on the inside than is conceivable, all to humour the beauty of the front ...'[27]

It says much for that beauty that Wade lived in the house till his death in 1748. Much the same was true of most of the subsequent aristocratic residents including the first Marquis Cornwallis, who died there in 1805, and the second, who did so in 1821. By this time the accommodation had been increased and the beauty marred by the addition of an attic storey and of an entrance vestibule to Old Burlington Street. In 1823 acquisition for hotel use settled its fate.

Here had been a piece of pure architecture, neither climate nor convenience being considered in the transfer of an Italian palazzo plan to London. 'Beautiful and extraordinary it looked in its London surroundings, being purely architectural, severe and wholly rusticated.'[28] Almost contemporary and equally uncompromising was a similar five-bay palazzo built for Lord Herbert in Whitehall. Henry Herbert, later ninth Earl of Pembroke (*c.* 1689–1750) – as befitted the owner of Inigo Jones's Wilton House – was another passionate Palladian. As an aristocrat, he thought it unfitting to be publicly involved with any particular building. His town house was built by Colen Campbell. Nevertheless some half-dozen works are attributed (with reservations) to Lord Herbert as architect, including Marble Hill at Twickenham.

Much like that designed for General Wade, *Pembroke House* was designed more for beauty than for use. Strictly Palladian, the centre three bays were

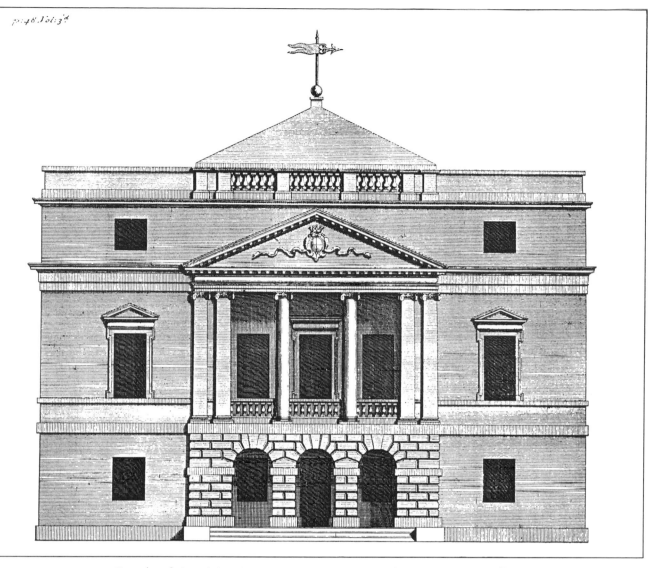

p: 48.Vol. 3.ᵈ

Elevation of the Right Honourable the Lord Herbert his House in Whitehall.

prominent and rested on an arched and rusticated ground floor. Behind the Ionic portico of two columns and four pilasters was a recessed and shadowed first-floor balcony. This palazzo may have looked a little out of place in Whitehall but its design could not have been more weighty and assured. Closely-spaced centre bays were framed by wide outer ones with large areas of plain wall punctuated by small openings. First floor windows were adorned with eared architraves and triangular pediments. The strongly horizontal emphasis of band and string courses added gravities. A second floor meant that the pyramidal roof was reduced to capping the centre only, unlike the Wade house where it sat, rather toy-like, on the *piano nobile*. The plan dimensions of these two town villas were similar – about 57 feet by 37 feet – and the five-bay

40 *Pembroke House, Whitehall. Colen Campbell's version of the aristocrat's town villa was almost the same size as that for General Wade, and quite as impractical – this time for the requirements of the Earl of Pembroke, a Palladian architect himself. It was soon rebuilt by his successors*

floors divided themselves into a similar number of rooms.

In 1750 the architect Earl died. The tenth Earl of Pembroke negotiated more site area in 1756. The ground was that formerly covered by the Queen's riverside apartments of Whitehall Palace, which had been destroyed by fire in 1698. The villa was demolished in 1757 and replaced by a more spacious edifice designed by Sir William Chambers. The Crown Commissioners considered the cost of £22,000 to be disproportionate to the site. Other

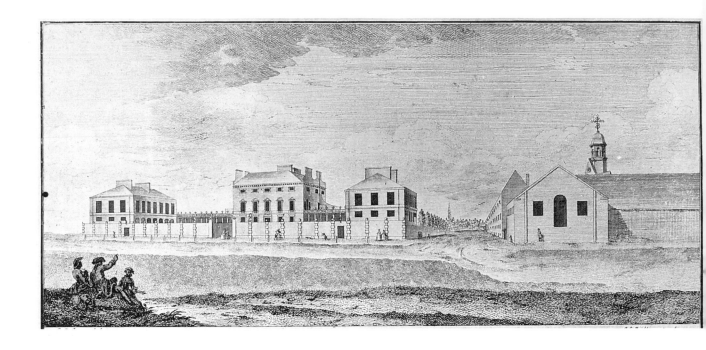

41 *Chesterfield House, South Audley Street. In 1750 the still incomplete house had only the Guard's stables and the south side of Curzon Street for company*

critics regarded the new building as no worthwhile exchange for the old.

Chamber's Pembroke House was approached via an arched entrance with a brick and stone lodge in Roman Ionic. The courtyard between house and lodge was soon to be glazed over, thus obscuring the elevation. Four-storey and in brick with stone dressing, it was somewhat like Chambers's later house for Lord Gower. The centre was slightly advanced, its ground level echoing Campbell's three arches, but the central feature of the principal floor was a large three-lighted Venetian window. There was a heavy cornice, with modillions, below the chamber storey and a balustrade above it. Inside, the rooms were lofty and grand with heavily coffered and ornamented plaster ceilings. The staircase compartment was impressive, as one would expect with Chambers. The saloon was very fine.

The Pembroke lease had been renegotiated to expire in 1866; however, that family had long departed the place. The last private tenant, the fourth Earl of Harrington, died in 1851 and the house was taken over as Government offices. A similar future was in store for the other buildings in Whitehall Gardens – Malmesbury, Cadogan, Cromwell and Gwydyr Houses. All except the last shared Pembroke House's fate – demolition in about 1913.

The perfect exteriors of Wade and Pembroke Houses were admired; at *Chesterfield House* it was the interior. Wheatley called it 'the chief glory of Mayfair'.[29] No longer can one say that 'the place remains, both as to structure and internal decoration, as it appeared when the great Earl's loving care was first bestowed upon it with such profuseness and with such artistic discrimination'.[30] Even when Chancellor wrote, the developer's maw had already digested the large side wings, much of the forecourt and the finest private garden in London.

Philip Dormer Stanhope, fourth Earl of Chesterfield (1694–1773) was well mannered, well educated and well travelled, 'the glass of fashion and the mould of form'. He impressed the new King, George I, who made him Gentleman of the Bedchamber to his son, the Prince of Wales, in 1715. The following year, elected to parliament, he committed the solecism of delivering a maiden speech while under-age. He was not destined for early office for a more important reason – opposition to Walpole. Succeeding to the Earldom in 1726, he was dispatched to the Hague as ambassador. While in the Netherlands, Chesterfield had an illegitimate son, later to be the recipient of the famous letters containing worldly and wise advice on deportment and duty. The fall of Walpole in 1743 was hastened by other Chesterfield correspondence; a pseudony-

42 *Chesterfield House. In 1937 came the end of the 'chief glory of Mayfair'. By 1870 the extensive grounds had been built over, the side wings demolished and the connecting arcades rebuilt as a facing to the small front courtyard. In its stripped-down form the building can be recognized as in the Burlington/Kent North Italian tradition, although the window-to-wall ratio is generous as a concession to Lord Chesterfield's wish for 'bright and cheerful rooms'*

mous series of public letters, the authorship of which was not so obscure as to prevent Sarah, Duchess of Marlborough bequeathing him £20,000 as a reward. Now public office was possible. In 1745 a short period as Viceroy of Ireland established him as an enlightened and tolerant minister. Next he was Secretary of State for the Northern Department, but resigned in 1748 when the Duke of Newcastle opposed his suggested peace with France.

The end of Chesterfield's brief political career coincided with the building of his town house. This was Isaac Ware's most important commission, though he had in 1733 converted the Earl of Landesborough's mansion in the fields at Hyde Park Corner into a hospital. Ware (*d.* 1766) had a career which paralleled Flitcroft's. Like him he was apprenticed to a Master Carpenter; like him he obtained a clerkship in the Works. Despite that, most of his buildings were for private clients. Ware

also owed much to Burlington, who may even have sent him to study in Italy.

Why did Chesterfield pick a Palladian of the second rank and persuade him to design a house 'à la française' which he must have known would cause the 'schola', as he called them, to 'fulminate'? The reason may have been that he realized that a 'star' architect would have found it more than difficult to tolerate the extent of the client's day-to-day involvement. For example, he wrote to a friend in August 1747; 'My colonnade is so fine, that to keep the house in countenance, I am obliged to

43 *Chesterfield House. Detail intact, it shows exceptionally finely carved stonework and wrought iron with its interlocking 'Cs' within the garter of which the Earl was the proud recipient despite opposition from Robert Walpole. The first floor with its plain band course and curved support to the centre window is very like William Kent's work at Devonshire House and 44 Berkeley Square*

dress the windows of the front with stone, those of the middle floor too with Pediments and Balustrades.'[31] These columns were brought from the Duke of Chandos's mansion 'Canons'; thus he called them his 'canonical pillars' in a letter to his son. His library he is 'finishing as fast as I can', he wrote and goes on to say, 'the ceiling is done and most of the wainscot up. The bookcases go no higher than the dressings of the doors, and my Poets which I hang over them will be in Stucco Allegorical frames and painted white; for I have determined to have no gilding at all in it . . .'[32]

The mansion of which Lord Chesterfield took possession in March 1749 was not sufficiently complete internally for the house-warming party until February 1752. It was built on a large site, the freehold of which was retained by Viscount Howe. It extended over a lot of ground, for all the world as if it was in the country, which it almost was. Neither did the main elements look especially urban: a square, hip-roofed brick box of three storeys linked by long colonnades to large wings, similar in character but of two storeys, which enclosed a large French-style forecourt. The extensive garden behind, Lord Chesterfield's 'scene of verdure', was more English. On the front, beside a rutted lane which became South Audley Street, was a substantial brick wall with rusticated stone posts.

The main block, five bays wide and double-pile in depth, was clearly not much more than an envelope for fine apartments. It had no order apart from a pair of stone columns supporting a small pediment over the main entrance. The pediment was ogee-curved and broken to contain an elaborately carved cartouche displaying the Earl's coat of arms.

The house-warming party created a stir; there the Duke of Hamilton fell in love with the beautiful Elizabeth Gunning – they were married two days later at the notorious Mayfair chapel 'with a curtain ring'. Guests entered a marble entrance hall opened up via an arched arcade with engaged Corinthian columns echoing those outside, to the high staircase compartment. There were wide marble treads 'each step made of an entire block and twenty feet in length', said Vertue. The Princely Chandos's staircase ironwork was sumptuous; it had only required the ducal coronet above the 'C' to be replaced by that of an Earl. The general scheme of the hall and staircase was Palladian very much in a Kent manner with boldly modelled plaster decoration, coffered ceilings, modillioned cornices and pedimented doorcases. The library and the dining room could almost have been in Devonshire House.

In 'a French taste', the rococo of the drawing rooms was a different matter. Here there was much gilding amidst the white, here a delicate richness in a style the English have always regarded as faintly wicked. Each apartment had its own mood. There was even an Italian drawing room. The music room with its organ had decorations 'illustrative of the art of St Cecilia'.[33] Most had French silk hangings, of various colours, specially made.

Lord Chesterfield's pictures were much like those of any rich and perceptive English collector of the period, ranging from Titian, Rubens, Carraci, Teniers, Poussin and Salvator Rosa to Van Dyck and Lely.

The Earl's entertaining, at what he sometimes (but not in the modern sense) called the Hotel Chesterfield, was lavish. 'Call it vanity if you will, and possibly it is so, but my great objective was to make every man and every woman love me', he wrote to his son. He attracted to his house most of

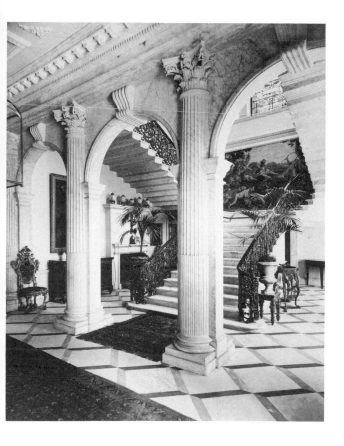

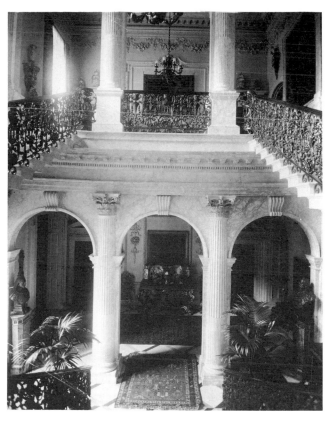

44 *Chesterfield House. Palladianism continued into the entrance and staircase halls, both largely of white marble. Chesterfield spoke of his 'canonical pillars' – they came from the Duke of Chandos's demolished mansion at Canons in Middlesex. The landing painting was by Hondekoeter*

45 *Chesterfield House. 'The staircase particularly will form such a scene as is not in England,' wrote Chesterfield. 'The expense will ruin me, but the joyment will please me.' The stair rails were also from Canons; the Earl merely had to replace a ducal coronet with his own above the intertwined 'Cs'*

the outstanding politicians, wits, artists and beauties, not least because he was among the first to import to London a supreme French chef.

Good looks were denied Chesterfield, but his wit was attractive. Writing one day to Lord Pembroke, an enthusiastic swimmer, he addressed the Earl 'in the Thames over against Whitehall'. Nobody was kind to 'Long Sir Thomas Robinson' who had asked Chesterfield to write some verses for him:

Unlike my subject now shall be my song,
It shall be witty, and it shan't be long

Chesterfield House remained in the Stanhope family until 1869, though for the last twenty years it was let to the Marquis (later Duke) of Abercorn. Then it was sold to Charles Magniac who built housing in the grounds at the rear. He demolished the wings for more redevelopment, re-erected the arcades on either side of the much reduced forecourt

and eventually sold off the mansion to Lord Burton, having made a great deal of money out of the operation. Early in this century the sixth Earl of Harewood lived there after his marriage to the Princess Royal. In 1937, almost coeval with the founding of the Georgian Group came demolition. Princely Chandos's staircase found its way into the foyer of the Odeon Cinema, Southend, whence it was delivered into eternity by one of Hitler's bombs.

The waning force of Palladianism was not strong enough to prevent one other sumptuous example of the rococo interior appearing in a London mansion of the 1750s. *Norfolk House* was situated unremarkably – a careful eye was required to pick out its nine-bay frontage in the south-east corner of St James's Square. Yet the design was very similar to that of the main block of Chesterfield House: three-storey, brick with stone dressings, the windows to the lofty *piano nobile* having alternating

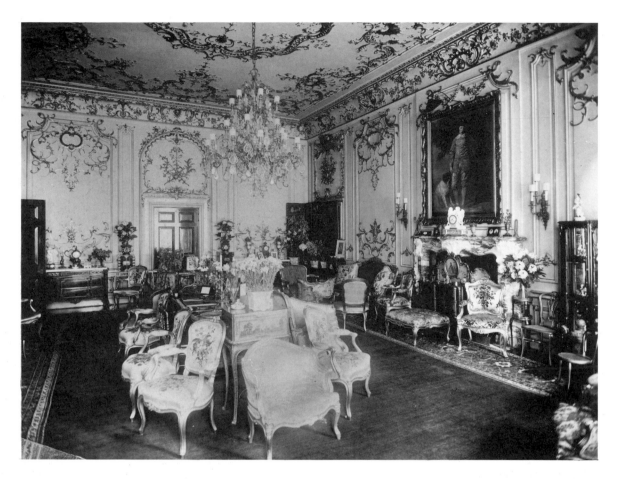

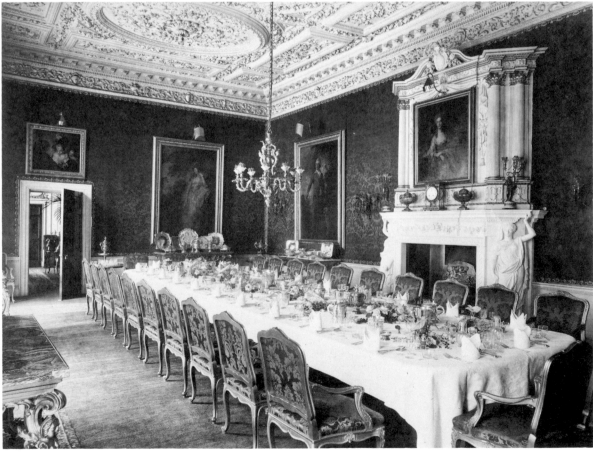

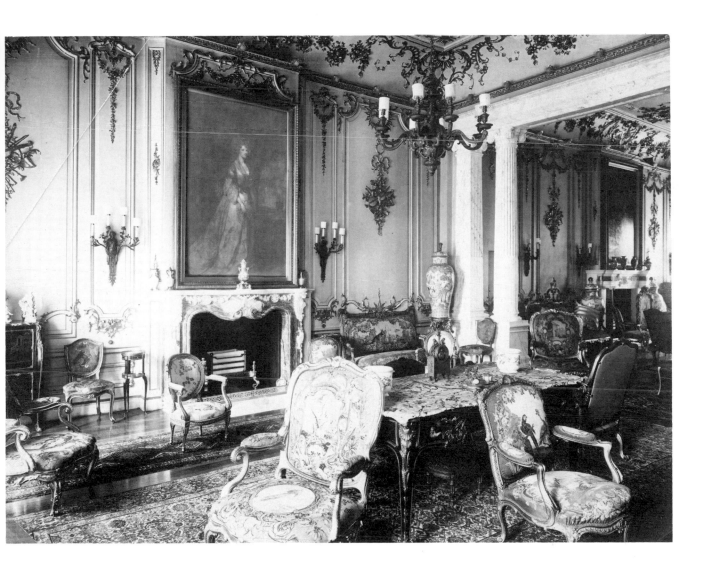

pediments. The architect was again below the first rank. The author of *Critical Observations* felt obliged to enquire if 'All the blood of the Howards can never ennoble Norfolk House?'[34] At least in 1842 the façade was to be given unity and emphasis by the addition of a stone porch with Ionic columns and a continuous iron balcony at first floor level; this was the work of a virtually unknown surveyor, Abraham.

St James's Square had been intended to be the *Place Royale* of London. It was to be lined with noblemen's mansions and was developed with uniformity, despite piecemeal leasing and despite the varying size of the 'palaces' behind the façades. It did indeed become the centre of London's aristocratic life, especially after the Court was officially moved to St James's Palace in 1698. Mr Wheatley wrote in 1870: 'In former times society, or the "world" consisted of a small circle of persons who were almost all known to one another, and lived within this district.'[35] Charles II had granted extensive leases in the St James's Field area in 1661 to Henry Jermyn, Earl of St Albans (*c.*1604–84) who

46 *Chesterfield House. The Earl was a Francophile and a sceptic about 'correct' classicism; some rooms were wholeheartedly rococo. Here in the drawing room in the early twentieth-century is Romney's 'Pink Boy' – a riposte to Gainsborough's more famous 'Blue Boy' then up the road in Grosvenor House. The chandelier had belonged to Prince Demidoff and would later be the property of Lord Dudley*

47 *Chesterfield House. The dining room (formerly the state drawing room) – there was no hint of rococo. It was distinguished by the splendid white marble chimneypiece with caryatids and, at this late date, by Gainsborough portraits*

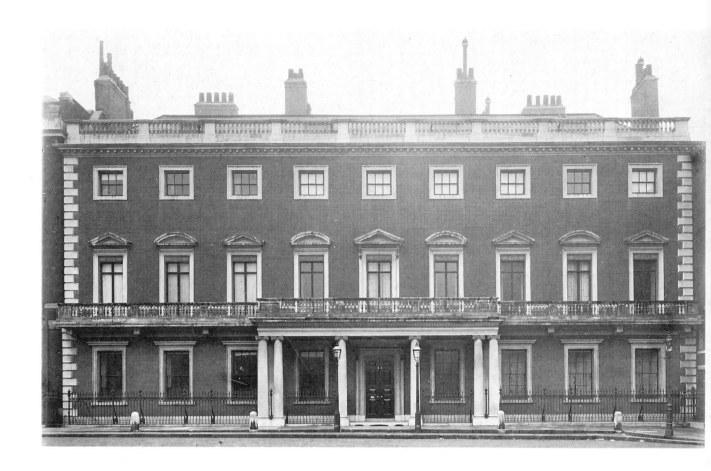

49 *Norfolk House, St James's Square. The dull façade of the 1750s was drawn together nearly a century later by the imposition of columns and a balcony. Otherwise this nine-bay façade was not unlike its contemporary in South Audley Street, brick with stone dressings, the lofty first floor windows to the state rooms given the extra importance of pediments*

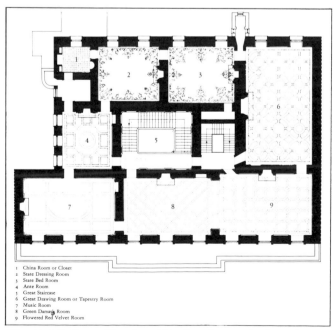

1 China Room or Closet
2 State Dressing Room
3 State Bed Room
4 Ante Room
5 Great Staircase
6 Great Drawing Room or Tapestry Room
7 Music Room
8 Green Damask Room
9 Flowered Red Velvet Room

50 *Norfolk House. The plan width allowed a parade of grand rooms circling the top-lit central stair. As can be seen from the ceiling designs, each apartment was decorated individually*

had been a close companion in exile. In 1665, Lord St Albans obtained much of the freehold. He made a great deal of money selling leases and, indeed, freeholds of the properties facing St James's Square itself. In the eighteenth century almost every site was occupied by a splendid mansion: No. 4, built in 1676 and remodelled in 1725 (by Leoni, or Hawksmoor); No. 5, by Brettingham (1748–51); Nos 9 and 10 by Flitcroft (1736); No. 11 by Robert Adam (1774–6); No. 15 (1764–5) by James Stuart.

In 1722 the trustees of the eighth Duke of Norfolk bought the original St Albans House for £10,000. This had a frontage of 68 ft on the most southerly part of the east side. Belasyse House next door to the north was bought on behalf of the ninth Duke in 1748. It was said to be in very poor repair and the price was low, £1830. The whole frontage of 107 ft was now available for rebuilding. The buildings facing the square were demolished, but a block at the rear was spared. This old building, adapted for use as lumber rooms, survived into this century – complete with battered murals and staircase – though few knew of its existence. The architect of *Norfolk House* was Matthew Brettingham the elder

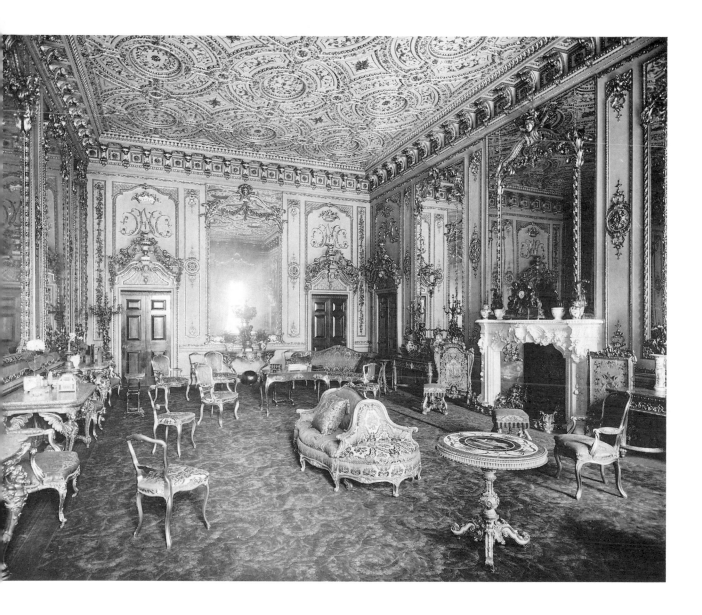

(1699–1769), whose most formative work had been the implementation of Kent's scheme for Holkham. Howard Colvin writes: 'Brettingham was an orthodox but unenterprising Palladian whose dull, well-bred façades betray neither the intellect of a Burlington nor the fancy of a Kent. No masterpiece stands out from the list of his works, but in nearly all of them the solid virtues of mid Georgian architecture are evident.'[36]

Work started in 1748 and continued for some four years at a cost of £18,575 of which £800 went in fees to Brettingham. Interior decorations continued until February 1756 when Mrs Delaney, that splendid gossip, wrote to her sister: 'The Duke of Norfolk's fine house in St James's Square is finished, and opened to the *grand mode* of London; I am asked for next Tuesday.'[37] Horace Walpole described the

51 *Norfolk House, great drawing room, or saloon. Dazzling richness was enhanced by gilded mirrors. Extra* boiserie *decoration was added in the 1840s*

occasion: 'The Duchess of Norfolk has opened her new house. All the earth was there last Tuesday ... In short, you never saw such a scene of magnificence and taste. The tapestry, the embroidered bed, the illumination, the glasses, the lightness and novelty of the ornaments, and the ceilings are delightful.'[38] The room sparkled: '... large, wainscotted in a whimsical taste, the panels filled with extreme fine Carvings, the Arts and Sciences all gilt, as well as the Ceiling ...' wrote William Farrington.[39]

The ground-floor plan consisted of a suite of six interconnected family rooms around a rectangular

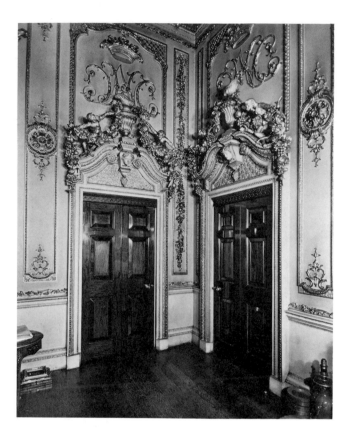

52 *Norfolk House, the famous 'monkey' doorcases in the saloon. Designed by Borra, carved by Cuenot in c. 1755. One door is preserved in the Victoria and Albert Museum*

stair approached by a spacious entrance hall. The principal floor above was loftier and more ornate; it followed a similar plan, except that two of the rooms at the front were combined to form a vast drawing room. Next was the famous music room now partially preserved at the Victoria and Albert Museum. The other apartment was the saloon or ballroom to the south. The staircase well continued up through the centre of the house to a lofty lantern height.

Some rooms were in restrained English taste; others were enriched by rococo riots of French-inspired plasterwork. In the saloon and elsewhere enriched scallops and festoons of fruit dated from an 1840s refurbishment, which even that age found 'splendid and showy'.[40] The front drawing room was in rich Palladian style recalling some of Kent's interiors at Holkham. There were marble fireplaces over which were elaborate gilded mirrors incorporating landscape paintings, probably by Zucarelli, in the upper stages. Such a house neither required nor

lent itself to an extensive display of paintings. The ground-floor rooms and the drawing room upstairs contained a predictable, but interesting, group of family portraits, including one of Thomas Howard, Earl of Arundel – the great picture collector – and his wife. Views of Arundel Castle and Park consorted with a number of Italian religious paintings by Guercino and others, as well as Dutch landscapes.

The destruction of Norfolk House in 1938 and its replacement in 1939 by an office building 'of no merit'[41] designed by Gunton and Gunton and financed by Messrs Palumbo and Rossdale was among the more disgraceful interwar losses. The London County Council regarded the buildings as of little architectural value.

The LCC would probably have been little more enthusiastic about *Spencer House*, '... a somewhat pretentious Palladian hybrid, something between villa and palazzo'.[42] There are four reasons why the design – for all the beauty of the setting and the originality of some parts – is unsatisfactory: the scheme was changed and enlarged after building work had started; that enlarged scheme remains incomplete; it was the product of a committee; and it had the fault of much English Palladian work, namely that its somewhat disparate parts did not quite add up.

The St James's Place site was let for 99 years to Henry Bromley, first Baron Montfort in 1752. He commissioned John Vardy to build a town house in this splendid position. Before building work could commence, His Lordship shot himself, this being his way of dealing with a financial crisis. His suicide took place on 1 January 1755; within six months Vardy himself had acquired both the building agreement and, by means of a published design for the house, a new client. This was John Spencer, who had inherited large estates from Sarah, Duchess of Marlborough, via his father. He was created Viscount Spencer of Althorp in 1761, and Earl four years later.

John Vardy (*d.* 1675) was a Palladian of the

53 *Norfolk House, the music room. A mixture of styles, painted in white and gilded à la française, but the rococo plasterwork was a little stiff and Italianate. Parts of this room are also at the Victoria and Albert Museum*

54 *Norfolk House. Two apartments across the front of the house combined to form a somewhat ill-proportioned drawing room*

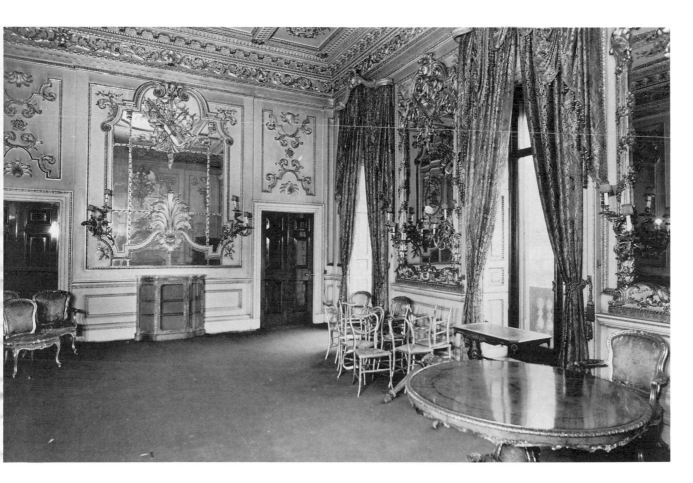

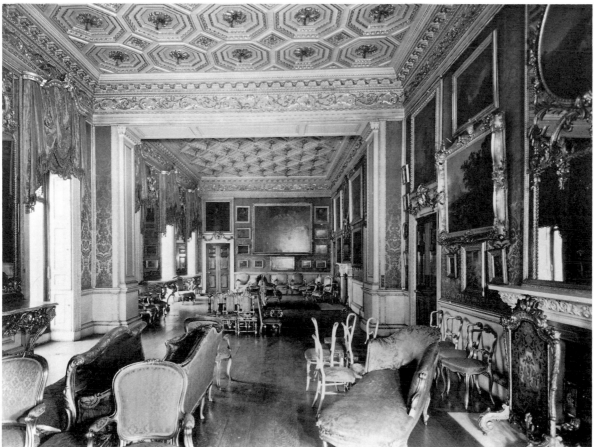

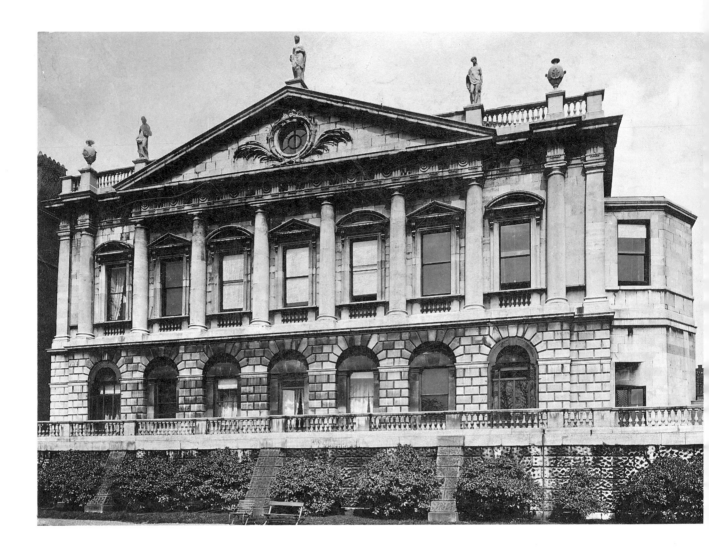

55 *Spencer House, St James's. One of the most appealing, eccentric but not quite satisfactory palace façades. Greek in much of the detail – triglyphs and metopes of the entablature – but Roman in its main order (Tuscan) and Palladian in basic composition. Odd features such as the entablature breaking forward over single end columns, and the sculptured figures by Spang, work well*

Burlington school. The immediate influence on him had been that of William Kent for whom he had worked on the Horse Guards. Like Flitcroft and Ware he held clerkships in the Works. Spencer House was his most important private commission. Seen from Green Park it is a two-storey stone building of palatial scale, with the look of a villa because five of its seven bays are surmounted by an oversized pediment. A lightness of touch in Vardy's design, especially of ornament, endows Spencer House with a cheerful air. The composition is raised on a plinth consisting of a basement storey extending beyond the house in every direction and forming a

broad paved terrace. This fulfilled the functions of bridging over the former narrow roadway, Catherine Wheel Yard, separating the house from the park, and also of acting as a retaining wall to the higher ground level on the north, or entrance side. The low proportions of the wide-arched and heavily vermiculated stonework meant that it must originally have almost 'grown' out of the untended landscape of the park.

There is an arched and rusticated ground floor and a very high first floor of plain ashlar. Window pediments are alternately triangular and segmental. Between them are plain three-quarter Tuscan Doric columns and, in the wider end bays, pilasters. Under the windows are balustraded aprons. The columns and pilasters support a bold entablature with strongly Greek overtones; this breaks forward over the single columns in the end bays and over the five central columns. Inside the pediment is a large circular window nestling in rather silly-looking

palm branches. Either side of the pediment and above its apex are statues by one Spang. Over the end columns are stone vases.

The west front is a memorable, if not wholly convincing composition; the north front is neither. The rusticated and arched ground floor, with its cornice and blocking course, does continue, as do four pilasters and the entablature on the slightly projecting end pavilion to the west. The answering east pavilion was never built. Everything looks small-scale. The aesthetic justification for the St James's Place elevation may have been that viewpoints in a narrow street are limited. The south and east fronts were even more constrained by neighbours, and the east wall was only 'temporary'.

The structure of Spencer House was substantially completed in 1756 on a site which had been somewhat enlarged compared with that in Lord Montfort's original lease from the Countess of Burlington. As plans in *Vitruvius Britannicus*[43] and by Vardy[44] himself show the house was to have been extended eastwards over what subsequently became 28 St James's Place. This change of mind, presumably intended to be a postponement, was not the only one. As early as 1758 Spencer had commissioned another architect, the highly fashionable James 'Athenian' Stuart, to produce designs for the interior. Here we enter the area of uncertainty concerning authorship and overall responsibility. Colonel, later General, George Grey, is said at least 'to have supplied the idea'.[45] He certainly played a supervisory role and approved many of Vardy's drawings, as is attested by his initials on them. Eventually Spencer eased Vardy out altogether, giving him some minor work at Althorp as compensation.

The principal rooms were finished by 1766 and were hugely admired. 'No expense was spared by the noble owner, and neither the brightest fancy nor the correctest judgment wanting.'[46] The second quality is evident in the entrance hall which strikes a note of austere grandeur, architectural rather than decorative. The most unusual features are the round corners, each with a large niche over a pedestal for a statue. A plaster roundel containing a profile portrait of Antinous, based on an antique Roman marble, demands attention. Only when eyes are used to the gloom – the large arched window opening facing the entrance has been blocked by a lift installation – is it realized that the stone fire-

place, ceiling, cornice and frieze are all richly moulded and carved. Motifs include bay-leaf garlands hanging from ox skulls which, together with the general treatment, suggest this to be Vardy's work. The same can be said for the original dining parlour to the west of the hall, which has a wide apse intended for a sideboard. Beyond this room are the three state apartments on the west side of the house at ground level: a drawing room, the 'great eating room' and Lord Spencer's room. They are also essentially Vardy's work, as his plan and his design drawing for the eating room attest. The considerable length of that room is visually reduced by the insertion of a colonnade across either end, a device used by Adam and even by Barry at the neighbouring Bridgewater House a century later.

In Lord Spencer's room, the last of the three, correct judgement and bright fancy are most effectively employed by Vardy. A chamber, square in plan and robustly detailed, opens into a curved bay which is domed, apsed and elaborately coffered. The doorcase, entablature and ceiling, with a deeply sunk oval panel and modillioned cornice, are Kentian in character. So might well have been the two sturdy Corinthian columns either side of the arch leading to the alcove bay. But with an imaginative stroke transforming this into one of the most memorably exquisite rooms in any London palace, Vardy wrapped those columns in palm fronds. The dome pendentives are similarly embellished.[47]

Lord Spencer's room illustrates a crucial distinction between the approach to decoration during the two centuries up to about 1750 and that in the periods following. In it there are both highly formalized and naturalistic motifs; such a mixture seldom occurred again. The fruit, flowers, vines and oak leaves carved in wood or moulded in plaster in the sixteenth, seventeenth and early eighteenth centuries, even by such masters as Grinling Gibbons, were efforts to evoke the real thing. Highly three-dimensional, often near to life-size, there is a tactile quality which invites the observer to reach out. From the age of Robert Adam onwards the function of decoration is more symbolic, more intellectual, seeking to evoke not Nature but Art. The highly stylized and much flatter representations of fruit, flowers, garlands, figures and vases are not intended to simulate reality, but rather to stimulate the imagination to look inwards and discover references to

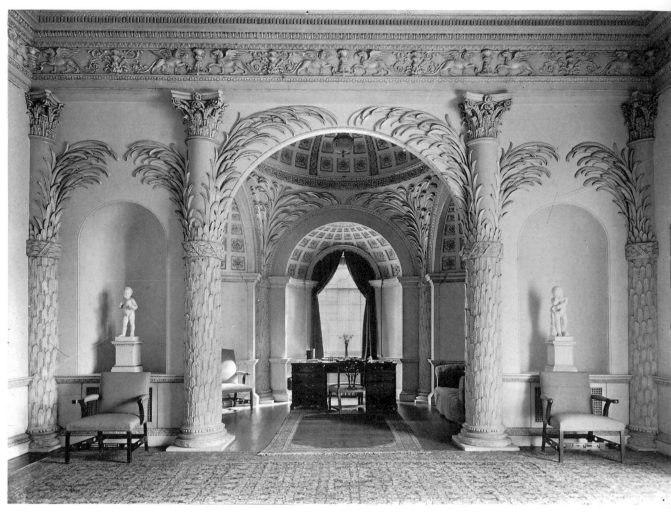

56 *Spencer House, Lord Spencer's room, of modest proportions but great impact. Jones and Webb had toyed with the palm motif for the royal apartments at Greenwich. It was Italian in origin. Vardy was a designer of some individuality, however, as is shown by some of his mythological beasts in the frieze*

57 *Spencer House, the great room or ballroom. Vardy's imaginative plasterwork again, especially in the coved, coffered and saucer-domed ceiling. Over the centre of each wall is a medallion with classical scenes, supported variously by putti, leopards and griffins. 1890s photograph shows many of the contents recently sold*

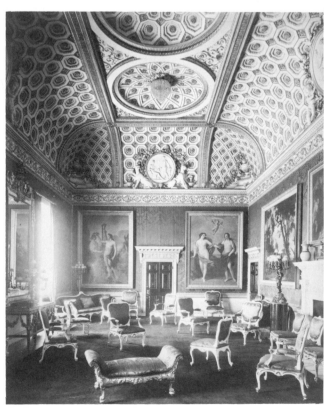

Rome and Etruria, or even Ancient Greece. The Spencer House rooms in the west range of the first floor are in that second world of historical evocation. The upper floor is approached via a staircase by Vardy, which continues the spacious and comparatively plain grandeur of his entrance hall. The coffered landing soffit and the frieze below it have typical Vardy motifs of ox heads and drapery festoons. The walls are plain, apart from Ionic pilasters and so, presumably, was the barrel-vaulted

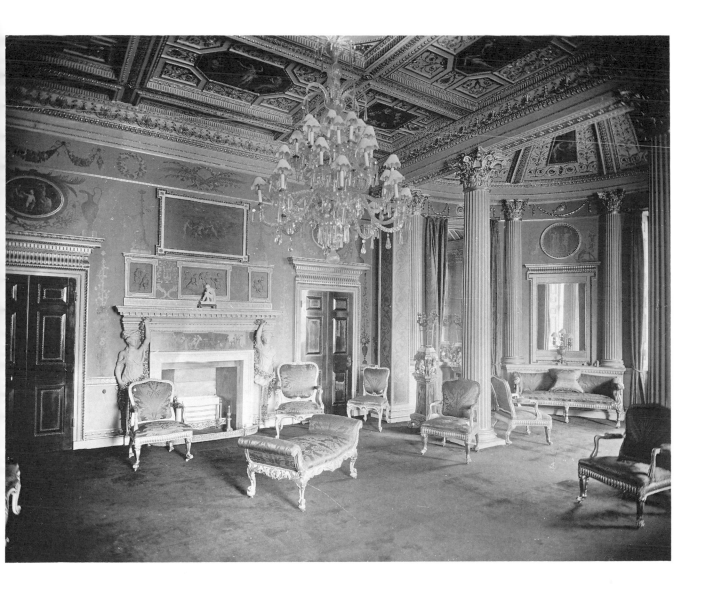

ceiling until richly decorated by Sir Robert Taylor. The first floor landing leads to the centre room of the west range, on this storey the space is not reduced by colonnades and so has the appearance of being almost a double cube, as Vardy intended. The decorations of the 'great room' are by Stuart 1763-4).

South of the great room is Athenian Stuart's famous 'painted room' which owes 'something to Pompei and more to the arabesque paintings of Raphael's school'.[48] It is a chamber of amazing delicacy and colour designed by Stuart in 1757 and executed by him over the next half-dozen years. Situated above Lord Spencer's room, it has the same basic square plan opening into an apse, but here the bow is simpler in form, separated from the main part of the room only by two free-standing Corinthian columns. Capitals are richly gilded, as are the door

58 *Spencer House. The painted room has three distinct types of decoration: canvases in gilt frames fixed to walls and ceiling, formalized vases, palms and wreaths on walls and pilasters, painted mural scenes above the dado and on the chimneypiece frieze. The mantel is supported by exquisite painted wooden figures*

architraves, the moulded ribs of the flat ceiling and the frieze ornamented with anthemiums.

Spencer House as created by Vardy and Stuart under the supervision of George Grey was altered by Sir Robert Taylor after 1768, when Lord Spencer bought the freehold. His chief contribution was the addition of the decoration to the staircase vault. The second Earl, who succeeded in 1783, employed Henry Holland to redecorate and to carry out a number of minor alterations involving the moving of some doors and chimneypieces. This Earl was a great bibliophile and by 1807 his collection required

extra library space, which was achieved by Sir John Soane who covered much of the palm decoration of Lord Spencer's room with bookcases. Happily this was later undone, the books now forming the core of the Rylands Library at Manchester.

Subsequent Earls, especially the third and fifth, had important political careers. In the latter part of the nineteenth century Spencer House 'was the rallying-point of fashion and political activity for many years'.[49] Later it was let to other aristocrats, including the Duke of Marlborough for a period, but in 1927 ceased to be a private residence. The furniture and mahogany doors were then removed to Althorp, as were marble chimneypieces and other decorative fittings during the last war. Considering the procession of institutional and commercial users in the last half-century, including the Ministry of Works, British Oxygen and then the Economist Group, the house has been well preserved. Indeed the present tenants have been responsible for extensive reinstatements; for example the Great Room, which the *Survey of London* described in 1960 as being 'of necessity, now divided into three by transverse partitions',[50] is divided no longer.

IV
The Age of Adam

The thirty years between the peace of Paris in 1763 and the outbreak of war with revolutionary France in 1793 were a period of national upheaval, but also of tremendous building activity. Wealth was unequally spread, so that pressures resulting from early industrialization, and a series of bad harvests in the 1780s, led to much unrest among the poor. The rich, on the other hand, were more numerous than before and they had ample means to indulge their refined and confident taste. There were fine architects too, the most influential of whom were Adam and Chambers. The competition between their styles and personalities dominated this golden age of architecture and was prominent in the intellectual life of the time. The houses discussed in this chapter are seen primarily as episodes in the careers of their designers.

Whereas London's population had more than trebled in the seventeenth century to about 675,000 by 1700, it then remained virtually static until 1750. But by 1801, the year of the first official census, it had risen to 900,000. In 1831 it was about 1,655,000.[1] The number of peerages had also increased, though not quite in proportion. The totals were in 1784 – 208; in 1801 – 270; in 1830 – 314; and in 1836 353.[2,3] A larger aristocracy in an expanding imperial capital led to an increased demand for town palaces. The idea that the nobility, especially the great Whig aristocrats, unlike their French counterparts, devoted themselves to their broad acres is at least an over-simplification. Such magnates as the Dukes of Devonshire, not all of whom had either political or cultural interests, devoted more resources to Devonshire House, Piccadilly, throughout most of the eighteenth and nineteenth centuries than to Chatsworth, as the household accounts and cellar books show.

These factors were reflected in the work of Robert Adam (1728-92). He built or rebuilt houses for noble clients in all the acceptable locations. The pressure on space meant that only one, Lansdowne House, was a detached mansion, although both Harewood and Apsley House were nearly so. He re-built fronts and interiors for houses in existing squares, as well as totally new mansions in new squares. With his brothers he was a speculative developer on the grandest scale. But more important than all that, he moulded and established a new taste, an architectural and decorative style which fully indulged the growing preference for lavish yet refined display. It was a style out of Roman, Greek and Etruscan remains, pottery and tomb paintings and fragments of interiors. There had been modes of interior decoration in classical times full of delicate lines, pale colours – and also deep rich ones. The inevitable reaction against Burlington's 'correctly' classical style, based on the transfer to interiors of external architectural elements – especially of temples – now had a voice.

Even Adam could not free himself of Palladian influences at one bound. There are touches of Kent in his south front of Kedleston in 1761, and more

than touches of Burlington's Egyptian Hall design, derived from Palladio, inside that house. At Lansdowne House, Berkeley Square (started the following year) the elevation and some of the interiors were cool and classically sculptured. Some had the novel delicacy recognized as Adam's chief contribution. They ranged from minor works, such as a ceiling and chimneypiece for Buckingham House, St James's Park (1762), to designs for superb rooms as at Northumberland House (1770–5) and Cumberland House (1780–1), the creation of suites of rooms in remodelled interiors such as those for the young Earl of Derby in Grosvenor Square (1773–4), and exterior as well as interior reconstruction, as at Roxburghe (Harewood) House, Hanover Square, in 1776.

At the Soane Museum are many exquisite drawings for wall decoration, furniture and, above all, ceiling designs, in Adam's easily recognizable language of roundels and lozenges, fans and octagons, arabesque borders, anthemium friezes, festoons and wreaths, allegorical figures and mythical creatures, musical motifs and military trophies. Colours were usually pale, his favourites Etruscan pink and green, light blue or turquoise, even yellow and gold as in the first drawing room of Lansdowne House or the Piccadilly drawing room of Apsley House. Sometimes wall panels or ceiling surfaces were left white, as was sometimes the linear patterning itself, but more usually the latter was partially picked out in gilding.

Occasionally, a more full-blooded effect was sought. Such was the rich crimson, blue-green and gold of the glass drawing room at Northumberland House. At least as attractive and almost as rare was Robert Adam's Etruscan style, the most striking examples of which were at Derby House, Grosvenor Square. This beautiful mode of decoration was based on a misunderstanding; the colours (terracotta and Pompeian red, with black and some white on a pale grey ground) and the motifs (vases, sphinxes, birds and antique figures) were based on pottery found in tombs in Etruria. These were in fact Greek.[4]

As the 1770s progressed exteriors had become plainer and interiors richer; it was so with Adam's work and so it was also with that of James Stuart (1713–88), whose London houses comprised Holderness (later Londonderry) 1760–5, Lichfield (1764–6) and Montagu (1775–82). Of Holderness and Montagu Houses Walpole's opinion of the former might well apply to the exterior of both, 'a formal piece of dullness'.[5] Both had beautiful apartments with elaborate ceilings, though the most ambitious at Montagu House were completed by Joseph Bonomi. The smallest of the houses and the only one surviving is *Lichfield House*. Its handsome classical façade in stone, has correctly proportioned and detailed Ionic columns standing almost proud of the Portland stone wall, supporting a plain, bold and thoroughly attic-looking entablature and pediment. For all the world it is as if a tetrastyle temple had been planted upon an arched and rusticated ground floor. The latter is of English Palladian form, but the details of the upper floor are self-consciously Greek.

Now an effort of imagination is required to realize how novel and highly cultivated this design by 'Athenian Stuart' appeared to contemporaries of Thomas Anson, an elderly bachelor and 'man of taste' who had inherited the house and a fortune from his brother Lord Anson in 1762. This was the year of the publication of *Antiquities of Athens*. Anson had no compunction about demolishing the 1670s house, built by Richard Frith. Ample patience and resources were required from clients of Stuart, and at least the former may have been stretched by 1770 when the house was still spoken of as being incomplete. The first floor front room ceiling is as good an example of Stuart's decorative work as is now to be seen anywhere outside Spencer House. With its gilt-framed and comparatively large paintings of classical subjects by Rebecca, with its gilded scroll, arabesque and palm ornament, it is reminiscent of Spencer House's painted room. The ceiling with its cornice and deep frieze is very similar to one that existed in the drawing room at Londonderry House, Park Lane until 1964.

Extensive alterations were carried out by Samuel Wyatt in 1791–4, the period in which he was similarly modifying Stuart's work at the Anson country house at Shugborough. He added a copper railed stone balcony to the first floor level of the St James's Square façade, as well as making changes to the plan which 'largely destroyed the formal character of Stuart's design'.[6] The then Viscount Anson was raised to the Earldom of Lichfield in 1831. As Postmaster General he introduced the

59 *Lichfield House, St James's Square. One of the few other examples left of Athenian Stuart's painted and gilded ceilings. The arabesque and scroll work is all more tactile than that of Adam. Inset paintings by Rebecca*

penny post; there was an annual parade of mail coaches from Lichfield House on the Queen's birthday. When Lichfield House was sold in 1856 the price of £12,750 was not much more than a third of its valuation by Soane in 1809. The fortunate purchasers were the General Medical Society, whose successors are still in possession.

Another architect, a third Scot, could and did dispute Adam's hegemony; this was William Chambers (1723-96). After 1775, when enthusiasm for Adam's complex, delicate, ornament-upon-ornament style began to pall, Chambers got the better of the contest. His greatest work involved not the building but the destruction of a private palace, Somerset House, and its replacement with the first government office block. His style was closer to Palladianism than Adam's, though it was also strongly influenced by the refined French neo-classicist architects with whom he studied during five years in Rome. The architectonic force of the works of Michelangelo and Bernini impressed him, but Chambers also valued restraint. His most important London mansion was Gower House, Whitehall – the dour exterior of which barely hinted at the riches within.

His other London mansion was the comparatively modest Melbourne House, Piccadilly, built 1771-4, the façade of which is still visible set back behind its courtyard. The building was reconstructed in 1803-4 as Albany Chambers. Otherwise the Chambers practice in this field consisted of the remodelling of houses such as Richmond and Pembroke in Whitehall, both in 1759-60, and alterations to Buckingham House, St James's Park, during the period 1762-73.

The clash between Adam and Chambers for dominance in English architecture was fierce. Either would have achieved dominance 'had it not been for the other. In a sense both achieved it – Chambers as the greatest official architect of his time and consolidator of English tradition, Adam as an innovator of great vigour whose influence flashed suddenly ..., penetrated far beyond that of his contemporary but vanished sooner.'[7]

When the influence of what Robert Adam had himself immodestly called his 'revolution in the whole system of this useful and elegant art'[8] had waned, serious minded young architects turned to the more solid and scholarly Chambers. Among them were Henry Holland (1745-1806) and James Wyatt (1746-1813). Neither of them was responsible for a great London house. Holland altered Spencer House, and more notably, added the portico and entrance hall to Dover House; Wyatt did work at Devonshire House and Dover House, Whitehall.

A greater architect than either, but one whose very considerable works in London have largely been destroyed, was Sir John Soane (1753-1837). He had assisted Holland for a while, but went on to evolve his own refined style of neo-classicism, most significantly represented among London houses by Buckingham House, Pall Mall (1792-95). He also re-modelled several St James's Square houses, notably No. 33 for Lord Eliot in 1805-7. But the nineteenth century, with its boundless resources and rootless eclecticism, was a world away from the stylistically inventive but essentially Georgian culture of the age of Adam.

Robert Adam had grown up, like any other mid eighteenth-century architect, under the predominant influence of Lord Burlington and 'Il Signor' Kent. In the *Lansdowne House* elevation of 1761 we see a Palladian essay, yet with hints of 'movement', a characteristically Adam ingredient. '"Movement" is meant to express the rise and fall,

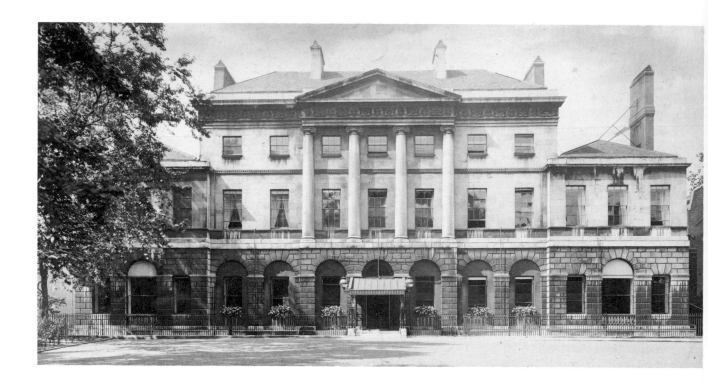

60 *Lansdowne House, Berkeley Square. A country house in town; as late as 1908 Chancellor described it as 'secluded'. Essentially Palladian arched and rusticated ground storey, but with typical Adam fluting at impost level and characteristic Ionic portico. Delicate contrast between plain ashlar (the windows have no architraves or pediments) and the intricate carving on the band course and frieze. There is an ambiguity of emphasis between ground and first floors which also recurs in Adam's work*

the advance and recess, with other diversity of form in the different parts of a building, so as to add greatly to the picturesque of the composition' wrote Adam himself in the first part of the *Works of Architecture* of 1773. At Lansdowne the vertical rise and fall of the centre against the sides combined with advance and recess in plan. Diversity of form is found in arch, pediment and pitched roofs. 'This august edifice... unites at once the gay, the elegant, and the grand,' as James Ralph observed.[9]

The site was on land sold off by Lord Berkeley's widow. As the 1783 edition of *A Critical Review* wrote 'Berkely Square is pleasantly situated on the side of a hill, and has a very cheerful aspect ... The south side is entirely taken up by Shelburne-House but this august edifice, far from adding grace to the square, can only be seen from thence in profile, and presents to view, on that side, an insignificant wall.'

Robert Adam's client was one of those Scottish aristocrats who assisted his rapid establishment in

London, Lord Bute (1713–92), who was held in the same sort of opprobrium as Lord Clarendon had been. He was attacked for building a palatial house on the proceeds of public office. Unlike Clarendon, Bute had little ability for government and the mob was unable to forget his part in the resignation of William Pitt the Elder in October 1761. He withdrew from public life and sold the house – still unfinished – to William, Earl of Shelburne in 1765. The price of £22,500 was said to be less than it had cost him and even then the gallery and interiors were to be completed to Adam's designs at Bute's expense. Lord Shelburne was also a politician and a gifted one. But as First Lord of the Treasury he was to be as unpopular for his signing of the Treaty of Versailles in 1783 as Bute had been for the Treaty of Paris twenty years before. Shelburne fell from office but did not desert the metropolis. He was created Marquis of Lansdowne.

The house had been completed by Adam in 1768 except for the gallery or, as it was labelled in the *Vitruvius Britannicus* plan, the library. This comprised a long wing at right-angles to the house on the north-west. Adam's scheme was for an enfilade of three separate apartments, the centre a rectangle, with octagonal ante-rooms at each end. Shelburne was a great collector and filled his house with fine furniture and pictures, books and manuscripts and,

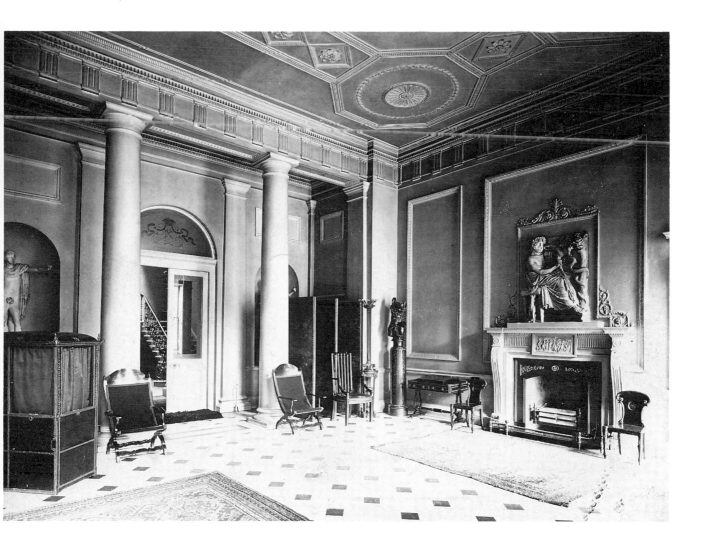

above all, statues. The last were an inspiration deriving from a long trip to Italy after the death of his wife in 1771. There were bookrooms on both ground and first floors at this time. So the wing, when completed in 1786 by Joseph Bonomi, was arranged as a gallery for the growing collection of classical sculptures. A hipped roof was cut away at the ends for circular lanterns over the nearly circular ante-rooms. The central space has a curved ceiling, already decorated by Adam.

In 1791 another architect, George Dance the younger, was appointed to alter the wing again. He opened up the space a little so that it was a long vaulted room with semi-domes at either end, which threw light into the room from nearly invisible sources. Dance's section drawing survives. It shows other changes such as the blocking up of the lower tier of windows, the enlarging of those above, the fitting of bookcases, and the replacement of Adam's chimneypiece with one in an 'Egyptian manner'.

George Dance (1741–1825), the son of the London Mansion House designer, followed to some extent in Robert Adam's footsteps. He travelled to Italy in 1758 just as Adam was returning. The ornament on his early buildings such as All Hallows, London Wall, owed something to the Adam style. But his mature neo-classical designs were an original and inventive contribution which in turn influenced Soane. At Lansdowne House he soon found himself altering the entrance hall, great staircase and the 'blue room'. According to Miss Stroud[10] he probably also created the bow room, with its saucer dome ceiling, out of a rectangular Adam space.

The Marquis of Lansdowne died in 1805. Dance spoke of him patronizingly: 'a man of even and

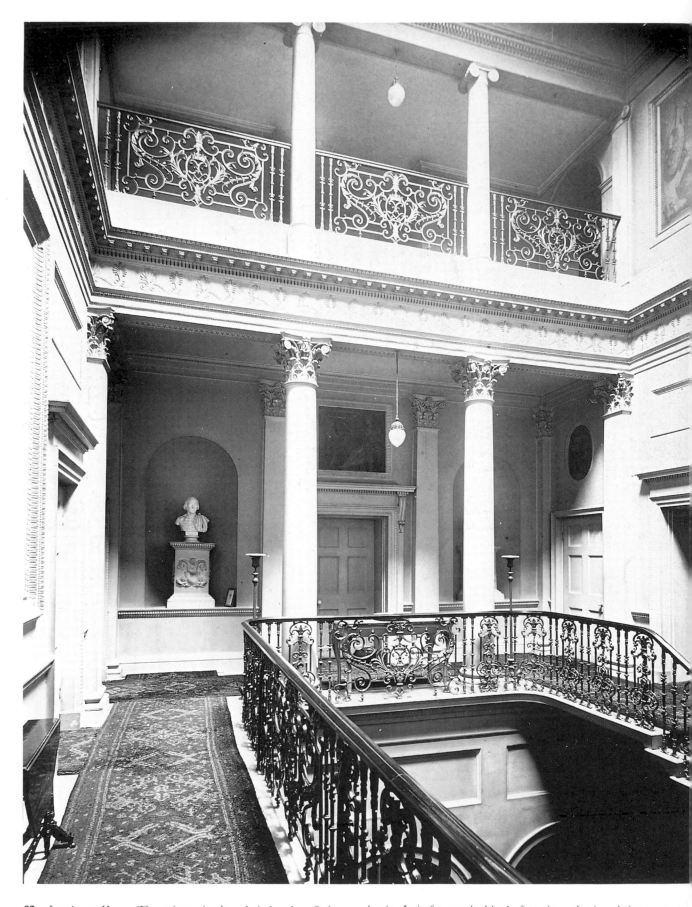

62 *Lansdowne House. The staircase is also relatively sober. Orders progress from Tuscan in the entrance hall, Corinthian for first floor loggia, Ionic for second. Adam's favourite anthemium design occurs on the frieze*

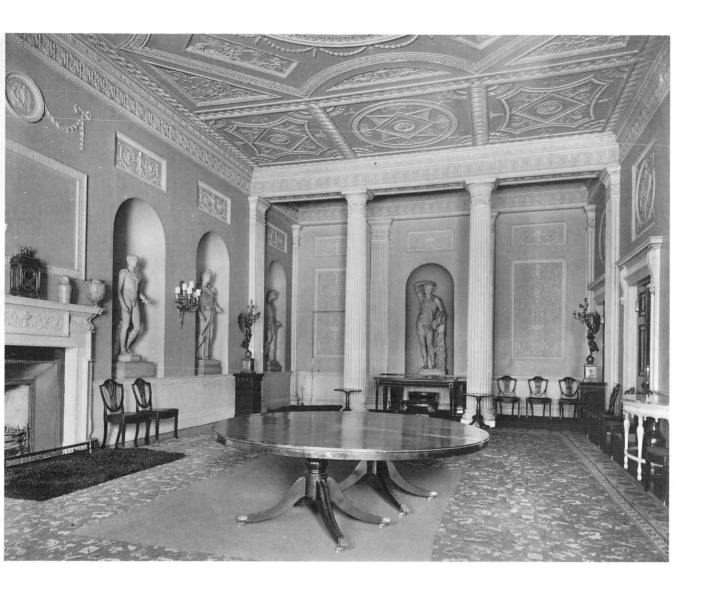

63 Lansdowne House. The dining room combines the two decorative streams, the Attic of columned screen and sculpture niches, and the elaborate eighteenth-century plasterwork of ceiling and wall panels

complacent manners and unruffled temper ... His lordship had a great desire to make his House princely, and such as he had seen abroad, and did so in a great degree, but he had no taste.'[11] More immediately that judgement could have been applied to his son and heir. The second Marquis dispersed much of the furniture, pictures, books and manuscripts. Fortunately the British Museum purchased the last with the first sum of money ever voted by Parliament for such a purpose. The sculpture collection was retained. Yet further alterations by Smirke in 1816 determined the final form of what at last became the sculpture gallery, housing most of the Greek and Roman marble figures belonging to the Lansdownes.

The third Marquis, a significant politician in the reigns of William IV and Victoria, had the novelty of a reputation for integrity. He was also a connois-seur, a patron of the arts and of literature. His collection of paintings, displayed in the interconnected reception rooms of Lansdowne House, included examples of Rembrandt, Murillo, Velasquez and several Italian masters. Many came, like Wellington's, from the Spanish royal collection, dispersed as a result of the Napoleonic wars. There were also a number of Reynolds canvases and at least one Gainsborough.

Lansdowne House was a major centre of London political and social life. The third Marquis was in the cabinet for much of the period between 1827 and 1858. We read of many dinners and dances at the 'palace' in Berkeley Square. Thomas Moore

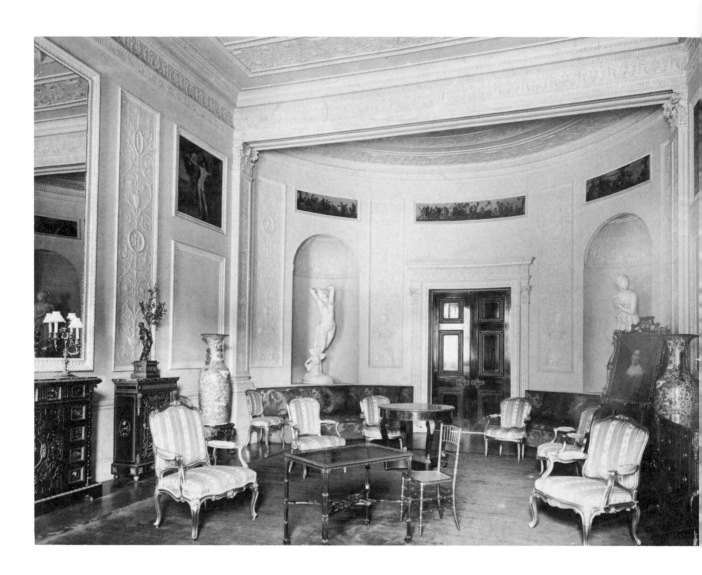

64 *Lansdowne House. The small dining room, with its more intricate plasterwork and inset paintings, is several steps nearer the exquisite*

remarked on one occasion when he was the only 'mister' among guests which included royalty. In fact other commoners such as Sydney Smith, Dickens and Macaulay were among visitors. There was also Madam de Staël. Concerts were given in the gallery which was often referred to as the saloon and sometimes in later years as the ballroom, one of the 'cool, grand apartments', as Lady Eastlake called them. Another such was the round room, with its neo-Greek frieze which can still be seen.

The dining room was more sumptuous; Ticknor writes of Lady Lansdowne going in to dinner 'surrounded by the most beautiful monuments of arts, she sat down with Canova's Venus behind her, she complained to me, naturally and sincerely, of the

weariness of London life ... but the table was brilliant.'[12] It was not too surprising that the Marchioness was weary; only a few days before she had held a party in honour of the Duchess of Gloucester, daughter of George III: 'All the Ministry was there ... the Duke of Cambridge, the Foreign Minister, Lord Jeffrey – just come to town – Lord and Lady Holland, the last of whom is rarely seen anywhere except at home .. Lady Holland was very gracious, or intended to be so; and Lord Holland was truly kind and agreeable.'[13] That dining room can now be seen in a somewhat altered form in the Metropolitan Museum in New York. The once adjacent drawing room, one of the finest and most characteristic interiors of Adam's early maturity, now graces the Philadelphia Museum. It was not finished in total conformity with the drawing in the Soane Museum.[14] The decorations had been incomplete when the family moved in in 1768. It was,

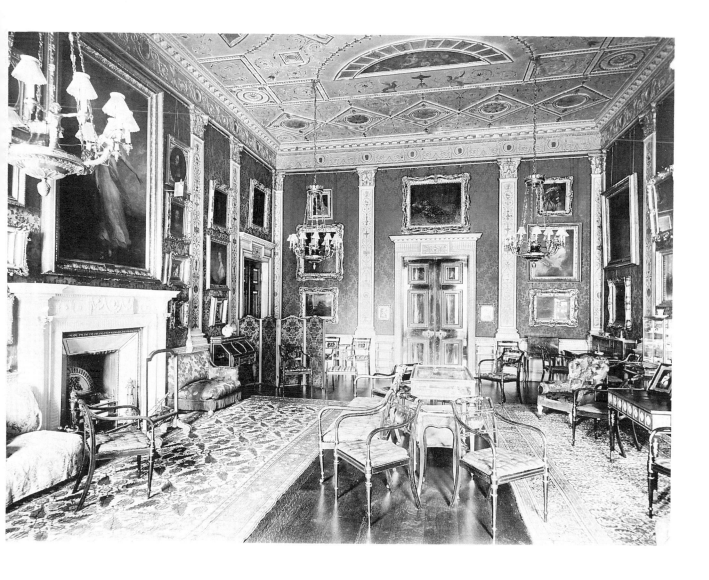

nonetheless, among the most felicitous of his light and decorative productions.

The mutilation of Lansdowne House was the result of a decision to create Fitzmaurice Place which entailed moving the front of the mansion back 40 ft, a process which, as Pevsner laconically remarks, 'naturally caused some disturbance inside'.[15] In vain did the Secretary of the Society for the Protection of Ancient Buildings suggest that 'carefully measured drawings should be prepared before it is destroyed, with full size details of the cornices and mouldings to the inside and out'.

Demolition of the service areas of Lansdowne House at this time highlights an area of fundamental loss in relation to London mansions, that of stables, coach-houses and other domestic offices. Here destruction has been virtually total. Whereas façades and grand rooms had defenders even in the 1930s, no one thought of resisting the pressures to

65 *Lansdowne House. The first drawing room is one of the most luxurious of all Adam's creations. Shallow Corinthian pilasters are supported on a fairly plain dado, then a delicate entablature and a rich ceiling with paintings by Cipriani. The trustees of the Philadelphia Museum of Art, having more taste than the Lansdowne Club of the 1930s, secured the room when the house was mutilated*

make more profitable use of the space taken up by kitchens, laundries, breweries or butlers' pantries. Thus at 44 Berkeley Square the basement has been turned into Annabelle's night club. Similarly, Adam's beautiful pavilion containing stables, coach house and laundry at the back of 20 St James's Square was swept away with barely a second thought in 1936. The rear part of Hertford House with service accommodation was converted into galleries in 1897. It is impossible to discover a palatial London house with surviving servants' and service quarters. Those parts of houses which often

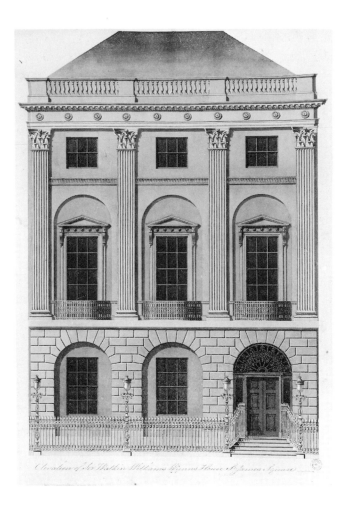

66 *20 St James's Square (sometimes called Wynn House) shows all the skill of Adam's reinterpretation of familiar ingredients. Paterae under the window pediments, a fluted band course below the chamber floor*

occupied a greater area in total than did the state rooms have all vanished. We are denied the study of the great house as a small society, as is possible at recent National Trust acquisitions such as Erthig, and on an even more impressive scale at Calke Abbey, Derbyshire.

Whereas Lansdowne House was reduced in size, another important example of Adam's work, *No. 20 St James's Square*, sometimes called Wynn House, was hugely enlarged at the same period. This mansion exemplified another of Adam's particular contributions – the creation of inter-related suites of varying sized and subtly articulated reception and living rooms in the restricted area available in the long, narrow town-house site. Tall staircase compartments, curved and apsidal ante-rooms led

through colonnaded screens to drawing rooms, dining rooms and libraries.

In June 1771 the first Earl Bathurst agreed to sell 20 St James Square to Sir Watkin Williams Wynn for £18,500 on the understanding that the purchaser would demolish and rebuild. The house was said to be 'very ancient and much out of repair'[16] though it had been built less than a hundred years before by Bathurst's grandfather, Sir Allen Apsley. Robert Adam was building Apsley House at Hyde Park Corner and Sir Watkin first employed James Gandon for his house. Work started in early 1772 and was not complete until three years later, by which time Adam was firmly in control. Finishings were still going on in 1777. Williams Wynn was a cheerful character who encouraged dancing below stairs and kept a cow in St James's Park. He was also highly cultivated and had studied theatre, the arts and architecture with some seriousness.

Built throughout in masonry the ground floor was rusticated with three round-arched recesses containing the door and two windows. A giant order of four fluted Corinthian pilasters rises from a plain band course at first-floor level to support an entablature with a rich modillioned cornice and stone balustrade. The plan of the house is simple, but subtly modelled to achieve a variety of spaces. There is an almost square room at the front on both ground and first floors connected with a larger room behind. These occupy two of the three bays. The third comprises an entrance hall (with ante-room over). Behind is a long rear wing containing a library, dressing rooms, bedchambers and subsidiary stairs. This wing connects with the rear service building separated from most of the main block by a paved court. Here were laundry, wash houses and hayloft above stables and coach houses.

The service block had an arched opening to the stables and, on the floor above, a great Venetian window flanked by pilasters, a pediment, a fluted frieze and a pyramidal roof. The side walls of the courtyard were highly decorated with three arched niches, flanked by engaged Ionic columns. There were to be classical statues on pedestals and festooned urns, but these may never have been executed. Both stable/laundry block and screen wall have gone.

The modelling of the half-dozen spaces on each of the two main floors provides the chief evidence

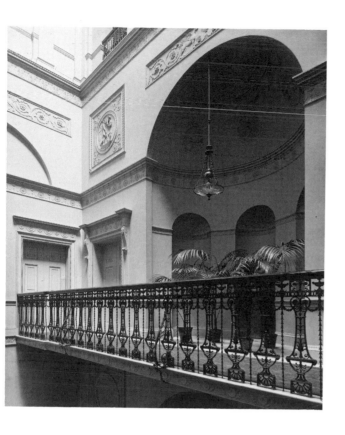

67 *20 St James's Square. The staircase landing here is the most architectonic feature, using apsidal niches within a larger apse*

of Adam's skill. Both large front rooms have a segmental apse at the rear with a doorway connecting to the back room which is itself apsidal at both ends. That of the eating room on the ground floor is elaborated by the inclusion of detached Corinthian columns as well as attached pilasters.

With all of this invention and delicacy it comes as something of a surprise to find a slightly leaden quality in the larger interiors. The very thinness of the filigree-like plaster decorations does not help. Adam's own drawing for the eating room ceiling, with its octagonal coffering casting directional shadows, looks much more dramatic than the shallowly modelled real thing. Another ambitious ceiling arches over the second drawing room in a wide vault. But even here the segmentally curved apses and ceilings appear as flat surfaces which have been forced into another form.

The three smaller rooms in the wings recede in scale towards the back of the house. The largest, on the ground floor, Sir Watkin's former library, has been considerably altered; but the corresponding

room above, Lady Wynn's dressing room, is one of the most beautiful in the house. Vaulted and arcaded with detached columns to its Venetian window, here is a space where Adam allowed the architecture to be more than skin deep. The frieze has 'basalt' plaques supplied by Wedgwood in designs by Antonio Zucchi, who executed paintings inset into other larger ceilings in the house as well as ornamental panels, and bookcases.

Wynn House was a celebration of the arts; indeed, a splendid organ in the music room reflected another of the enthusiasms of the first owner. Now the building is a celebration of commerce, having been bought by the Distillers Company in 1935 along with the neighbouring No. 21; but at least the principal interiors of Wynn House have been preserved within an elevation more than double its original 45-foot width.

The even more remarkable interior of *Derby House* was destroyed long before, largely as a result of Grosvenor Estate policy. Both the creation and the loss of architectural beauty in that quarter of London long regarded as the most fashionable has been the responsibility of this family and its agents. For two centuries from its origins in the 1720s, Grosvenor Square was an aristocratic and expensive place to live. The rack rents and high premiums for renewals limited tenancies to the wealthiest members of society. Such people were often lavish in pursuit of the last word in chic surroundings for their life in town. Each generation called in the most sought-after designers. In the eighteenth century, Adam, Chambers, Soane and all relevant Wyatts were employed to build, rebuild or remodel. And so, less fortunately, were their nineteenth-century successors, who often managed to increase plot coverage by a storey or two and replace genuine English eighteenth-century interiors with mock French ones.

Such was the case with No. 23, *Derby House*, which was later and confusingly renumbered as No. 26. Started as early as 1723, it was bought in 1730 by Sir Robert Sutton, husband of the dowager Countess of Sunderland. In 1771, at the age of nineteen, Lord Stanley inherited the house and commissioned Robert Adam to engage in the first major refurbishment. Between 1773 and 1775 he created one of his masterpieces, yet the façade was only slightly altered by the addition of a shallow Doric

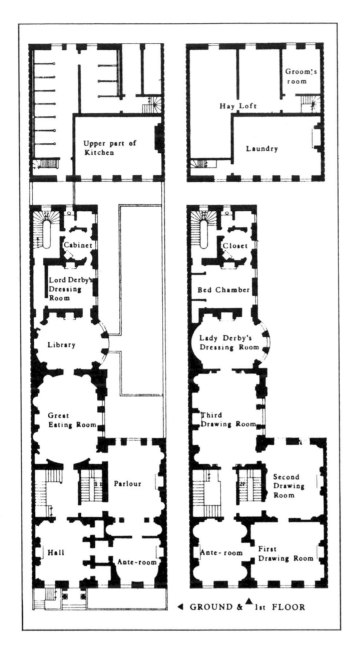

68 *26 Grosvenor Square (Derby House). Adams plan of c. 1773 achieved an extraordinary sequence of grand and varied spaces within a 50-foot site width*

portico. Otherwise Adam retained the modest early Georgian character in 'token of the proud disregard to external appearance of which English noblemen liked to Boast', as Sir John Soane pointed out in a Royal Academy lecture.

The interior was another matter. Adam was determined to achieve the sequence of grand apartments typical of a French *hôtel*. On the ground floor, a square hall with advancing and receding surfaces consisting of pilasters, alcoves and niches led, via a

vestibule and an opening punctuated with two detached columns, into an ante-room. One wall of that room gently directed the visitor via a segmental curve towards the parlour. This long room was entered, just off-centre at one end, through a colonnade. From its far corner a door led into the great eating room, the apsidal ends of which were themselves modulated by smaller apses. Beyond was an elliptical library, a square dressing room and a round closet. So much could be achieved within the 50-foot width of a London House, the site of which did, however, extend over 200 feet to the rear. On the first floor an equally inventive suite of state rooms interconnected.

Besides the paintings and other designs in wall and ceiling panels by Angelica Kauffmann and Antonio Zucchi there were door panels in ornamental *papier mâché* by Henry Clay of Birmingham which were highly japanned, i.e. lacquered, so as to look like glass. The architect was also responsible for chairs, sofas, commodes, beds and looking glasses. The fact that the house was really too small stimulated Adam to greater invention. One practical move was to extend the rear wing to contain 'private' apartments connected with the sequence of ceremonial rooms, 'all devised for the conduct of an elaborate social parade'.[17] The house provided a setting for a public way of life, by and for a comparatively small society of wealthy and powerful people, who lived in rooms 'where a sentence might be delivered, which would echo round political England'.[18] The rooms had to be effective, both as display and as functional spaces. So Adam planned for the assembly of guests, the procession into dinner. He made space where the upper servants could stand still and routes for the lower servants to pass unnoticed.

Adam's client was an imaginative patron. He was unconventional in marriage too. His second wife was an actress, Miss Farren, who brought her mother to live with them in Grosvenor Square. The family resided there until 1852 when the fourteenth Earl sold the lease to the dowager Countess of Cleveland; he had moved to St James Square meanwhile. After her death in 1861, Sir Charles Freake destroyed Adam's great creation. He built a new house on the site. It was occupied by the dowager Duchess of Norfolk. Final demolition came in 1957.

Almost contemporary with Derby House but

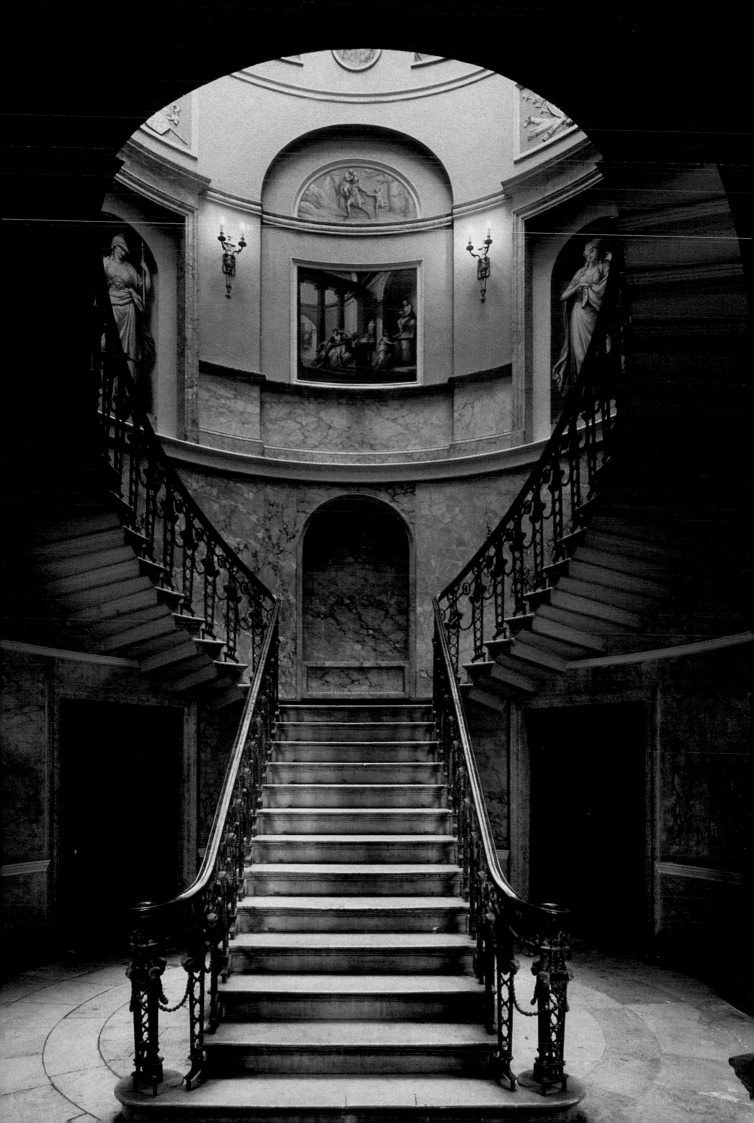

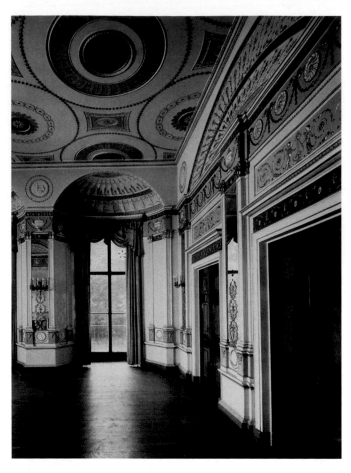

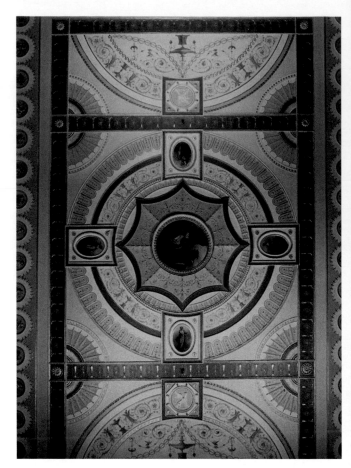

Home House: Adam's best surviving London palace retains its impressive classical staircase (previous page). Elements of Adam's Etruscan style can be seen in some of the house's colour schemes (top left and right). © Crown Copyright. NMR.

Devonshire House (below) was a country mansion with a three-acre garden, built in 1672. It stood on a lane called Piccadilly, which linked London and the village of Knightsbridge.

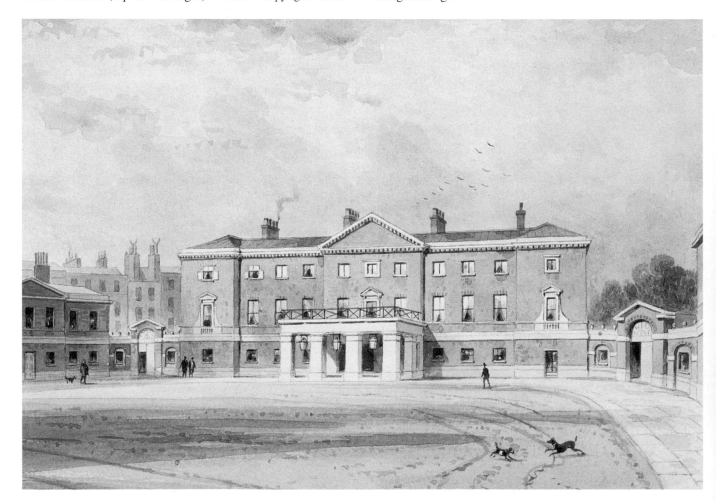

Apsley House (below). The Portuguese Service (above) was a gift to the Duke of Wellington for his role in the post-Napoleonic peace. © Courtesy of the Trustees of the V&A.

Among the Duke's other trophies was a giant statue of Napoleon (above), formerly a prized possession of the Emperor himself. © Courtesy of the Trustees of the V&A.

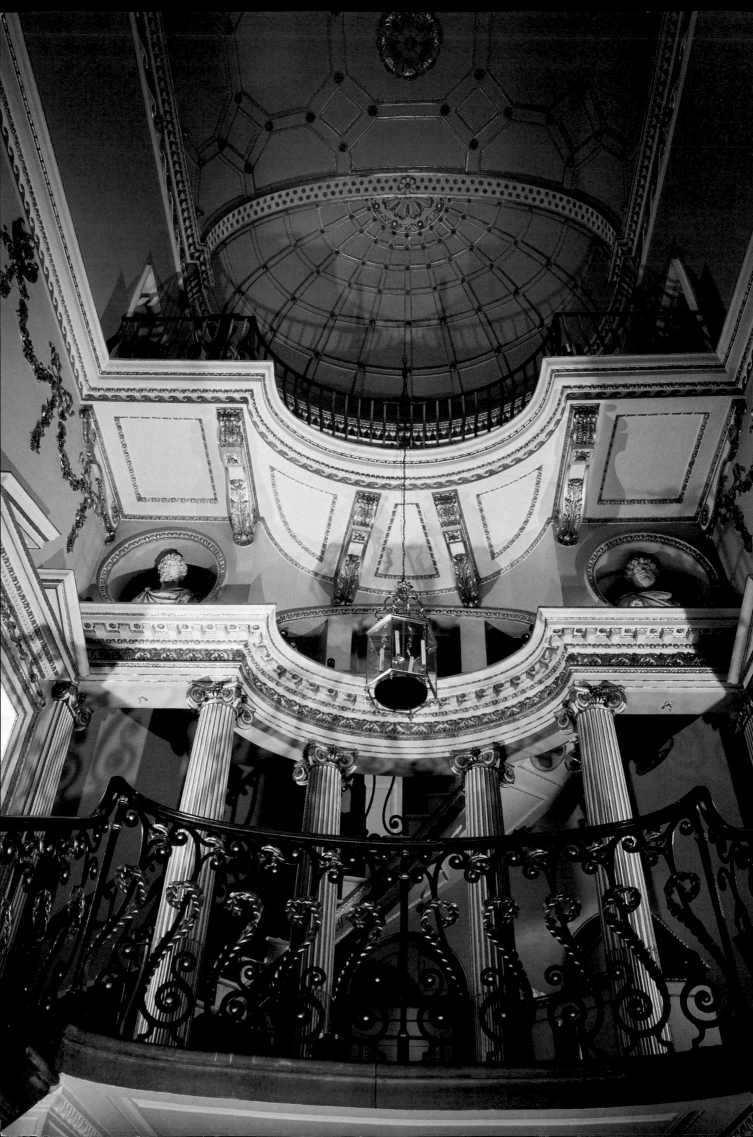

44 Berkeley Square: Kent's mastery of the theatrical effect is exemplified in the staircase (left). The coffered ceiling of the Great Chamber (top left and right) evokes the decadent glamour of ancient Roman interiors. © A.F. Kersting.

20 St James' Square (below): This Robert Adam design for a Welsh baronet exemplifies the most delicate of the architect's mature work. © Crown Copyright. NMR.

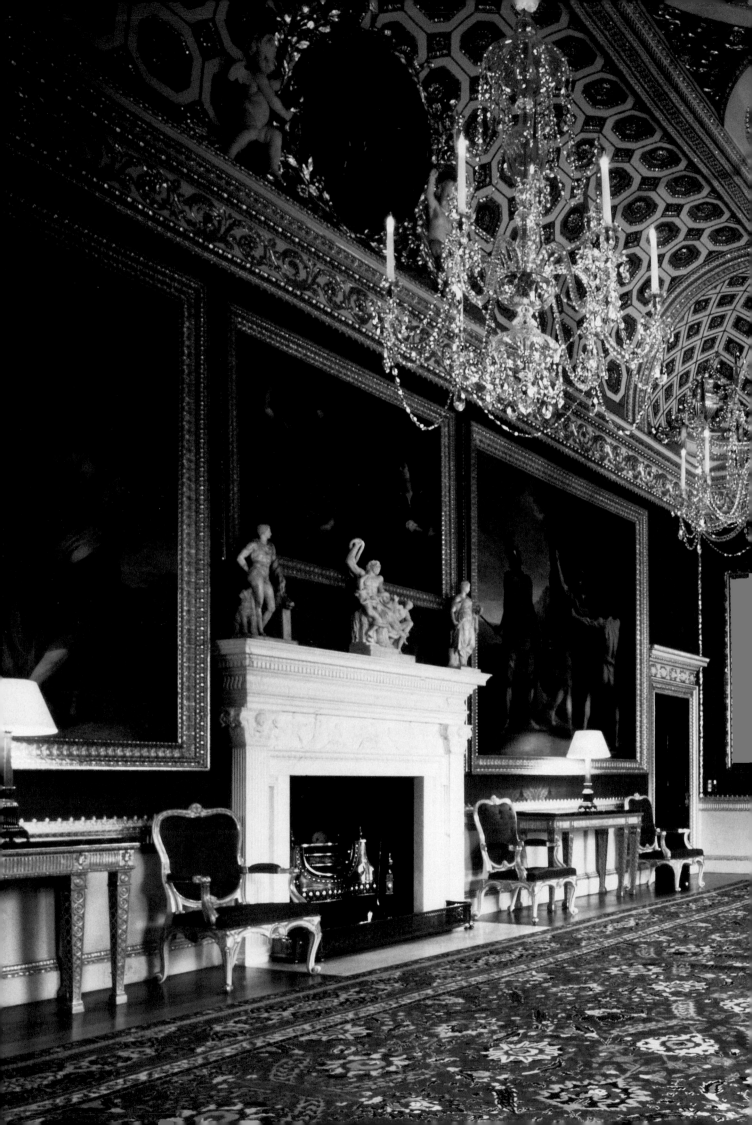

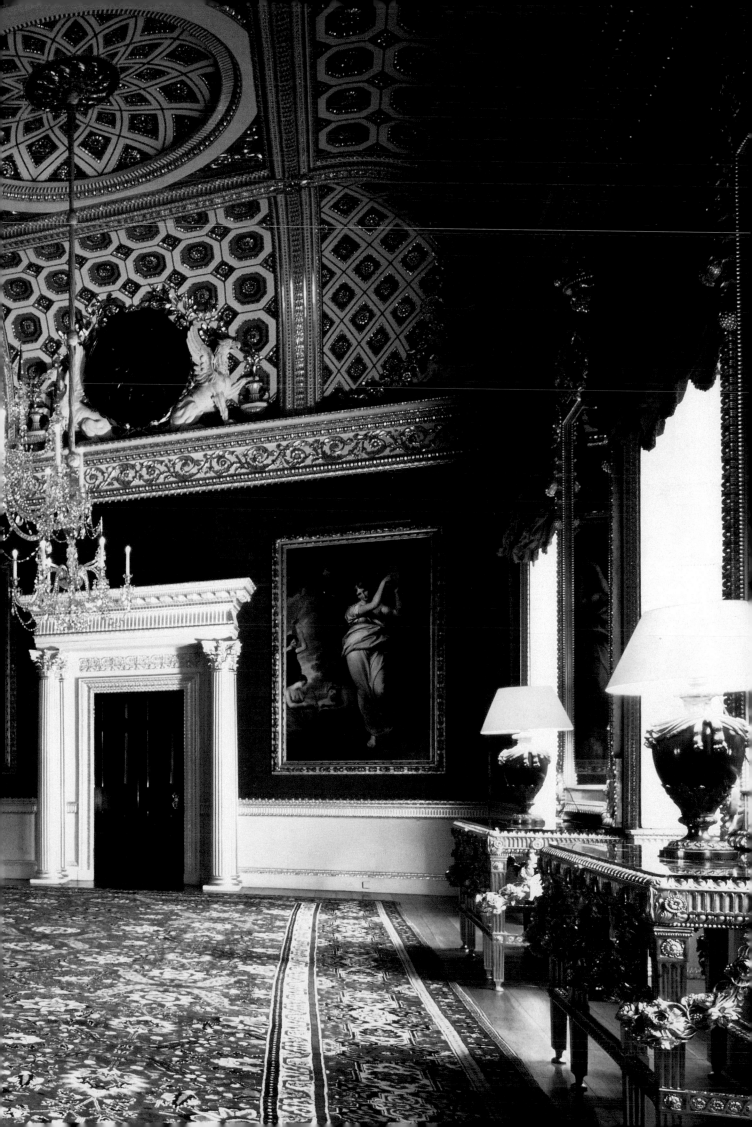

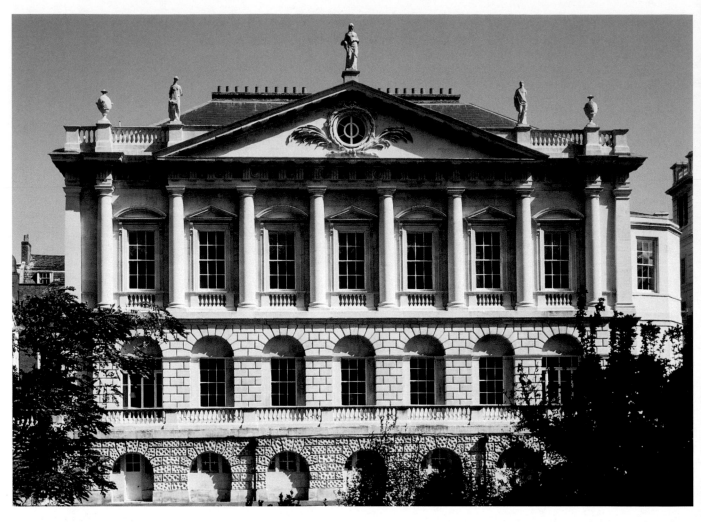

Spencer House: The West Façade (above). The Great Room (previous page) is today furnished largely with facsimiles. © Spencer House.

Smaller in scale and more fanciful in design, the Palm Room (below) has been opulently restored. © Spencer House.

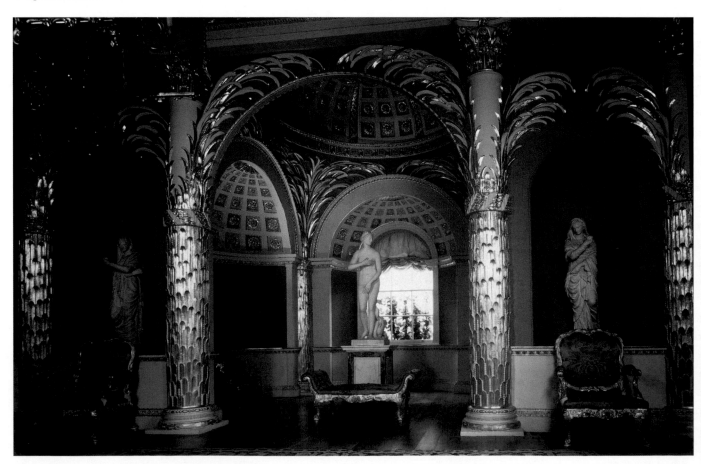

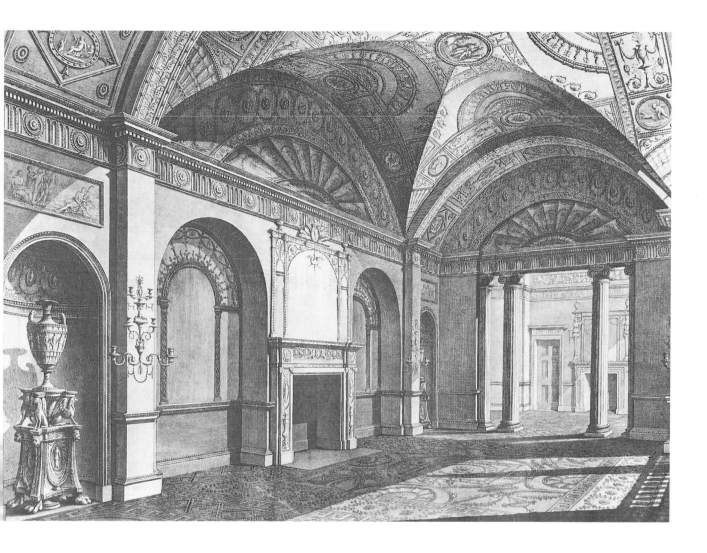

more monumental in character was a mansion on a larger site in a new, if less fashionable, square. *Home House* in Portman Square is one of the best examples of Adam's mature work, representing many characteristic features even today popularly recognized as belonging to his 'style'.

Elizabeth, Countess of Home, was a formidable woman. Said to be excessively unattractive, except in respect of her fortune, she married and was widowed twice. Childless and rich, she suddenly decided when almost seventy to build herself a grand house in the latest mode in one of London's new locations. Portman Square, where she already occupied No. 43, was then nearing its complete development. In December 1777 Lady Home was able to occupy the mansion where she was to live the remaining six years of her life. Having indulged herself in a house of the grandest sort, the Countess entertained with a lavishness irresistible even to the many in society who were amused to call her 'a

69 *Derby House, third drawing room, its cross vault somewhat like Giulio Romano's at the Villa Madama in Rome, but every feature and surface had Adam's stamp. This 1777 engraving has a wide opening into Lady Derby's dressing room, which the architect clearly regarded as* en suite *with the reception rooms despite its alleged function; the plan showed a more restricted doorway*

witch', a 'hag' and the 'Queen of Hell'.

William Beckford was of that ilk; he wrote a well known account of an evening in Lady Home's house. 'Aware of my musical propensities she determined to celebrate my accession to Portman Square [he had taken a house there] by a sumptuous dinner and concert of equal magnificence.' No doubt because Beckford's wealth, like hers, stemmed from the West Indies, the Countess 'happened to meet with a brace of tall, athletic negroes in flaming laced jackets, tootling away on the French horn as loud as their lungs permitted. "By God," exclaimed her majesty (she swears like a

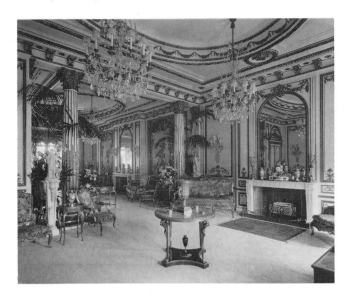

70 *26 Grosvenor Square; after the rebuilding in 1862 the drawing room was vulgar*

trooper), "You play delightfully. Get up behind the carriage and come home with me. You shall perform tonight at my concert."' This was to be conducted by Felice Grandini, the celebrated violinist. As Beckford remarked, 'Poor old Grandini, who, for the punishment of his youthful sins, I presume, is become her Maestro di Capella, went fairly distracted.'[19]

The façade spanned sixty-five feet at the western end of the square's north side, much of which was completed in a manner not unlike Adam's own by James Wyatt. Ornament on the brick elevation is sparse, and limited to decorative band courses, paterae, and large panels over the first floor windows festooned with garlands. There is a typical porch with fluted Doric columns to mark the off-centre front door. Running the full length at first floor level is a balcony. Its lightness of design means that it does not detract greatly from Adam's façade to which it is an addition.

The other major alteration however, was hugely destructive of the design, throwing both front and rear elevations off balance. This was the extra floor, rather loftier than Adam's original top floor beneath it. The extra storey is even more oppressive at the rear, upsetting again the very conscious relationship between ground and first floors. Here two-storey masonry bays with Ionic orders at

ground level, Corinthian above, frame three groups of tall windows and supporting pediments. Adam's famous 'movement' was exemplified here: the Coade stone medallions with zodiac signs bouncing along above and below the pediments; the half-round portico with four detached and two engaged columns. Originally this was just held in balance by a single sober top floor.

The history of Home House after the death of the Countess was uneventful. The French Ambassador leased it until the Napoleonic wars. A series of aristocratic occupants included the Duke of Athol, the second Earl Grey (of the Reform Bill), and from 1820–61, the Dukes of Newcastle. Sir Francis Goldsmid was followed by his family in the house till 1919, then Lord Islington till 1926, and Samuel Courtauld from 1927–32.

The plan is unlike many in terraces, because its very width allows it to be nearly square, with four major apartments on each principal floor – including the entrance hall and the ante-room over it. The circular drum of the great staircase is in the centre. A description of the plan in its basic simplicity conveys no idea of the intricately modulated series of spaces, not one of which is a simple volume without curves, apses, bays or corner columns to modify the geometry.

The entrance hall is square with marbled walls up to door-head height. In the half-domed alcove is a slightly uncomfortable-looking fireplace where an obelisk-shaped stove was intended. The cornice and entablature is deep and complex with the sort of detail invented by Adam anew for every situation. By his standards the hall is sombre and weighty, an apt overture for the grand circular stair which leads off it and rises through the three original levels of the house. The sombre orange-brown 'Siena' marbling establishes a base for the lightening of the colour scheme upwards towards the skylight.

The front parlour, originally used as a drawing room, is a comparative failure. A scagliola column at each corner supports nothing more than a kink in the entablature and achieves nothing, either

71 *Home House, Portman Square. The design drawing for the staircase varies only in detail with the building today. The dome is rather larger and the arched ground floor opening is unencumbered with the columned screen*

Lady Home's Staircase

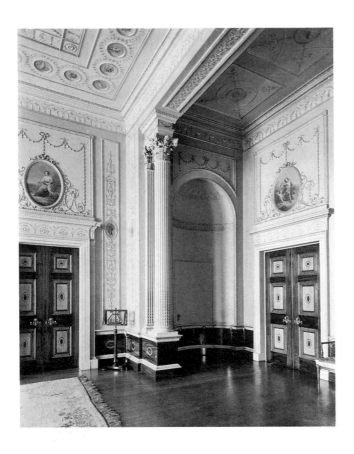

72 *Home House, second drawing room, or ballroom. Entrance is by the jib door in the apse; the door on the right is fake. Delicate decorations are firmly 'anchored' on a strong dado again, here of inlaid mahogany, rather like the doors*

structurally or decoratively. A critic wishing to establish the inconsequential character of late eighteenth-century architectural interiors would be well served here. Otherwise the walls are unusually plain – some stucco decorations having been omitted. The ceiling however is a full-blown Adam essay with a large oval motif adorned with paintings probably by Angelica Kauffmann. The walls of the back parlour are also somewhat plainer than in the design drawings, although delicate Corinthian pilasters and a particularly refined ceiling, with paintings in grisaille, enhance a space the outstanding feature of which is a large apse at the end facing the window.

The library, at the rear of the staircase, completes the ground floor. It is formally more restrained than some rooms, but has arched recesses in each wall. There are painted panels over the doors and over the mantelpiece, the latter being signed and dated 'Ant. Zucchi 1776'. As in many libraries, there are

portraits of various notables; Drake, Bacon, Newton, Addison, Locke and Adam himself, among others. These are executed on circular ceiling panels painted in grisaille. Other ceiling paintings, as well as the fireplace carvings, represent arts and sciences.

The first floor landing leads straight into the splendid ballroom (or second drawing room) via a door concealed in a side apse within the large apse. The ceiling is among the most intricate ever conceived by Adam. Though marginally less grand, the music room is even more original in detail. There are five apses, three on the window wall, two opposite. So when Hussey described 'a fantasia of circles' he had more than the ceiling design in mind.[20] Naturally the ceiling paintings are of musical subjects. Music rooms in great London houses (for example Northumberland House, also by Adam, and Norfolk House by Brettingham) seem to have inspired designers to the happiest creations.

The so-called Etruscan room is less happy. 'A mode of Decoration which differs from anything hitherto practised in Europe,'[21] was Adam's own claim for the style. His description of it as 'Etruscan' has stuck and indeed the colours are characteristic of some Etruscan vases. But many of the subjects are found in Pompeiian frescoes or Greek vases. The sadness is because now little more than the inlaid marble fireplace exhibits this fascinating archaic style. It is not certain whether the scheme has been destroyed or was never fully carried out. Recent cleaning and re-painting has emphasised this room's crisp elegance. The whole house is well preserved and aptly used as the Courtauld Institute of Art.

The 1770s saw the building of another mansion which was to virtually complete the enclosure of Portman Square on the healthy north-west fringe of town. Again the client was a formidable old woman, but unlike the Countess of Home, Mrs Montagu was a lady of learning and charity, an original 'blue stocking'. Apparently she employed James Stuart to design *Montagu House* 'on account of disinterestedness and contempt for money'.

James Stuart (1713–88) was another of the many Scottish architects to achieve success in London. He was well equipped in every way except the ability to apply himself to work once he had struggled into a position to receive it. Despite a penurious background he succeeded in learning to draw and paint and applied himself successfully to Latin, Greek and

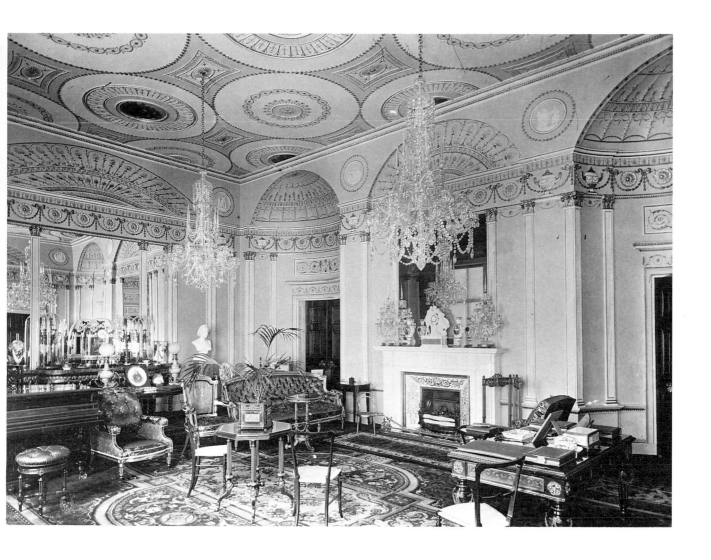

mathematics. In 1742 he set off for Rome, travelling on foot most of the way. Having arrived he established himself as an informed companion for well-to-do Englishmen on the Grand Tour. Some of these agreed to sponsor him and Nicholas Revett, whom he had met in Italy, to survey, describe and draw classical ruins in Greece.

They returned to England in 1755 with many drawings although another seven years was to elapse before publication of the first volume of *Antiquities of Athens*. Stuart had very soon bought out Revett, though it was the latter who had done the essential measured drawings. Thus it was 'Athenian Stuart' who became famous and never lacked commissions. He was an arbiter of taste, being consulted on designs for medals, on monuments, on designs for Wedgwood products. He was soon financially secure. However, many buildings he designed had to be completed by others, and Mrs Montagu soon found herself with cause for complaint that draw-

73 *Home House, the music room. A composition of circles*

ings for workmen were not provided, and that accounts were muddled. Joseph Bonomi was brought in to finish the interior.

The designs for Montagu House were begun in 1769; it appears that work did not start until 1774 or 1775 and was not completed until 1782. Meanwhile Mrs Montagu was ensconced in her house in Hill Street, Mayfair, where she had lived since 1759. There her salons were attended by Horace Walpole, Joshua Reynolds, Edmund Burke, David Garrick and even occasionally Dr Johnson. Equipped to be a patron of the arts with a fortune bequeathed by her husband Edward Montagu, grandson of the Earl of Sandwich, she had established herself as a literary figure with the publication of various essays including several on Shakespeare.

Mrs Montagu was occupied for many years in

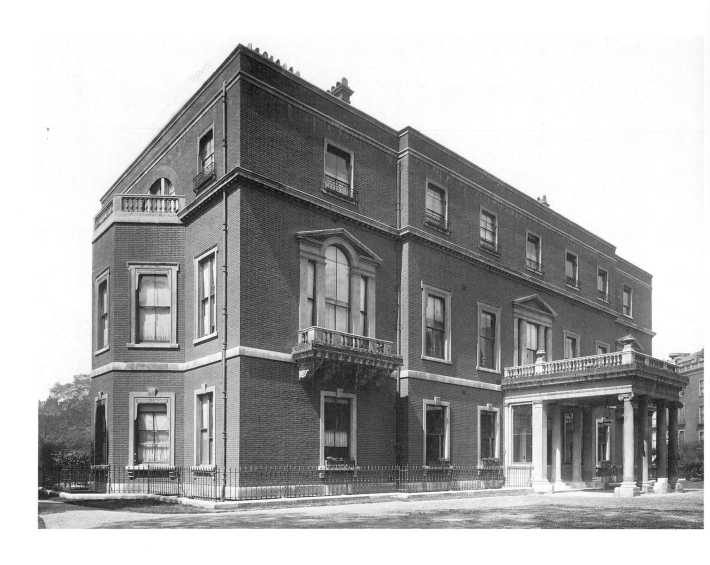

74 *Montagu House, Portman Square. Nineteenth-century* porte cochère *and balconies detracted little from Stuart's dull brick box. 1894 photograph shows the building as it was externally even after a 1940 fire bomb largely gutted the interior*

75 *Montagu House. A restrained entrance hall and unimpressive staircase led to a noble parade of state apartments on the first floor. Free-standing columns of Grecian proportions were a feature of the interior*

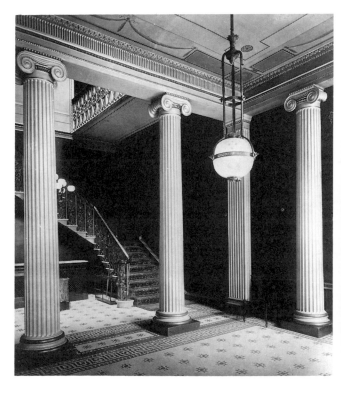

adorning her new house. Despite the morning room of feather hangings which she collected or begged from all her friends and her 'Room of Cupid' (a boudoir painted with flowers and cupids), which both suggested a frivolous approach, Mrs Montagu was a woman of intellect with a great gift for friendship. Fanny Burney described her as 'brilliant in diamonds, solid in judgment ... sometimes flashy and an immense talker; but still eminently courteous and agreeable'.[22]

Plain, detached, closing the corner of the square, Montagu House was three storeys high in brick with

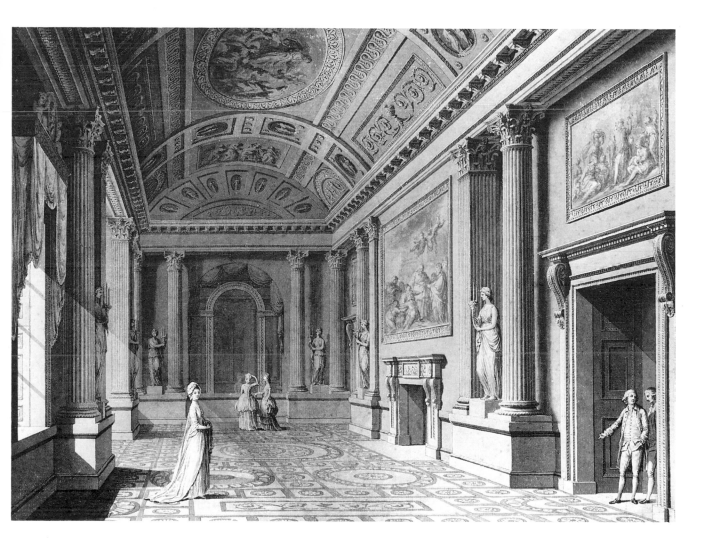

76 *Montagu House. Design for great drawing room by Joseph Bonomi, who was brought in to help complete the interior delayed by Stuart's indolence. The taste of the blue-stocking lady (is that her in the foreground?) was evinced by the classical statues and allegorical paintings*

a basement lit by an area; it was rectangular in plan with five narrow centre bays somewhat advanced, and wide end bays set back. In those bays Venetian windows on the first floor were crowned with rather weak triangular pediments, similar in scale to that over the centre window. Mouldings and other detail were Greek in character. All the emphasis was on the principal floor, at least until Lord Portman attached to the entrance a bulky *porte-cochère*, with six plain Ionic columns supporting a balustraded balcony.

The interior had a strongly three-dimensional and architectural quality, with many detached or nearly detached columns and heavy entablatures. In the entrance hall the columns were fluted, with Greek proportions and robust Ionic capitals. The saloon columns were of green marble, unfluted but with deep, rich and gilded Corinthian capitals. Above was a 'segmental ceiling decorated in a flattened *cinquecento* style.'[23] Another feature of the

room which struck visitors was that the frames of the deeply recessed windows and indeed of the doors were of solid white marble.

After his first visit on 22 February 1782, Horace Walpole wrote: 'I dined with the Harcourts at Mrs Montagu's new palace, and was much surprised. Instead of vagaries it is an noble, simple edifice. Magnificent yet no gilding. It is grand not tawdry, not larded, embroidered and *pomponned* with shreds and remnants, and *clinquant* like the harlequinades of Adam, which will never let the eye repose an instant.'

Mrs Montagu died aged about 80 in 1800. The house was bequeathed to her nephew, Matthew Robinson. He let it to the Turkish Ambassador. It

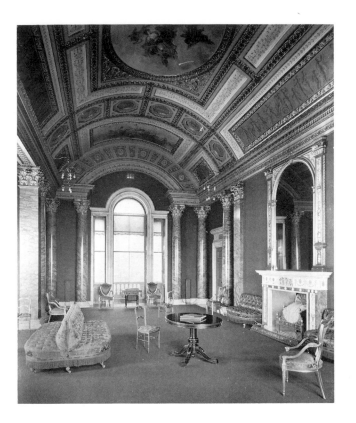

77 *Montagu House. The saloon in 1894, of similar proportions to the great drawing room, but architect's drawings exaggerate scale and grandeur. Cipriani executed the ceiling paintings in c. 1790*

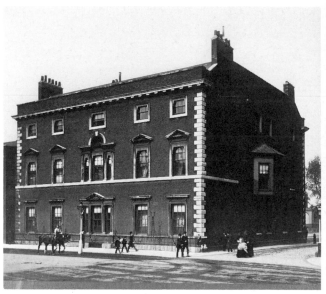

78 *Carrington (ex Gower) House, Whitehall. The undemonstrative façade, with no orders, relied for emphasis on three-light windows to central rooms on round and first floors (not unlike some at Montagu House). Perhaps Chambers was wise to produce a modest brick box alongside Jones's Banqueting House*

was back in the hands of a member of the family, Lord Rokeby, in 1835. In that year his distinguished son-in-law Henry Goulburn was also residing there. He was Chancellor of the Exchequer in the administrations of both the Duke of Wellington 1828–30 and Sir Robert Peel 1841–6, and Home Secretary 1834–5. Montagu House had its political connections. In 1874 the ground lease reverted to the Portman family. Viscount Portman occupied the house. Portman House continued to be the home of the wealthy property owners until bombed in 1941. Fire gutted much of the interior, but the structure was largely intact and quite capable of repair. However, more profitable uses were found for the three-acre site.

In the year when building work had started on 'Mrs Montagu's new palace', another somewhat similar mansion was nearing completion in the heart of the capital. Gower House, later *Carrington House*, Whitehall, also had a plain brick exterior and a very fine and highly architectonic interior. It

was Adam who reported on Chambers's reputation in Rome, where he had spent some early years, as 'a Prodigy for Genius, for Sense & good taste'. His career certainly proved the latter two qualities.

The son of a Scottish merchant in Gothenburg, William Chambers (1723–96) was educated in England, but returned at the age of sixteen to work in the Swedish East India Company. In the 1740s he voyaged to China and India, but was chiefly engaged in saving money in order to study architecture. This he commenced in Paris in 1749, conceiving a life-long predilection for the refinement of French neo-classicism. This was reinforced in Italy where he continued to study under French drawing masters, such as Clérisseau. Chambers set up in practice in England in 1755 and two years later was in royal service, through the recommendation of Lord Bute. He also published energetically; his *Treatise on Civil Architecture*, the first part of which came out in 1759, became a standard work on the details of the orders and their enrichments. In 1756 he joined Adam as one of the Architects to the Office of Works, of which he later became sole head. Chambers was a good administrator and also

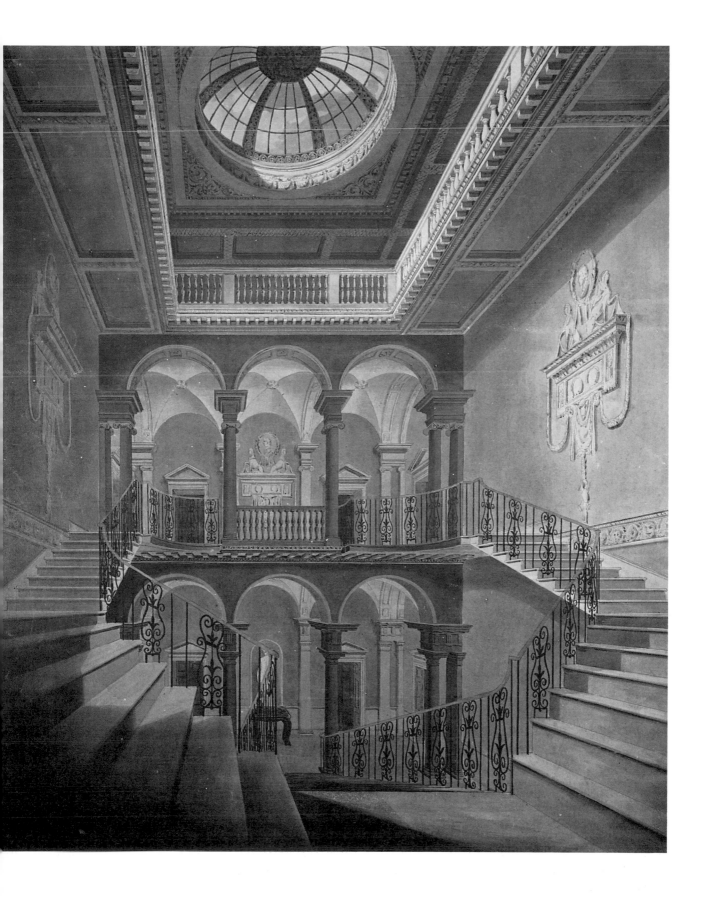

79 *Carrington House. The staircase was perhaps the finest in any London private palace. Drawn by Basevi, used by Soane for his lectures*

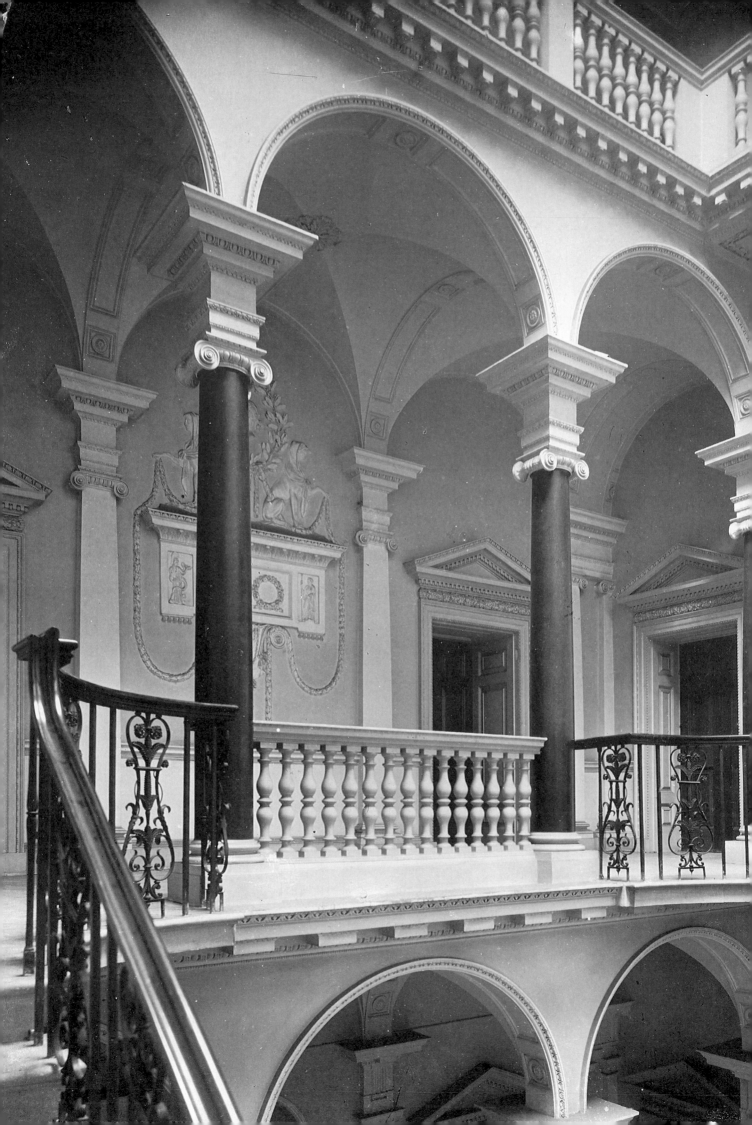

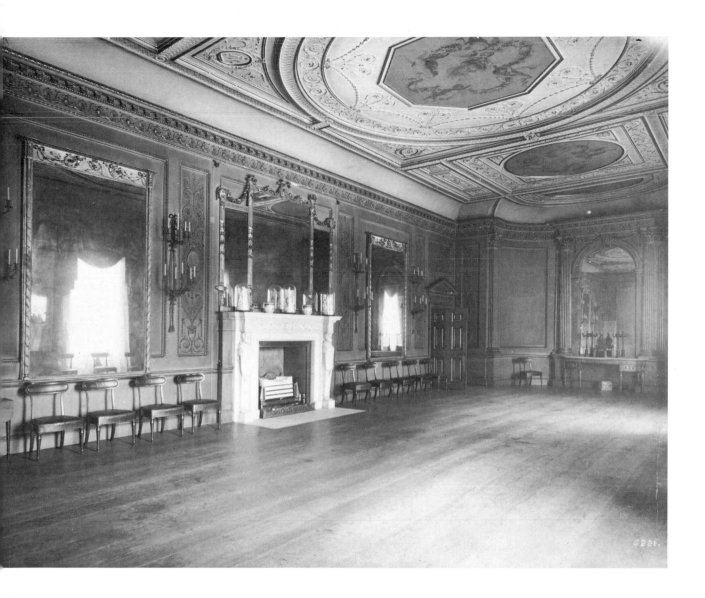

turned his hand to such matters as the design of the state coach – which is still used.

There was an instinctive side to Chambers – after all he married a Bromsgrove milliner girl who had followed him to Paris, as the story goes – but he preached restraint. He told a pupil, 'correct that luxuriant, bold, and perhaps licentious style, which you will have acquired at Rome ...' He even suppressed much of his own taste for French neo-clasicism, in favour of a simplified Palladianism which went down better in England. His houses were all stamped with Chambersian dignity' and as Summerson continues, they avoided 'the least suggestion

81 *Carrington House, ballroom. A 60 feet by 30 feet chamber in which the plaster and painted decorations were not unlike Adam's, except that each feature reads individually in a more architectonic way. The marble chimneypiece is now in the Carrington country home*

of the elongations and lawless omissions and embellishments of Adam'.[24]

The story of Gower House had begun in 1721, when Lord Newborough was granted a lease for a cluster of lodgings adjacent to the Whitehall Banqueting House. The Crown Commissioners were anxious to redevelop the area devastated by the fire of 1698. Newborough's house was demolished when the Earl Gower obtained possession of the site in 1765. It was an irregular L-shape and Chambers's first decision was unexpected, for he chose not to place the entrance on the longer and more

80 *Carrington House. The splendidly Italianate loggias to the landings – Doric below, Ionic above – the plasterwork ornament most judiciously placed for effect*

prominent Whitehall front, rather on the rear elevation facing east, into Whitehall Yard. It seems that there was a requirement for major suites of connected rooms on both floors. On the Whitehall side a 'parade' consisted of a central octagon flanked by an almost square apartment on either side. The secondary front was taken up with a spacious entrance hall and an eating room beside it. Over these was the great drawing room, sometimes called the gallery, later the ballroom. Between these two splendid groups of reception rooms was the central staircase.

The exterior closely reflected this arrangement. A five-bay, two-and-a-half-storey brick box, with stone quoins, band course and cornice, it was enlivened with two sets of tripartite windows, which could loosely be called Palladian. On the street side they emphasized the two levels of great rooms by being placed above each other in the centre. At the rear they were both on the ground floor, one lighting the eating room, the other being the main entrance.

The brilliantly modelled, arched and vaulted staircase was adapted from Longhena's seventeenth-century essay in S. Giorgio Maggiore, Venice. Its first single flight was approached through a Doric loggia at ground level and then divided to return through an Ionic loggia on the first floor. The compartment rose to a domed lantern in a boldly coffered and ornamented plaster ceiling to the chamber floor, the rooms of which were approached off a balustraded gallery around three sides. On the plain walls were large neo-classical compositions of most delicate plasterwork decoration.

Lofty and austere, separated from Whitehall by the moat of a railed area, Gower (Carrington) House had the aristocratic aloofness thought appropriate in great London houses. The very fact that the splendour within was hidden from the passer-by added to the esteem in which·it was held. It was an important step in Chambers's career, despite the length of time – seven years – taken to complete it.

Lord Gower was patient, but he could certainly afford to be aloof. His wealth was increased by both inheritance and marriage, and he was raised to the marquisate of Stafford in 1786. His son, an enthusiastic art collector, succeeded in 1803. But having also inherited Cleveland House from an uncle, the Duke of Bridgewater, he sold the Whitehall house in 1810 to Lord Carrington. That peerage, prominent in recent times, was then a new creation. When the crown lease expired the house was so highly regarded, by among others Mr Gladstone, that attempts were made to preserve it, even by moving the building. The estimated cost of doing so (at £4000 it was less than a tenth of the house's value) was considered excessive. Demolition took place in 1886.

The Carringtons' comparatively modest picture collection, which included Dutch sea pieces, English seventeenth-century topographical and eighteenth-century portrait paintings, was removed to their country home, Wycombe Abbey in Buckinghamshire, together with fittings such as the ballroom fireplace.

The architects whose London houses have been treated here had a hand in several others which are touched on in other chapters. Their work together with that of the Palladians before them epitomized a cultural golden age. Never again were architectural matters to preoccupy society at its highest levels. The next chapter examines another of the determinants of the form and location of London mansions, namely the ownership, development and re-development of land.

V
Landlord's Mansions

The wave-like development of London was closely related to periods of economic boom following peace treaties or similar political settlements: such events were the Restoration of 1660, the Revolution of 1689, the Treaty of Utrecht of 1713, and the Treaty of Paris of 1763. Development for housing of land formerly attached to a mansion provided scope for population growth. This was the pattern with Bedford House and Bloomsbury, Leicester House and Leicester Fields, Berkeley and Burlington Houses and their land to the north. Farming land on the edge of town may have been in a family for generations, as with the Portmans who had owned 200-acres in Marylebone since Tudor times. It may have been obtained for speculative development, as was the case with Soho Fields and St James's Fields given by Charles II to Henry Jermyn, Earl of St Albans. A fortunate marriage alliance may have taken place between two families with adjoining property ripe for development, such as happened when the Cavendish and Harley estates north of Oxford Street came together. A large proportion of landed property was in the hands of titled families. When by chance of marriage or entrepreneurial skill large properties were obtained by commoners, titles were usually bestowed.

If the 1672 betrothal of the seven-year-old Mary Davies to the second Lord Berkeley of Stratton had resulted in the expected marriage, her 100 acres bounded by Oxford Street and Hyde Park would have been linked to the small but valuable estate behind Berkeley House. Without the Davies marriage the Grosvenors might well have remained in the comparative obscurity of Cheshire.

When areas go down in the world mansions may be split into tenements and their gardens divided up, as happened in the City in the sixteenth century. Or they may be demolished for redevelopment by larger-scale operators as happened in the Strand area in the seventeenth century with property 'undertakers' such as Nicholas Barbon. Demolition can also happen when property values rise so rapidly that a temporarily hard-up aristrocrat is unable to resist offers made for the site of his house. Such was the case with the Duke of Albemarle when he sold his Piccadilly house and garden to a consortium led by John Hinde and Sir Thomas Bond in 1683-4.

Some important eighteenth – and nineteenth-century developments were more systematic. Squares and streets were symmetrically laid out and large sites let off specifically for the building of noblemen's or gentlemen's houses. Lord Burlington, as we have seen, either supervised, or himself designed such mansions as Queensberry House or General Wade's on his 'Ten Acres'; the Harley/Cavendish estate had guidelines as to style and materials laid down by its architect James Gibbs. The Grosvenors, through their surveyors, control all building and rebuilding to this day.

In 1713 the Earl of Scarborough started promoting the development of Hanover Square. It was

lined by the spacious residences of Whig generals who had fought under Marlborough and, having returned to favour with the accession of George I, helped put down the 1715 Rebellion. On land, the freehold of which was owned by Sir Benjamin Maddox, they would appear to have co-ordinated their building plans. At about the same time a group of leading Tories were developing land north of Oxford Street. Edward Harley, second Earl of Oxford, son of Queen Anne's minister, and his wife Henrietta Cavendish-Holles, together with their daughter who married the Duke of Portland, gave their names to a group of West End streets. Other streets nearby were provided with the names of their country houses, including Wigmore and Welbeck. Oxford Street itself might well have retained its alternative name, 'The Waye from Uxbridge', had Harley's title not reinforced the Oxford link.

Their Tory architect, Gibbs, seems to have had little to do with the central feature of the estate, Cavendish Square, which was to be dominated by the town palace of the Princely Chandos. Occupying the whole of the north side, it was designed to close a vista from Hanover Square across Oxford Street. Two 'wings' – in the event separate houses – were built by Edward Shepherd 1724-8; they were to flank a large forecourt in front of the main block, to the north of which were to be the usual extensive gardens. But the Duke, beset by family and financial problems, abandoned the project. The early Georgian building boom having petered out, Cavendish Square remained incomplete until the 1770s. By then urban development was once more proceeding westwards; two squares, Manchester and Portman, were well under way. The grandest residences here were once again on the northern side with open views to country behind them. In Mayfair the pattern was somewhat different. With the end of the eighteenth century, attention turned south again to the western fringe of the Grosvenor domains. Earlier mansions had turned their back to the narrow, rutted Park Lane alongside a brick wall. From 1730 a handful fronted it, but it took another century before a whole series of houses were enlarged, refronted, even re-oriented to take advantage of the park which Decimus Burton was improving. Apsley House and Londonderry House were remodelled; Dudley House was rebuilt and Grosvenor House enlarged.

In the course of two centuries the development of streets and squares, many of them on aristocratic estates associated with, or centred upon, great mansions, had moved across two miles of London. The process had begun in Bloomsbury.

By Letters Patent of 9 June 1545 Thomas Wriothesley, Lord Chancellor of England, was granted possession of the fields, crofts, gardens and mansion of the manor of Bloomsbury. The property, which had been that of the Carthusian monastery of Charterhouse, included some outlying parcels of land. Indeed part of the deal (Wriothesley paid £1666 11s 3d) involved quite extensive estates in Hampshire and Wiltshire. These latter were regarded as more valuable than a few fields on the edge of London.

A year or so later Lord Wriothesley was created Earl of Southampton by the young Edward VI. His town house on the south side of Holborn outside the bar marking the City boundary, was thenceforward known as *Southampton House*. To the west Holborn wended its way through fields to the hamlet around St Giles. Much of the land to the north of the road as far as Tottenham Court Lane was part of the estate. Its manor house, formerly that of the Blemund family, was in the south-east part of the property surrounded by gardens and orchards. These, together with the 'long-fields', continued to be let to the former tenants of the Prior of Charterhouse.

Both the second and the third Earl, Shakespeare's patron, continued to occupy the Holborn mansion and, despite being from time to time out of favour with the monarch, managed to secure further property fronting Holborn High Road, which was gradually being built up. The fourth Earl, finding his house and garden increasingly hemmed in by humbler dwellings, determined to sell for redevelopment and move to a more fashionable quarter. The official prejudice against population expansion delayed the Letters Patent for the demolition of Southampton House and the building of smaller houses on the site till 1638.

The Bloomsbury estate was becoming more suburban in character; several market gardens were cultivated, one of these, belonging to William Short, is commemorated in the name of Short's Gardens. Yet a further licence was required for the Earl's new mansion to be built in Long Field. This was granted in 1640 but the Civil War delayed the implementa-

82 *Bedford (ex Southampton) House, built 1661, Bloomsbury Square, of which it comprised the north side. Here the later wings, on which the Duchess of Marlborough remarked in 1732, are included*

tion of plans till 1657. Even then the conditions to the consent were strictly applied – five acres enclosed by a brick wall were to surround the house which was itself to be of brick and stone and was to have appropriate outbuildings, coach-houses and stables.

'Southampton House in the Fields' (as it was known, to distinguish it from the earlier building) was just such an establishment. The designer is unknown, but like many another mansion it was later attributed – by among others the Duchess of Marlborough – to Inigo Jones. A brick building with a long three-storey central block and two-storey wings, it was regarded by most commentators, including John Evelyn, as 'too low'. But the Great Rooms were widely admired; there were 18 of them on the principal floor.

The fourth Earl of Southampton was three times married and was survived by three daughters. At his death in 1667 lots were cast; Rachel, the second daughter, was possessed of Southampton House, certain manors in Hampshire and the manors of

Bloomsbury and St Giles in Middlesex. She was already the childless widow of Lord Vaughan when, in the year of her father's death, she married William Russell, second son of the fifth Earl of Bedford. This alliance eventually resulted in the addition of the Wriothesley properties in Bloomsbury to those of the Russells.

That latter family had also attained wealth and privilege under the Tudors. Sir John Russell had come from Dorset to be a courtier and then an envoy for Henry VIII. He was made an earl in 1550. At about that time he had exchanged a house he owned in Chiswick for one on the Strand. Later there had been two Russell Houses, one on either side of the street. After the 1667 marriage the southerly one was pulled down; that on the north side remained the Earl's residence until 1704. Meanwhile William and Rachel took up residence in South-

ampton House, her old family home. His elder brother Francis, a weakling from childhood, met his expected end in 1678 and William became heir to the Russell estates. He was not, however, to inherit the Earldom. His enthusiasm for the Protestant religion put him under suspicion of involvement in the Rye House Plot to murder the King and the Duke of York. After the plot's failure, Russell was himself executed in 1683, despite a widespread belief that he was innocent.

Rachel lived on for 40 years, a disconsolate widow. With the accession of William II the family came out of the shadows, indeed in 1694 the Earldom of Bedford was raised to a Dukedom. Wriothesley, the heir with the new title, Marquis of Tavistock, married a great heiress, Elizabeth Howland. This union brought estates in Streatham, Tooting Bec and Rotherhithe via the bride's father. She also inherited handsomely from her mother, the daughter of Sir Josiah Child for whom Colen Campbell had built the influential Palladian mansion at Wanstead.

Wriothesley succeeded as second Duke in 1700; though not yet 21, he was the richest peer in England with an income reputed to exceed £20,000 a year. He had 11 years to live. His son the third Duke, also named Wriothesley, married Anne Egerton, grand-daughter of Sarah, Duchess of Marlborough, at the age of seventeen in 1725. At that time Southampton House was a gloomy and old fashioned place. Although officially the Bedfords' London home after 1704, it had remained that of Lady Rachel Russell until her death at the age of 86 in 1723. Younger members of the family had lived most of the time in the manor house at Streatham; indeed it was there that the second Duke had caught smallpox, a disease particularly prevalent in that village.

Not surprisingly his young successor determined to make Southampton House his London home, but the newly married couple were too occupied with a brilliant and extravagant life in Society to pay much attention to refurbishment. It was grandmother Marlborough who saw to that. Duchess Sarah's enthusiasm for buildings was only equalled by her disdain for architects, 'knowing of none that are not mad or ridiculous'. She swept like a hurricane into the house, '... the handsomest, the most agreeable and the best turned that ever I saw either

in town or country. There is everything in it that can be wished. He that built it (my Lord Southampton) had a great character and I think that house represents one part of it very well.'[1] No doubt the plainness of the spacious building pleased her. Her few complaints were of fittings too ornately carved for her taste, such as the marble mantelpiece in the big dining room which had cost no less than 90 pounds. The Duchess saw to decorations, furniture and paintings, but the young couple seldom visited the house. Very soon there was more than a lack of interest in Southampton House to complain of. For Wriothesley's behaviour threatened the future not only of that but of the whole Bloomsbury estate. He gambled with recklessness capable of dissipating even his vast fortune. His desperation was increased by an unsatisfactory, perhaps even an unconsummated, marriage.

As early as 1726 the Duchess of Bedford had left her husband; she was persuaded to return, and having done so became more involved in the life of the Court. At St James's Palace she was often seen dancing with the young Prince of Wales, an ardent admirer. Despite that Hanoverian connection it was also reported that, 'The Duchess of Bedford is to put herself at the head of the Jacobite party, as one of the conditions of living with her Lord.'[2] Typically the Duke had reacted against the Whig traditions of his family. That family was now intent on keeping him at Woburn, or elsewhere out of town, where his gaming habits were taking him into ever lower haunts and company. In 1732 he was dispatched further afield, on a voyage to Spain undertaken for the benefit of his failing health. At the time such a voyage was reckoned to either kill or cure; in the case of the prematurely aged third Duke of Bedford the former was the outcome. He was little mourned, least of all by Duchess Sarah, whose other granddaughter, Lady Diana Russell, was married to the heir.

Now there was no more talk of selling Bloomsbury or Southampton House to pay gambling debts. The fourth Duke was prudent and long-lived, unlike his first wife, Sarah's 'dear Angel', who died of consumption in 1735, aged 26.

Before that event the Duchess of Marlborough had once again supervised alterations to the house. These were chiefly in the matter of the replacement of wall tapestries and leather hangings with

portrait paintings. The large entrance hall became something of a gallery. To add to the fine Kneller portrait of herself which Sarah had given to her beloved Diana, likenesses were commissioned of the late Duke of Marlborough and of the new Duke and Duchess by Isaac Whood. Sarah failed to persuade the Duke to replace 'the stairs in the first court which, though they were [the works] of Inigo Jones' doing, they certainly are not handsome and look too much pinched in the middle. And I think now the house is so extremely fine and large, with the two wings, it would be much handsomer if it was made with a flight of steps like those at Marlborough House . . .'.[3]

The Duke re-married in 1737. Gertrude Leveson Gower was the eldest daughter of the first Earl Gower. The couple entered upon a long period of happiness and Bedford House, as the family's London mansion at last became known, entered into its heyday. The high-handed manners of the Duke and his second Duchess – even George III remarked upon their arrogance – did not preclude leading roles in both society and politics. A powerful clique known as the 'Bedford House Whigs' dominated several ministries. An angry mob besieged the place in 1765; they blamed him for opposing measures to relieve unemployment among Spitalfields weavers. A squadron of cavalry was posted in the grounds.

The house was renovated again, by Henry Flitcroft in 1758. Those regarding the locality as desirable included Frederick, Prince of Wales – no doubt its distance from St James's was a recommendation in his eyes. The prince's attempts to possess it were frustrated.

When Duchess Gertrude found herself, aged 55 in 1763, facing many long years of widowhood she had much with which to contend. She was the butt of society malice, Mrs Delany referring to her as the 'old Hoyden'. Apparently the Duchess engaged in a series of flirtations with noblemen inferior to herself in rank and wealth, as well as junior in age. Her chief concern, and one she took seriously, was the upbringing of three orphaned grandsons. Her son Francis having pre-deceased his father by four years; his son the fifth Duke, also called Francis, succeeded, aged six.

Powerfully supported by her agent, Mr Palmer, Gertrude administered the estate with a mixture of flair and good sense. Development of the environs

of Bedford House was restrained in order to maintain its open vistas; land to the north, later to be Russell Square, was left open. But Bedford Square was created by them, as was Gower Street, named after her brother. At his majority, however, Francis lost no time in coming into his own; 'The Duke of Bedford has ordered Mr Palmer to have all his palaces ready for him – which is considered an explusion of the Queen Dowager', said Horace Walpole.

The young Duke soon moved in the Whig circles natural to his family. He became an associate of Fox and a friend of the Prince of Wales. 'Intimate at Carlton House, he was adored in the Devonshire House circle; and at that other centre of the Whig beau monde – Holland House – his hostess, who admitted that "his manner to all is rude, and to his acquaintance must be intolerable" found his society among the greatest of her pleasures.'[4] This Duke of Bedford had the wit and capacity to enjoy the many advantages of his birth and wealth; enthusiasm is infectious and, in his case compensated for arrogance. Tiring of politics, he became a keen agricultural improver. He raced his horses at Newmarket and Epsom, he gambled at Brooks's Club and at Devonshire House. As landlord he took a great interest in both Drury Lane and Covent Garden theatres. Handsome and brilliant, he was for some time seen as a possible suitor for the King's daughter, Charlotte, until the advantages of a foreign alliance prevailed.

At this time the London private palace is seen as the setting for an aristocratic life of untroubled and unquestioning splendour and self-confidence. It was before the French Revolutionary wars, Jacobinism, Corn Laws and parliamentary reforms. The fifth Duke had his London home modernized, in particular the dining room was remodelled by Henry Holland in 1787. Development plans for the estate still aimed to retain an open aspect for Bedford House as late as 1795. But five years later it was demolished. As often, the fate of a great house was sealed by the imponderable circumstance of the state of the owners mind. Since 1794 when, at last, his grandmother had died, the Duke had become increasingly eccentric. At 35 he was a bachelor, though with at least two bastards. He seemed to have a sense of doom which, perhaps allied to ideas of financial gain, led to the destruction of Bedford

House. The disposable materials and fittings were sold for about £6000, then Messrs Christie auctioned the contents. Many paintings went for less than the family had paid for them: a Raphael for 95 guineas, a Gainsborough for 90, a Teniers for 210 and a wonderful Cuyp landscape for 200 guineas. The chapel altarpiece found its way to nearby St George's Bloomsbury. The collection of 24 Canalettos are now at Woburn. The fifth Duke's sense of doom was justified, he died in 1802.

Before the house was pulled down there had been references to its verdant pastures, where 'in perfect safety were grazing various breeds of foreign and other sheep'.[5] Development was now almost instant. In 1800 James Burton started building Nos. 18–27 Bloomsbury Square on the site of the house. Bedford Place was laid out it and beyond that the impressively spacious Russell Square was started by Humphrey Repton.

That which the Russells still hold in large part they had obtained, as was so often the case, by marriage. Much of the land had been the patrimony of Lady Rachel and her Wriothesley forebears. The family names and titles were commemorated during this period in the streets which were being somewhat haphazardly cut through the fields. During the decade 1671 to 1681, building leases for 40 houses were granted along the street previously laid out by the Earl of Southampton to connect his house with Tottenham Court Lane. This had acquired the name Russell Street, to which was shortly to be added the prefix 'Great'.

There another great mansion was started by the second husband of Lady Rachel's step-sister, Ralph Montagu. At the time third Baron Montagu of Boughton, he was to be raised through the peerage to become Duke of Montagu in Queen Anne's reign. The site, Baber's Field, was a little west of Long Field where Southampton House had been built. The two mansions were separated by a half-dozen humbler dwellings. As had been the case with the Earl of Southampton's building licence, *Montagu House* was to be a 'fair and large dwelling' with a courtyard in front and stables and other offices to the rear as well as spacious gardens. Exits in the wall to the north of that garden were only to provide access to the open fields for recreation; no road was to be formed there, nor was any building to be erected. In fact the chief use of those fields between

1680 and 1750 seems to have been for the fighting of duels.

The chosen architect was Robert Hooke (1635–1703), an inventor and Secretary of the Royal Society, a near contemporary, colleague and friend of Christopher Wren. Their careers were curiously parallel; he was appointed Professor of Geometry at Gresham College where Wren had been Professor of Astronomy. Hooke was 'a pioneer in almost every branch of scientific enquiry'.[6] He produced a post Fire plan for the rebuilding of London, appointed a Surveyor to the City, collaborated with Wren on many churches. There was one essential distinction; Hooke was not an architectural genius. 'French planning and Dutch detailing are the most obvious characteristics of Hooke's architectural style', according to Colvin.[7]

Hooke's French sympathies appealed to Montagu who had been ambassador in Paris. He had also taken the precaution of marrying an extremely rich woman, Elizabeth, widow of the Earl of Northumberland and daughter of the Earl of Southampton. A site on this healthy north-west fringe of town and adjacent to her old family home was available.

The house, built at huge cost in the years 1675–9, was stunningly palatial and urbane for London at this period. Pictorial records are sketchy – apart from a bird's-eye view in Ogilvy and Morgan's 1682 map – but its basic ground plan is known, having been reproduced in the successor building. Even that is a little tantalizing, as John Evelyn's chief criticism was that the elevations of the house were 'not answerable to the inside'.[8] The interior was impressive, especially the extensive mural paintings, a feature then *de rigueur* in great houses. Those for the saloon were especially admired, Evelyn saying that Verrio's work here 'exceeds anything he has done, both for design, colouring and exuberance of invention'. The diarist provided much of the available information regarding this first Montagu House. On 5 November 1679 he wrote: 'To see Mr Montague's new palace neere Bloomsbery, built by our own curator, Mr Hooke, somewhat after the French; it was most nobly furnish'd, and a fine, but too much exposed garden.' On 10 October 1683 he again praised Verrio's ceilings and spoke of 'some excellent paintings of Holbein and other masters'.

On the night of 19 January 1686 the house was destroyed by fire. This was during a tenancy by the

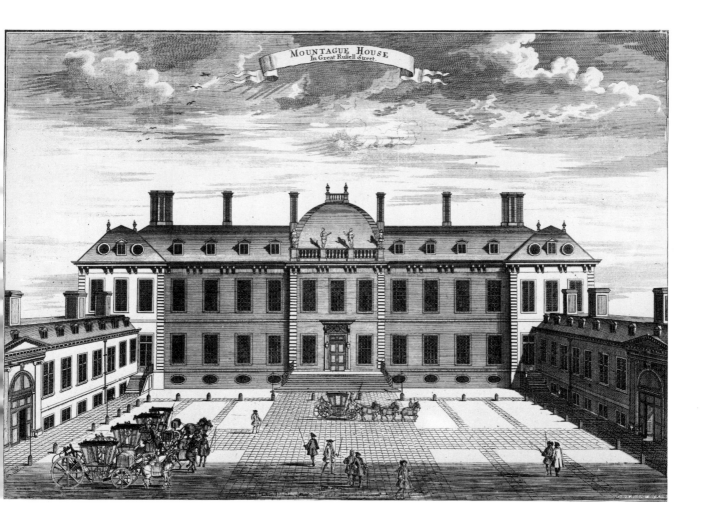

family of the Earl of Devonshire, to whom it had been let at a rate of 500 guineas a year. The near neighbour, Lady Rachel Russell, described how the countess and her children escaped in blankets to shelter in Southampton House. She recorded how the blaze had started as a result of airing some hangings, the steward 'sending afterwards a woman to scc that the firepans with charcoal were removed which she told him she had done, though she never came there'.[9] The loss of Montagu was estimated at £40,000 plus £6000 for plate; Lord Devonshire lost pictures, hangings and furniture too. It is notable that these figures exceed those for losses at Berkeley House, also burnt down during Cavendish occupation half a century later.

The extent of the surviving fabric and therefore of the rebuilding is uncertain. On stylistic evidence it is likely that the boldly designed screen and gateway to the forecourt of the second mansion was Hooke's work. It was strongly reminiscent of similar features at his College of Physicians. The octagonal

83 *Montagu House, Great Russell Street, built 'after the French pavilion way', i.e. with an enclosed courtyard. The wings probably pre-dated the fire of 1686 after which the main block was rebuilt in the form of two lofty floors and a prominent French-style roof, all raised upon a semi-basement. The 17-bay front had no orders, but prominent quoins to projections at the centre and ends added emphasis. The dome-like roof, balustrading, statues and broad steps all accentuate the entrance to this impressive ducal palace*

cupola over the entrance gate, as well as the concave, pyramidal roofed towers at the street corners of the wings, appeared to be of the 1660s, as did the substantial side wings themselves. The main block was, however, new work, that of the otherwise virtually unknown French designer, Pouget. It was very Parisian, and quite advanced stylistically for 1687, with prominent mansard roofs above the boldly bracketed eaves cornice. The slightly projecting centre was finished at both cornice and rooftop levels with balustrading, statues and urns. It was a lofty, austere and sophisticated building, the interior and exterior quality of which can best be

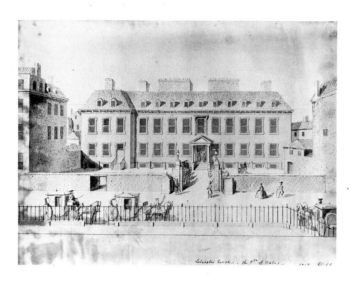

84 *Leicester House, Leicester Square. George Vertue's 1748 drawing shows an archaic mansion, then occupied by the Prince of Wales. Unpretentious brickwork and a pantiled roof evoke the original rural setting, long since built upon*

appreciated on a visit to the same family's Boughton House, Northants, described by Pevsner as 'perhaps the most French-looking seventeenth century building in England'[10]; Boughton had been altered by the Duke of Montagu in 1683.

The architect of the new mansion could not bring himself to notice the earlier and, no doubt to him, primitive wings with which his block more or less collides. The screen wall, blank to the street, was elegantly colonnaded to the inside; its Ionic columns may well have prompted Lord Burlington's curved version half a century later.

The 'lofty magnificence' of the state apartments, which were so admired by Walpole, were decorated throughout by French artists: La Fosse, Rousseau, and the flower painter Monnoyer. The stair was especially broad and noble, continuing the generous width of the external steps to the main entrance which put those at neighbouring Bedford House to shame. The great central saloon, entirely painted[11] 'from the Corinthian columns to the delicate floral swags and Elysian landscapes'[12] overlooked the gardens which were, as usual, to the north. State rooms continued either side of the saloon, these to the west being particularly grand with coved and painted ceilings.

The Duke of Montagu, having increased an inherited fortune by being successful at Court and in his first marriage, proceeded to augment it further

through a second marriage, his first wife having died in 1691: he won the hand of the crazy dowager Duchess of Albemarle. The second Duke, John, abandoned his father's palace and built himself a more modest mansion in Whitehall. Bloomsbury was declining in terms of fashion and Whitehall had the advantage of being near the Court. Following his death in 1749, Montagu House was bought by the British Museum Trustees. The building was demolished to make way for Smirke's new galleries in the 1840s. The famed wall and ceiling paintings were destroyed or dispersed, but some fittings and furniture had found their way to Boughton in the 1730s.

Leicester House was also, in its time, one of the biggest in London. That time was the unsettled decade before the Civil War, one of little building and that mostly undistinguished, with the dazzling exception of designs by Inigo Jones. 'Leicester-square, or, as it is commonly called, Leicester-fields, consists of a pleasing inclosed grassplat [sic] on the side of a hill Leicester House, now Sir Ashton Lever's museum, is a low plain building, worthy of little estimation.'[13] Ralph's comment was published eight years before the house's demolition. It had been built by Robert Sidney, second Earl of Leicester, between 1631 and 1635. The expense, at about £8000, was considerable. The site of four acres sloped down to the south towards the Royal Mews at Charing Cross, the land, like so much on London's fringe, having been in monastic ownership until seized by Henry VIII. The usual opposition to the growth of the City resulted in a Privy Council decision that the fields in front be left open for the use of parishioners in exchange for their former rights on the actual site of the house.

The mansion was set back behind an extensive wall on the north side of what became Leicester Square. It was built around a spacious courtyard and behind it were even more ample gardens extending up to what became Gerrard Street. Being on slightly elevated ground on the north-west of London, and thus windward of the smoke, Leicester Fields was regarded as a healthy spot.

The Earl of Leicester being away as ambassador in Denmark and then France between 1632 and 1641, there was no lack of interest by other would-be occupants. The Earl of Strafford borrowed it in 1640. Even when recalled by Charles I, with whom

he was not in sympathy, Leicester spent most of his time at Penshurst. He was obliged to rent his town house to Charles II's aunt, Elizabeth of Bohemia, in 1662. But the 'ayre' did little for her health – she soon died. The French ambassador Colbert, brother of the renowned minister of Louis XIV, succeeded her. Lady Sunderland was a tenant after him. She entertained lavishly and among her guests in 1672 was John Evelyn, who reported the after-dinner entertainment was provided by Richardson, 'the famous Fire-Eater who before us devour'd Brimstone and glowing coales, chewing and swallowing them downe'.[14]

A long, plain building of brick with two main floors on a semi-basement, Leicester House had a steeply pitched roof with some dozen dormers. What is remarkable is the architectural flaccidity of the deisign. Of the original architect, if any, we know not. In 1718-19 Dubois carried out alterations for the Prince of Wales and further minor works were supervised by Colen Campbell between 1720 and 1724. In 1732 Benjamin Timbrell, a prominent speculative builder, was paid 'for supervising the Repairing and fitting up'. Within Leicester House all was impressively rich and spacious, especially in the long run of the inter-connected state and presence chambers in two ranges on the first floor.

The third Earl reduced the ground by letting land for the building of Lisle Street and Leicester Street, and even for some buildings on the north of the square alongside his house. His successor modernized the interior. But the fifth Earl sold off much of the contents, including 206 pictures and much plate, to pay debts. Neither he nor the sixth Earl lived much in the house which was let to various ambassadors and to Lord Gower between 1712 and 1717. In the latter year George, Prince of Wales moved in; he had quarrelled with his father in the violent Hanoverian custom and was 'expelled' from St James's Palace. The adjoining Savile House was acquired for his retinue. There in 1727 he was declared King.

The Leicesters resumed their ever-intermittent residence, the sixth Earl until 1737, the seventh until 1742. Then royalty again took over; this time in the person of Frederick, Prince of Wales, whose relationship with his father was even worse than the previous generation's had been. He spent £5000 on

repairs before his death in 1751. The Princess Dowager stayed on till 1764. The Earl Harcourt, who was in residence for a further ten years, was probably acting as 'Governor' to the Princess's son, the future George III.

Leicester House went down in the world when leased to Sir Ashton Lever, who opened it to the public as a museum for fossils, shells, birds, insects and reptiles. It was finally demolished by Elizabeth Percy, heir to the seventh Earl of Leicester, in 1791.

Almost immediately west of Leicester Square is the large tract of former Crown land granted to Henry Jermyn, Earl of St Albans, faithful adherent of Charles I and close friend of Henrietta Maria. He was rewarded by their son with a lease of no less than 40 acres, chiefly St James's Fields, which had been appropriated in former times for royal recreation and which had included the 'stately alley' used for the game of Pall Mall. Both Jermyn Street and St James's Square were intended to be lined by palaces, and indeed at least the latter could hardly have been more aristocratic in terms of residents. In about 1720 there were no less than six dukes in the square as well as seven earls. This quarter, for nearly two centuries the focus of aristocratic London, recurs in any account of town houses. Its development was largely speculative. Its freeholder at first had a modest residence in the south-east corner. This was the southern part of the site of the later mansion of the Dukes of Norfolk. But in 1675-6 a much bigger house was built for him at the west end of the north side. Although 120 ft and 11 bays wide, this did not assert itself architecturally and was difficult to differentiate from the continuous terrace. Richard Frith, the prominent builder, had leased two adjoining sites, constructed the house for £15,000, then conveyed it back to the Earl. In 1682 the house was sold for £9000 to the first Duke of Ormonde.

A vivid impression of the sparse grandeur of life in *Ormonde House* is conveyed through an inventory of 1685. There were twelve principal rooms to a floor; several were of a utilitarian character, though water closets do not seem to have been present until the 1730s. On the ground level the porter's lodge contained fifty leather buckets, each adorned with the Ormonde crest and coronet. In the next room were firearms and halberds, a reminder that riot as well as fire was seen as a real danger. These are

references to paintings, as fixtures over doors and chimneypieces as well as attached to the staircase ceilings. Furniture was minimal; most rooms had but a table and a few chairs, usually of walnut, though some were japanned or even gilded. Clocks, looking glasses and of course tapestries were among other important items.

If furnishings were not lavish, staffing was almost unimaginably prodigal: 40 household servants, plus a gentleman of the horse, 2 coachmen, 8 other stablemen, a 'chasseur' or huntsman, and several water-men. The stables housed 20 horses, 5 coaches and 14 dogs. As was so often the case there were periods of rental to other nobility: for example in 1698 Count Tallard the French ambassador was in residence.

In 1713 the second Duke and his Duchess were living there, and conditions were somewhat more luxurious. More occasional tables, corner cupboards, easy chairs and settees were listed in an inventory of that date. Damask hangings were replacing tapestries, and there were some pictures in frames; leather hangings and covers were out of fashion.

The previous year the Duke of Ormonde's downfall was signalled by his appointment to replace Marlborough as Captain General of the British and Dutch forces. He need not have worried about following England's greatest soldier/statesman, for the pro-French government did not want victories. So successful was Ormonde in hindering them, that he was impeached by the new regime in 1715.

Five years later the house was sold by the government to the Duke of Chandos. He had extensive alterations carried out; these included the addition of ceiling paintings by Bellucci, who had done similar work for the Duke at Edgware. An inventory of this period makes mention of books and bookcases for the first time on any significant scale. The most valuable furnishings were in the Duke's 'visiting room' on the ground floor, with its painted ceiling, marble chimneypieces and framed paintings which were valued at £1420. Fittings were luxurious: flowered velvet hangings, curtains and valances lined with 'yellow persian', silk upholstery, silver sconces and hearth furnishings, drinking vessels and tea services.[16]

Chandos was hit by the South Sea Bubble disaster. He tried to sell the house for most of the period 1724–35. Finally in the latter year it was bought for redevelopment by Benjamin Timbrell.

Another interesting mansion connected directly with the Jermyns was that of St Albans's nephew, Henry Jermyn, Earl of Dover. It was sited in the street of that name on the north side of Piccadilly. Jermyn had acquired the land as a partner in Sir Thomas Bond's development of Albemarle Ground (the former site of Clarendon House), in 1684. Created Earl in 1685 he started developing Dover Street the following year.

At first Jermyn seems to have occupied a house on the east side of the street, probably while his mansion on the opposite side – called by Macky 'a very noble one'[17] – was being built. Rate books show him in *Dover House* by 1700. He died in 1708 but his widow remained in residence until her death in 1726. Then there was an auction of 'the large dwelling House of the Right Hon. the Countess of Dover deceased in Dover Street, St James's; consisting of seven rooms on a floor, with closets, a large and beautiful staircase finely painted by Mr Laguerre, with 3 coach-houses and stables for 10 horses, and all manner of conveniences for a great family'.[18] A clear idea of the requirements for a nobleman's town house is obtained: location near St James's; an impressive staircase decorated with murals; adequate stabling.

The mansion was unsold; it was no doubt regarded as old fashioned now that the Palladian taste prevailed. It appears that by 1729 the house had been rebuilt by Henry Brudenell. He was succeeded there by a relative, the Earl of Cardigan. The latter, having married the daughter and co-heiress of the second Duke of Montagu, moved to that family's mansion in Whitehall in 1749. Soon afterwards the house was bought by the second Earl of Ashburnham, for whom Robert Adam made alterations and additions, including a gateway and lodge, in 1773–6.

Ashburnham House, No. 19, re-numbered as No. 30 Dover Street, was set back behind a forecourt with railings to the street frontage. While not having so distinguished a façade as that provided by Sir Robert Taylor for the Bishops of Ely at No. 37, it had more the appearance of a separate mansion. Perhaps for that reason the Ashburnham family were able to let it to several embassies including that from Russia led by Prince Lieven in the years 1824–9. Later in the century it reverted to use by

the Earls of Ashburnham. Sale in 1897 led to demolition.

While the Earl of Dover was carrying out the original development of the street which still bears his name, he would have seen work start on the east side of Berkeley Street immediately to the west. 'I went to advise and give directions about the building two streetes in Berkeley Gardens, reserving the house and as much of the garden as the breadth of the house,' wrote John Evelyn on 12 June 1684. He was advising the widow of Lord Berkeley who had died in 1678. He greatly regretted the loss of 'that sweete place', but he found some excuse for Lady Berkeley in letting out her ground 'for so excessive a price was offered, advancing neere £1000 per ann. in mere ground-rents; to such a mad intemperance was the age come of building about a citty by far too disproportionate already to the nation; I having, in my time, seene it almost as large again as it was within my memory'.[19]

Berkeley Square itself was not constructed until the 1730s. One reason for the delay and, indeed, for the fact that there was no range of buildings on the south side of the square for a further two centuries, derives from the choice of a rural site for Berkeley House in 1664. When they sold the house in 1696 the Berkeleys, who then retained the land to the north, undertook not to allow buildings nearer than the north side of Berkeley Square.

Large houses were constructed by developers on the east side in 1738-9; those which followed on the west were generally even more spacious. Some of these survive, particularly Nos. 42-46 and 49-52; they are among the finest of mid-eighteenth-century London houses. Incomparable here, and among all London terrace houses, is *No. 44 Berkeley Square*. The power of architecture is used with masterly authority to create behind a three-bay brick façade one of the 'smaller palaces – like Kent's enormously grand house for Lady Isabella Finch in Berkeley Square'.[20] By no means a landowners mansion this house is included here as a supreme example of what could be achieved within the restraints of Georgian London's estate development. Begun in September 1742, decorations were completed in mid-1747, but her ladyship's name appears in the Rate Books for 1745, when she was disputing the rateable value. Well she might, for at few other times would a middle-aged spinster, aristocratic but

not very rich, be impelled to devote most of her resources to building. But also how sensible for the seventh daughter of the seventh Earl of Winchelsea, from whom she had inherited only £5000, to recognize that she might as well divert her declining years by entertaining and impressing her friends in the most splendid surroundings contrivable.

The now elderly William Kent had shown himself more than capable, at Holkham and elsewhere, of creating a big effect, but now he had to do so within a small compass. No doubt his talents were pressed on Lady Bel, as she was known, by her nephew by marriage, Lord Burlington.

Kent's client moved in royal circles, being Lady-in-Waiting to the Princesses Amelia and Caroline, unmarried daughters of George II. Through Lady Bel's own sisters she was related to the Dukes of Somerset and Cleveland, the Marquis of Rockingham and the Earl of Mansfield. There had been rumours of a royal lover – how did she afford a house costing over £7000? – but her enthusiasms may have lain in another direction. Her closest friend was a rich widow, the Countess of Pomfret, whom Walpole thought silly and pretentious, and for whom the Gothic Pomfret Castle in Arlington Street was built. 'Dont you remember', he wrote, 'how the Countess used to lug a half length picture of Lady Bel behind her post-chaise all over Italy . . .?'[21]

Gossips like Walpole were happy to accept hospitality from such as their Ladyships Finch, Home and Pomfret, and satirize them afterwards. When, in 1764, Lady Bel's favourite niece ran off with a footman, fashionable London was in an uproar of mirth. As Lady Mary Coke wrote : 'Lady Mansfield went with a Doctor and Surgeon to acquaint poor Lady Bel Finch . . . they blooded her; but everybody is apprehensive it will go near to kill her'[22] She survived, no doubt hardened to embarrassment. Like her father and six sisters, she was very dark in colouring. Lord Winchelsea had been known as 'Don Dismal', being not only swarthy but earnestly religious. His daughters were the 'black funereal Finches', and Lady Bel was sometimes referred to as 'the sable Dame'. It was a free-speaking age.

And what did Kent provide for Lady Bel? First of all, an elevation in his Devonshire House manner, brick with stone dressings, plain and reticent, yet

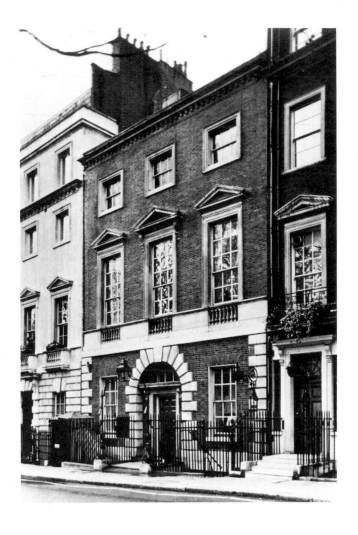

85 *44 Berkeley Square. A wider-than-average terrace house is turned into a small palace by the scale and assurance of Kent's architecture. Mannerist quoins suggest the rusticated Palladian ground floor, and the wide-arched entrance says 'this is a house of parade'*

enormously self-assured. It was Palladian in the wide window spacing and pedimented windows on the *piano nobile*, and there was a suggestion of both rustication and arcading to the ground floor. It was weighty in the plain stone band at first-floor level, broken at window aprons with balustrading, the heavily modillioned eaves cornice and the sheer scale of the elements. Even in this apparently restrained façade there was much for effect; a sense of ceremony is established by the almost mannerist emphasis to the entrance. Falsity is not eschewed; the upper windows are a sham in front of the tunnel vaulted 'great chamber' which rises through two floors.

The entrance hall, a modest stone-flagged room, gives no hint of the drama of the staircase in the centre of the house. Only when the visitor has ascended the first flight and is gently turned by the curved wall to climb one of the two sweeps of stairs to the principal floor does he fully realize that he is in what Walpole somewhat grudgingly called 'a beautiful piece of scenery'. In a sense it is just that; the power of Kent's imagination forces the observer to believe that he is in a palace – so, in effect, he is. No matter that the treads are only four feet wide; the high style and ceremony of the setting carries the message.

The potential architectural impact of the stair in general was slow to be recognized in England. Even in the early century, the courtyard house such as Lord Northampton's at Charing Cross tucked the stair away because it led to private chambers. Inigo Jones changed all that, but few contemporaries followed his lead toward classical magnificence. At Ashburnham House, Westminster, the staircase had been only a particularly imaginative version of the usual pattern of straight flights attached to the walls of a box-like compartment. The scale increased; wide oak or stone treads, splendid plasterwork on the soffits of landings and fine doorcases were all admired. The French habit of large-scale wall paintings was adopted enthusiastically after the Restoration.

Kent demonstrates the theatrical power of curved flights splitting and leading back on themselves, of bridging landings, of flights disappearing behind screens of Ionic columns. The effects derive from repeated rhythms and inter-penetrated spaces. Even the doorcase pediments are 'broken', in the general interests of dynamism.

The apsidal screen of columns on the first-floor landing, behind which the stair sweeps to the second floor, diverts the formal visitor sideways into the great room whither the elegant staircase rail also impels him. Here, once again, Kent's highly modelled architectural forms transmute a 30-foot by 23-foot room into a palatial apartment. If it were less lofty and steeply vaulted this space could be oppressive, being the very opposite of the ethereal sky painting of so many slightly earlier ceilings, with angels and aristocrats floating off into a heavenly

86 *44 Berkeley Square. A staircase of Roman splendour and Baroque theatricality is contained in a modest space – a near square with a semi-circle at either end*

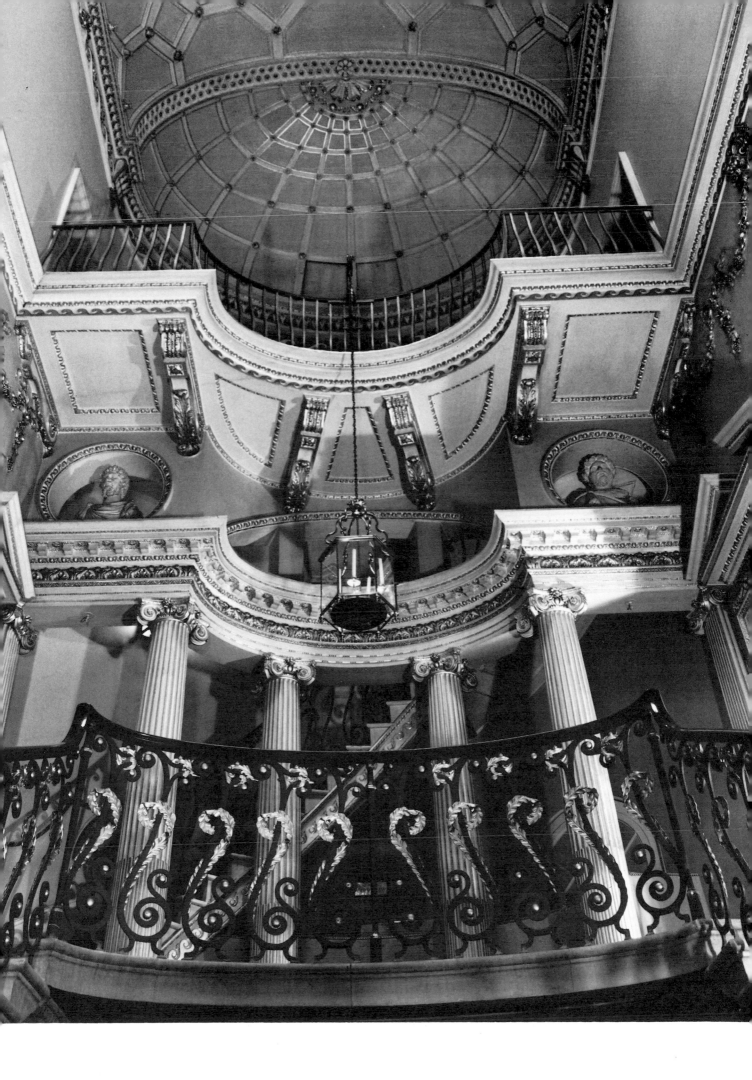

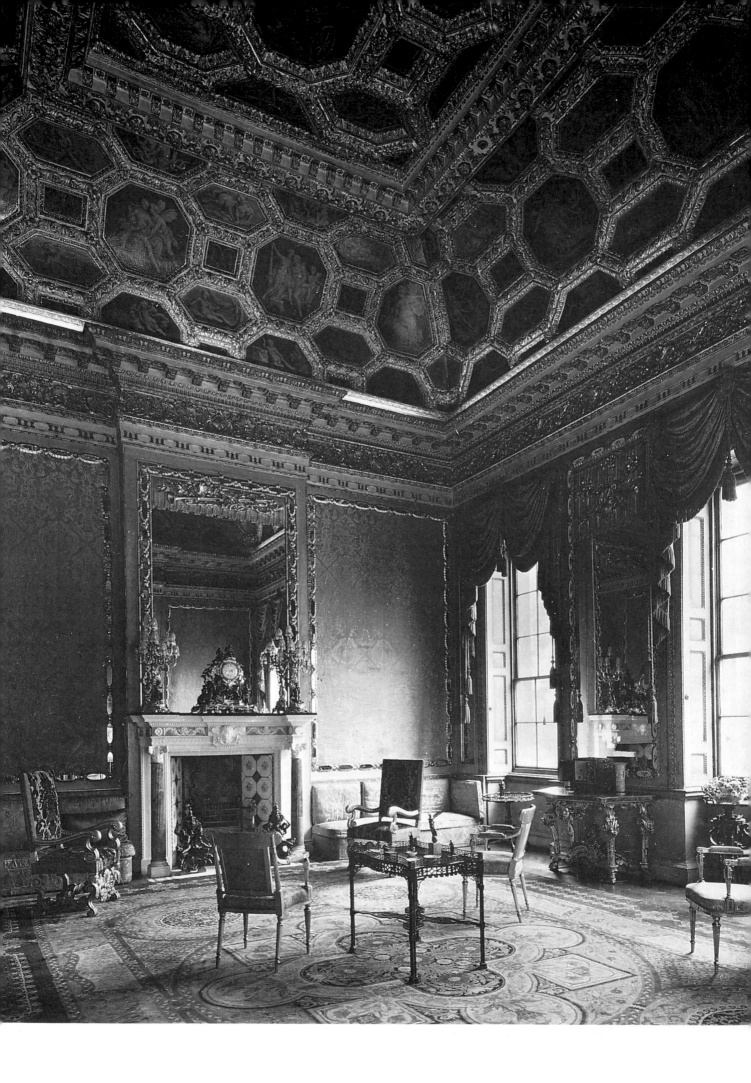

nfinity. This is like the interior of an earthly and inite jewelled casket, the panels between the heavily gilded ribs being painted in *grisaille* on dark red and blue grounds, probably by Kent himself. In English terms he was again innovating, for the coffering and modelling of the coved ceiling was real, not *trompe l'oeil*.

The Great Chamber in the Berkeley Square house had all the rich worldliness of the Italian High Renaissance. The present owners have added features in this vein, even if not quite eighteenth-century in character. Such are the rich blue fabric panels and curtains; such also are the nineteenth-century ornamental frames to the panels and mirrors with facetted glass insets.

A main bedroom and a boudoir at the rear of the first floor, with servant bedrooms above, completed the accommodation provided for Lady Bel. After her death in 1771, her brother sold the house to Lord Clermont, an Irish Earl with sporting interests - his horse won the Derby in 1785. His wife, a friend of Marie Antoinette, was a Francophile. The principal bedroom was redecorated in a French Panelled style now often associated with superior hotels. But being skilfully done, probably by Henry Holland, it consorts well enough with Kent's ceiling, fireplace and doorcases.

Sold by the second Earl of Clermont in 1826, the house passed through a succession of ownerships during the next half-century. It was then purchased by the Damer Clark family who retained it until about 1960, when the present not inappropriate use as a Gaming Club started. Lavishness rightly associated with such a use has meant that, if anything, too much money has been spent. The first refurbishment, wittily conducted by Messrs Jebb and Fowler, also involved the addition of a delightful dining pavilion in the former garden.

Work in 1984 by Messrs George Trew and Dunn has reinstated some Kent features. It has also integrated the garden pavilion with the house as well as installing an air-conditioning plant above the ceiling of the Great Chamber. In essence this small mid-eighteenth-century palace is fortunate in its modern use. In the course of time the house has

become completely dissociated from the large basement where refreshments for Lady Bel's card evenings were prepared. 'We had a funereal loo last night in the great chamber at Lady Bel Finch's', said the ungracious Walpole. Perhaps today it ought to be the Finch rather than the Clermont.

A five-minute walk northward to Cavendish Square might have taken Walpole to a mansion already twenty years old when Kent started work for Lady Bel. *Harcourt House* was regarded as the gloomiest in London up to the time of demolition in 1906, far more suitable for the 'funereal' Finch than her small palace. Chancellor recalled the 'dreariness of its interior' as well as 'sombre exterior', but this was just prior to destruction when 'the very size of its rooms, and the remains of their former magnificence, with their elaborately carved and moulded cornices; their ceilings painted *en grisaille* and their fine old chimney-pieces, added to the sense of desolation'.[23]

The authors of *Old and New London* a generation earlier also speak of a 'large and heavy mansion',[24] and they quote Ralph writing in the *Critical Review*, only a decade after the house was built, that it was 'one of the most singular pieces of architecture about town. In my opinion, it is rather like a convent than a residence of a man of quality ... what I esteem Gothic, heavy and fantastick ...'.[25] It will be remembered that this commentator was a great Burlington admirer and used his terms of opprobrium in ways we should consider imprecise. Nevertheless this mansion was uniquely and universally condemned throughout its near two centuries of existence as 'dull, heavy, drowsy-looking'. Walford goes on to remark that 'Its seclusion of late has been increased by high walls in the rear.'[26] That was in the time of the eccentric fifth Duke of Portland, who lived in fear of being seen by the common herd. His family had acquired the freehold of the house, as indeed they had much of the estate, before the middle of the eighteenth century – the first at cards it was said,[27] the second by marriage. The high screen walls added to the appearance that Chancellor suggests had always been mysterious. This had encouraged Thackeray to base his 'Gaunt House' on it.

This, the first and, in default of the completion of Chandos House, the largest mansion was started in 1722, five years after the square was laid out. As

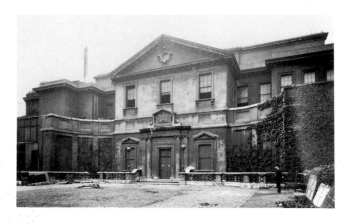

88 *Harcourt House, Cavendish Square. Despite Baroque curves embracing the entrance court and an over-size pediment, this is not quite skilled enough to be by Archer. A weighty breadth and confidence speak of the early eighteenth century*

to the architect of the 'convent', its first owner, Lord Bingley, was a renowned architectural amateur, probably responsible for the design of his own Yorkshire seat in 1710.[28] He may well have designed this house too.

The chief cause for confusion has been a Rocque engraving of a design for 'Lord Harcourt's House in Cavendish Square'.[28] This, by Thomas Archer, was 'built and altered' by Edward Wilcox; but Archer's was an earlier, smaller Harcourt House, No. 1, on the east side. Bingley House, on the opposite side of the square, which was bought by the first Earl Harcourt in 1773, was indeed a clumsy and amateur production. Oddly it did have features reminiscent of Archer designs, particularly that for Monmouth House of 1717–18. The second Earl Harcourt altered and enlarged Harcourt House as it was thenceforward known.

Transfer of ownership to the Portland family most probably occurred through reversion of a 99-year lease. The second Duke of Portland had married Lady Margaret Cavendish Harley, heiress to the second Earl of Oxford, with whom that peerage became extinct. Thus the mansion came to the immensely rich and increasingly eccentric Portlands. The estate was managed by the architect Samuel Ware (1781–1860), who also designed stabling at the rear of Harcourt House, as it continued to be called. Alterations were also carried out by Thomas Cundy, Junior (1790–1867), better known for additions to Grosvenor House.[30]

Tales told of the reclusive fifth Duke of Portland were not the 'flimsy rumours' claimed by Chancellor, whose veneration of aristocracy was boundless.[31] The Duke hardly quelled gossip by ordering the building of a garden wall no less than 80 feet high. It was said that he wore three pairs of socks with his cork-soled boots, used a handkerchief three feet square and built an underground tunnel a mile and a half long between Welbeck Abbey and the town of Worksop, so that no-one would notice his rare visits to London.[32] Following his death in 1879 Harcourt House was left empty for a period. Gloom was lifted for a few years under the ownership of Lord Breadalbane, but in 1906 this strange symbol of aristocratic nuttiness was reduced to rubble.

Edward Wilcox, the builder of the earlier 'Harcourt House' was also asked by the Duke of Chandos to 'look over' the plans for his London House 'to reduce them into a less expensive compass'. In 1721 he invited him to 'undertake the whole care and conduct of the structure'.[33] Nothing came of it. Chandos was in the habit of changing designers. The original architect for a 'new house in Mary-Bone Fields for the Duke of Chandos', published in *Vitruvius Britannicus* was the fourth to be employed at Canons. It was labelled as being 'Design'd by John Price, architect, 1720'. Price's palazzo would have been a splendid masonry affair with giant Corinthian columns, a larger version of Buckingham House (later Palace) though in detail more like the 1713 rebuild of Powis House, Great Ormond Street. In fact the Duke lived in St James's Square.

Yet another Chandos House was that usually known as Buckingham House, Pall Mall. When in 1822, the Marquis of Buckingham was raised to the title of Duke of Buckingham and Chandos, his mansion was sometimes referred to by his second title. This caused confusion with the one surviving *Chandos House*, that built by Robert Adam in 1770–1 off Portland Place for the third Duke. It was one of a group of three of Adam's finest creations built in quick succession: 20 St James's Square followed in 1772 and Derby House in 1773. The simple elevation in fine ashlar, enlivened by a columned porch and superb metalwork, remains one of London's most refined façades. Chandos House was leased to the Austro-Hungarian government between 1817 and 1866. Prince Esterhazy, ambassador for nearly a generation, lived and entertained in legendary

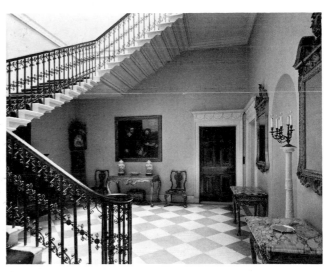

90 *Chandos House. Once again a cool and restrained entrance and staircase hall provides a fitting prelude to the lavishly decorated reception rooms above*

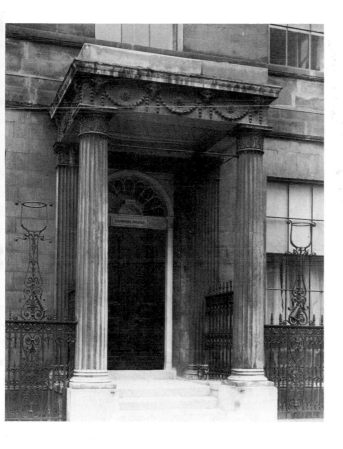

89 *Chandos House, Queen Anne Street. Towards the end of the century Robert Adam raised the impact of a comparatively modest mansion, not by architectural bombast, but by consummate refinement and sparseness*

style. From 1866 the family returned in the person of the Duke of Buckingham and Chandos. Curiously he was a successor of the Grenvilles and Temples of Buckingham House, Pall Mall and also of the Brydges of all the other Chandos Houses. From 1890–1902 another relative, the Earl Temple, lived there. In 1905 the house was sold to Cora, Countess of Stafford. In 1924–7 the Earl of Shaftesbury was the occupant and from 1927 to 1963 Viscount Kemsley. Now Chandos House is the headquarters of the Royal Society of Medicine.

'Among these suburban territories ... towards Tyburn, there are certain new and splendid buildings, called in honour of his present Majesty, Hanover Square, – some finished and some erecting; consisting of many compleat and noble houses.'[34] In 1720 the first inhabitants of the square, were Lord Carpenter, Sir Theodore Janssen, Lord Hillsborough, the Duke of Montrose, Lord Dunmore, Colonel Fane, Mr Sheldon, the Earl of Coventry,

Lord Brook, General Stewart, the Duke of Roxburghe, General Evans, and Count Kinski, the Austrian ambassador.[35]

No. 13 (originally No. 12), *Roxburghe House*, on a north corner of Hanover Square, was one of the earlier mansions. Nothing is known of its designer; the house which lasted over a century was that resulting from a thorough reconstruction by Robert Adam in 1776 for the third Duke. That nobleman was renowned as a bibliophile; when after some 20 years he removed to 13 St James's Square, he took his library of over 10,000 rare volumes with him. It was dispersed in 1812 after his death.

Despite the work of Adam, Roxburghe House was never much admired. There were fine and spacious interiors with good plaster decoration, in particular some ceilings not unlike those at Home House. But the visual impact of the exterior was limited, probably consciously, to conform to the uniformity of the square. Built in brick, but stone faced on the chief elevations, it consisted of three lofty storeys with an attic concealed behind an eaves-level balustrade. Above a ground floor, which was arched and rusticated in proper Palladian manner, rose a giant order of Ionic pilasters supporting a deep entablature. To the side elevation Adam added a two-storey bow window, thereby increasing the variety of room shapes internally, but not adding much

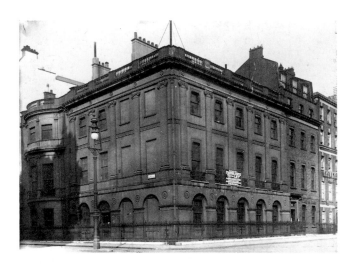

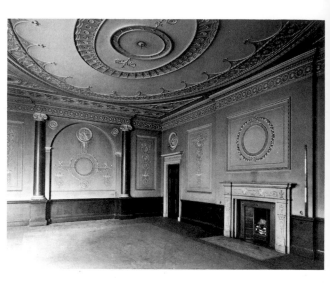

91 *Harewood (ex Roxburghe) House, Hanover Square, a little-known house which survived until 1908, at which date it had a grim and unattractive air. Adam's touch – he carried out alterations – can be seen in the delicate pilasters, paterae and band course*

92 *Harewood House, large north room in 1907. Adamesque motifs applied to an earlier room of mundane proportions could not produce a room of elegance or plastic interest*

to the external impact. The stables behind the house fronted the mundane highway of Oxford Street, as did those of Camelford House a little further west.

In 1803 Harewood House, as it was then known, was again altered by one Samuel Page, 'builder, surveyor and architect'[36] for the first Earl. The Lascelles family lived here from 1795 to 1895, but the Earls of Harewood were not a particularly distinguished bunch apart from the first, who replaced the best library in England with the best collection of porcelain. Most of that had been inherited from his flamboyant, artistic brother, 'Beau Lascelles' who had died unmarried in 1814. After 1895 Harewood House was occupied by the Royal Agricultural Society. Demolition followed in 1908.

The origins of the Mayfair estate, still probably the most valuable property of the Dukes of Westminster are described elsewhere (page 168). This family has never owned a London palace consonant with its vast wealth; Grosvenor House is described in the chapter highlighting great art collections. Mayfair, however, provided the setting for other families' town houses second only in importance to those in the area around St James's Square. No estate has ever been so closely controlled as that of the Grosvenors. Neither the form nor tenancy of the following houses were the product of accident.

No. 16 Grosvenor Street was built in 1724, its

tect Thomas Ripley providing the barely competent elevation expected from the designer of the Admiralty. It was one of the largest houses on the estate, being 55 feet wide, and survives today, much altered at ground level but retaining considerable character on upper floors despite the estate's preference for regular refurbishments. Evidence of Adam's decorations – he designed a ceiling for a drawing room in 1763 – is hard to find, however. A stone staircase, iron-balustraded, as well as several fine marble chimney pieces, are among the more durable elements still to be seen.

A series of aristocratic tenants included the Marquis of Hertford from 1740, the third Duke of Portland from 1763, and the fifth Duke of Rutland from 1801. The lease was not renewed in 1820 – the terms set by Porden as estate surveyor were too steep. After four years empty the house was taken over by Seddons, the cabinet makers, who sublet parts to the Oriental Club and, from 1837 to 1859, the RIBA. From 1860 to 1909 piano makers were in occupation, but in the latter year social glory of a near-aristocratic kind reappeared in the person of Mrs Keppel. Extensive alterations were approved by King Edward VII for the lady, but were incomplete at his death in 1910. The last private occupant, Capt. Gerald Leigh, was succeeded in 1935 by a firm of dressmakers.

No. 44 Grosvenor Square was built three years later

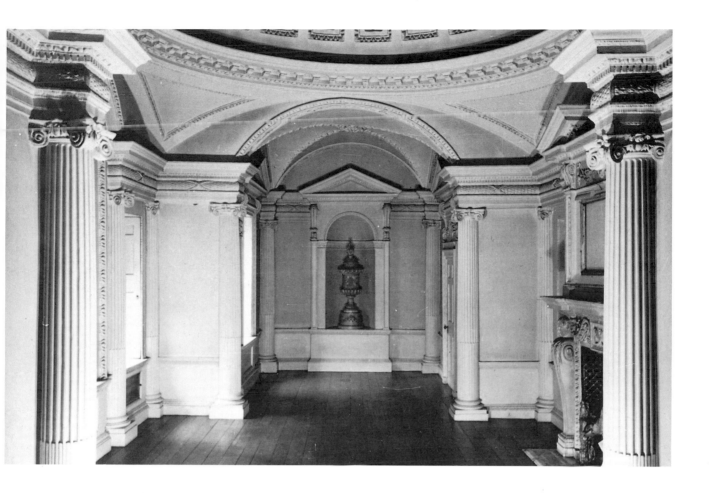

93 *11–12 North Audley Street. Bold modelling handled with this degree of skill could achieve the palatial within an unpromising space. Groin-vaulted end compartments and a coffer-domed centre are articulated with Ionic columns and pilasters. Designed by Lovett Pearce, but supervised and detailed – rather crudely – by Shepherd*

than the Grosvenor Street House; its history is dissimilar in that it was greatly altered before demolition in 1967. The outstanding feature of this house, the painted staircase compartment of about 1730, survives in part in the Victoria and Albert museum. From 1804 to 1908 this house was the home of the Lords Harrowby; after that it was occupied by the Dowager Duchess of Devonshire.

Houses off the square and the streets leading immediately from it were slightly smaller in scale; such were *11 and 12 North Audley Street*. Mentioned together because they were at various times joined and then separated, these two are the only survivals from the original development of the street by Edward Shepherd *c.* 1725–30. A century later they were refaced and stuccoed. Originally of six bays, with giant pilasters on a rusticated ground floor, a seventh bay was added about 1820. This house is famed for its fine early Georgian interior; in particular the gallery at the rear which is connected to both houses. This 'perhaps the most beautiful early Georgian room surviving in London'[37], was added to No. 12 when both were occupied for a time by

General Ligonier. The architect is now thought to have been Sir Edward Lovett Pearce, the leading Irish Palladian designer who died in his thirties in 1733. He was in London in 1729–30, the relevant date.[38]

Unlike most private palaces a recent history is relevant. Leaving No. 20 Portman Square to London University after the death of his wife in 1932, Samuel Courtauld removed here. In 1947 No. 12 North Audley Street was bequeathed to Lady Aberconway who stayed until 1974. In 1948–9 she reunited the houses which had been separated in the nineteenth century.

On the opposite side, *No. 22 North Audley Street* is more prominently sited, being on the west corner of Grosvenor Square. This building represents a distinct type: 'one of those palatial stone-faced private

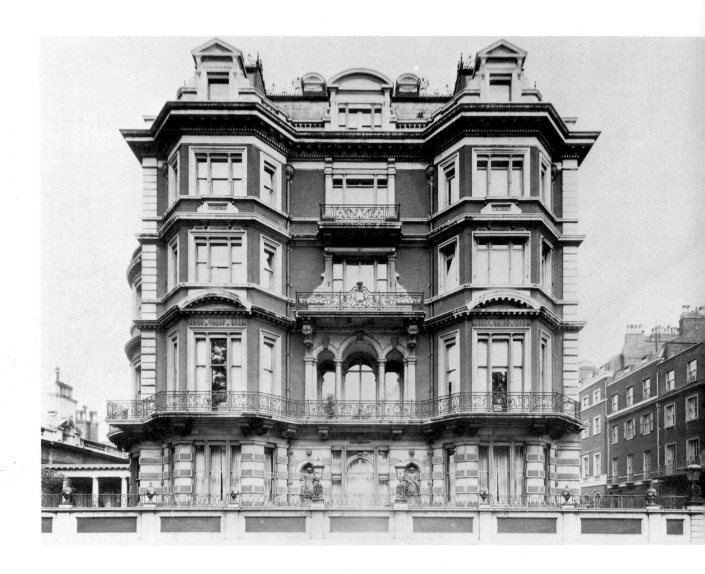

94 *Brook House, Park Lane. Another kind of Mayfair grandeur – the later nineteenth century did not go in for understatement. This multi-storey French-style palace manages to look like a grand hotel on a promenade. Or perhaps the resorts aped Brook House?*

mansions which in this part of Mayfair were built by confident noblemen about 1900'.[39] The model for this kind of grandiloquence was *Brook House*, a massive French-style mansion built by Thomas Henry Wyatt (1807–80) for Sir Dudley Coutts Marjoribanks in 1867–70. From 1905 to 1921 it was occupied by Edward VII's friend the multi-millionaire Sir Ernest Cassel. He filled the splendid rooms with paintings and *objets d'art* in silver, bronze and jade. In the twenties Lord and Lady Louis Mountbatten were there, she being Cassel's grand-daughter. In 1933 Brook House was replaced by a block of flats, also called Brook House in the insulting Park Lane fashion. Part of the agreement involved

the provision of a penthouse for the Mountbattens.

Almost as assertive, lofty and eclectic as Wyatt's mansion was another built 30 years later by Fairfax Wade. *54 Mount Street* was also of brick heavily dressed with stone at corners, windows, and gables. Both houses had a lower storey of stone, at least partly rusticated; both had horizontal stone bands, and both had prominent windows arched and keystoned. The only difference was that Wade had plumped for an exuberant English classicism, arts and crafts out of Wren. 54 Mount Street survives, its opulently vaulted marble interiors providing a fine setting for the Brazilian ambassador's private entertaining.

The official Brazilian Embassy is in another large mansion on a corner site nearby. *32 Green Street* was built for the fourth Baron Ribbesdale in 1897–9. Much more restrained than its Mount Street contemporary, its garb is a 'very pure neo-Georgian,

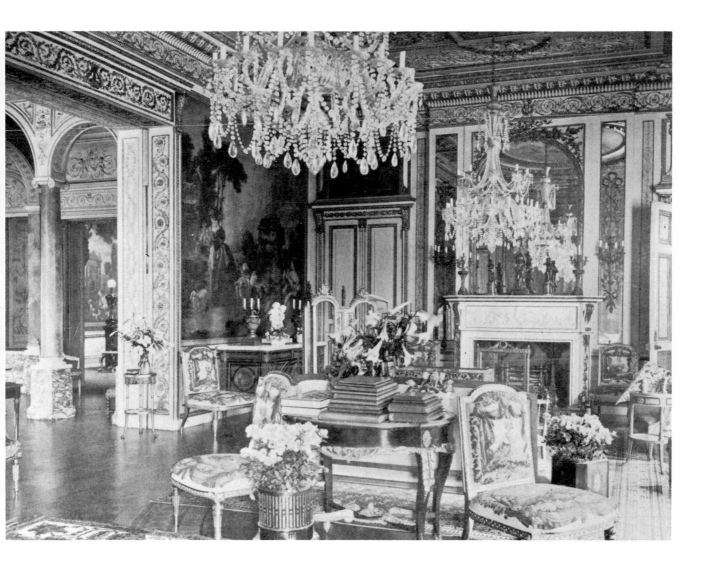

95 *Brook House. The drawing room, with paintings by Boucher. In its latter days, prior to demolition in 1933, the Mountbattens lived here*

by Sidney Smith'.[40] An impressive feature is a 42-foot first-floor drawing room. Between 1931 and 1946 this was the London residence of the Earl and Countess of Harewood (the Princess Royal).

Further along Green Street, No. 61, *Hampden House*, is a large agglomeration of buildings occupying a site with a frontage of 125 feet and a depth of 150 feet. No. 61 was built in 1730 for himself by Roger Morris (1695–1749), the Palladian architect and associate of Lord Pembroke. It consists of a three-bay centre and two rather lower and slightly recessed two-bay wings. No. 60 was built, also by Morris, for James Richards, King's Master Sculptor and Master Carver in Wood. It has been much altered. The two houses were combined under the ownership of the eleventh Earl of Kinnoull in 1833. The lease was bought by the Duke of Abercorn after he had vacated Chesterfield House in 1863; much redecoration was then carried out in an eighteenth-

century revival style. The early twentieth century was a great time for balls; the first change made by the fifth Duke of Sutherland on taking over the mansion in 1919 was to form a ballroom by combining two apartments. Hampden House was placed at the government's disposal in 1949 and so it has remained ever since.

Private palace building in Mayfair continued while great houses were being abandoned elsewhere in London. *Aldford House* in Park Lane was the curious outcome of an attempt to control development by Eustace Balfour, the Duke of Westminster's surveyor. The idea was to encourage the building of two large villas on the site bounded by South Street and Chapel (now Aldford) Street. Eaves heights were to be limited to 27 foot to protect the

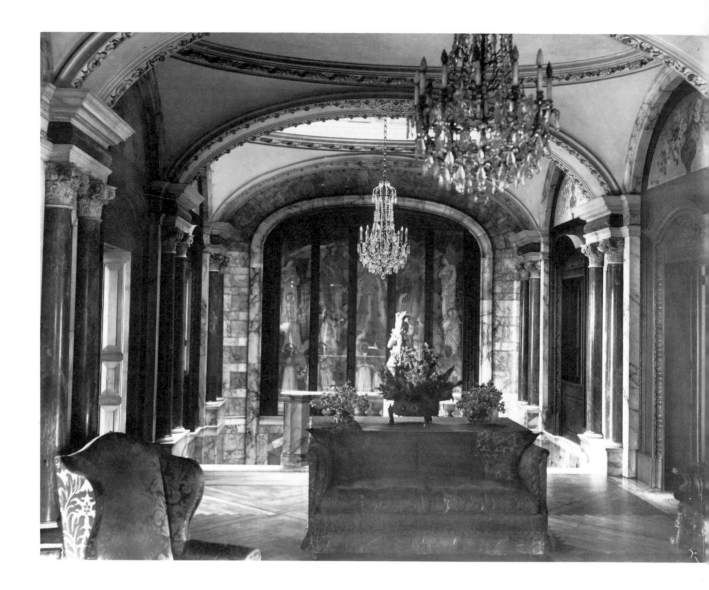

96 *54 Mount Street. The wealth of residents, Grosvenor estate rebuilding policies and the* fin de siècle *seeking aesthetic novelty produced some marvellously opulent eclecticism. The top-lit stair landing is marble-clad and saucer-domed*

outlook of new houses on the east side of Park Street. Two applications by South African mining magnates were turned down, the Duke taking particular exception to the 'vulgar' Barney Barnato. Eventually a not too different person – Sir Alfred Beit – was allowed to take the north plot in 1893 and given permission for a single-storey extension on the south plot the following year. This was to contain a billiard room and conservatory. The combined results of delays, changes, height restrictions and the tastes of Balfour and his partner Thakeray Turner, who designed Aldford House, was a curiously muddled and archaic Cotswold manor house with touches of French pretension and classical bombast. It was beautifully built in Portland stone with, for example, alternate thick and thin courses. But architects wedded to the Arts and Crafts movement and to the principles of William Morris's Society for the Protection of Ancient Buildings, should have had no business building *fin de siècle* palaces on Park Lane for South African millionaires.

The interior was to be oak-panelled, but Beit didn't take to this serious approach and had it fitted out in a riot of eclectic styles. After his death in 1906 Aldford House was empty until sold to Captain Guest in 1912. The staircase and entrance hall were monumentally rebuilt in stone. But on the departure of Mrs Guest in 1929 the Grosvenor Estate made it a condition of a new lease that the mansion be demolished.

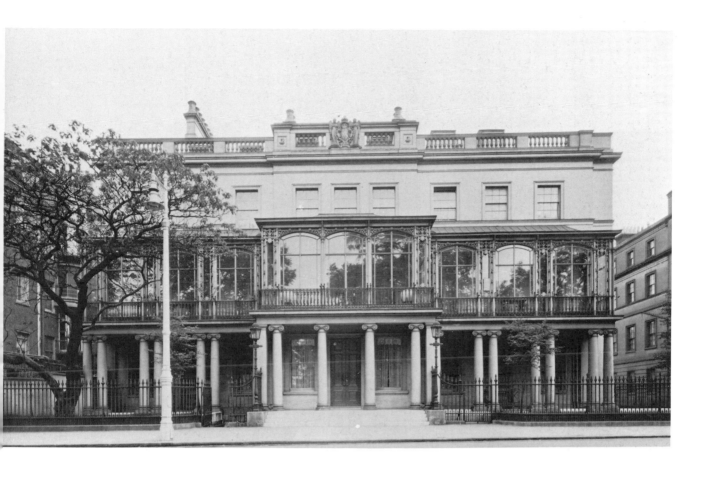

97 *Dudley House, Park Lane, still surviving despite bomb-damage and commercial use. An unimposing brick building, which has been stuccoed, stripped and stuccoed again, has been enhanced by the addition of a long balcony/conservatory overlooking the park*

Mayfair still abounds with important and interesting houses, most greatly altered and many in diplomatic if not commercial use. Such is No. 57 South Audley Street, formerly *Bute House*. Basically eighteenth-century, it was refronted in 1907 in what Pevsner called 'the unmistakable French Embassy taste'.[41] Despite further rebuilding after the Second World War, the important discovery of ceiling paintings by Tiepolo in the main first floor room took place only in 1965. The house was then, and is now, the Egyptian Embassy. The last really large private mansion to be built on the estate was that erected for Lord Aberconway in 1920–22. With the modest address of *38 South Street*, this 90-foot-wide neo-Georgian residence was taken over for office use in 1948.

There remain four significant aristocratic town houses of Mayfair which demand notice: two, Bourdon and Dudley Houses, still exist; the others, Camelford and Breadalbane Houses, are long gone. Of these the first is the least grand, but is of interest as an early Georgian building – almost a little brick manor house in Mayfair – and because it was for a time the town residence of the Grosvenors. *Bourdon*

House (No. 2 Davies Street) was built in 1721–5 and is named after the original owner Captain Bourdon. A detached house of five by two bays, it was modestly detailed with brick quoins and a two-bay pediment on the long (south) side. Inside there remains some good panelling and chimney-pieces, also an attractive staircase with carved tread ends and turned balusters. In 1909 the Duke of Westminster decided to enlarge the building by adding a wing to the east containing five bedrooms, a garage and staff quarters.

Bourdon House was let to the seventh Earl of Essex for use during the Season, 'but it is nonsense to talk about their giving receptions and entertaining there, for the house, delightful as it is, is quite a small one, and they are going to use it simply as a London *pied à terre*'.[42] But having moved there in 1917, the Duke of Westminster so much preferred the intimacy of the Davies Street house that when,

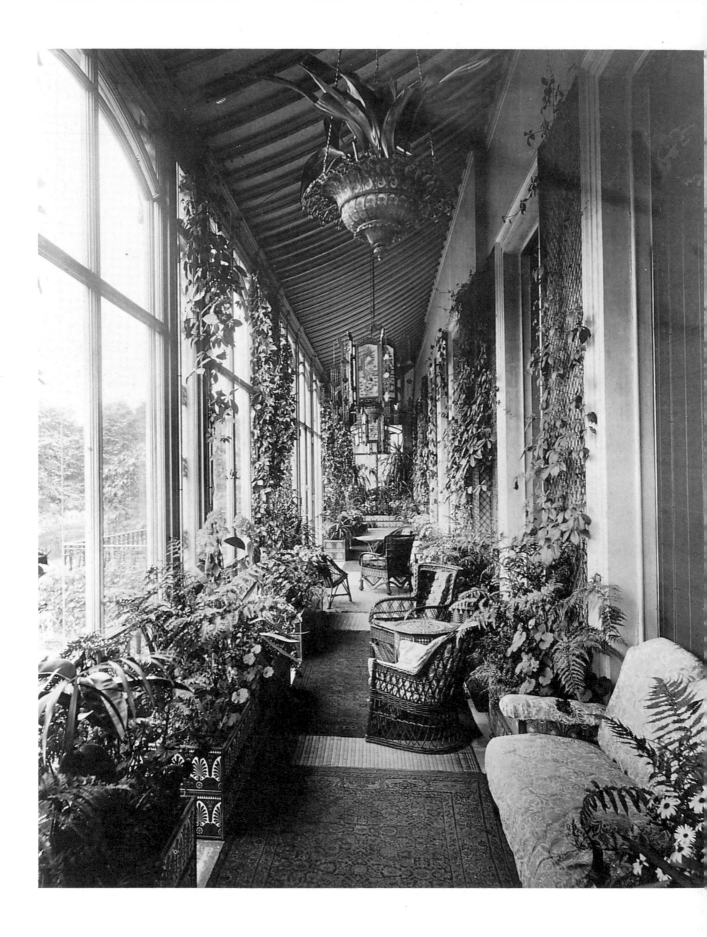

98 *Dudley House. Inside the conservatory in the 1890s was a miniature winter-garden*

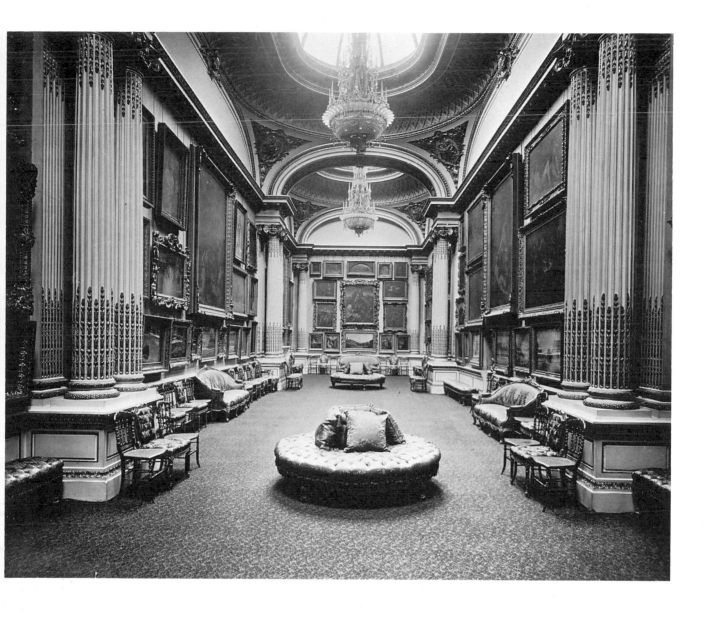

in 1920, Grosvenor House was released by the government, he decided to stay put. After the death of the Duchess in 1957, Bourdon House passed into commercial use.

One family, the Wards, were connected with *Dudley House* for over two centuries. In 1737 Anna Ward built a house, said to have had an 'elegant Palladian façade'[43] on the southern part of the Park Lane site. That building was later converted to livery stables. But in 1758–9 the sixth Baron Ward built another house on the larger northern part. This modest, 50-foot-wide building was altered in 1789 by the then owner, the third Viscount Dudley and Ward. In a complicated sequence during 1824–8 further alterations were almost immediately followed by total rebuilding to create the nine-bay, three-storey mansion with its long Ionic colonnade

99 *Dudley House. Another typical nineteenth-century addition was a picture gallery, its 82-foot length punctuated by two sets of double Ionic columns. Each of three compartments was lit by a large oval lantern and a massive chandelier. The gallery was bomb-damaged and later subdivided*

surmounted by an ornate cast-iron balcony. The last was later extended into a conservatory overlooking Hyde Park, which is unique to the house.

Architect for the fourth Viscount (created Earl of Dudley in 1827) was William Atkinson (*c.* 1773–1839) who began life as a carpenter in Durham, and worked his way up as a builder and then in 1805 via a volume of *Views of Picturesque Cottages* to a practice in architecture specializing in country houses in a romantic Gothic style. This progress was assisted by an association with James Wyatt,

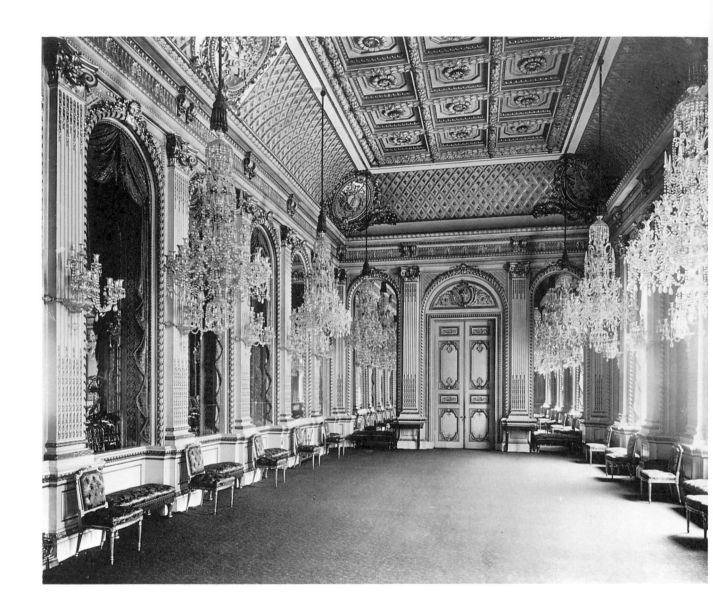

100 *Dudley House. Of similar date and even more pretension was the ballroom. With its chandeliers and mirrors there is more than a suggestion of Versailles*

whose pupil Atkinson had been and whom he succeeded as architect to the Board of Ordinance in 1813. He was a capable and practical man – successfully marketing his own 'Atkinson's' Roman cement. Dudley House is one of his few classical works; its most notable feature being the ceilings of four rooms in the 'mixed Greek and Roman manner prevalent in the late 1820s'.[44]

Ambitions in the fields of picture collecting and in entertaining were high in the later nineteenth century. They resulted in two major and typical additions to Dudley House, carried out in 1858 by Samuel W. Dawkes, who was at the time also in-

flating Witley Court in Worcestershire for the Earl of Dudley. Contemporary accounts made play of the size of the ballroom (50 feet by 24 feet and 27 feet high) and of the picture gallery (82 feet by 21 feet and 33 feet high). Both rooms, decorated and gilded in a Louis XVI manner, provided palatial settings for Lord Dudley's famous collection of Italian and Flemish paintings. Dawkes also added the conservatory, as well as applying stucco to the whole exterior.

In the 1890s, as has been remarked above, Park Lane was subjected to an invasion by South African mining millionaires; Sir Joseph Robinson, who took a lease of Dudley House, further enriched it into 'a veritable palace, adorned with splendid pictures, beautiful statuary and priceless art treasures'.[45] Sir John Ward re-purchased the lease in 1912, how-

ever, and lived there until 1938; during this period the exterior stucco was removed. In 1940 the house was badly bombed. The damage, which was particularly extensive in the ballroom and gallery area, conveniently allowed the subdivision of those large spaces for an office use which persists today in '100 Park Lane', as the mansion is now known. The interior was restored and 'excellently modernized' according to Pevsner[46], to provide a headquarters for the property group Hammersons. Sir Basil Spence and Anthony Blee once again stuccoed the façades in 1969–70, created a new upper hall in a 'classical taste' and introduced new chimneypieces, including one in the former yellow drawing room which had once been in Gloucester House, the predecessor of Grosvenor House, Park Lane.

Nearby *Breadalbane House*, also in Park Lane, had features in common with Dudley House. In particular, it also received the attentions of William Atkinson and was stuccoed to aggrandize the principal front. Built by the accomplished Palladian James Paine (1717–89), for the ninth Lord Petre in 1766–70, it survived for a century. During that time it was for 60 years the London home of two Marquises of Breadalbane. For the first of these was added in the 1820s, perhaps by Atkinson, a Gothic passage, an Elizabethan staircase in carved oak and various other features in 'ancestral styles'. In 1854, even more outlandishly, a baronial hall was erected on an adjacent site in which to entertain Queen Victoria and the King of Portugal. This 'temporary' ballroom was not demolished until 1863. The following year Edward Bulwer-Lytton bought the lease; he resold it three years later to Lord Palmerston's widow. In 1876 the house, though 'in very good order',[47] was demolished.

VI
Political Houses

A number of mansions treated in this chapter are political in the sense that they existed where and when they did precisely to be close to the centres of power, such as Whitehall, adjacent to both Parliament and the Court. Such was the motivation for the creation of Wallingford House and, in varying degrees, of Portland, Schomberg, Fife, Dover, Richmond and Gwydyr Houses. Other residences described below were occupied by those whose chief concern was the country's government. In Camelford House cabinets were held, in Londonderry House they were said to be made. Somerset House, Park Lane was the home of Warren Hastings and of Lord Rosebery. Yet others were headquarters of political parties – Buckingham and Devonshire, for example.

Today there is only one political town house – the residence of the Prime Minister. 10 Downing Street is but slightly touched upon in these pages, being questionably palatial and certainly not 'private' by most definitions. It does, however, exemplify an important common characteristic – that of reticence. The quality was well described by John Soane in a Royal Academy lecture; in reference to Adam's Derby House he spoke of the proud 'disregard to external appearance of which English noblemen liked to boast'. Behind the plain brick house, built as part of a speculative development by Sir George Downing in 1682, there is a larger mansion facing Horse Guards built by Charles II for his illegitimate son, the Earl of Lichfield. After the

building was presented to Walpole by George II it was substantially reconstructed by William Kent, assisted by Henry Flitcroft. Much of their interior decoration survives.

Many early Prime Ministers continued to live in their own houses where they conducted much of the government's business. For several years the administration was led from wherever Edward Hyde, Earl of Clarendon was residing. Thomas Pelham-Hodges played his not inconsiderable roles in government on the stage provided by his Lincoln's Inn Fields mansion. The Rockingham ministry often met in the Park Lane mansion shortly to be known as Gloucester House. The Duke of Cumberland – the Butcher of Culloden – died just as he was about to preside at a cabinet meeting in his Park Lane house in 1761. The Duke of Wellington used both Downing Street and Apsley House at various times during his terms of office. Lansdowne House was started by Lord Bute, one Prime Minister, and completed by Lord Shelburne, another; the third Marquis of Lansdowne was a minister for much of the 1827–58 period, and the house was a great Whig stronghold in succession to Bedford and Devonshire Houses. The first cabinet of Lord Grey's administration was convened there; at the beginning of this century the Marquis of Lansdowne held important government office. Nonetheless Lansdowne House will be remembered above all as one of the most beautiful of Robert Adam's buildings.

A statesman such as Lord Lansdowne might be

impelled to build a great town house for aesthetic pleasure as much as for utility. It also provided a setting for his collection of paintings, statues, books or porcelain. Such were very much the concerns of the Duke of Wellington when he retired from his military campaigns and was, from time to time, obliged to run the country. Such aloof independence as allowed Wellington to live in an out-of-the-way place like Hyde Park Corner was impractical two centuries earlier when, in any case, the town was smaller. Being in easy reach of the court at Whitehall – if necessary by boat – was essential.

Wallingford House stood at the end of the Tilt Yard of Whitehall Palace. It was so named after Sir William Knollys, created Baron Knollys in 1603 on the accession of James I, and Viscount Wallingford in 1616. Treasurer of the Household in two reigns, he followed his father in that office and in occupation of the house. Knollys rose even higher, being raised to the Earldom of Banbury in 1626. But by that time the Duke of Buckingham had obtained the house, which assumed the character of an official residence; when Buckingham was appointed Lord High Admiral he established at Wallingford House a Council of the Sea, later to be called the Board of Admiralty. He continued to live there even after securing possession of York House.

It was at Wallingford House that Buckingham lay in state after his assassination in 1628. His widow remained there with her young son, but parts of the large building were reserved for meetings of the Council of the Sea and also to provide offices for the Lord Treasurer, as well as quarters for his family. The latter were displaced however when the Duchess of Buckingham remarried, to Lord Dunluce, in 1635. In 1646, at the conclusion of the Civil War, the second Earl of Peterborough took possession of the house. Later during the Commonwealth the Earl of Rutland was in occupation (1649 55). An inventory of the period, now at Belvoir Castle, provides a glimpse of the mansion; 54 rooms are listed, including a long gallery, a great drawing room, a dining room and extensive service accommodation.

After Cromwell's death the 'General Council of the officers of the Army' met at Wallingford House, their intention being to thwart Monk's plans to restore the monarchy. However, Charles returned to his kingdom and the Duke of Buckingham to his Whitehall mansion. He lived there till 1672, a man of many parts and no principles. A diplomat and playwright, having helped to engineer the downfall of Clarendon, he joined the disreputable CABAL ministry. An event recorded for the period was the death and lying in state of the Duke's close friend, the poet Cowley, who was taken in impressive procession from Wallingford House to burial in Westminster Abbey in 1667.

The second Duchess of Buckingham, largely abandoned in favour of a succession of mistresses, lived at the house until 1692. But as in a previous generation, she shared it with various Lords Treasurer whose residence and office it also was. The Duke, frequently in debt, almost as frequently imprisoned in the Tower for ridiculous exploits of ambition, later preferred hunting on his estates in Yorkshire. In 1686 the Crown bought the house, perhaps to ease the Duke's debts. Following a dissolute life and an ignoble death, this aristocrat was buried in Westminster Abbey. Wallingford House was demolished in the 1720s and rebuilt as the Admiralty by Thomas Ripley.

The Whitehall mansion known for a century and a half as *Dover House* has been occupied by government offices since 1885, but many times before then it was associated with political events. In 1670 the lodgings of James, first Duke of Ormonde, were on the site. He bought a house in St James's Square in 1682 but did not necessarily abandon these lodgings. The second Duke obtained a new lease in 1696; its 42 years were unexpired when he was attainted in 1715. The next tenant was Hugh Boscawen, created Viscount Falmouth in 1720. His widow died in 1754 and the house was sold to Sir Matthew Featherstonehaugh.

The new owner set about building a much larger house which was, perforce, sited for the most part on the garden of the earlier mansion. Designed in an essential Palladian style by James Paine and completed by 1758, this remains one of London's less known private palaces, chiefly because its principal elevation faces west and overlooks Horse Guards. The building is not readily distinguishable from other official edifices surrounding the parade ground. It is a rusticated symmetrical design in Portland stone, of three storeys with an attic; the outstanding feature a three-light central window in an arched recess, framed by Ionic columns.

101 *Dover House, Whitehall. The main front overlooks Horse Guards. To give prominence to the entrance on Whitehall, Henry Holland designed a portico in 1787. Carrington House can be seen across the road*

Sir Matthew died in 1772, and his widow sold the lease in 1787 to Prince Frederick, Duke of York and Albany. The Duke appointed the architect Henry Holland to dignify the entrance from Whitehall. A portico of four Ionic columns was erected across the east front, which necessitated building over the street. An entrance vestibule leads to a drum-like circular hall; eight weighty Doric columns in scagliola, representing Siena marble, support an entablature above which is a saucer dome and a circular lantern light. An eight-sided upper hall was also remodelled by Holland. York House, as it was then known, ceased to satisfy the Duke who, after only five years in his completed residence, came to terms with Lord Melbourne to exchange it for his house in Piccadilly.

After a few years as Melbourne House, the property was sold by the statesman's executors to Mr

Agar Ellis, a notable author, later created Baron Dover. His family lived there for half a century, but Dover House was taken over for government use in 1888. It is now the Scottish Office.

Others of the Whitehall houses had started as lodgings associated with the palace. But the origins of *Stanhope House*, south of Dover House, are particularly obscure. Occupying the site of what had once been the Duke of Monmouth's lodgings, it was apparently first leased to the Stanhope family in 1717. But there must have been an earlier connection for an advertisement in the *London Gazette* asks that any who can give 'tidings' of a trunk lost from the Duke of Albemarle's coach on 18 July 1672 contact the Duke's steward at Stanhope House. It is clear that the house was bought by the Duke of Dorset in 1723. He secured a new lease of an enlarged site, and probably shortly thereafter reconstructed the property. His third son, created Viscount Sackville in 1782, lived in Dorset House, as it was now known, from 1763 to 1785, then the lease was transferred to his nephew who had

succeeded as Duke of Dorset. His widow sold the remainder of the lease in 1808. Writing in 1908 Chancellor stated that a portion of the Whitehall front of Dorset House still remained.

A number of mansions were sited on the opposite side of Whitehall in the vicinity of the Banqueting House, notably Montagu, Portland, Richmond, Fife and Pembroke Houses. The first and last are discussed in other chapters; the others were not of the first rank, so will be noted here in brief. *Portland House* was leased to the first Earl of Portland in the Bentinck line in 1696. He was a friend of William III, by whom he had been raised to the peerage in 1689. Bentinck's son was elevated to a Dukedom in 1716 by George I. At that time the mansion was said to be large and impressive, but by 1772 when the third Duke applied for a fresh lease, the building was apparently ruinous. Subsequent history is complicated; it would appear that the Portland interest was sold to the Crown in 1805, and that at least part of the site was incorporated into Whitehall Gardens. There Sir Robert Peel built a house in 1824, and there he lived until his death in 1850.

Fife House was also on the Thames side of Whitehall; in fact it was near the river bank. The lease of an existing house was bought by the second Earl of Fife in 1764. He employed Robert Adam to carry out alterations in 1766–7. The most important owner of the house was the second Earl of Liverpool who paid £12,000 for the assignment of the lease in 1809. Sir John Soane supervised repairs for Lord Liverpool, who was Prime Minister from 1812 to 1827. A year or so later he had a fatal stroke in the library. The property remained in his family until shortly before its demolition in 1869.

In the 1760s Lord Fife had sought to embank the Thames down to the low-water mark and to include the ground in his garden to prevent the foreshore being an unhealthy dumping place for refuse. Much the same problem occurred on the river bank alongside nearby *Richmond House*. This was sited south of the Privy Garden and looking towards Charing Cross. Built in 1660, the house was occupied in 1668 by Charles Stuart, third Duke of Richmond and his wife, 'La Belle Stuart', a noted beauty, mistress of Charles II and the original model for Britannia on coins.

She outlived her husband by 30 years and retained the house until 1702. It was then taken over

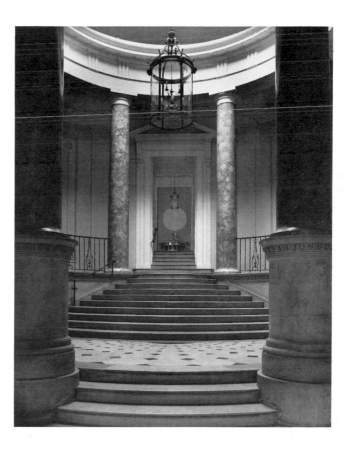

102 *Dover House. Behind the portico was also built a domed and top-lit ceremonial entrance. The eight columns are in scagliola, representing Siena marble*

for government use, becoming the residence of the Secretary of State and then of the Comptroller of Army Accounts. By a strange quirk of ownerships and titles, a second Richmond House was built alongside the first in 1730. This was on land formerly occupied by the apartments of the Duchess of Portsmouth, whose son by Charles II was created Duke of Richmond in a new line in 1675 only three years after the death of the former holder of the title. He obtained a lease in 1711 and, apparently, rebuilt the house. His son was ill-content with the site, which he succeeded in extending by taking in adjoining properties in 1717 and in 1732. Then he rebuilt the mansion, this time to a design by Lord Burlington. To judge by surviving drawings,[1] this was a three-storey, stone palazzo of seven bays, the central three of which projected. Within the centre was a recessed Italianate balcony under a pediment. Seven principal rooms on the first floor were arranged around a circular staircase.

In 1738 the older Richmond House was also

granted to the second Duke. It was very soon demolished, thus enhancing the splendid open views. Lavish outdoor entertainments included a firework party to celebrate the Peace of Aix La Chapelle in 1749: '. . . after a concert of music. Then from boats on every side were discharged water-rockets . . . and then the wheels that were ranged along the rails of the terrace were played off; and the whole concluded with the illumination of a pavilion on the top of a slope. . . . You can't conceive a prettier sight; the garden filled with everybody of fashion. . . . The King and Princess Emily were in their barge under the terrace; the river was crowded with boats. . . .'[2]

The third Duke, who succeeded in 1750, was greatly interested in classical sculpture; he set up a kind of private academy in part of his property where his large collection of plaster casts could be studied. He also fitted up a small theatre, 'where for two winters plays were performed by people of quality', as Walpole reported.[3] The Duke was also engaged in politics as a fierce opponent of Chatham. In 1782 James Wyatt carried out alterations; these involved the addition of a staircase and two extra rooms. But Richmond House was not long to survive; it was destroyed by fire in 1791, partly rebuilt, but sold in 1819 and entirely demolished to make way for Richmond Terrace.

The interiors of the Richmond Terrace houses were very fine, until recently gutted. *Gwydyr House*, a little to the north, had few pretensions to grandeur and, after 144 years of official use, only vestiges of the original decorations survive. Sir Francis Burrell, Surveyor General of Inland Revenue, started off modestly, petitioning to be allowed to build a house on a 'small piece of void and useless ground' which happened to be convenient for his office. When he obtained a lease in 1771, he managed to extend the plot with another parcel of land to the north. His house, built for £6000 in 1772, may have gone up without benefit of architect.

The house went up in the world with the family; Burrell's son being created Lord Gwydyr in 1796, he had had the sense to marry 'a person of very great importance in the fashionable annals of her day'.[4] A brick box, five-bays by three, it had three main floors on a semi-basement behind an area. Rather mean stone dressings included plain band courses and a prominent eaves cornice below an

additional storey of 1886. The wide centre bay was given emphasis with a first-floor Venetian window echoing the arched main entrance. The most graceful element remains the ironwork supports to a handsome lantern over the stone flight rising to the front door.

The rise of Lord Gwydyr's family proceeded apace. Two daughters married dukes. His second son's wife succeeded to the ancient title of Willoughby d'Eresby on the unexpected death of her brother the Duke of Ancaster – a process which, incidentally, has recently been paralleled in that a Baroness Willoughby d'Eresby has inherited from the Earl of Ancaster. Lady Willoughby d'Eresby bought the lease of Gwydyr House and in due course bequeathed it to her daughter, the Countess of Clare. That lady did not occupy the house, letting it in 1838 to the Reform Club, while Barry was building their new Pall Mall premises. In 1842 the government took over the building for offices.

During most of the century following the construction of Somerset House in the 1770s few purpose-built government offices were initiated, despite the growth of population, trade and empire. Having taken over many of the Whitehall mansions, the bureaucrats turned to nearby Pall Mall. Three adjacent mansions were absorbed by the Ordnance (later War) Department, Schomberg, Buckingham and Cumberland Houses. They had not been without political connections while in private hands.

The first Duke of Schomberg perished in the Battle of the Boyne; he had come to England in 1688 as second-in-command to William III. His first successor was short-lived and it was the third Duke who built *Schomberg House*. He was also a soldier and, indeed, also Commander-in-Chief. The site chosen was that which had been occupied by Portland House since 1670. In that year the Countess of Portland had combined two modest countrified dwellings in the meadows south of Pall Mall, which was gradually becoming a formal elm-tree-lined avenue.

In 1694 the Duke of Schomberg, having obtained possession, set about aggrandizing the mansion. He did not demolish Portland House; fabric exposed during the extensive demolition and partial rebuild of the 1950s was clearly earlier than 1698-9.[5] Indeed many of London's palaces, private or otherwise, present a misleading appearance; an archaic

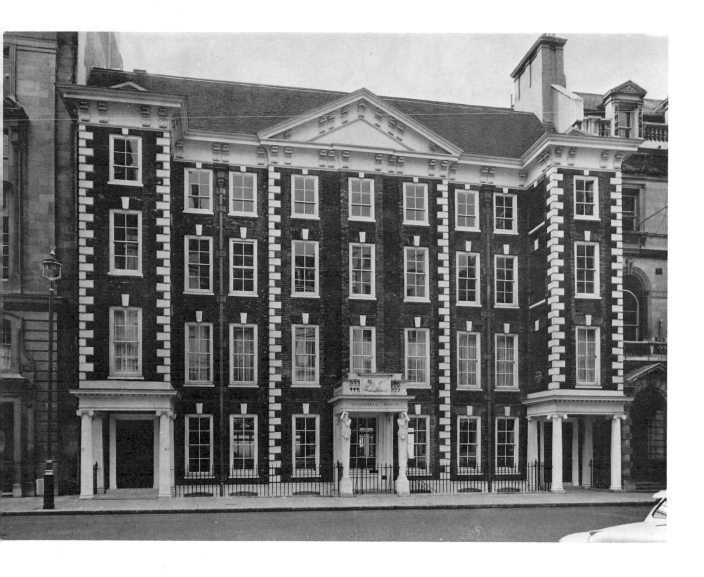

structure has often been re-cased in a later skin. Such was the process with, for example, Buckingham Palace several times, and with Apsley House once. The present Pall Mall building, although bearing a close resemblance to that built for the third Duke, has gone through many vicissitudes. In 1769 the house was divided into three. Alterations were carried out to the requirements of various occupants during the late eighteenth and early nineteenth centuries. The eastern wing, then a separate house, was demolished in 1850. In 1956 the building was largely demolished for commercial office development. Surviving parts of the seventeenth-century elevation were preserved however. The interiors lost were eighteenth-century in character and not without interest, especially in the west wing where Thomas Gainsborough lived from 1774 to his death in 1788. There was compensation in 'streetscape' terms; the original form of the front

103 *Schomberg House. It represents, so John Summerson suggests, an attempt to be continental by an English builder. Its late seventeenth century warmth and exuberance is a unique survival. Largely rebuilt in 1956*

elevation, including the demolished east wing, was restored.

It is a remarkable façade, with both the self-confidence and the gaucheness of the period. The impression is of more than a four-storey building; high-ceilinged first- and second-floor rooms are lit by tall and slender windows. The verticality is emphasized by the single-bay projections almost like square towers at either end and a three-bay centre topped with a prominent coved and shell-bracketed pediment. The last is simply a continuation of the eaves-level cornice; it is painted cream. So are other stone dressings: the six vertical bands of quoins, the three porches, the male caryatids at the centre and

the Ionic columns under the end bays, as well as the keystones to the windows. The window frames are prominent because, before the early eighteenth-century building regulations against fire forbad it, the practice was to place the wooden frame and sash box on the front wall plane, rather than recessed behind the outer skin of brickwork. So bold are all the 'dressings' on this elevation that it is easy to miss more subtle features such as the fine brown brickwork with red-brick vertical bands and trims to the windows.

It is impossible to take this building too seriously; the squashed columns to the side bays seem to be protesting, good-humouredly. The terminal caryatids to the late-eighteenth-century centre porch supporting nothing more than a little balcony interrupted by a tablet in Mrs Coade's stone also seem to be complaining of headaches. The elevation – all that is left of Schomberg House, apart from a marble chimneypiece re-used in the Ministry of Defence building – is unique. The high aesthetic seriousness of the Palladian and subsequent eras was yet to come.

Various bird's-eye views, by Kip and others, suggest that the seventeenth-century house had a central cupola, probably octagonal in plan. There were possibly smaller cupolas, or lanterns, above the side wings too. The roof of the house was radically changed by the eighteenth-century artist occupants, several of whom built studios. The original plan is also impossible to determine in detail. A main feature was a central entrance hall, with a colonnade of four Doric pillars, forming an east-west passage in the centre of the house. This was reproduced by a corridor on the first floor.

The history of later occupiers of Schomberg House, or Nos 80, 81 and 82 Pall Mall as the address became, is complex and colourful. The third Duke lived there until his death in 1719, despite being the object of attack by disbanded soldiers threatening to sack the house. With him the title died. He was succeeded by his daughter who married Lord Holderness. He sub-let to the Earl of Sandwich and later to Viscount Weymouth, before surrendering the lease in 1769. The next tenant, John Astley, a portrait painter, was responsible both for dividing the mansion into three houses and for starting its artistic associations. Astley occupied the central portion in some style, having contracted a

judicious marriage. He added a staircase and constructed the first studio at roof level. But in 1781 he was superseded by a Scottish quack, Dr James Graham, who established his 'Temple of Health and Hymen'. This seems to have been a species of 'bunny club' without the non-touching rules. Facilities for sex, gaming and music were provided, as well as magic medicines. Dr Graham departed the house in 1784 and was eventually confined to an asylum.

Richard Cosway, who had raised himself from abject poverty to the position of being a fashionable portraitist, rented No. 81 until 1791. During the next occupation, that of picture reproducers the 'Polygraphic Society', the rather quaint central porch was added. The two figures which emerge out of the top of the tapering columns were modelled and executed with typical flair and skill by the Coade manufactury.

The list of residents continued with Michael Bryan, picture dealer and publisher, then Peter Coxe 'auctioneer and poet'. By this time the lease of the whole of Schomberg House was reunited in a Crown agreement with Anthony Harding, a successful haberdasher who had followed a long line of shopkeepers as lessee of No. 82, the most westerly house. From 1804 to 1850 the centre was occupied by a bookshop under a succession of Paynes, father, son and son's nephew. Then in 1854 new leases were granted to Harding & Co, on condition that they rebuild. However, having moved into No. 81, they found themselves incapable of financing the redevelopment, apart from the east wing. In 1859 the whole of Schomberg House, new and old parts, was taken over by the War Office. Thomas Gainsborough's residence is marked by a blue plaque. The decade or so before his death in 1788 was the period of his glittering success as a portrait painter. During that time he was in friendly rivalry with Joshua Reynolds. The latter's last visit to Gainsborough's sickbed was a moving moment and worthy of recounting, even as poeticised during the nineteenth century. 'If any little jealousies had subsisted between us, they were forgotten in those moments of sincerity,' said Sir Joshua. The dying artist looked at him and averred 'We are all going to Heaven, and Vandyck is of the company.'[6]

When Devonshire House was the headquarters for the Whigs during much of the eighteenth cen-

tury, *Buckingham House* was that of the Tories. After Charles James Fox was returned to Parliament as member for Westminster in 1784, he was carried by triumphant supporters from Covent Garden to Piccadilly. Abuse was hurled at Buckingham House *en route*. The house belonged to George Nugent Temple Grenville, the latter two names being adopted in 1779 when he had succeeded his uncle as Earl Temple. In 1784 he was created Marquis of Buckingham, the name by which the house was thereafter known. The connection with prominent Tories went back further.

Between 1710 and 1726 the westerly of the two houses on the site of the later mansion was occupied by Thomas Pitt, an East India merchant and sometime Governor of Madras. He was the grandfather of Thomas Pitt, first Earl of Londonderry and grandfather of William Pitt, first Earl of Chatham. From 1726 to 1779 another statesman lived there, Richard Grenville, created Earl Temple in 1752. He had had grand ideas for the creation of a finer house and 'was upon the point of sending peremptory order to Duffour to fit up our Pall Mall palace in the most expeditious and most expensive manner, according to the designs he has shown you ...', as he wrote to the Countess of Denbigh. Apparently he had been encouraged by hopes of the removal of the Land Tax. But 'happily for me you have waked me out of that fit of extravagance'.[8]

So it was a comparatively modest house, built in about 1700, refaced in the mid-eighteenth century, which the second Earl Temple inherited in 1779. Two years later he purchased the loftier and later house adjoining to the east. This was occupied by his younger brother and fellow politician Thomas Grenville, until in 1786 he 'laid the said two messuages together'.[9] The architect then employed was Robert Furze Brettingham, but it appears that his services were not entirely satisfactory. For when, in 1792, Lord Temple having obtained an extension of both Crown leases, decided to rebuild, he appointed Sir John Soane (1753–1837) as architect. His plan was ingenious, retaining much of the 'substantial modern-built house', to quote the Surveyor General's 1790 report, to the east while rebuilding the older one to the west. Changes in level between new and old were subtly masked in a 'fine sequence of variously shaped rooms' as the *Survey of London* puts it.

Before proceeding to examine Soane's typically refined design it would be meet to refer to a political episode in the house's history which just preceded its reconstruction. In 1789, so we are informed by *Old and New London*, Buckingham House was tenanted, at least in part, by the Duchess of Gordon, whom Pitt and Dundas put forward as the Tory 'Queen of Society' in opposition to the Whig Duchess of Devonshire. She would have been pressed to trounce the lovely Georgiana, but apparently the effort was strenuous. 'With five unmarried daughters she brought together here the leaders of the "constitutional" party, both Lords and Commons, summoning doubtful members to her receptions, questioning and remonstrating with them, and using all other feminine arts for confirming their allegiance to Pitt.'[10] To the extent that the Duchess was successful she did her country a service. The allies' responses to revolutionary France, which was beginning to hit out in every direction, were for some time to be febrile; Pitt's ministry which was so important to the prosecution of the looming war was at that time vulnerable. That war did not come for Britain until January 1793; by then the Duchess of Gordon had vacated Buckingham House, for work on rebuilding had begun the previous summer.

At Buckingham House Soane produced a subtle essay in neo-classicism, remarkable in its proportions and its details, but with no expansive gestures. Refined Palladian touches were seen in the absence of a giant order, in the plain ashlar of two upper storeys and the rustication of the lower one, and in the wide spacing of the windows. Less reticent was the staircase compartment however. Apsidal and arcaded, it was as theatrical a design as Kent's in Berkeley Square, allowing for the austerity of Soane's neo-Greek language. The entrance hall was also oval in plan and had a deep frieze with roundels, as did the stair. Otherwise the interior was simple, though the library walls were designed as a series of arched recesses.

That library was altered, together with other ground floor rooms, in 1813–14. The work was at the behest of the Marchioness; indeed her husband died during its progress. His son, having succeeded, was raised to even greater estate as Duke of Buckinghamshire and Chandos in 1822. The house was occasionally known by the latter title. There were

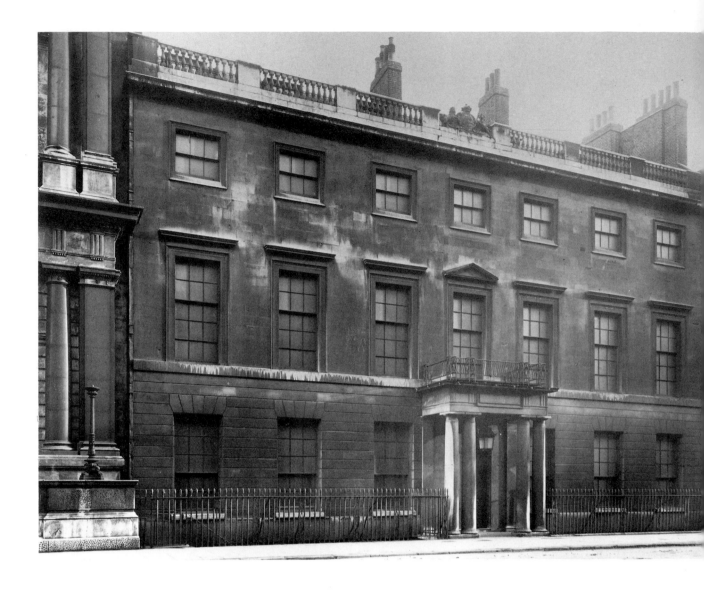

104 *Buckingham House, Pall Mall. A Tory stronghold as well as a typically subtle essay by Sir John Soane in the neo-classic vein of his early maturity. The refinement of the architrave mouldings, the paterae beneath the single pediment and the sinuously curved ironwork were characteristic*

other 'Chandos' reverberations, for this Duke presently became financially pressed and sought to dispose of the house. He finally did so in 1847 to a speculator, having overridden the opposition of the Surveyor to the Crown Commissioners, James Pennethorne.

Plans to demolish and redevelop as a club or as club chambers came to nothing, however. The Carlton Club was a tenant during the rebuilding of its premises during 1854–5. Then Buckingham House was taken over by the War Department, in whose hands it remained until 1906. Demolition

followed in 1908, the site being required for the Royal Automobile Club.

Cumberland House, was built by Matthew Brettingham for the Duke of York and Albany, so was originally called York House. On the south side of Pall Mall from which it was set back behind a courtyard, the seven-bay, three-storey brick elevation with stone dressings and parapet was dull even by this architect's standards. The Duke of Cumberland, nephew of 'Butcher' Cumberland, took up residence in 1768, the year after his brother the Duke of York had died. Before his own death in 1790 he had enlarged the building by purchasing the house to the west and rebuilding it as a wing to his own. The answering wing on the site of the adjacent house to the east was not realized until later.

In the Soane Museum, among the extensive and

beautiful collection of drawings by Robert Adam, some 55 are for work at Cumberland House. Most of these designs were not carried out. But Adam certainly altered the music room ceiling in about 1780 and may have designed the west wing in 1773, as well as the east and west 'lodges' flanking the forecourt. These were attractive Doric pavilions built in 1785.

The Duchess of Cumberland left the house empty from 1793 to 1801, apart from the occupation of the west wing by Lady Elizabeth Luttrell. In 1801 it was sold and occupied by the Union Club. In 1806 all three sections were acquired by the Board of Ordnance which in 1809 built the planned east wing. The Board, later the War Office, occupied the building till it was demolished in reverse order to its building, the eastern part in 1908, the western in 1911.

London's political houses played their greatest role in the eighteenth century when they provided party headquarters for the 'Bedford House Whigs', or the 'Buckingham House Tories', for example. The uses to which a town house were put depended on personal enthusiasms of the owners from generation to generation. A statesman may well be followed by a reclusive scientist, keen agriculturalist or patron of the arts who would have engaged in no more political activity than his position in society demanded. Such was the case with several succeeding generations at *Devonshire House* (ex *Berkeley House*).

Built in 1672, it was on a country road, rutted and dangerous – renowned for footpads – and known as Portugal Street, in honour of Queen Catherine of Braganza. Only the eastern part, from the windmill (Great Windmill Street), was called 'Piccadilly', after Piccadilly Hall, north of the road. The name derived from the fashionable 'picadils', stiff collars sold by the successful haberdasher, Robert Baker, who lived at the hall. Separated from the road by a courtyard like Lord Burlington's, the new house also had side wings in the Italian style. A bird's-eye view on Morgan's and Lea's 1682 map and a watercolour drawing of 1730 in the Crace Collection, hardly justify Evelyn's opinion that it was 'One of the most magnificent palaces of the towne.' The same writer on 25 September 1672: 'I dined at Lord John Berkley's newly arrived out of Ireland, where he had been Deputy: it was in his

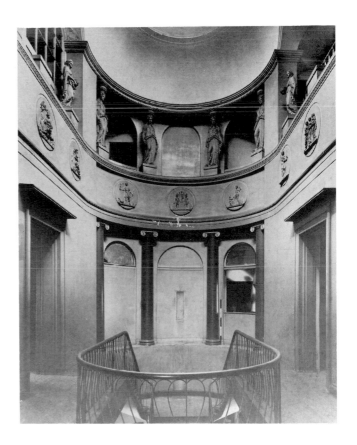

105 *Buckingham House, the staircase. One of the most strikingly Attic conceptions in any London house. Roundels in high relief in the style of antique gems were, like the caryatids, cast in Coade stone. Plain surfaces provide a context for such incidents as the wittily curved ironwork*

new house, or rather palace ... It is very well built, and has many noble roomes, but they are not very convenient, consisting of but one *Corps de Logis*: they are all roomes of state without clossets. The staircase is of cedar; the furniture is princely ... above all the gardens which are incomparable by reason of the inequalities of the ground ...'

Hatton, in his *New View of London* of 1708, provides more exterior detail: 'The house is built of brick with stone pilasters and pitched pediment, all in the Corinthian order, under which is a figure of Britannia carved in stone. At some distance on the east side is the kitchen and laundry and on the west side stables and lodging rooms, which adjoin the mansion by brick walls and two circular galleries, each elevated on columns of the Corinthian order, where are two ambulatories.' All were agreed on the attractiveness of the setting. 'The back hath a beautiful vista to Hampstead and the adjoining country', said Macky. The extensive grounds, formerly part of Hay Hill farm, included all of what

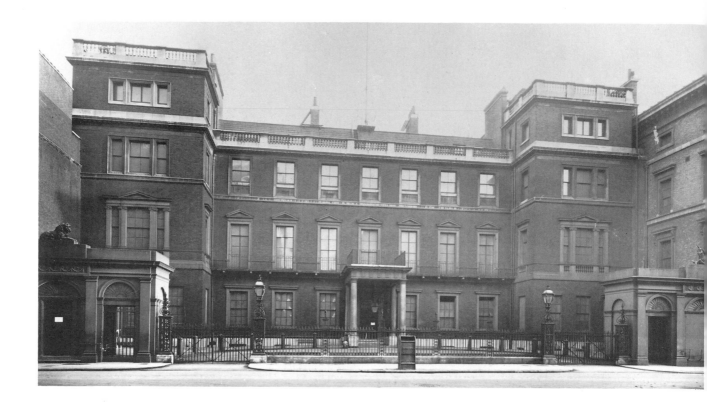

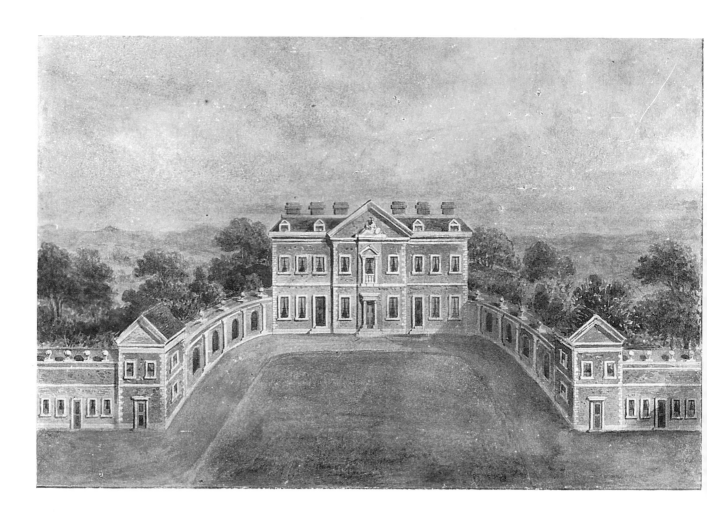

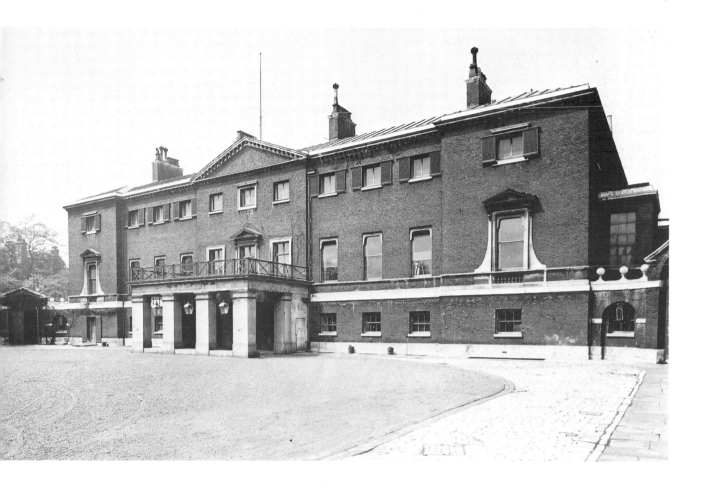

became Berkeley Square and surrounding streets. They were reduced by Berkeley's widow who, advised by a reluctant Evelyn, only retained 'as much of the garden as the breadth of the house ... I could not but deplore that sweet place (by far the most noble gardens, courts and accommodations, stately porticoes, &c anywhere about towne) should be so much straightened and turned into tenements', he wrote on 12 June 1684.

Between 1692 and 1696 Princess Anne, on bad terms with her brother and sister-in-law, William and Mary, lived in Berkeley House. In 1697 the property was sold to William Cavendish, first Duke of Devonshire. But in 1729 it was burnt to the

108 Devonshire House, rebuilt by Kent in the 1730s after a fire. Any grace in the austere north-Italianate composition had by this time been sacrificed by removing the entrance from the first to the ground floor and by building a porte-cochère in front of it. The stone dressings – band course, balustraded window aprons and curved supports – are Kent motifs, but there is a touch of Inigo Jones's 'handsomest barn in Europe' in the almost rustic brickwork

ground. The tale was the not uncommon one of builders and a pot of boiling glue. Much of the contents were saved, including the *trompe l'oeil* painting by John Vander Vaart of a violin on a door, now at Chatsworth. The greatest artistic loss was of the Laguerre murals in the staircase compartment. The Duke was £30,000 plus £3500 worse off, these being the estimated values of the house and of the statue of Britannia.

He lost no time in commissioning an architect to design a new house. William Kent was an unexpected choice no doubt recommended by his friend and patron Lord Burlington, with whom he lodged nearby. Kent was best known as a painter and this was only his second major architectural design. His plan, published in *Vitruvius Britannicus*, was not

106 Cumberland House, Pall Mall. The centre block was originally built for the Duke of York by Matthew Brettingham in 1761–3. The wings and the entrance lodges (by Robert Adam) were later additions

107 Berkeley House (later rebuilt as Devonshire House). This watercolour of 1730 is a little naïve architecturally speaking, making it difficult to grasp the prodigious expenditure on this mansion – though it is favoured with a multiplicity of doors! The open, almost wild setting to the north is evident and the statue of Britannia can be descried in the pediment

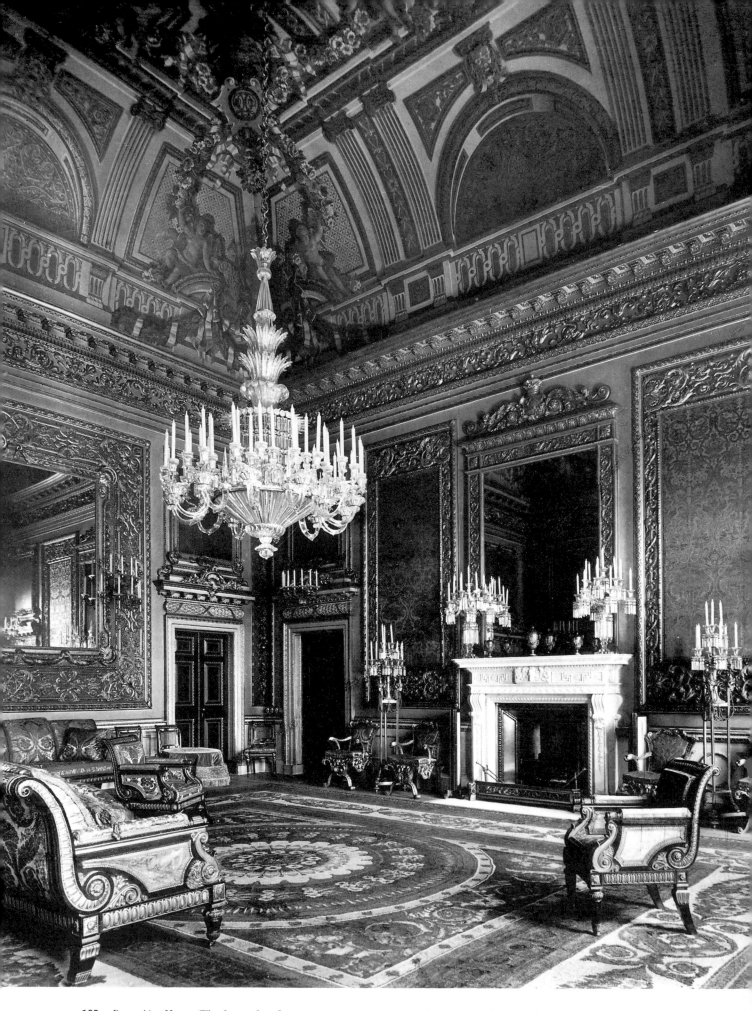

109 *Devonshire House. The former first floor entrance was converted into a saloon for the sixth Duke. Original elements can be seen –* *doorcases, cornices and chimney piece – but a great deal of gilding and trompe l'oeil architecture has been added*

110 *Devonshire House. Even in such domestic rooms as the Duchess's boudoir the paintings (mostly Dutch here) were often of museum quality*

unlike the earlier house, with a pavilion and service wings. The elevations were in his most restrained, indeed almost rustic, Palladian style. The barely adorned brickwork, strong in its sense of scale and composition, had the extra gravitas of a low window-to-wall proportion. That this house is plainer than Burlington's own, which had been refaced by Colen Campbell a few years earlier, possibly had something to do with economy. It cost £20,000, excluding Kent's £1000 fee. If the Duke wanted a large house built rapidly, severe without and rich within, that is what he got. London got a building it never much liked. The main block of eleven bays and three storeys had no orders. Projections at the ends and in the centre were the only articulation. James Ralph, who had admired the former house, did not approve the replacement. He complained about it being concealed behind a 'horrid' blank

wall and then adds that, 'The public have nothing to regret in losing the sight of Devonshire House. It is spacious, and so are the East India Company's warehouses; and both are equally deserving praise.'[11]

The interior was impressive, though its eleven inter-connected state rooms on the principal floor were all much of a size, only the entrance hall being of more than one storey. That room was 30 feet by 35 feet and with the library at 40 feet by 20 feet was the largest. There was no saloon and little of the grand effect contrived in the hall and staircase compartments at Holkham and at 44 Berkeley Square. Indeed the stairs were almost concealed in

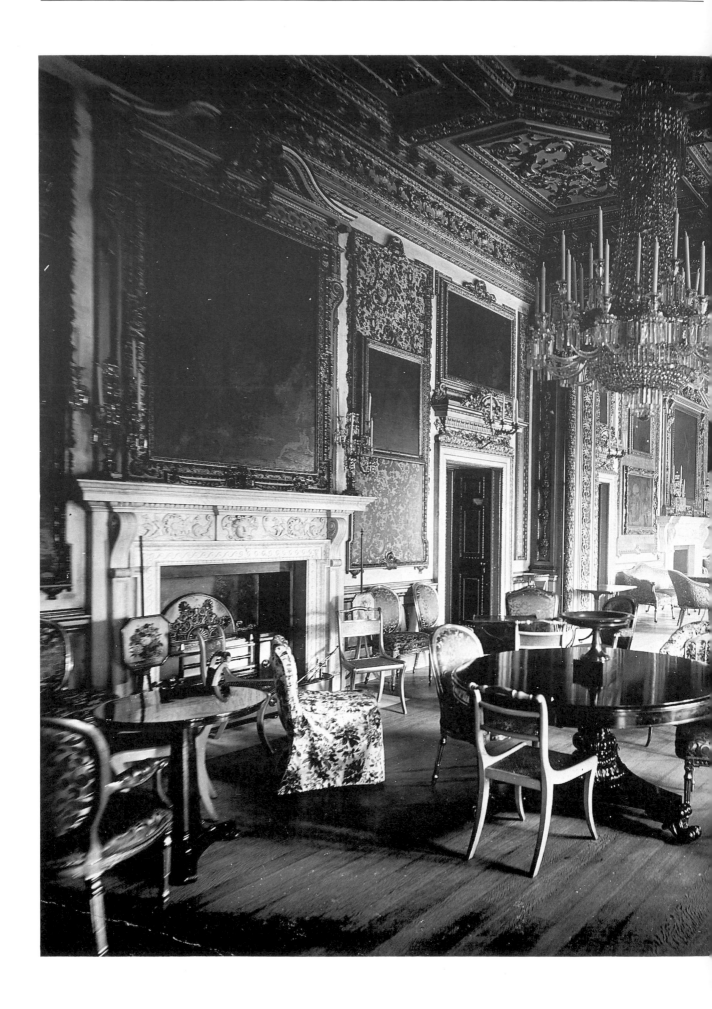

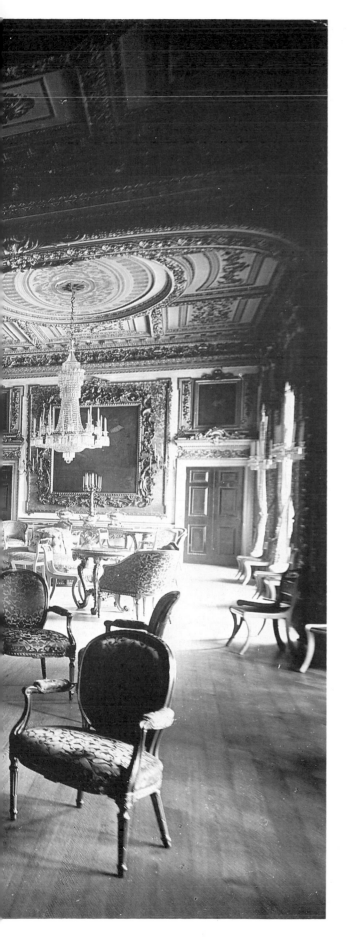

the central core so that there should be no interruption to the sequence of state apartments, chief of which were the drawing rooms facing north over the gardens.

They were adorned with splendidly decorated and gilded ceilings, entablatures, doorcases and carved marble fireplaces all with the bold architectural relief typical of Kent. Much of the heavy, gilded furniture was also his. The opulence became more crowded during the eighteenth century as the collection of pictures continued to expand. For, as John Cornforth has pointed out, the best part of the collection was kept in London. In a 1798 valuation the books, prints and pictures at Chatsworth were put at £3400 and those at Devonshire house at £13,300.[12]

Here we touch upon a central argument, for it is often suggested that the English nobility, especially the great Whig landowners, eschewed town, court and government, seeing their central role as the management of vast country estates. The comparative failure of the attempt to create squares lined with aristocratic 'hotels' in the French sense is cited. The Dukes of Devonshire were Whig landowners on the grandest scale, but many of them based their lives in London. Research in the account books at Chatsworth shows that in almost every year household expenditure at Devonshire House well exceeded that elsewhere. In 1833, for example, £21,000 was spent at the Piccadilly house and under £17,000 at the Derbyshire one. The stocks and consumption of wine and other drinks as recorded in the Cellar Books are proportionate: in 1853, 92 dozen bottles of wine were drunk at Devonshire House and 71 dozen at Chatsworth. Both these dates are in the sixth Duke's time, and he was said to be a recluse.

Most of the dukes played a role in national affairs. The fourth was labelled 'King of the Whigs', a position virtually inherited by his son, the fifth Duke. 'But the more active part of disseminating liberal views and preaching the liberal propaganda'[13] was played by his Duchess.

111 *Devonshire House. The ballroom was created from two drawing rooms on the garden front, to which was added a new grand circular staircase to provide a ceremonial approach. Months after demolition in 1924, Chancellor described this apartment as 'a fitting setting for our ancient regime, which begins to grow as dim as that which a different sort of revolution swept away in France'*

During the later eighteenth century the 'Devonshire House Whigs' led by Fox, but presided over by the beautiful Georgiana, daughter of the first Earl Spencer and first wife of the fifth Duke, became a centre of political life. Her energetic campaigning helped Fox to win the vital Westminster election. With her friend, Lady Duncannon, she visited the humblest of voters

> Arrayed in matchless beauty, Devon's fair
> In Fox's favour takes a zealous part;
> But Oh! where'er the pilferer comes beware
> She supplicates votes and steals a heart.[14]

Georgiana was energetic and forceful in an age when an affectation of *ennui* was the mode. She was unconventional in other ways living with the Duke and Lady Elizabeth Foster in apparent contentment as a *ménage à trois*. She also gambled. But it was as a 'presiding genius' of the Whigs that she was indefatigable – even when her husband was relaxing at Fox's Chertsey house his Duchess, the beautiful Georgiana, was laying down the law to her political allies in the salons of Devonshire House.

The mansion was periodically brought up to date. James Wyatt carried out extensive repairs and decorations in 1776 and 1790. But in terms of Devonshire House as a building, a particularly significant Duke was the sixth. Young when he inherited in 1811, rich, witty and handsome, he had redecorated and re-gilded most of the house by 1819 – except his mother's (Georgiana's) blue and silver boudoir. We read a German Prince's report in 1826 of receptions in London: '... the Duke of Devonshire, a king of fashion and elegance' in his house, 'perfect order combined with boundless profusion'.[15] But the Duke tired of London. In 1836 he removed most of the pictures to Chatsworth, and a few to Chiswick. His notebook, with sketch elevations of each wall of every major room at Devonshire House, decrees that out of 274 canvases only about 80 were to stay.

In the 1840s however, he returned to Piccadilly and transformed the house. The external entrance stair was replaced by a *porte-cochère*. Decimus Burton added a curved extension to the north front; domed

112 *Devonshire House. In the dining room the 'bones' are Kent's but mid-nineteenth-century enrichment abounds. Portraits by Franz Hals, Van Dyck, Reynolds*

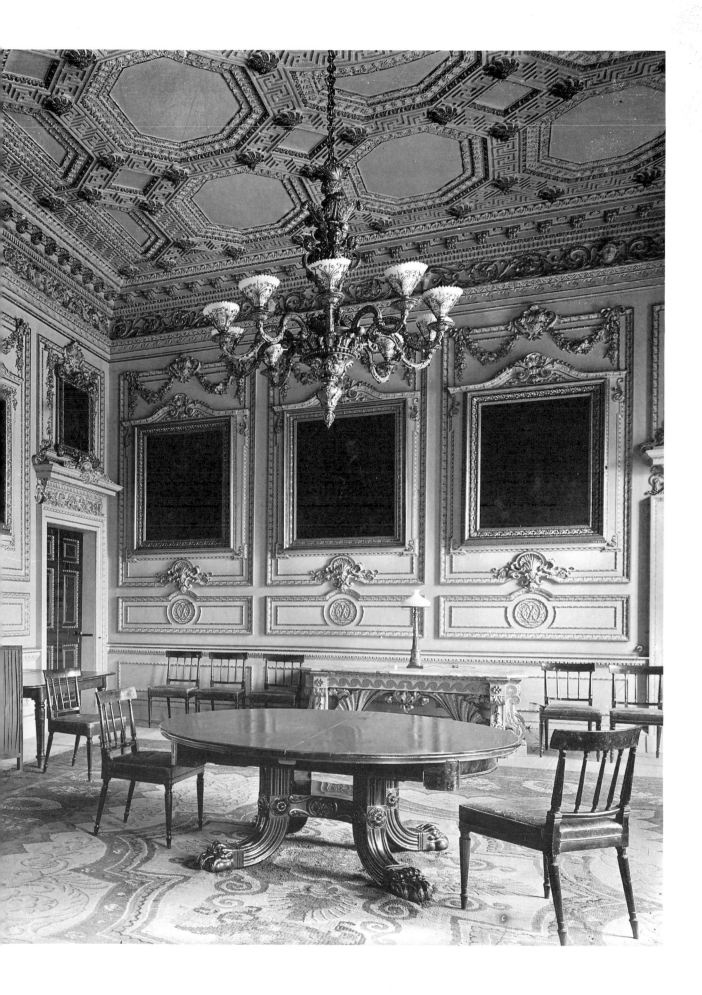

and top-lit it contained a circular stair. A splendid
saloon was created in the former entrance hall –
this had already become a sitting hall with Grecian
couches which are now in the Chatsworth library.
At this time a ballroom was created by combining
two of the drawing rooms on the garden side of the
house. A great deal of extra enrichment, in terms of
gilded ornament to the walls and ceiling, was added
to Kent's original boldly panelled ceiling and hand-
some doorcases and fireplaces. The walls were in
part brocaded in blue and gold.

The sixth Duke died in 1858. His successor was
a scholar who lived quietly. He also attempted to
rebuild the family finances, depleted by his prede-
cessor, developing both Eastbourne and Barrow-
in-Furness on two of the estates. Another period of
political activity was that of the eighth Duke, a
rather lethargic swell, who apart from having to
cope with his wife the 'Double Duchess' giving the
most lavish fancy-dress ball ever, for the 1897 Ju-
bilee, had to refuse the Prime Ministership three
times. He died in 1908 and was succeeded by his
nephew who had himself been a member of Parlia-
ment since 1891. The ninth Duke held office as
Financial Secretary to the Treasury and in 1916–21
was Governor-General of Canada. He had been
forced to spend large sums to render Chatsworth
habitable; this, together with death duties of half a
million pounds (he was the first Duke of Devonshire
to be liable), and a great burden of debt arising
from the failure of the seventh Duke's business ven-
tures, led to the disposal of Devonshire House.

The house and gardens were in any case a sad
sight by the time of the Great War; the latter were
peopled only by some of the statues to be seen now
at Chatsworth. But quite late in the day there had
been changes to the front on Piccadilly. The
wrought-iron gates which had come from Lord
Heathfield's Turnham Green house to Chiswick in
1838 were installed in front of Devonshire House in
1898. They were re-erected a little further along
Piccadilly, on the Park side, after the sale in 1921.

Ample if haphazard contemporary documenta-
tion makes possible an imaginary tour of the house
just before the Great War. The lack of room plans
of the period allows considerable scope for confusion
over rooms which have changed their name and
function several times. Generally the daytime living
rooms seem to have gravitated towards the south

front over a period of nearly two centuries. One
entered what Augustus Hare called a perfectly un-
pretending building via a 'low pillared entrance
hall'. Stone-floored and sparsely furnished, it led to
the 'crystal staircase' via an inner hall dominated
by a massive marble basin. The curved stair had
shallow cantilevered treads, gilded ironwork and a
handrail of glass. The landing led to the ballroom,
reminiscent 'or those Venetian Palaces in which
colour is enriched by gold and gold takes on a
hundred shimmering hints from adjacent colour'.[16]
Furniture and mahogany doors were also picked
out in gilding. There were two splendid chandeliers,
now at Chatsworth with most of the others from
this house. Amidst all this glitter was also an im-
pressive assembly of pictures, despite the removals
of 1836. The Tintoretto and the Poussin are both
now in the yellow drawing room at Chatsworth; the
Bassano was destroyed in a 1940 fire; the Rubens
'Holy Family' went to the Walker Art Gallery in
1960 and several paintings including those wrongly
attributed to Caravaggio and Veronese are now in
obscure corners of Chatsworth.

The dining room had a splendidly robust Kent-
designed plasterwork doorcase, fireplace and over-
mantel. Additional, more fussy, mouldings and
enriched panelling were of the 1840s, as was the
chandelier. Among outstanding painting was Rem-
brandt's 'Philosopher' which went to the National
Gallery in 1958, presumably as part of the death
duties for the tenth Duke. Over the fireplace as a
'Church Interior' by Steenwick; this is now in the
west sub-corridor at Chatsworth.[17]

The green drawing room (formerly the dining
room) had another fine Kent ceiling and fireplace.
Lined with bright green silk damask, its furniture
was covered in gold and dark-red brocade. Paint-
ings included two Salvator Rosa landscapes. In the
saloon the few paintings, mostly Kneller portraits,
were over the doors. The ceiling was among the
Craces' more exotic efforts and looks parvenu beside
the self-possessed early eighteenth-century fire-
places. The latter was moved to the family's next
London house, 2 Carlton Gardens, in 1924. The
house had been sold together with its three acres for
no less a sum than a million guineas. A massive
apartment block, masquerading under the same
name, was the replacement.

The fourth and most easterly of the Restoration

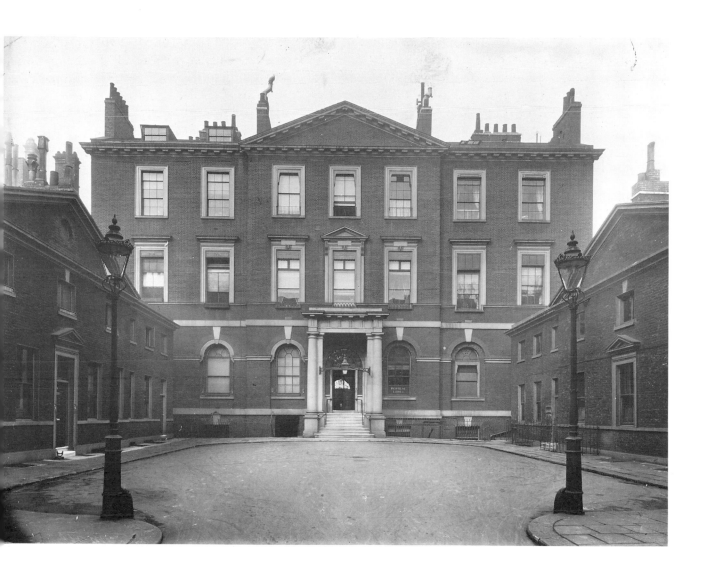

113 *Melbourne House, Piccadilly. Chambers's handsome mansion for a Prime Minister is now the frontispiece to the Albany – a superior apartment complex. The seven-bay composition is very similar to Cambridge House*

mansions on the north side of Piccadilly was that of Sir Thomas Clarges, built in *c.* 1670 on a plot 100 feet wide and 550 feet deep. Having been subdivided, the house was sold in 1710 by Clarges' grandson to the Secretary of State, Charles Spencer, third Earl of Sunderland, for £4600. Macky described it in 1714 as the Palace of the Earl of Sunderland; 'Next to Burlington House ... with a high wall likewise before it, which hides it from the street, and tho' it be inferior to the former in many other respects, yet the library is looked upon as one of the completest in England, whether we regard the beauty of the building, or the books that fill it. This edifice is an hundred and fifty foot in length, divided into five apartments ...'.[18]

The collection found its way to Blenheim where it remains as the core of the library; for Sunderland's son became the third Duke of Marlborough. After 1745 Sunderland House was sold to Marlbor-

ough's brother-in-law the fourth Duke of Bedford. Then in 1763 Henry Fox, the Paymaster-General, who was about to be created Lord Holland, bought it for £16,000. The next year Robert Adam produced a beautiful design for a new house with an elliptical colonnaded forecourt and rooms more plastic in form than any he had yet built. But nothing came of it. In 1771 the house was sold to the recently ennobled Viscount Melbourne for £16,500. To provide him with a mansion in established taste the new owner commissioned the other leading architect, Sir William Chambers.

Melbourne House was a well-proportioned but unremarkable seven-bay, brown-brick, stone-dressed

block recessed behind a courtyard on Piccadilly. The ornaments were limited to refined mouldings for windows, a Doric porch and a three-bay pediment. There were also low side wings of nine bays and one-and-a-half storeys, brick and pedimented. Of Chambers's interior, of which he was rather proud, almost nothing survives. Only the ceiling of the north-west room on the first floor can now testify to his claim to have done as much as Adam to invent a new 'manner of decoration, eliminating the ponderous units of the previous period'.[19] Writing a century later in *Round About Piccadilly*, Wheatley reports that Lord Melbourne 'spent large sums. ... The ceiling of the ballroom was painted by Cipriani, and those of other rooms by F Wheatley and Rebecca'.[20] Chambers's interior design here was intended to be classically plain, apart from richly painted and gilded ceilings, fireplaces – which were mostly by another architect, Paine, in any case[21] – and the splendid furniture specifically designed for the rooms by Thomas Chippendale.

The plan was basically a square, though with two large bays on to the garden, which as usual faced north. There were three rooms along each front, those with the bays at the rear being the largest. In the centre was a large, rectangular and top-lit staircase compartment into which Chambers inserted a superb stair, exceeding the inventiveness even of that at Gower House. Approached through a colonnade, it rose in two flights against the farther wall to 'fly' back over the visitor's head to a landing above him. This was made possible by the cast-iron technology of the day.

Lord Sunderland's screen wall was replaced by Chambers, and this was remarked upon in the 1783 edition of Ralph's *Critical Review*. The author admitted it to be smaller than that in front of Burlington House, and therefore the lesser of evils; perhaps this should be regarded as a merit and 'less productive of insult and danger to unprotected females, who may pass that way after dark. The pediment over the gate is heavy, and the house deserves neither censure nor praise'. That sourness was not universally shared: '... all the world is delighted with it,' Chambers wrote to Lord Grantham in 1773.[23] Lord Melbourne said, 'few people have had better reason than myself to be pleased with so large a sum laid out'.[24] In 1779 the future Prime Minister, the second Viscount, was born there. Shortage

of funds was one reason for Melbourne to agree to the Duke of York's proposal to exchange Melbourne House with his Whitehall Mansion in 1791.

Ducal tastes were changeable. In 1802 the then York House was sold to Alexander Copland, a builder, for conversion and extension by Henry Holland into chambers for bachelors. That Holland could have destroyed 'one of the finest staircases in London' seems, as Harris remarks, 'inexcusable'.[25] The name 'Albany' was borrowed from the Duke's second title.

'Passing along Piccadilly, we soon arrive at No. 94, the Naval and Military Club. The building, the site of which was once occupied by an inn, was originally erected for the Earl of Egremont, and called Egremont and afterwards Cholmondeley House. The house has a noble appearance; it is fronted with stone, and overlooks the Green Park. It has a small courtyard in front of it.'[26] The view of an uncritical layman, in *Old and New London*, permits an alternative perspective of a building usually regarded as dull, partly because designed by a notoriously dull architect. But *Cambridge House*, to employ its most abiding name, was outstanding in its political significance, as the home of notable men.

The architect appointed by the second Earl of Egremont in 1756 was Matthew Brittingham (1699–1769), the senior and most important of that Norwich architectural dynasty. A mildness of manner was among his chief qualities. Certainly, his designs in a pedestrian Palladian style were unobtrusive, and there was little to excite comment, let alone envy. Perhaps this appealed to the several aristocrats who commissioned Brettingham in the 1750s. Commenting upon the last, that is the most westerly, mansion in Piccadilly in 1761, Dodsley described it as 'of stone and tho' not much adorned is elegant, and well situated ...'.[27] Even the *Critical Review's* 1783 edition says much the same, and it characteristically adds the remark: 'an appearance not unpleasing, to which the cheerful open railing tends much to contribute'.[28] Ironically the building has, in its later history, been masked by a high brick wall, the openings in which, labelled 'In' and 'Out', have given the place its usual name.

Lord Egremont's house was of a familiar pattern: three storeys, ground, principal and chamber – that is, entrance, reception and bedroom floors. Win-

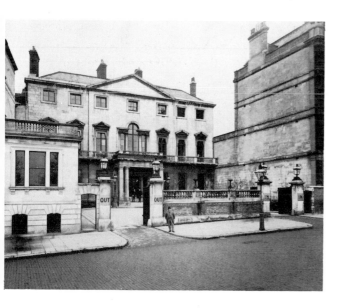

114 *Cambridge House, Piccadilly, now familiarly known as the 'In and Out' club because of the prominently marked gateposts. The large areas of unadorned ashlar stonework endow the façade with a handsome self-assurance – which is the most that may be hoped for from a Matthew Brettingham design*

dows were organized again in the familiar seven bays, the centre being wider than the others and emphasized by a robust three-light Venetian window. The other first-floor windows have triangular pediments which like the large pediment over the three slightly projecting central bays, are plain. The Doric porch and balcony, the balustrade of which continues across the elevation at first-floor level is of later nineteenth-century date, as is the long, low west wing and major extensions to the rear of the house.

Egremont House was something of a Tory stronghold from its beginning, although Buckingham House was then the party's chief centre. In 1761, Lord Egremont was appointed to succeed William Pitt as Secretary of State in the Southern Department in George Grenville's administration. He held that post until his death in Egremont House on 31 August 1763. His successor devoted the considerable family resources to agricultural and scientific pursuits. He moved to Grosvenor Place in 1794.

The Marquis of Cholmondeley is known to have lived in the house from 1822 until his death in 1827. He may have been there some time before the earlier date. Here again was a political man, close to George IV as Prince Regent and King. In 1829 Cholmondeley House became Cambridge House,

following its purchase by the Duke of Cambridge, and thus a semi-royal residence until disposed of once again in 1850. The next owner was the most important politically, this time a Whig; Lord Palmerston. Prime Minister from 1855 to 1865, with only a short break in 1858–9, Palmerston entertained freely in the house. 'During his premiership it was the headquarters of the Liberal Party [as Whigs were becoming known] and of the fashion of the metropolis,' said Wheatley.[29] On 'Pam's' death his body was carried to the Abbey from Cambridge House. Shortly thereafter the building was sold to the Naval and Military Club.

Two other Picadilly mansions between the 'In and Out' and Apsley House are No. 105, known before that in Manchester Square as *Hertford House*, and, almost next to it, *Coventry House*. The former, built by the Marquis in a 'noble Italian' style in 1850, had as its main purpose the housing of part of his lordship's fabulous art collection. It was bequeathed to Lord Hertford's natural son, Sir Richard Wallace.[30] Coventry House must have been substantial, being sold to the sixth Earl by Sir Hugh Hunlocke in 1764 for 10,000 guineas. The Earl had, in 1752, married Maria, the elder of the two beautiful Miss Gunnings. The interior was remodelled by Robert Adam (1765–6). One of the Earls, so we are informed in *Old and New London*,[31] 'procured by his influence, the abolition of the "May Fair" in the rear of his mansion.' After a century as the residence of the Earls of Coventry, it became the St James's Club.

A description of the private palaces of Piccadilly can hardly exclude those of the great Rothschild family, even though their political influence has been unobtrusive. At No. 107 Piccadilly was the first West End Rothschild House, occupied by Baron Meyer, younger son of Nathan Rothschild. At No. 143 Baron Ferdinand had a splendid residence decorated in lavish *Louis Seize* style. His sister lived at No. 142. Behind them at No. 5 Hamilton Place Leopold de Rothschild lived for many years. Most palatial of all was a five-storied pile, built in 1861–2 for Lionel de Rothschild by architects Nelson and Innes, at No. 148 Piccadilly. Wildly eclectic and immensely lavish, with a three-storey, marble-columned and galleried hall, it was a mixture of French, Italian and Baronial styles. If only for its superb materials and craftsmanship it should have

115 *Londonderry House, Park Lane. It remained a 'formal piece of dullness' (Horace Walpole) even after Stuart's original house had been transformed by the Wyatts*

been preserved. But 148 Piccadilly epitomized the kind of nineteenth-century excess regarded as expendable in the early 1960s, when it was demolished for a road scheme.

It was but a step from the mansions at the west end of Piccadilly to *Londonderry House* in Park Lane. The site was part of the pre-Dissolution property of Westminster Abbey which included the manor of Ebury and what became Hyde Park. After being annexed by Henry VIII various ownerships came into being, including that of the Curzon family who began to develop Brook Field where the May Fair had latterly been held. The fourth Earl of Holder-

ness bought a large plot from Sir Nathaniel Curzon and commissioned James Stuart to build a mansion in about 1760. It was completed five years later. As with his later design for Mrs Montagu, Stuart seemed content to construct a plain exterior envelope for sumptuous apartments within.

Robert d'Arcy, Earl of Holderness, was a prominent diplomat and statesman, former ambassador in Venice, Secretary of State for the Southern Department and Governor of the Prince of Wales. He was a keen member of the Dilettanti Society and Holderness House was, in his time, a meeting place for artists and writers. He died in 1778, but Lady Holderness remained in residence until 1801. The house was then transferred to Lord Middleton, a rich northern landowner.

It was in 1822 that Charles Stewart, third Marquis of Londonderry and half-brother of Lord

Castlereagh, came on to the scene. He bought the house, sometimes known as No. 25 Hertford Street, and the adjoining house as well as the freehold of both, and a parcel of 'garden ground' on the other side of Park Lane, for a total of £43,000. A quarter-century later the isolated plot passed to the LCC. The buildings on the main site were re-modelled and enlarged at great expense by Benja-min and Philip Wyatt, although two of Stuart's first-floor rooms survived until 1963–4.

The Wyatts' work, occupying the years 1825–8, consisted firstly of replanning the mansion so that it was entered from Park Lane – the entrance hall which had been approached from Hertford Street was converted into the dining room – and secondly of the addition of princely state apartments. Apart from the great ceremonial staircase, these comprised

116 *Londonderry House. Neither the interior, nor the entertaining within it, were dull. The landing of the splendid stair where the Mar-chioness of Londonderry – often bedecked in the famous Londonderry diamonds – greeted her guests*

the ballroom, the gallery and banqueting hall, all in a lofty, much gilded and decorated *Louis-Quatorze* manner. The money for this aggrandizement came from Lady Londonderry's inheritance. The Mar-quis's marriage, his second, to the former Lady Frances Anne Vane-Tempest, had taken place in 1819, after the failure of a law suit brought to prevent it. He had been a distinguished diplomat, following a career as one of Wellington's ablest commanders in the Peninsular War and in the 1814–15 campaign. His wife was even more re-markable. She dominated London society as a Tory

hostess for 40 years. Disraeli described the London-
derry banquet to celebrate Queen Victoria's coron-
ation as the 'finest thing of the Season. Nothing
could be more recherché'.[32]

The art collection in the house was famed, espe-
cially the Canova statues in the ballroom. The place
was also filled with great paintings, largely collected
on the advice of a friend of the family, Sir Thomas
Lawrence, a dozen of whose canvases were in-
cluded. Correggio's 'Mercury, Venus and Cupid'
and 'Ecce Homo' were among the Londonderry
paintings; they are now in the National Gallery.
Titian's 'Venus and Cupid' was sold to Alexander
Baring.

After the Marquis's death in 1854, Lady London-
derry was less in society; she became more interested
in the family's mining and other industrial interests.
She died in 1865 at Seaham Hall, County Durham.
The fourth and fifth Marquises also spent most of
their time out of London. The sixth Marquis, how-
ever, revived the aura of Londonderry House as a
centre of arts and politics. He was a statesman, a
Viceroy of Ireland and a cabinet minister. The Park
Lane mansion was once again a centre of the Con-
servative Party, as the Tories were now more
usually called; the Londonderry House group was
strongly opposed to Irish Home Rule among other
causes. Lady Londonderry was a great hostess, re-
creating the spirit of Frances Anne in late Victorian
and Edwardian times. A friend of Edward VII, she
organized a banquet for the Kaiser on Edward's
behalf.

The seventh Marquis and Marchioness continued
to entertain, though on a somewhat reduced scale
during the inter-war years. Once again London-
derry House was a Conservative meeting place;
from 1919 to 1934 an annual reception for the party
leader was held there. Despite this strong affiliation,
the first Labour Prime Minister, Ramsey MacDon-
ald, was also drawn into the Marchioness's circle.
She had a great deal of what today would be called
'charisma'. On grand occasions she greeted her
guests at the top of the staircase bedecked in the
famous Londonderry diamonds. Even after the
Second World War Lady Londonderry held a

117 *Londonderry House. The drawing room extended the length of the
Park Lane front. There were family portraits by Hopner, Lawrence,
Romney and others*

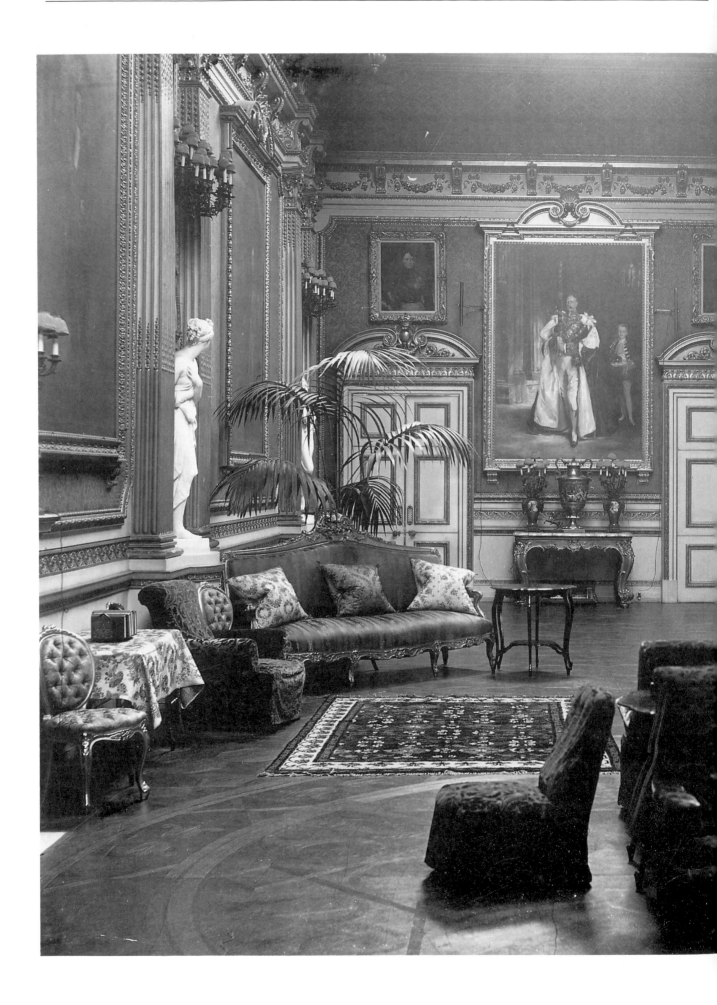

number of memorable receptions in the last of the Park Lane palazzi. But in 1962, already overshadowed by the gross Hilton Hotel to the immediate north, the mansion was sold and shortly afterwards demolished.

Londonderry House had survived into the space age. Two more modest mansions towards the north end of Park Lane had then been demolished and virtually forgotten for half a century. Wheatley was dismissive in treating of *Camelford House*: 'The entrance from Oxford Street is mean and the house itself dowdy. There is but one staircase, and that narrow and low. The courtyard is completely exposed to Oxford Street.'[33] The surviving visual records tend to reinforce this view, which is surprising because the house was built by and for himself by Thomas Pitt, first Baron Camelford (1737–93), an amateur architect widely admired in his own day. Soane in his memoirs remarked on Pitt's 'classical taste and profound architectural knowledge' and even coupled his name with those of Burlington and Pembroke as leaders of English architectural taste.[34]

Lord Camelford was the only son of Thomas Pitt of Boconnoc in Cornwall, elder brother of William Pitt, first Earl of Chatham. Having suffered from ill-health from an early age he led a quiet life, mostly in Cornwall and at his house in Twickenham, designing various buildings for himself and for friends, such as Lord Temple, at Stowe. But after his marriage in 1771 to the daughter of a wealthy London merchant, he built Camelford House at the Oxford Street end of Park Lane. It was not much more than a formal, late Palladian villa with a modest garden behind and a square courtyard in front. The neo-classical interior was very refined, with plasterwork of the highest quality. There was a notable variety of form in the main first-floor reception rooms; two were octagonal and one circular. During 1783–5 Sir John Soane carried out alterations, an old friend of Pitt's and an appropriate architect with his sensitive, linear taste.

Already by 1787, Lord Camelford was thinking of letting his 'palace in Oxford Street'. After his daughter's marriage in 1792, there remained no pressing social reasons for staying in town. His

118 *Londonderry House. The great gallery was dominated by Sargent's portrait of Lord Londonderry in robes worn at the coronation of Edward VII*

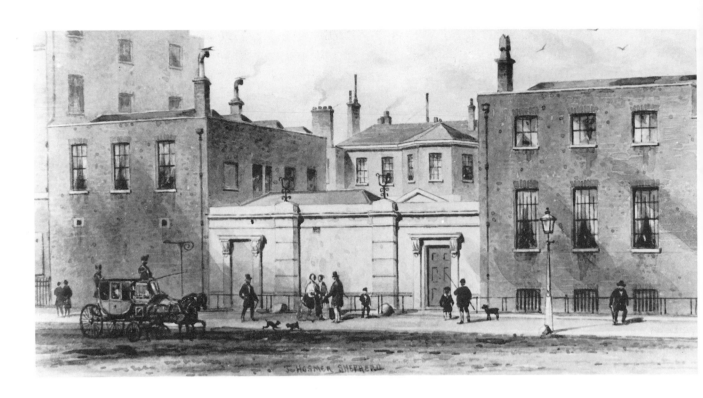

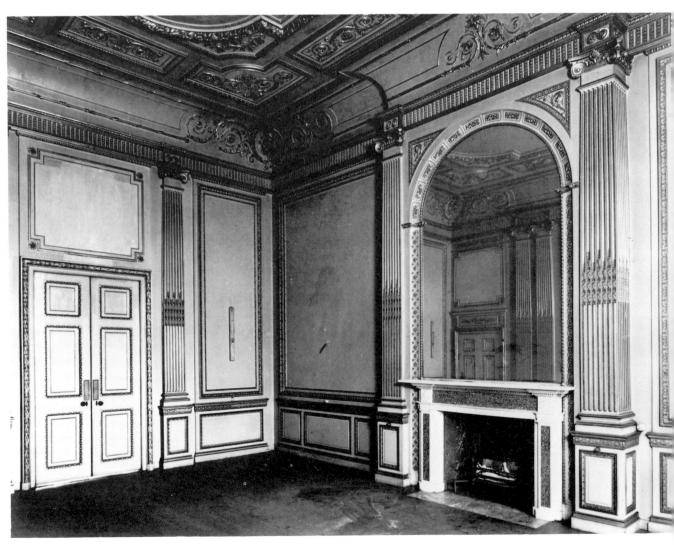

daughter and son-in-law moved into the house and Pitt went to Italy. But that proved a temporary arrangement. At the time of Pitt's death, Lord Grenville, head of the 'Ministry of all the Talents', was living there. It was for him that an extension to the library was designed by Smirke in 1814; it does not appear to have been carried out.

In 1816 there were new tenants, the Prince and Princess of Saxe-Coburg; they were followed by the Earl and Countess Tankerville. Even the Prince Regent's daughter, Princess Charlotte and her husband Prince Leopold, afterwards King of the Belgians, did not disdain to live in 'one of the most unpleasant habitations in London', as Lady Williams-Wynn described Camelford House, not entirely unjustly. Lord Middleton took the house in 1824, as did between 1828 and 1872 Sir Charles

119 *Camelford House, Oxford Street/Park Lane, carried the concept of unobtrusiveness to an extreme. Two storeys of brickwork were only relieved by three-sided bays to front and rear. The Oxford Street entrance was mostly for service use*

120 *Camelford House. The interior was graced with excellent plasterwork. This was one of the first recording exercises carried out by the LCC, in 1912 just prior to demolition*

Mills, of Glyn Mills Bank. His son, who in 1886 was created Lord Hillingdon, and then his grandson kept the house on until 1907. Shortly before demolition in 1913 the LCC photographer carried out an early recording exercise.

No. 40 Park Lane, *Somerset House*, deserves mention only as the 'alter ego' of its neighbour Camelford House. Even less architecturally distinguished, it was as comparatively tall as the other house was squat. Warren Hastings lived in Somerset House from 1789. During the long trial of this the first, and possibly the greatest, Governor-General of India, he stayed there. In 1797, shortly after his acquittal, he sold the house to the third Earl of Rosebery.

By 1808 the eleventh Duke of Somerset was in occupation, he tried several times to extend the house, but was opposed by his neighbour, Lord Grenville. Following the death of the twelfth Duke in 1885 the house was empty. So it remained until 1906, when Mrs Murray Smith was in residence. There were plans to rebuild Somerset and Camelford House as one mansion. These ideas were finally abandoned at the approach of the First World War. The house was demolished in 1915.

VII
Palaces of Art

Sparsely furnished houses of Tudor noblemen contained few pictures apart from a line of stiff and rather naïve family portraits. Just a handful of the grandest people possessed works by first-rank foreign artists such as Holbein, but again the subject matter would usually be portraiture. Finely carved and inlaid furniture was imported from Italy, France and Holland. Splendid tapestries were also brought from abroad as well as being made at home. Later seventeenth-century inventories often listed plate ahead of other items.

The early Stuart period, before the Puritan age, was visually more sophisticated. The first great collection, largely of classical marbles, was assembled from about 1615 at Arundel House by Thomas Howard. Painters from the Low Countries were attracted to the Stuart Court, Charles I also bought widely on the Continent. George Villiers, Duke of Buckingham, filled York House with art treasures, including Roman sculpture which had belonged to Rubens. Great artists were lured to London and expected to achieve the impossible: Rubens to apotheosize James I on the ceiling of the Whitehall Banqueting House, Van Dyck to turn short, ruddy and robust English noblemen into etiolated and elegant seigneurs.

Inigo Jones had begun to create truly classical buildings, based on the principles of Vitruvius as interpreted by Palladio. He had even built the first art gallery, at Arundel House. Unfortunately for posterity his greatest endeavours and the best resources of the Stuart Court were devoted pre-eminently to an ephemeral art-form – the masque. Enormous sums were spent on these elaborate and inventive classical concoctions of poetry, music, dance, costume and temporary architecture. The cultivated Court circle was destroyed by the Civil War and the Puritan Commonwealth. Collections were dispersed abroad.

With the Restoration, aristocrats returned from France and Holland with new standards of luxury and culture, although even in Charles II's reign the attitude towards painting was philistine. When the pictures in a private palace were listed, as for example those at Clarendon House by Evelyn, they still consisted almost entirely of portraits. Only the sitter's name was given, that of the artist being ignored. In many cases the only glimpse of the treasures in a house was to be found in an account of its burning to the ground, such as with Montagu House in 1686 or Berkeley House in 1733. But by the time of the fire at Richmond House in 1791 priorities were different. The contents had been collected with discrimination, well-recorded, used for the instruction of students and, in the event, largely preserved from the flames. The crucial change in attitudes took place in the mid eighteenth century.

Previously, rooms had usually been panelled, or 'wainscotted' and tapestry-hung. Pictures were limited to over doors. Even above chimneypieces, they had to compete first with wood or plaster carvings and then with mirrors. Pier glasses between

windows, and elsewhere, were increasingly valued since they had the functional advantage over fabrics of reflecting candle light. When she took in hand the redecoration of Bedford House for the young Duke and his new bride, her grand-daughter in 1734, the Duchess of Marlborough sought to introduce more paintings. She had in mind a whole collection of family portraits in addition to the few that were already in the entrance hall (including one of herself by Kneller, of which she disapproved). She chose Isaac Whood, who was adept at copying existing paintings by such as Kneller and Van Dyck. The Duchess was explicit as ever: 'You will not forget to make a bargain with Mr Whood, since most people as well as he are apt to overvalue their works.' He should also be clearly told what to paint: 'For painters, poets and builders have very high flights, but they must be kept down; . . .'[1]

The Duchess was old-fashioned in her appreciation of art, and dismissive of the taste of Lord Burlington et al. She clearly regarded paintings as items of wall furniture, rather than among mankind's highest aesthetic achievements. She could also recognize the function of huge mural paintings, such as those at Marlborough House recording her husband's victories. She would not have approved interiors like those in Hogarth's 'Marriage à la Mode', illustrating a fashion for littering damask-covered walls with paintings of agonized Italian saints or French concubines in attitudes of abandon. Topographical pictures by Canaletto were soon to have a vogue; they were undemanding. Lord Leicester's purchase of Leonardo da Vinci's notebook in 1719 and Lord Burlington's of Palladio's drawings were early examples of discrimination.

Burlington's buying of paintings on his first Italian visit was more typical of the enthusiasm of the rich 'milord', a privileged traveller who, in time, became more informed. The concept of collecting pictures as examples of beauty, proofs of taste and learning replaced that of buying them as décor. A gallery was added to Northumberland House in 1749; a house such as Lord Lansdowne's, completed 20 years later, was designed with sculpture, paintings and books in mind. Apsley House, enlarged in the 1820s, was conceived by Wellington as a place in which to entertain his old comrades, to store his trophies, but, above all, to display his great collections of pictures. Another half-century later the absurd position is reached whereby the Marquis of Hertford buys or builds several houses in both London and Paris simply to contain his great collections.

By the mid nineteenth century the idea of the major town house being part-palace, part-picture gallery, was well-established. Stafford (now Lancaster) House was followed by those other great palazzi, Bridgwater, Montagu and Dorchester, as artistic treasure houses. The most remarkable example of the picture-collecting 'tail' wagging the domestic 'dog' – apart from Lord Hertford's ventures – was Grosvenor House. In the nineteenth century every private palace had to have its ballroom and art gallery. They were achieved by internal alterations, or by rebuilding, as at Dudley and Londonderry Houses. But at Grosvenor House the picture galleries comprised vastly palatial additions to what was little more than an inflated villa.

The palaces of Victorian London were awash with works of art. Even allowing for many doubtful attributions, of which Chancellor writing at the beginning of this century was becoming aware, there was sufficient in a dozen houses around St James's and Mayfair to fill several galleries in North America, as well as to enrich hugely the National Gallery in London. That redistribution, by the agency of Lord Duveen and others, started about a century ago. A visit to Apsley House, or to the admittedly specialized Hertford or Home Houses will give an idea of what was lost from other houses. But by no means all the treasures of London's private palaces have been sold. Many of the Devonshire House paintings, which hugely exceeded in value those kept at Chatsworth, were taken to the latter house in 1920. Many of those from Spencer House were taken to Althorp in 1926; some of those from Lansdowne to Bowood in 1936.

The eclecticism of nineteenth-century taste was not limited to architecture; art collections were equally catholic. Sheer opulence came to be valued. Accumulation of objects had progressed dramatically from the sparseness of seventeenth-century interiors. Via the judicious ornament of the Palladians, the attenuated filigree of Adam and the linear restraint of the neo-classicists, the later nineteenth century arrived at an uncontrolled riot. Bedford Lemere's photographs show rooms with barely space to move between the palms and ferns, the

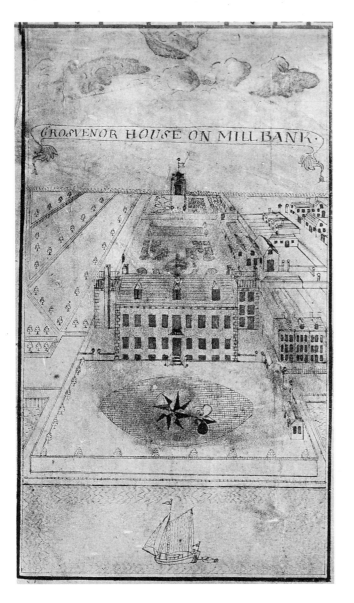

121 *Grosvenor House, Millbank. For much of the eighteenth century, while they were developing their Mayfair estate, this immensely wealthy family made do with Lord Peterborough's old house near the marshy banks of the Thames*

multitude of gilded Louis Quatorze tables, chairs and chiffoniers cluttered with silver-framed family pictures, the walls festooned with pictures of every size and type.

Not until the 1930s was there a thoroughgoing reaction to clutter; by then the days of the private palace were past. Only the Mountbatten's penthouse above the rebuilt Brook House provided a clue to what would have been the character of the 'moderne' town house, had such a building type evolved. This never happened: Brook House and its

ilk were the last true private palaces. This chapter concentrates on that type of nineteenth-century palazzo designed as much to display the owner's works of art as to provide him with a dwelling.

Among them, as has been suggested, *Grosvenor House* was a remarkable oddity. Edward Walford had the Duke of Westminster's collection in mind when in 1890, he wrote: '... although we are sadly deficient in public collections of such works of art, yet it can safely be asserted, that no country in Europe can boast of such magnificent private galleries as England, and no capital as London. ...'[2] Grosvenor House was insignificant architecturally, bearing in mind that its nineteenth-century owners were the richest noblemen in England. Its part in the intellectual and social life of the capital was generally modest too. But the Grosvenors' collection of pictures was unrivalled.

As early as 1819 the American ambassador wrote that the 'four greatest incomes in the Kingdom' belonged to the Duke of Northumberland, Earl Grosvenor, the Marquis of Stafford, and the Earl of Bridgewater.[3] All of those received over £100,000 a year net, an almost unimaginable sum when translated into 1980s terms. The families concerned also each maintained or built during the nineteenth century a great London palace.

In 1865, the Grosvenors were said to be the wealthiest family in Europe. Four years later, H.A. Taine reported a visit to the House of Lords, where, 'The principal peers present were pointed out to me and named, with details of their enormous fortunes: the largest amount to £300,000 a year. The Duke of Bedford has £220,000 a year from land; the Duke of Richmond has 300,000 acres in a single holding. The Marquess of Westminster, landlord of a whole London quarter, will have an income of £1,000,000 a year when the present long leases run out.'[4] Virtually all the greatest landowners were still of noble family.

The 1677 marriage between Sir Thomas Grosvenor and Mary Davies brought with it the property of a London 'scrivener', Alexander Davies of Ebury in Middlesex, including a sizeable block of land to the west of London. The latter divided into two adjacent estates. One of a hundred acres, bounded by Park Lane on the west and Oxford Street on the north, constituted about two-thirds of the area known as May-fair, after an annual fair

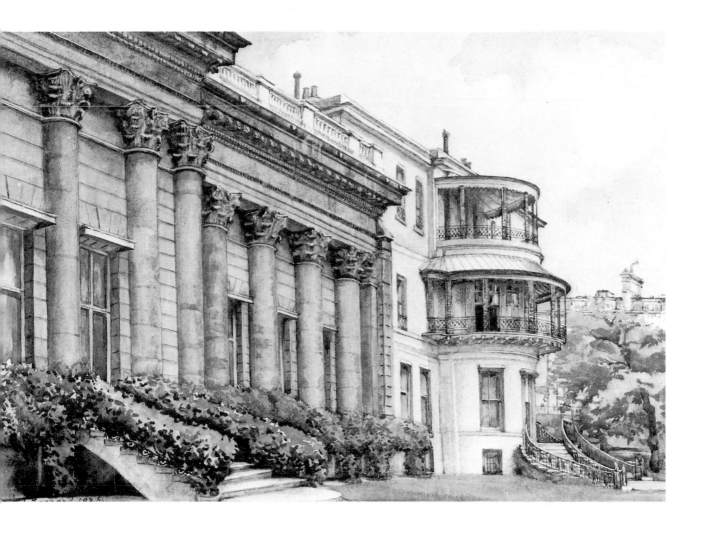

held in Brook Field at the beginning of May. Mayfair was developed by 1770; the larger, marshy area further south, known until 1826 as Five Fields, was little regarded until developed as Belgravia and Pimlico in the nineteenth century.

Mary Davies's inheritance also included a riverside house on Millbank. This had been built in the late seventeenth century for the Earl of Peterborough. 'That part beyond the Horse Ferry hath a very good row of houses, much inhabited by the gentry, by reason of the pleasant situation and prospect of the Thames', wrote Strype,[5] but he went on to be a little less enthusiastic: 'The Earl of Peterborough's house hath a large courtyard before it, and a fine garden behind it; but its situation is but bleak in winter, and not over healthful, as being so very near the low meadows on the south and west parts.'

The name, Peterborough House, was retained until the death of 'that great but irregular genius, Charles, Earl of Peterborough in 1735'.[6] Although the Grosvenor family appear to have been in occupation from 1719 to 1755, it went out of their hands for a generation during which their London house was No. 45 Grosvenor Square. Towards the end of that period the architect William Thomas refronted the mansion in a neo-classical taste. Then in 1789 the lease was re-purchased by the first Earl. The future second Marquis of Westminster liked to go shooting snipe among the ditches with his younger brother, Lord Ebury. The attraction of the place kept the family there till about 1809. Then the building of a penitentiary nearby resulted in demolition.

Knowing of these plans, the second Earl Grosvenor had purchased the lease of Gloucester House in Upper Grosvenor Street in 1805 for £20,000. The building had had a colourful history, having

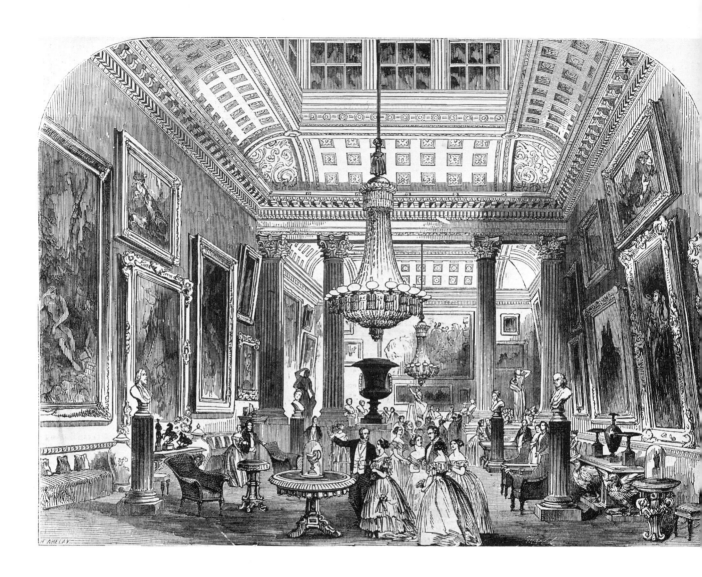

123 *Grosvenor House. Inside the gallery, looking west from the Porden building of 1818–19, to the Cundy extension of 1825–6*

been occupied by, among others, some of the less attractive Hanoverians. Its origins were mundane, dating from the period when the area was being developed. The first mansion on the site was built in 1732 for the first Viscount Chetwynd. It was sold in 1738 to the Duke of Beaufort for £8,000. He also bought leases of the land to the south to protect the open view in an area becoming built up. The Duke of Cumberland, the 'Butcher of Culloden', was the next occupier in 1761. He died four years later when about to chair the Cabinet which met at the house during Lord Rockingham's administration. The lease was assigned by the executors to his nephew, the Duke of Gloucester, brother of George III. So the mansion was known as Gloucester House until 1805.

William Porden, surveying the house for Lord Grosvenor, found it 'dirty' and 'not so cheerful as the situation would lead one to expect'.[7] The site was odd, with a funnel-shaped courtyard restricted on its Upper Grosvenor Street frontage by buildings on both sides. The grounds widened considerably behind the house thanks to the additional land leased by the Duke of Beaufort. There were formal gardens sloping down to Mount Street in the south and a long frontage with a stable yard alongside Park Lane. The house, which would appear to have been rebuilt in the 1780s, was regarded as old-fashioned. It consisted of a compact three-storey block over a basement. Planned around a central staircase, the main reception rooms were on the ground floor.

It was altered and redecorated by Porden in 1807–8 with an eye to economies, crimson damask from Eaton Hall, the Grosvenor's country house in

Cheshire, was rehung on some of the walls. The exterior was stuccoed – most buildings on the Mayfair estate were then of brick – and a pair of two-storey bays were added to the garden front. The work was calculatedly lavish where an effect was sought. It included extensive gilding of plasterwork including ceiling decorations and cornices as well as the replacement of existing doors with larger, highly polished and decorated ones. *The Times* in its report, when the house was re-opened to the fashionable world in June 1808, said that it was 'now transformed into a residence which combines, in a superior degree, the several qualities of magnificence, elegance and convenience ... a metamorphosis under the influence of a pure and solid taste ...'.

Lord Lonsdale was less sycophantic when describing the newly refurbished Grosvenor House as 'most expensively furnished, but in a bad taste'.[8] We can learn a little more of what that taste consisted of from Lady Sarah Spencer, who wrote, 'It is said to be a mass of damask, velvet, gilding, statues and pictures and magnificence of all sorts, beyond all powers of description or imagination.'[9] Alterations had cost £17,000 and furniture £7000. Most of the latter was supplied by Gillows, the successful Lancaster firm which had set up in London. But these figures were dwarfed by the sums being spent on paintings, the display of which had been one of Porden's chief priorities.

Lord Grosvenor had inherited a number of pictures commissioned by his father – Stubbs, Gainsborough, Benjamin West – as well as an assortment of Italian and French paintings. In 1806 he raised the collection well above the ordinary by the purchase *en bloc* for £30,000 of the renowned collection of Welbore Agar Ellis. These paintings, unlike some of the earlier 'old master' purchases, were of high quality and certain provenance. Another picture bought that year, was from the sale by the second Marquis of Lansdowne of the works assembled by his father in Lansdowne House. Rubens 'Adoration of the Magi' cost 800 guineas. Today it adorns, albeit incongruously, the east end of King's College Chapel, Cambridge. The Grosvenors secured the services of experts. William Seguir, the future first curator of the National Gallery, was employed at £100 a year to look after the growing collection. In 1818 four large canvases were added at a cost of £10,000. These were from a set of nine religious subjects, painted by Rubens' studio in a broad style, perhaps as a basis for tapestries, for Philip IV of Spain. Presented to a Carmelite convent near Madrid, they had been looted by the French in 1808.

In 1821 the collection included 143 major paintings. Porden had added a 50-foot-long, double-storey-height gallery, and in 1824 the elder Thomas Cundy, as the new estate Surveyor, designed another. He also proposed to unify them both in an overall scheme for the virtual rebuilding of the house in a grand symmetrical palace design. Then after his death in 1825, his son Thomas produced several alternative schemes, as did Sir Robert Smirke. All depended on the demolition of the stables of Breadalbane House to the west and of other properties in Park Street.

There seems to have been a conflict of views between Lord Grosvenor, who managed to be both free-spending and parsimonious, and his wife who resisted the idea of losing her pleasant house with its south-facing bow windows. These remained unaltered but in 1825–7 Thomas Cundy junior (1790–1867) remodelled the gallery wing; he added detached Corinthian columns in Portland stone in front of the earlier gallery and attached ones to the new Rubens room on the west. New ceilings were given to Porden's interior. Some £23,000 was spent at this time. Foundation and mason's work for the matching east wing was started but the unified palace design went no further.

Anthony Salvin carried out minor works in 1834. But it was Cundy again who made the last significant addition to Grosvenor House in 1842. This was at the north front where a splendid colonnaded screen of Roman Doric design, with handsome cast-iron gates, extended 110 feet along Upper Grosvenor Street. The Grosvenor arms were carved in the pediments over the two carriage entrances. Between the columns were massive candelabra. This £10,000 screen was in the new scale of London palatial building of the mid-century. Cundy produced one further design for reconstructing Grosvenor House in that spirit; it was for a 140-foot square building on the lines of the recently completed Stafford House. Nothing was done.

Subsequent changes were in 1870 the entrance hall was enlarged by Henry Clutton for the third Marquis. A *porte-cochère* in a Doric style to match the entrance colonnade was added. Clutton enhanced

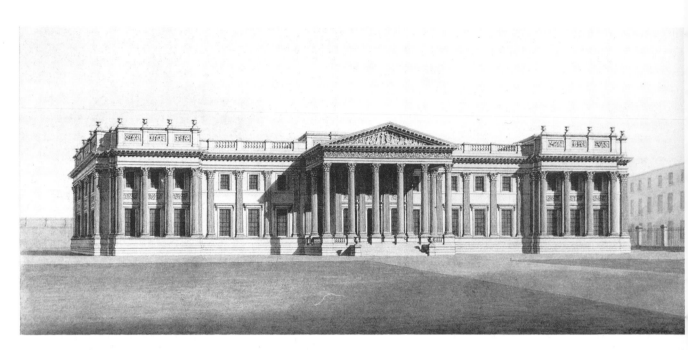

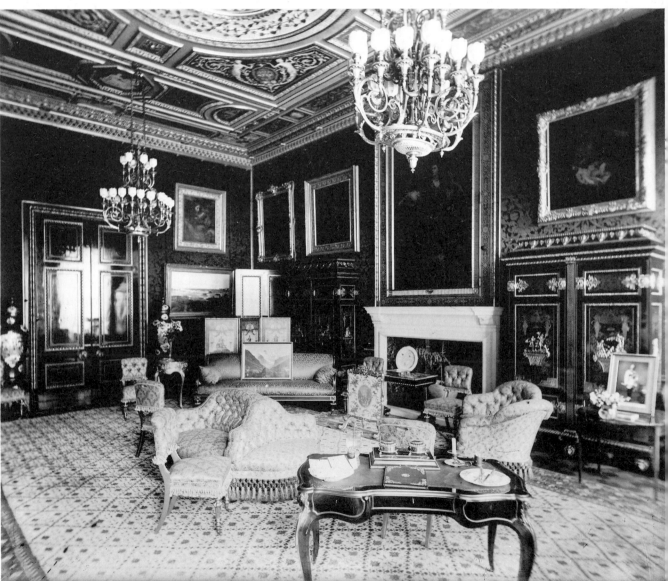

the grandeur of the ground floor state apartments. He lengthened the dining room and added tall windows to the south walls of the gallery and Rubens rooms. On the north side of the galleries, a corridor was added to allow access for the public to charity concerts and other events.

At this time the opulently classical interior was embellished and gilded with an even heavier hand than before. There was painted decoration, probably by J.G. Crace, but at least it was centred round the paintings. There was also an eye to progress; gas lighting had been installed as early as the 1820s; electricity was introduced in 1889. New materials for ever more elaborate ceilings, especially in the great gallery, were supplied by Messrs Jacksons. Both fibrous plaster, and *papier mâché* which had the advantage of light weight, were used. Eventually Clutton added a loggia to the west front in Roman Ionic style. This was allowed by the extra space provided by the long-anticipated demolition of Breadalbane House.

The increasing opulence of Grosvenor House was consonant with the advancing ennoblement of its ever-wealthier occupants. The progress was from a baronet who married a scrivener's daughter in 1677, to their son who developed the London estates and laid out Grosvenor Square, to his nephew who was created a baron in 1761 and raised in 1784 to Viscount Belgrave and Earl Grosvenor. His son, created Marquis of Westminster in 1831, having married the heiress to the Earl of Wilton in 1794, was humble compared to the second and third Marquises, who married daughters of the second and third Dukes of Sutherland respectively. The third Marquis was rewarded by the creation of a dukedom in 1874.

In 1916 the Government occupied Grosvenor House. The Duke, who was happily ensconced in the more modest surroundings of Bourdon House in

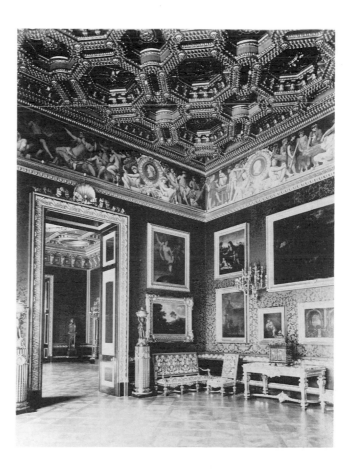

126 *Grosvenor House. Other paintings would now be more highly valued, including the Velasquez portrait of Don Balthazar in front of the riding school in the corner of this gallery. It led into the Rubens room*

Davies Street, was disinclined to return after the war. Grosvenor House was demolished in 1927 to make way for the block of luxury flats and for the attached hotel – the first in London with a swimming pool – which unashamedly bear its name to this day.

Many of the paintings formerly at Grosvenor House were dispersed, some to the United States where great collections were being assembled. The most popularly renowned pictures both hung in the drawing room: 'The Blue Boy' by Gainsborough and 'Mrs Siddons as the Tragic Muse' by Reynolds. There were two outstanding Gainsborough landscapes, 'The Cottage Door' and 'A Coast Scene', in the ante-drawing room. The dining room was adorned with seven canvases by Claude including 'The Worship of the Golden Calf'. Diners also had seven portraits attributed to Rembrandt on which to feast their eyes. In the gallery as such were many

124 *Grosvenor House. The galleries were to be one wing of a palace, among abortive designs for which this was the first by Sir Robert Smirke. It was to extend 230 feet – right across Park Street*

125 *Grosvenor House. Porden's interiors were impressive, but cost-effective! Money was saved by re-using damask from the demolished Grosvenor house in Cheshire. Two pictures in this drawing room were, Chancellor averred, among the best known in the world. 'Mrs Siddons as the Tragic Muse' by Reynolds, can be seen over the chimneypiece; Gainsborough's 'Blue Boy' is not visible*

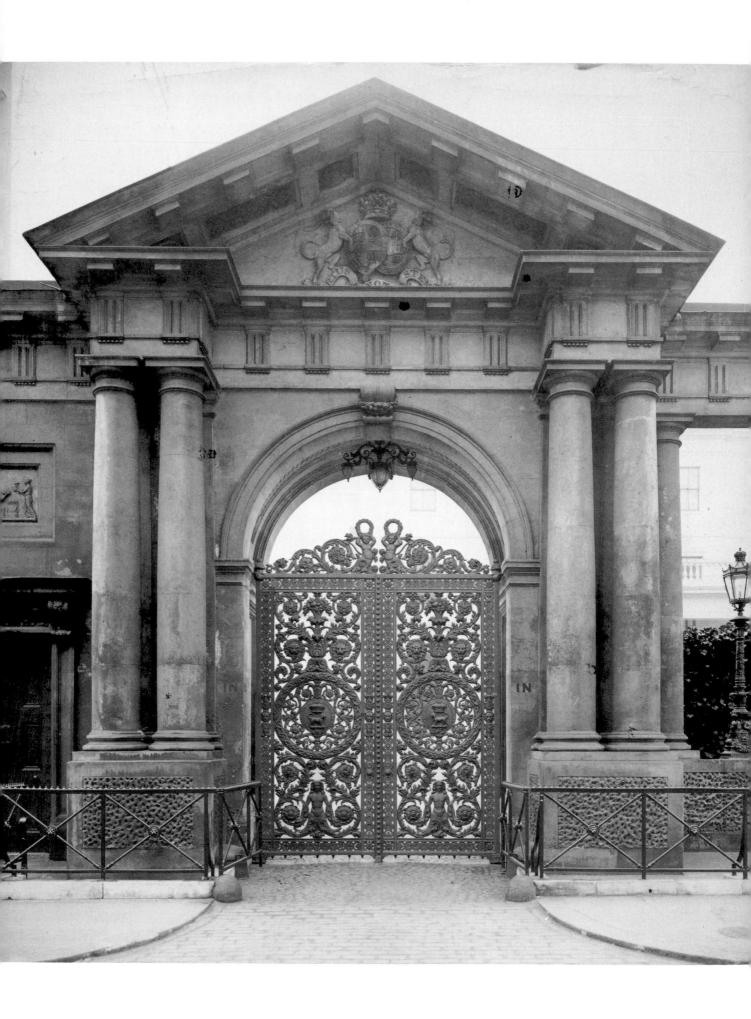

large convases, including several doubtful Raphaels. About Turner's 'Conway Castle' there could be no quibble. The vast paintings for which the Rubens room had been built were among the works of art which found their way to England after the Napoleonic Wars.

The collection in *Apsley House* was even more intimately related to that victory. That the Duke of Wellington was a remarkable man was well recognized in his time. His austerity of manner and conduct was a little hard on lesser mortals. At his death in 1852, a grateful nation sought absolution for its temcrity in occasionally throwing stones at his windows by according him the most elaborate state funeral an Englishman was ever given. One ingredient of greatness is a command of the unexpected. Arthur Wellesley was a discriminating aesthete. He left behind one of the finest art collections in London. Unlike others described in this chapter, it survives.

Like most long-lived private palaces the Wellington Museum, as Apsley House is now prosaically called, has gone through radical alterations. First built between 1772 and 1778 for the second Earl Bathurst (1714–94), it takes its name from the title, Baron Apsley, he had held before succeeding his father in 1775. At that time he was an undistinguished Lord Chancellor. The situation of the house was an open one; Apsley House was at the northwest extremity of London adjacent to the turnpike marking the boundary. Not surprisingly, it acquired the informal address 'No. 1, London'.

As befitted the semi-rural situation, Robert Adam built an unpretentious three-storey brick house, five bays square. The 1783 edition of the *Critical Review* remarks, 'Lord Bathurst's house is roomy and convenient within, which is all the merit it can claim.'[10]

The lease was bought from the third Earl Bathurst in 1807 by the Marquis Wellesley for £16,000. Having made a fortune in India, he proceeded to spend lavishly on his London house, which was extended by James Wyatt and Thomas Cundy. In 1817 Wellesley sold Apsley house to his young brother Arthur for £42,000.[11] For the following 35 years 'Wellington's house' was the usual appellation.

The Duke had just returned from France where he had been ambassador, and arbiter of the post-Napoleonic peace. He employed his former secretary, Benjamin Dean Wyatt, to alter and extend the house further. For some years there was talk of a Waterloo Palace in London, as well as one in the country on the lines of Blenheim Palace. Neither was built, though the nation did vote £200,000 for the purpose. The country estate of Stratfield Saye was chosen partly because it was centred on a rather humble house which was to be demolished to build something appropriate to the Duke – it has now become a second Wellington Museum.

The London house was by degrees made worthy to display paintings, trophies and decorations given by most of the monarchs and several of the parliaments of Europe. A 13-foot-high neo-classical statue by Canova of Napoleon as a naked Greek hero – disgorged by the Louvre and paid for by the Prince Regent – was installed at the foot of the main stairs by Wyatt in 1818. In 1819 he added the somewhat sombre dining room in the north-east corner; Waterloo banquets were held there in 1820–29.

Wellington's ascetic personal tastes were expressed in his private rooms. A narrow iron bedstead is as striking a testament of his character as the 90-foot Waterloo Gallery with its richly gilded ceiling, its walls of yellow silk damask, its 130 paintings. Here mirrors concealed in the wall-space

128 *Apsley House, Hyde Park Corner. Originally a modest red-brick mansion by Robert Adam, its position on the edge of town was marked by the turnpike*

127 *Grosvenor House. A massive stone and iron entrance screen added by Thomas Cundy in 1842. One of two carriage arches; the Grosvenor arms in the broken pediment*

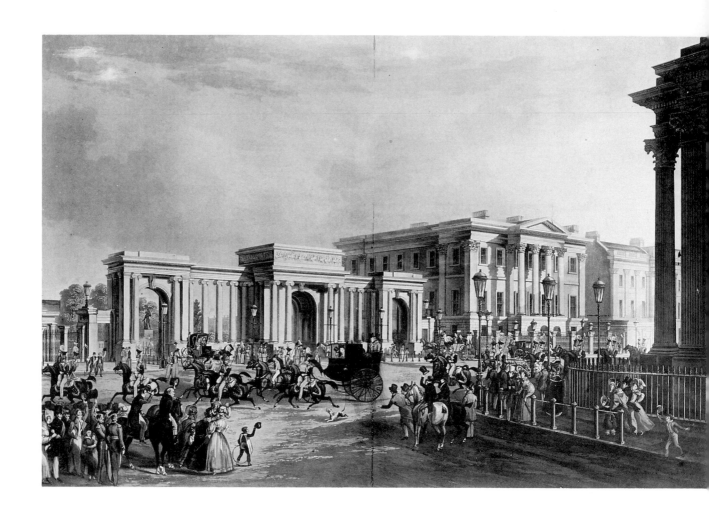

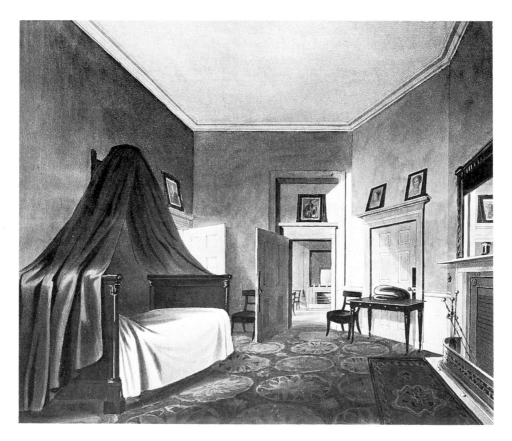

between windows slid in front of them at night. They reflected the chandelier and the two massive candelabra of grey Siberian porphyry given by Nicholas I of Russia. This gallery was part of the works carried out by Wyatt after 1827, when the duke had finally decided against building a new palace. Two drawing rooms were also created in 1828 out of Adam's bedroom and dressing room of the 1770s. They formed ante-rooms for the assembly of surviving officers from Waterloo before the anniversary banquet in the gallery. The walls are still lined with their portraits.

The exterior of Apsley House was transformed, enlarged by two bays and encased in Bath stone. The Corinthian tetrastyle portico and the warm buff of the stone do not alleviate the sombre gravity of a building which is little ornamented apart from a modillioned cornice and pediment. Even the railings, painted a reticent grey-green though elaborately embellished, have a neo-Greek restraint.

Wyatt was not building a 'country house', as the architects for Lords Burlington, Berkeley and Clarendon did further along Piccadilly a century or so earlier. The urbane, neo-classical coolness of the exterior which also characterized his Stafford House a few years later, was complemented by a heavily impressive interior. The *Louis Quatorze* style of decoration in the major apartments, such as the gallery and dining room, hall and staircase, contrasts with the remaining Adam interiors, in particular the delightfully graceful and delicate Piccadilly drawing room.

The French style did not discountenance the vanquisher of that country – what did put him out was the cost. His friend Mrs Arbuthnot, who had encouraged him in extravagance, joined in self-righteous indignation when Wyatt presented the accounts totalling £43,657 18s 6d. 'Mr Wyatt had just exceeded his estimate three times over and had made the sum so enormous that he did not know how to pay it and had seriously been thinking of selling the house . . .'[12] Mrs Arbuthnot railed against

Wyatt, but concluded that '. . . the house is so beautiful and as it will hold his pictures and all his fine things he must consider it as his Waterloo House and use part of that money'.[13] By 1831, £64,000 had been spent on Apsley House. The Crown freehold had also been purchased for £9,530.

Most of the outstanding paintings are displayed in the Waterloo Gallery. The position of the three large portraits above the chimney pieces was predetermined, their heavy frames being designed by Wyatt as part of the scheme for the room. They are the portrait of Charles I by Van Dyck, Queen Mary by Antonio Moro, and Rudolph of Hapsburg by Hans von Aachen. None of them rival the powerful Goya portrait of the Duke himself, but this was disliked by its subject and kept by him in store. Interestingly there are a half-dozen representations of Napoleon in the house, as well as of his brother, sister and wife.

The majority of the other paintings are typical of Wellington's catholic taste for most species of art, except the hedonistic and whimsical. His favourite canvas was 'The Agony in the Garden' by Correggio. This like several of the great Spanish paintings, including 'The Water Seller of Seville' and 'Two Young Men Eating at a Humble Table' both by Velazquez, were captured by Wellington at the battle of Vittoria in 1813. He offered them back to Ferdinand VII of Spain, but that monarch confirmed the Duke's right to the collection.

The second Duke of Wellington opened the house to the public on written request. In effect it became almost immediately a national museum. There were only minor changes until after the Second World War when the seventh Duke presented it to the nation. Nearby bombs and routine decay necessitated modest repairs completed in 1952. But a road built to the east, to continue Hamilton Place into Piccadilly, resulted in the splendid isolation of Apsley House today. A new east façade was built, and the forecourt 'rendered symmetrical'.

A mansion isolated from its inception, grander and more florid than Apsley House, but little known because it has less historic interest, is *Bridgewater House*. 'The hospital of St James was founded for leper maidens, in a lonely and desolate spot west of London.'[14] Henry VIII dissolved the hospital in 1532 and built himself a house. Faithorne and Newcourt's map of 1658 shows St James's Palace

129 *Apsley House was enlarged and refaced in stone for the Duke of Wellington. The style consorted with Burton's constitution arch and screen. Here the 'Iron Duke' is acknowledging popular acclaim. It was not always forthcoming*

130 *Apsley House. The Duke was as unmoved by vagaries of esteem as he was uninterested in personal comfort. His bedroom was stark*

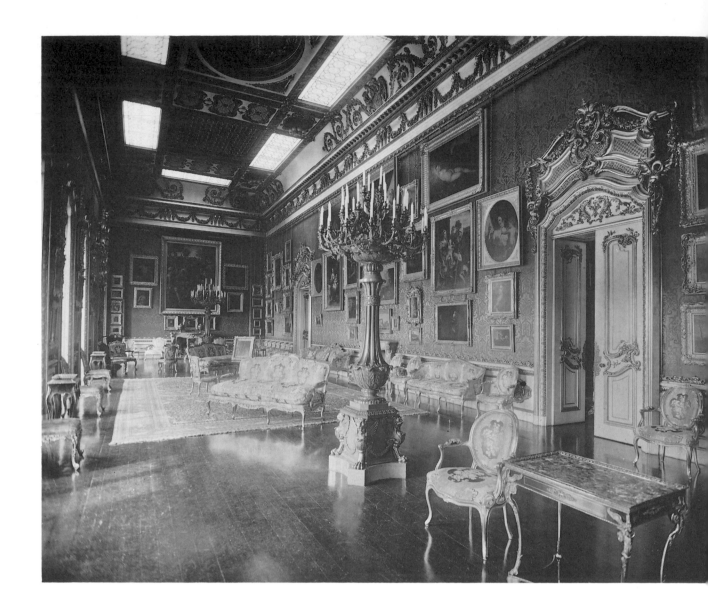

131 *Apsley House. The Waterloo Gallery, added in 1828 by B. D. Wyatt to display paintings, but particularly to accommodate the annual Waterloo banquets*

near-rural isolation, its large deer park separating it from Westminster to the south and open country stretching to the north, only divided by the lane from 'Knights bridge' into 'Peckadilly Hall' and by one mansion 'Barkshire house'. This building was almost part of the palace complex, its extensive knot garden running north–south near St James's Street.

Berkshire House had been built about 1626–7 for Thomas Howard, second son of the Earl of Suffolk, who had himself a year earlier received the Earldom of Berkshire. Occupied during the Civil War by Parliamentarian forces, the house became the resid-ence of the Portuguese ambassador in 1654 and the French in 1665. Records of fitting-up at the later date indicate an extensive building with 45 chimneys, the grounds of which included a vineyard. Charles II bought the house for his mistress, the notorious Barbara Villiers, Countess of Castlemaine. Created Duchess of Cleveland in 1670, she renamed the house which was also extended. It was a sumptuous mansion described by Evelyn as 'too good for that infamous *** [whore?]'. Having fallen out of favour, she took herself off to France in 1677 and probably did not re-occupy the house on her return in 1684.

After a number of changes of ownership and division of the property much of it was purchased in 1696 and 1700 by the Earl of Bridgewater. In the latter year he was succeeded by his son, Scroop

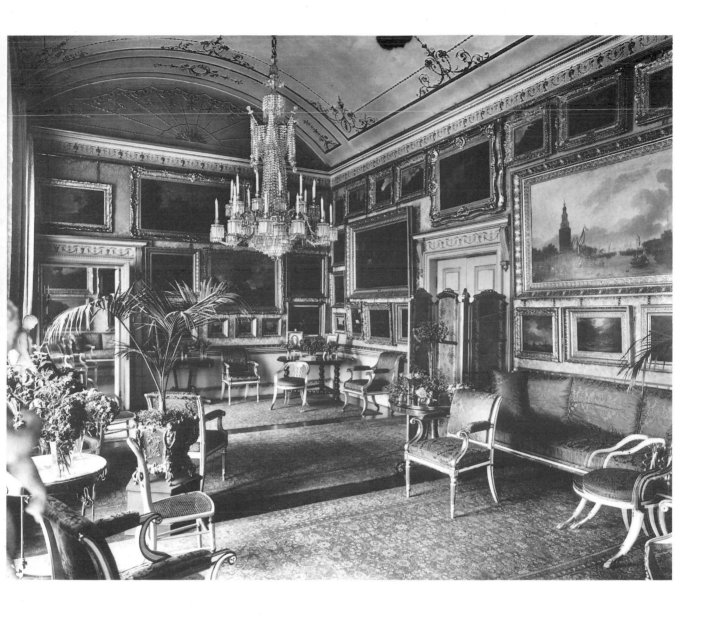

Egerton, created Duke of Bridgewater in 1720. During this time the house was variously known as Bridgewater or Cleveland House. Indeed parts were separately let for periods and were numbered as being in 'Cleveland Square'.

Frances Egerton, third and last Duke of Bridgewater (1736–1803) assembled a great collection of paintings and bought No. 3 Cleveland Square in 1795 to reunite that part with the house and to provide more display space. By 1795 he had virtually rebuilt the mansion transforming it from a large but somewhat formless seventeenth-century agglomeration into a unified design. James Lewis, the architect, was a rigorous neo-classicist.

In 1795 the Duke bought the Trumbull collection; three years later he participated in a spectacular deal whereby the Orléans paintings were

132 *Apsley House. The Piccadilly drawing-room was designed in 1774 by Robert Adam, it is one of the most attractive survivals from the earlier house. Here seen in* c. *1890*

obtained and divided between himself, the Earl of Carlisle, and his nephew Earl Gower. In 1803 the last-named Earl inherited mansion, pictures and plate.

Six months after inheriting from his uncle, Earl Gower succeeded his father as Marquis of Stafford. He continued building at Cleveland House, adding a large new gallery designed by Tatham in 1806 for the combined Bridgewater and Stafford collections. The nineteenth-century custom of rewarding the wealthy with ever grander titles resulted in his elevation to the Dukedom of Sutherland in 1833,

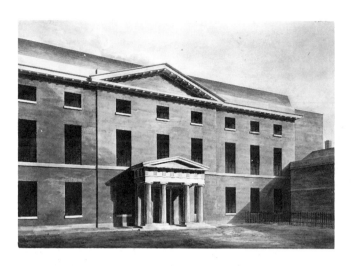

133 *Cleveland House, St James's. Converted from the Earl of Berkshire's residence into one for a royal mistress in the 1670s, it was altered again and given a neo-classical front for the third Duke of Bridgewater in the 1790s*

shortly before his death. His second son, Lord Francis Egerton (created Earl of Ellesmere in 1846), inherited Cleveland House. The core of the structure, the early-seventeenth-century Berkshire House, was greatly decayed. Apparently he had a fear of fire. In 1840 he decided to rebuild.

The appointed architect, Sir Charles Barry, was in the 1840s at the height of his fame as a masterly designer in both neo-Gothic and neo-classic modes. He was engaged upon the rebuilding of the Palace of Westminster in the first and had completed both the Travellers and Reform clubs in the second. A natural choice for the London palace of one of the richest of peers, in 1841, he exhibited a plan for a vast Italianate palazzo no less than 195 feet by 144 feet at the Royal Academy. The cost of that scheme was estimated at £68,696. That, and negotiations to enhance the site, meant that work on the building did not start in full till 1846, when Barry was limited to an expenditure of £30,000. The final plan form was not settled till 1849 when Barry persuaded his clients to spend an extra £4600 to transform the proposed inner courtyard into a central hall or saloon.

The picture gallery was completed in time for the Great Exhibition of 1851. It was opened to the public via a separate staircase attached to the north-east corner of the building. But the house as a whole was not ready for occupation until 1854. It

consisted of a 120 by 140 foot block of brick and stucco. Stone was limited to the principal (south and west) façades. Even so the original cost limit was exceeded by 50 per cent.

The design of the exterior, being without a major order of columns, was very 'modern'. Like Barry's Reform Club of 1837 it was an uncompromising statement, with deep relief and a heavily prominent eaves cornice. In both buildings we recognize the massive, brooding character of Sangallo's Palazzo Farnese in Rome, but Bridgewater House, which more nearly approaches the scale of the sixteenth-century prototype, is less effective than the Reform as an architectural statement. Its impact is reduced by a dissipating over-elaboration. Typical of this are the greatly emphasized quoins, vermiculated like the alternate stone courses in the six columns of the fussy entrance porch.

The ground floor is rusticated; the lofty principal storey is of fine ashlar, its windows crowned with richly carved segmental pediments. The chamber storey forms 'a frieze-like band of windows between panelled piers below the splendid *cornicione* and crowning balustrade'.[15] Above the corner quoins rise huge Jacobean-like chimneys. Venetian windows to the first floor of the wide end-bays on the park front are little more convincing and less stylistically explicable than on the north front of nearby Spencer House.

The Italianate interior is also a combination of Barry's masculine formality in plan and in certain spaces such as the barrel-vaulted entrance hall and main stair, with a contrary inclination towards almost decadent decoration. In the saloon this was carried out by the German decorator, Gotzenberger, who was appointed, despite Barry's protests, by the second Earl who had succeeded in 1857. The chief areas of his work – the spandrels of the lower arcade – have been painted over. The upper parts of this arcaded central space are the most exuberant features of the building. This is what the latter-day, partly *trompe l'oeil* saloon at Devonshire House was pretending to be. Marble-lined, the coving to the plaster and faceted glass roof is supported by almost full-sized nudes. It is of a Roman magnificence as well as depth and richness of colouring.

The ground- and first-floor corridors have arcades open to the saloon. The upper level balustrade is of alabaster on a green plinth with pedestals

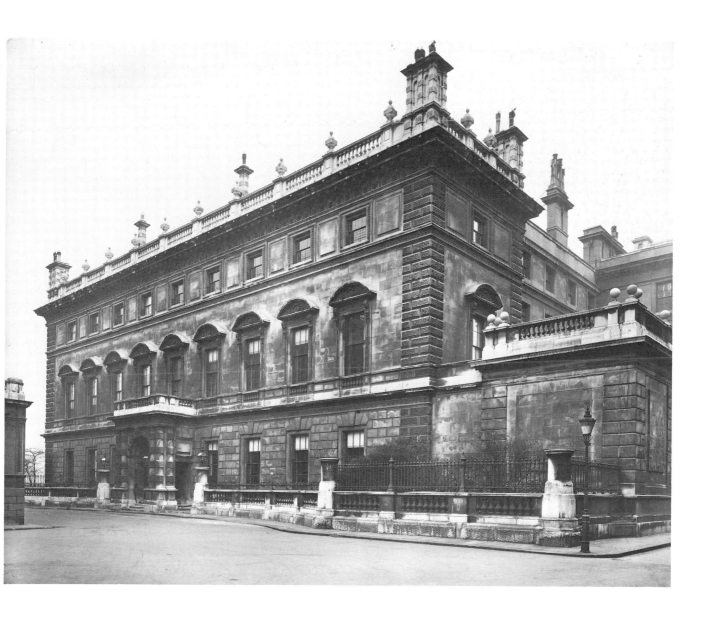

of red porphyry. Each bay on both levels has a saucer dome decorated as elsewhere in the style of Raphael's Vatican loggia. In the bays of the west corridor walls are inset carved marble reliefs by Richard Westmacott.

The principal rooms are on the upper level. Here the ceilings, doorcases and chimney pieces are in Barry's eighteenth-century French style. The dining room, with its Corinthian-columned bay to the wide Venetian window overlooking the park, is a vastly impressive apartment. Its walls are hung with red and gold embossed leather, restored as part of extensive works by new owners in 1984. The gallery was too extensively damaged to ever be fully refurbished. Only the scale of the room can be perceived. The Corinthian columns forming loggias at either end are partly replaced in concrete. No light falls

134 *Bridgewater House, Cleveland Row. In Barry's great mansion of the 1850s, built on the site of Cleveland House, the stonework is massively articulated, to the extent that the parts detract from the impact of the whole*

from the modern roof onto the long north and south walls where the pride of the great collection was hung. At the turn of the century there were over 400 paintings, plus 150 drawings by Ludovico and Annibale Caracci and by Giulio Romano, formerly owned by Sir Thomas Lawrence.[16]

The picture gallery itself contained six Titians, including 'Diana and Actaeon' (once in Charles I's collection) four paintings by Tintoretto including 'The Entombment' and 'Presentation in the Temple', and three of the six Rembrandts in Bridgewater House. Dutch paintings were also well represented

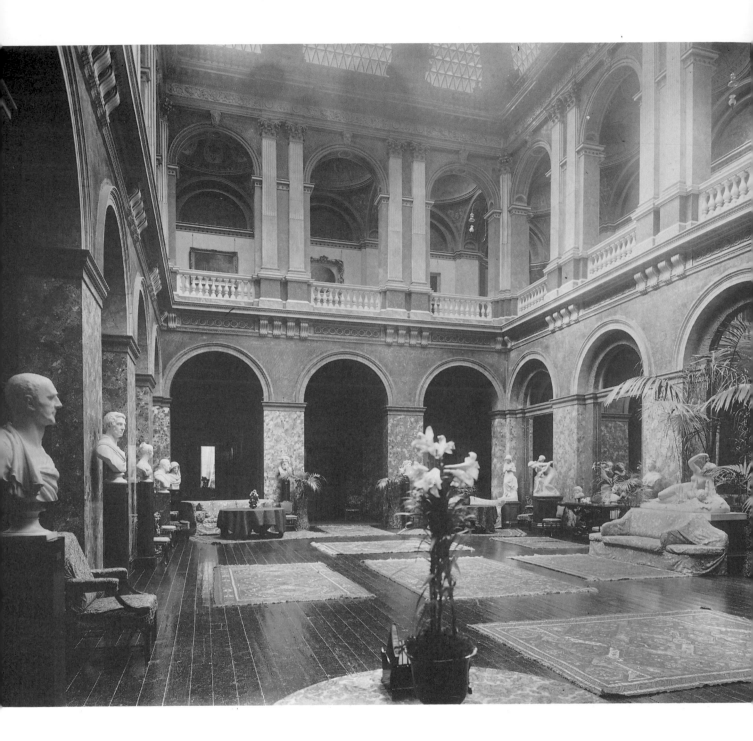

135 *Bridgewater House. Designed as a cortile, but roofed to provide one of the grandest spaces in any London private palace*

in a catholic assembly on the walls of the north drawing room – Ostade, Dou, Teniers, Jan Both – alongside Murillo, Hogarth, Velasquez and Pietro da Cortona. The state (or south) drawing room had a fine landscape by Cuyp and seascapes by Turner and Van der Velde, jostling with two splendid

Claudes: 'Demosthenes on the Sea Shore' and 'Moses and the Burning Bush'.

The ground-floor sitting room housed perhaps the outstanding paintings of this remarkable collection, including three Raphaels from the Orléans collection. Many of those catalogued in the sitting room – Correggio, Domenichino, Guido Reni, Claude, Salvator Rosa, Palma Vecchio and Luini – have found their way into international collections. 'Christ Carrying the Cross' by Domenichino, sold by Lord Ellesmere in 1947, is now in the Getty

136 *Bridgewater House. Behind the upper arcading to the hall, the ceiling consists of the most delicately painted saucer domes. The artist was Gotzenberger*

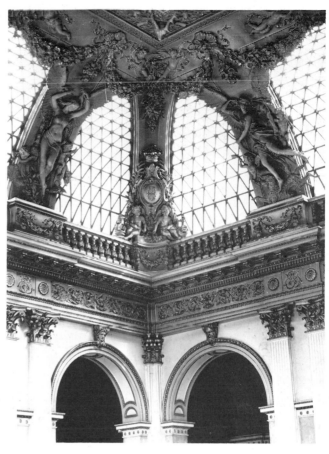

137 *Bridgewater House. The roof of the hall itself is an exuberantly invented and superbly crafted confection – and Barry was allegedly cost-cutting!*

Museum in California, for example. The extensive library, also on the ground floor, contained one of the finest collections of rare books in the kingdom. The sixteenth- and seventeenth-century representation was strongest, it included a four-folio Shakespeare.

After the Second World War the fifth Earl of Ellesmere sold Bridgewater House to the Legal and General Assurance Society who in turn let it to various major companies as offices. It masqueraded externally as Marchmaine House in the television series 'Brideshead Revisited'.

A few years after the completion of the Italian-style Bridgewater House, an equally large mansion in a French style was undertaken in Whitehall. *Montagu House* was built in 1858–9 on an historic site, that of York Place, the former palace of the Archbishops which came into the hands of Henry VIII in 1529 when he compelled Wolsey to surrender his properties. Around it had grown the royal palace of Whitehall, extending in Queen Elizabeth's time to over 20 acres. Various lodgings on the Montagu House site had been occupied by Prince Rupert, Sir Edmund Waller, the Earl of Lauderdale and Mrs Kirk.

If a ducal residence was to impose itself on its surroundings, sheer scale was the obvious means. The nineteenth-century Montagu House had few other distinctions as a building. Its story began in 1731 when John, Second Duke of Montagu had taken a lease of a site consisting of three former plots. By 1733 he had 'erected a large and substantial house with outhouses and appurtenances thereto belonging'.[17] From the distant views surviving, including Canaletto's of Whitehall, the building appears undistinguished. The site was soon extended and again ten years later to include, *inter alia*, the adjacent Thames foreshore between high and low tide. This latter was to improve the surroundings by preventing the tipping of rubbish at the water's edge.

The Duke was succeeded by his daughter, whose husband became Duke of Montagu in a new creation in 1766. Again a daughter came into the property in 1790. She had married the third Duke of Buccleuch which brought Montagu House into that wealthy family's possession. The site was once again

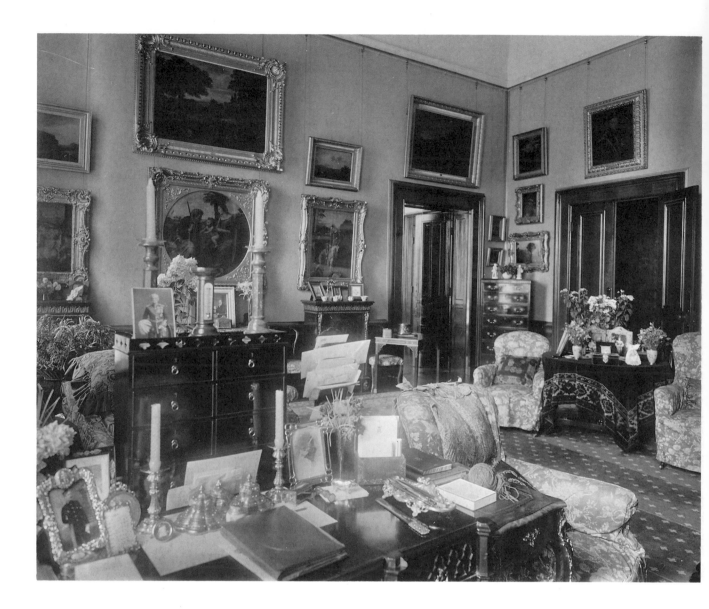

138 *Bridgewater House. Intimate sitting-rooms were crammed full of furniture and works of art. Lady Ellesmere's boudoir in 1890*

enlarged, this time with the addition of what had been part of the old Privy Garden.

A 61-year lease, granted in 1810, was surrendered in 1856 by the fifth Duke who wished to rebuild the house. Having obtained a new 90-year lease he demolished the old building, apparently re-using much of the old materials in the provision of extensive foundations, most necessary prior to the embankment of the Thames.

William Burn (1789–1870) was a Scottish country-house architect who had the sense to spend three early years' pupillage under Robert Smirke in London. Among his many aristocratic clients was the Duke of Buccleuch. He designed in a variety of styles including Grecian, 'Jacobethan', and Gothic, before evolving the 'Scottish Baronial' style of which his younger Scottish partner David Bryce was the greatest exponent. 'For his great patron the fifth Duke of Buccleuch he provided an appropriate forecourt to the seventeenth-century mansion at Drumlarig; a Jacobean conservatory and two Gothic churches at Dalkeith, an addition to Bowhill in the late Georgian style and a French Renaissance chateau in Whitehall!'[18] Mr Colvin adds that, of Burn's vast output 'not a single building stands out as a masterpiece'. His planning was renowned for convenience, for ensuring the privacy of the owner from both guests and servants.

Montagu House, one of the last and largest palaces, had the swagger its owner could afford, its

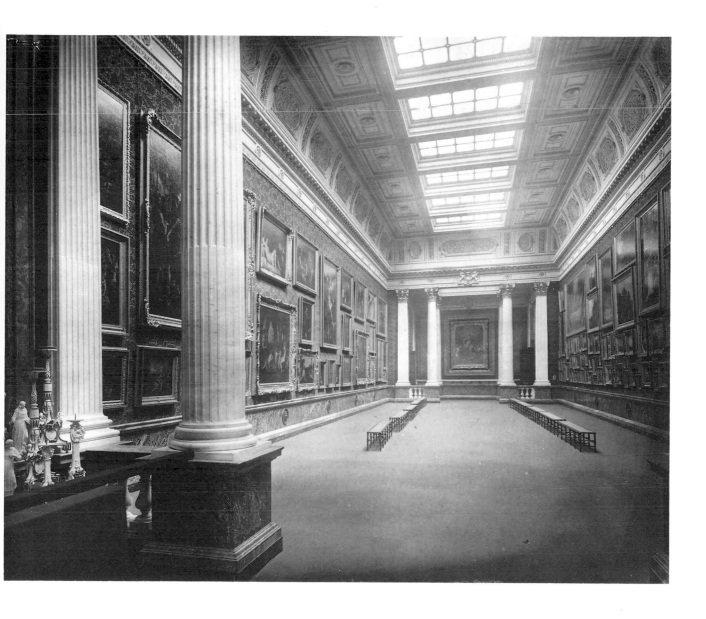

139 *Bridgewater House. The bulk of the great collection was displayed in the picture gallery. It was bombed in 1943 and never restored*

function allow, and the self-confidence of its period justify. Of superb-quality Portland stonework, the repetitive French-renaissance-style elevations complete with steep mansard roof, corner towers, high dormers and lofty chimneys could be a prototype for the nineteeenth-century grand hotel.

The principal rooms on the first floor were approached by a wide stone staircase. The saloon was an impressive space arcaded to the staircase side. It had state rooms leading off it with heavily coffered ceilings and curved cornices. The impressive mantelpieces were carved in marble or stone. There was much gilding and several ceiling panels of 'highly coloured amorous paintings' which must have diverted the toilers in the Ministry of Trade which took over when the Crown repossessed the building somewhat prematurely in 1917. Apart

from the saloon, the chief apartments consisted of the ballroom, the drawing room, the dining room and the Duke's sitting room.

For the half century or so of its heyday, Montagu House was greatly admired. 'The interior, both in decoration and contents ...', wrote Chancellor in 1908, 'shows that not only was money lavishly expended on its beautification, but that consummate taste and judgement were also exercised. Five great rooms: the Drawing Room, the Ball Room, the Dining Room, the Saloon and the Duke's Sitting Room, are particularly noticeable, not only for the beauty of their ceilings, which are alone things of

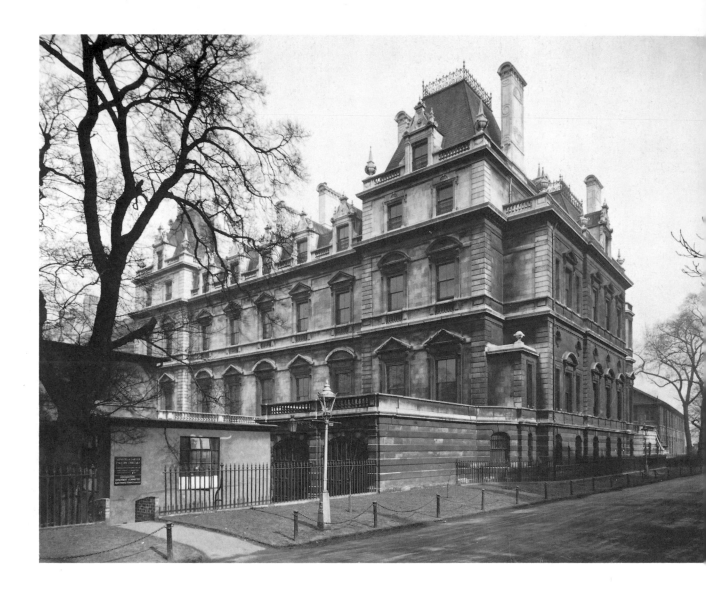

140 *Montagu House, Whitehall. William Burn designed an elaborate French-style chateau in 1859. One of London's last and largest palaces, it cost the then vast sum of £100,000*

joy in themselves, but also on account of the splendid furniture, the exquisite porcelain, as well as those masterpieces in half-a-dozen arts which we are accustomed to call *objets d'art*.'[19] Above all, he values the Van Dycks and the incomparable series of miniatures.

In the Duke's sitting room at the turn of the century was a motley collection of Italian paintings such as 'The Magdalen' by Guido Reni, some landscapes by Zucarelli, a number of English portraits by Dobson, Walker, Riley, Lely and Beechey. The most impressive portraits were of the heiresses whose marriages maintained the house's ducal connections: Lady Mary Montagu, daughter of the second

Duke and wife of the Duke by the 1766 creation (by Gainsborough) and Lady Elizabeth Montagu, Duchess of Buccleuch (by Reynolds).

In the Duchess's boudoir the pictures were, surprisingly, more austere, the work of Pourbus and of followers of Holbein. The drawing room contained major works by Rembrandt, including a self-portrait, one of his mother, and one of Saskia his first wife. Among landscapes were 'The Watering Place' by Rubens, and examples of the work of Poussin, Claude, Jan Boll and Van der Heyden. The anteroom displayed a portion of a Raphael cartoon, as well as the kind of religious paintings by Andrea del Sarto, Pietro de Cortona and Carlo Maratta favoured by the English aristocrat.

The 760 miniatures were unrivalled outside the royal collections. They hung in cases on the walls of the ballroom and gallery and represented the

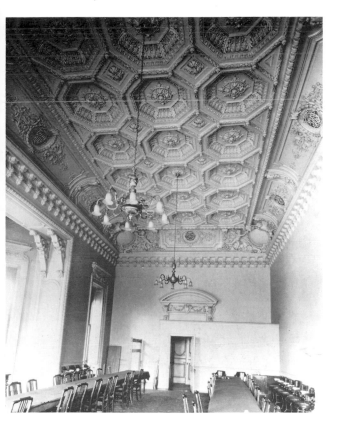

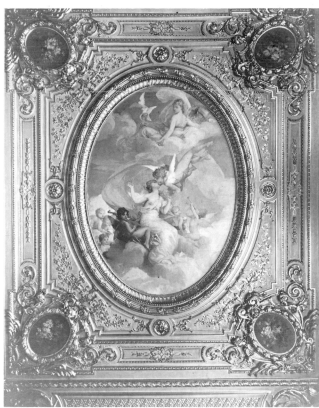

141 *Montagu House. After government occupation in 1917 this was known as the conference room. Every effort has been made to suppress and disfigure the opulence of the space*

142 *Montagu House. The bureaucrats did not get around to covering up the voluptuous painting and rich decoration of this reception room ceiling*

quintessential image of several generations. Holbein portrayed Henry VIII, and Hilliard painted Elizabeth and her Court. Isaac and Peter Oliver represented the reigns of James I and Charles I; Samuel Cooper extended the coverage from the Commonwealth into the reign of Charles II.

Dorchester House was only a few years older than Montagu and of almost the same date as Bridgewater. All three were private palaces on the grandest scale; four-square, lofty, and predominantly of the finest Portland stone. All were of classical style, Montagu being of French character, both Dorchester and Bridgewater Italianate. Vulliamy, like Burn and Barry, could turn his hand to most styles. The millionaire builder of Dorchester House, R. S. Holford, had him do a large 'Elizabethan' country house at Westonbirt in Gloucestershire. His design for Dorchester House was widely admired. Chancellor called it; '... the finest private dwelling in London, as well as London's most graceful and

beautiful attempt at modern domestic architecture'.[20]

In 1929 it was demolished to make way for the hotel. At the sale of fittings in August of that year there were no bids at all for many items. Two Louis XV chimney pieces of carved marble went for 16 and 27 guineas respectively. Enthusiasm for an arcaded and sculptured Italianate palace had utterly vanished.

The site had formed part of the manor of Hyde given by William the Conqueror to Geoffrey de Mandeville, but the story of the house began in 1751, when Joseph Damer built a mansion on 'Tyburn Lane'. In 1792 he was created Earl of Dorchester. The courtesy title of his son, 'Lord Milton', gave rise at the time to the derisive name 'Paradise Lost' for the isolated house. That son succeeded in 1798 but died in 1808. Bought by the third Marquis of Hertford, it was sold after death in 1842, to Captain Robert Stayner Holford.

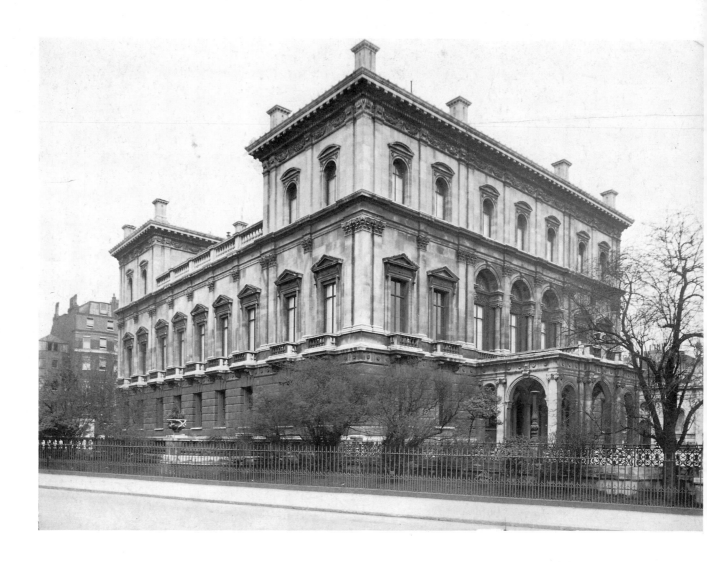

143 *Dorchester House, Park Lane. Built a year or two before Montagu House, this was Italian in inspiration. Built in the finest masonry to last for centuries, the exterior, with all its Roman ingredients, did not add up to a thing of beauty*

144 *Dorchester House. Here is the archetypal palace sequence from entrance to* piano nobile, *all in the marbles that only the nineteenth century could afford. The entrance hall decoration was Pompeian*

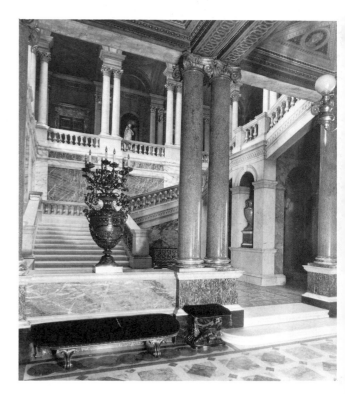

Lewis Vulliamy (1791–1871) was commissioned to design a palace. A rectangle 105 feet by 136 feet, it was modelled loosely on Peruzzi's Villa Farnesina in Rome. The shell was completed in 1857. But the features which aroused most artistic interest were not commissioned until 1859 – the decorations by the sculptor Alfred Stevens for the dining room and in particular the chimneypieces for the red drawing room and the saloon, as well as the woodwork of the doors on the staircase galleries. Stevens was ill in 1874 when he wrote promising the dining room chimneypiece. At his death the following year it had

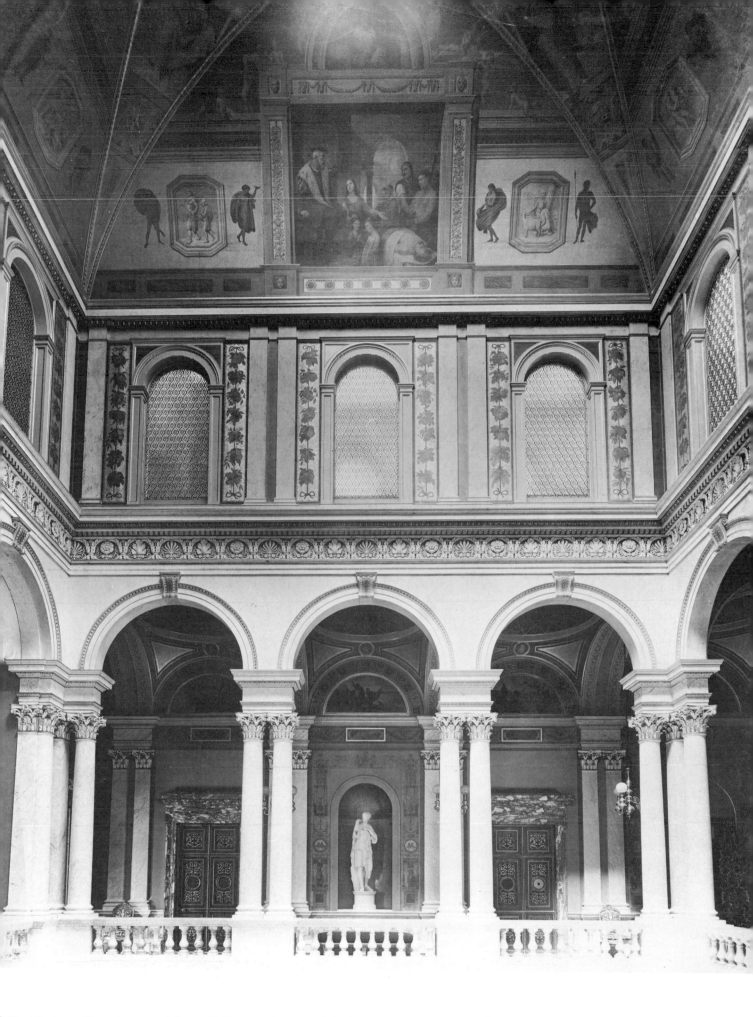

145 *Dorchester House. A vast arcaded central hall was much more convincingly evocative of the Italian Renaissance than that at Bridgewater House*

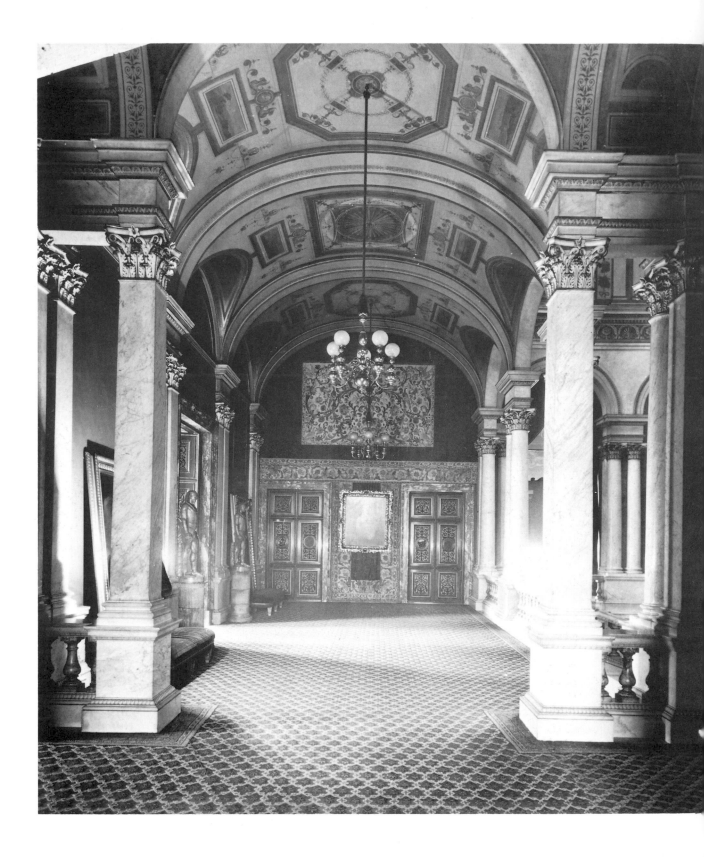

146 *Dorchester House. A first-floor corridor behind the hall arcade was designed more for the processions of nobles and retainers than the town house of a commoner*

147 *Dorchester House. Neither were the drawing-rooms designed for ordinary mortals*

148 *Dorchester House. The commissioning of a decorative scheme for the dining room from the heroic sculptor, Alfred Stevens, was an imaginative act of patronage by Mr Holford. Great resources were expended by this client – in the case of Stevens's work patience was the chief of these*

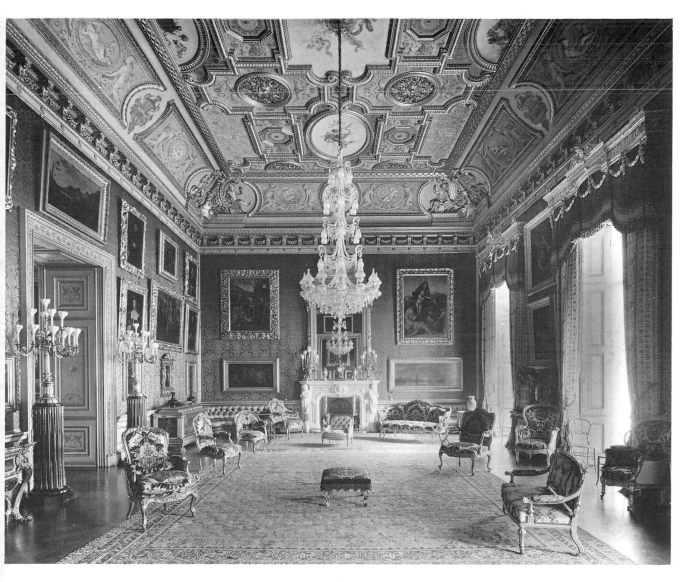

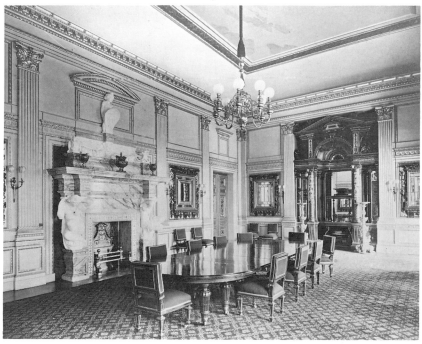

149 *Dorchester House. The dining room fireplace, when at last delivered and assembled by Stevens's successors, proved to be a work of sculpture worthy not only of this artist but almost of Michelangelo himself*

still not been delivered, although the marble supporting figures were released by the artist's executors.

Mr Holford was a great collector; he built his palace largely for the reception of the pictures he had assembled in the former residence of Sir Thomas Lawrence in Russell Square. The hugely ambitious white marble staircase was central. It led to a series of state rooms which were in effect picture galleries evolved from an arcaded upper-level corridor. These rooms, the saloon, green drawing room, red drawing room, and state drawing room, were intricately decorated in an Italian style to consort with the paintings, by Italian artists. To later eyes the interior, sumptuously impressive as it was, exhibited precisely that nineteenth-century hyperbole of scale and fussiness of unrelated detail which came to be held in contempt. Stevens's work, so often compared by his contemporaries to that of Michelangelo, was of a different order.

In the saloon there were splendid portraits by Velazquez, Rembrandt, Van Dyck, Bronzino, Murillo, Domenichino. There were landscapes by Gaspar Poussin and indeed by that fine English artist, Richard Wilson. The green drawing room contained several religious paintings including, apparently, a Perugino, as well as examples by Guercino and Domenichino. There were more portraits by Veronese, Tintoretto, Palma Vecchio, as well as the essential Reynolds and the similarly favoured groups of rustics by Teniers. The outstanding picture was considered to be the 'View of Dort' by Cuyp.

More Dutch and Flemish paintings were in the red drawing room, together with two Velazquez portraits and a Murillo. Formerly in Hamilton Palace was Hobbema's 'Water Mill' of 1663, for which Holford had paid the then large sum of £4,000. There was a fine Van Dyck, as well as a Rembrandt portrait of his son Titus.

After Holford, the house was occupied by the American ambassador. In the Great War, Dorchester House served as a military hospital. It never recovered its glory, which was that of an age when the owner of a London house could command the world's masterpieces of art.

VIII
After the Palaces

More than a handful of London's mansions have survived; some can be visited. The Wellington Museum is in Apsley House which, uniquely, still contains family apartments. Hertford House in Manchester Square is devoted entirely to the superb Wallace Collection of paintings, furniture and armour. The former Home House is occupied by the Courtauld Institute and can only be viewed by arrangement; that also applies to Marlborough House, the premises of the Commonwealth Secretariat. All these houses contain works of art and, in at least some rooms, furniture appropriate to their past.

Great houses used as offices by commercial firms tend to retain less of their internal character; those used by government departments almost none. Spencer House, in the first category, has fared better than most; Bridgewater, which has recently been lavishly refurbished, is splendidly palatial. Its bomb-damaged gallery will probably never be restored, while that of Dudley House, similarly attacked during the Second World War, has been repaired but subdivided into offices. Lord Wimborne's former mansion in Arlington Street has been the headquarters of an insurance company since soon after the war – ill-regarded, subdivided, its state rooms filled with desks and filing cabinets. Indeed demolition for redevelopment was only narrowly averted in 1960, the year that Bath House was lost with barely a protest. But now the mid eighteenth-century core of Wimborne House has been carefully restored, demonstrating that some major companies have realized that the fine rooms of an historic house can provide headquarters, at least as prestigious as the top floor of a skyscraper. The potential of Crewe House was not recognized by its commercial owners; the building has been sold for conversion to the Saudi Arabian embassy. It is to be hoped that it receives better treatment than did the Chinese embassy.

None of these buildings is usually open to the public, though some can be seen by appointment. Houses occupied by two other kinds of office user are even more difficult to visit: those used by professional firms such as lawyers, for whom the earlier, rather smaller type of mansion, such as Newcastle House, are ideal. Such buildings have been treated gently, at least in recent times. Houses long in government occupation, such as Dover and Gwydyr, provide witness to their former beauty only in the most indestructible parts such as entrances and staircases. Bureaucrats can be embarrassed by working in gilded salons. The contrary is the case when lavish entertainment, especially of foreigners, is seen as justified. Lancaster House could have been built for government receptions and international conferences.

Several West End clubs have found happy homes under the painted ceilings and chandeliers. Of the Lansdowne, the least said the better. The Oriental, which took over Stratford House in slightly more enlightened days, has cherished the older parts of

the building. Such clubs can generally make good use of the rooms designed for eighteenth-century routs, assemblies, dining and gaming parties. The Naval and Military actually had to increase the reception rooms of the former Cambridge House, though now the spaces are probably a little too lavish. The use of one of the more beautiful eighteenth-century houses, 44 Berkeley Square, as a gaming club is quite appropriate; in that context a sumptuous interior is at a premium and Lady Bel's lack of bedrooms no problem. Whereas for clubs providing accommodation for those gentry who, in the later nineteenth and early twentieth centuries, had given up their town houses, a large number of additional bedrooms were required. Such was the case with the Oriental. A more permanent and spacious town house surrogate was provided much earlier in the bachelor chambers of the Albany erected behind the former Melbourne House. The latter remains as little more than a facade.

Access to the surviving fragments of medieval houses, Ely House chapel, the hall of Crosby Place which finds itself beached like a surprised whale in Chelsea, and the Charterhouse, is less difficult.

The end of the great town house is usually associated with the First World War. Certainly several were vacated then and never re-occupied by their owners – the Dukes of Devonshire and Westminster, for example. Others had gone in the years 1908–12, including those in the Mall – Buckingham, Cumberland and Schomberg (in part), which had long been used by the War Office, and such private examples as Somerset, Camelford and Harcourt. Others, again, survived until about 1930 – Montagu and Pembroke, long engulfed in Whitehall and Dorchester, Chesterfield and Lansdowne, still in private hands until then. Portman House functioned in some style until bombed in 1940, Londonderry until bulldozed about 20 years later.

The process of physical destruction has been long drawn out. In a sense it has been continuous during the six centuries covered in this book. But the situation as the end of the twentieth century approaches is radically different from that in any other period. In the past destruction was part of a process of renewal and relocation. Now there are no palaces in private occupation, nor are there likely to be again. Such a radical change in the political, archi-

tectural, social and artistic life of a nation usually emerges over a long period. The end of the significance of the aristocratic town house was foreshadowed a century before the 1914–18 war.

After Waterloo in 1815, 'An aristocratic society with bourgeois leanings had become a bourgeois society with aristocratic leanings ...,' wrote John Summerson, and he went on to draw the architectural lesson, 'The time for an architectural élite serving an aristocracy and preserving fastidious academic standards, was already past. It was time for the general practitioner – and the general dealer in styles.'[1] Here was the real sea-change, whereas the new nobility of Tudor times evolved into a discriminating and often learned aristocracy, the nineteenth-century industrialist and entrepreneur, rewarded for the accumulation of wealth by the accumulation of titles, found himself in an age dominated by vulgar values and eclectic tastes. This could at best produce, as a reaction, a generation of Arts and Crafts enthusiasts, refined but outré, as far from the centre of power as Aldford House was from being a convincing town palace.

If the governance of the country ceased to be essentially aristocratic after 1815, a change which was formalized with the Reform Act of 1832, there was a similar time lapse in the habits of patronage. So often the greatest monuments of a society are built when its power is receding. So it was that Lutyens New Delhi was completed in the dying days of the Raj. So it was in the first half of the nineteenth century; a proud aristocracy at the centre of the dominant world power disposed of vast incomes. Pride and wealth were deployed in an effort to outdo the grandeur of Louis XIV. 'As they owned most of the furniture of the Old Court of France and had Benjamin Dean Wyatt to recreate Versailles in London, they were able to do this convincingly.'[2] The London Versailles par excellance was *Stafford House* (formerly York and latterly Lancaster House). This, like the other mansions described in this final chapter, fulfills a valuable function today.

In its day second only to Dorchester House in scale, and now the most palatial survival, this mansion also has the least altered setting, although the claims of Bridgwater House in those respects are also strong. Unlike its neighbour Marlborough, Stafford House was not ruined by later accretions,

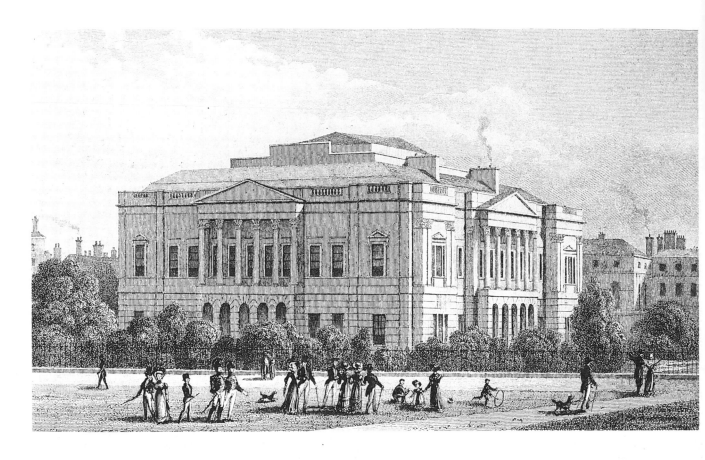

150 *Stafford (now Lancaster) House, Cleveland Row. This view from the west in 1828 shows the short-lived two-storey form of what was then York House. Even though a massive building there was more force in its composition than after the addition of an extra floor five years later*

although an early enlargement did somewhat reduce the effectiveness of the original design. As a result this building, though coldly impressive, makes almost no architectural impact on London. It was the work of many hands: the Duke of York and successive owners employed almost every eminent architect of the period to design, build, supervise, alter and extend the mansion. This meant that the rich interior was quintessential of an eclectic age. Its scale and pretension was princely. John Cornforth, not given to hyperbole, conclude that 'it is arguable that Stafford House was the only true private palace ever built in London, even if it did not surpass Versailles as Wyatt intended'.[3]

Frederick Augustus, Duke of York and Albany (1763–1827) was not more decisive in his residential decisions than in his military ones. It will be remembered that, having marched his 10,000 men to the top of the hill, he then changed his mind. Having exchanged his Whitehall mansion for that of

Lord Melbourne's in Piccadilly in 1792, he sold it in 1802 and took himself off to South Audley Street. In 1807 he settled in the seventeenth century Godolphin House in Stable Yard, St James's, shortly after it was vacated by the dying Charles James Fox. A neighbouring building was a library built by William Kent in 1736–7 for Queen Caroline. The Duke annexed this in 1815. Having become heir to the throne on the death of Princess Charlotte two years later, he determined to build himself a suitable palace on the site of the two buildings. Following his brother's example at Carlton House, he ignored a chronic lack of the funds necessary for the style of life he thought appropriate. No doubt the government would be forced to pay the bills in the end, as they had done with the Prince Regent. Robert Smirke was appointed architect in 1820.

Progress was slow at first. Site work seems to have started early in 1825; the foundation stone was laid on 27 June that year, and from then on the building was all set to rise rapidly. But the ever volatile Duke decided to sack his architect; influenced by his close friend, the Duchess of Rutland, he appointed Benjamin Dean Wyatt (1775–1852). The latter, having followed his cousin, James Wyatt (1746–1813) as

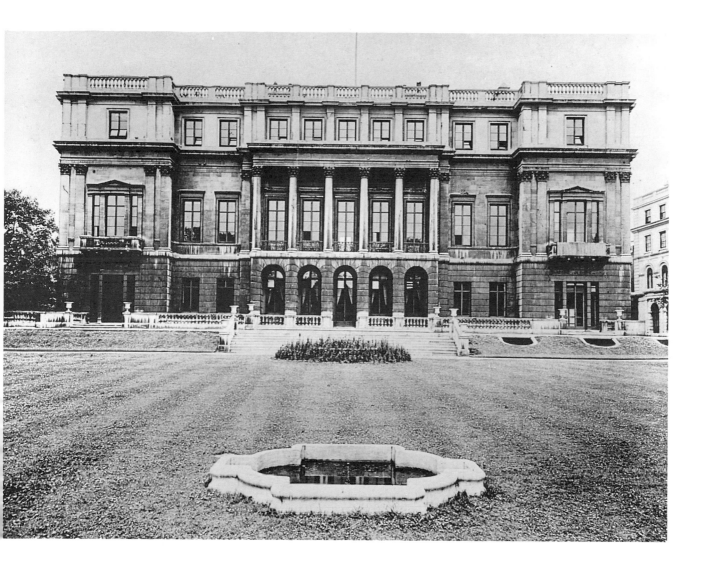

151 *Stafford House. The south front is considerably different from that visible on the right of illustration 150. The pediment has gone and a heavily balustraded floor of bedrooms added to accommodate the vast household of a nineteenth-century duke*

architect at one of the Rutland's country seats, Belvoir Castle, had been encouraged by the Duchess, a keen architectural patron, to produce alternative designs for York House. These were now preferred to Smirke's. That architect engaged in a furious public row, for his basic plan must have determined the shape of what was later called 'Benjamin Dean's masterpiece'.[4] It is most likely that the foundations and basement had been constructed and that the walls were well above ground level when the second architect took over.

The York House elevations were certainly Wyatt's. They have much in common with his re-facing of Apsley House, including the use of Bath stone and of the Corinthian order in two-storey porticoes. Yet the exterior of this large, four-square building has never elicited much admiration. In its original form, the shell of which was complete by 1827, Wyatt's design did have a certain confident

brio. A massive Burlingtonian exercise with a rusticated ground storey, arched beneath the south portico, it had a lofty *piano nobile* surmounted by a high entablature and parapet. The bulk, with its complicated projections at the centre and corner of each elevation, was unified under a steeply pitched roof in two stages.

Then everything changed. The Duke of York died in January 1827 in the Duchess of Rutland's house in Arlington Street. He left an unfinished palace, an unpaid architect, and debts of £200,000. The government paid off the mortgages on York House and sold a 99-year lease for about £72,000 to the Marquis of Stafford, one of England's richest

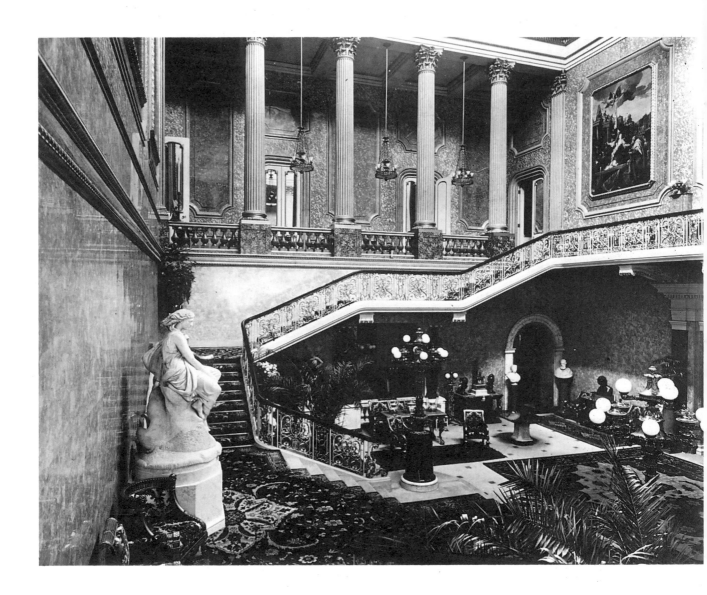

152 *Stafford House. The staircase hall was the first and largest such space in a London private palace. The top-lit stair compartment, common throughout the eighteenth century, has evolved into the ceremonial central core of the building. Here it is 80 feet square and 120 feet high. Constructed by B. D. Wyatt, it was altered and its decorations completed by Sir Charles Barry*

peers and the late Duke's largest creditor. He was created Duke of Sutherland in 1833, the year of his death. The second Duke, who had a large family, set about adding an attic storey and completing the interior of Stafford House. The architect was again B. D. Wyatt, assisted, but not too strenuously, by his feckless brother Philip. This weighty extra storey, more a chamber floor than an attic, was flat-topped and, on the principal elevations, balustraded. It destroyed the dynamism of the design. At least at Marlborough, Home and Burlington

Houses it was a different and later architect who did the damage. Indeed that was partly so here too, for the Duke called back Sir Robert Smirke to supervise the work – an arrangement which, not unnaturally, led to discord and inefficiency.

The interior, however, was the wonder of the age, and mostly Wyatt's work. The huge state rooms outdid in pretension any other London palace, even that of the monarch, as Victoria when visiting her neighbours was wont to remark. The great glass entrance doors were only opened for state occasions or royal visitors. They led, via a coolly classical entrance, to the central staircase hall – 80 feet square and 120 ft high to its central lantern. The walls, marbled in a not particularly attractive *giallo antico*, were relieved by white marble Corinthian columns. Large canvases set into them were painted with copies of Veronese compositions on religious

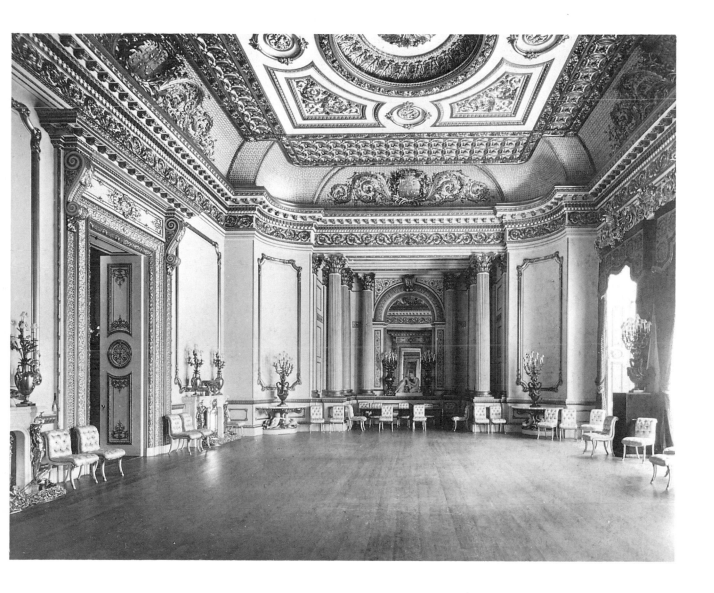

and allegorical themes, chosen for their visual im-
pact rather than for their coherence or relevance.
These, the upper wall decorations and the final
form of the large glazed lantern, were the result of
alterations by Charles Barry, another architect
brought in to the job in 1838.

The first-floor state apartments, the drawing
rooms, the ball-room (sometimes called the music
room) and the gallery, were decorated in white and
gold, often against a background of red or green
fabrics, in a style usually called *Louis Quatorze*. Ben-
jamin Dean Wyatt was chiefly responsible for in-
troducing this to London, originally in the Apsley
House gallery of 1828–9. It was partly an invented
style, many of the decorative details being evolved
by the designers as they went along. So while the
main elements may be characterised as being of
Louis XIV type, many of the richly elaborate motifs

153 *Stafford House. In the ballroom we see all the elements of the gold
and white style then thought fitting for England's imperial grandeur. It
was employed at Buckingham Palace too*

applied by Messrs Jacksons were in the freer, more
rococo vein favoured in the time of Louis XV and
even Louis XVI. The flamboyant concoction can
hardly even be embraced in the American term
Tous-les-Louis, though it is probably the aptest, for
Pevsner speaks of it as being 'Baroque' which 'may
be Venetian, or of the Louis XIV kind, or mixed'.[5]
The design work for such schemes was emphasized
in court in 1838 when Wyatt was attempting to
obtain payment of his fees of £1772. One reason for
the total of 2851 days expended was that three times
as many drawings were required at Stafford House
as had been needed for similar work at Windsor

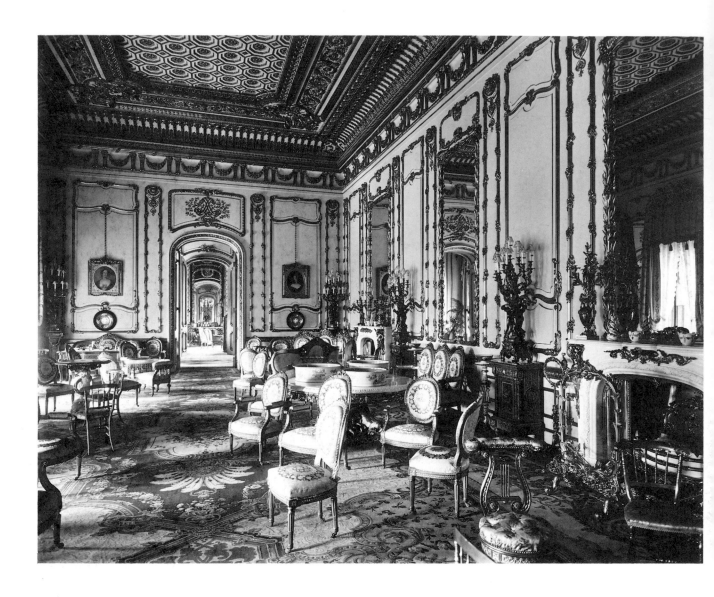

154 *Stafford House. In the state drawing-room, decorated by Wyatt in 1835, the rather lighter* Tous-les-Louis *mode of decoration is employed. Of such features as the rounded doorways Pevsner speaks of 'the general looseness of the reins of classical discipline'. The* enfilade *is, nonetheless, impressive*

Castle, according to William Payne, who had been principal assistant to Wyatville at the latter between 1828-32 and to Wyatt at the former thereafter.[6] Apart from the complication of the style and of the involvement of Smirke, there was continual and uninformed interference from the clients who would return from Paris loaded with ornamental objects to be incorporated in half-completed rooms.

The technique of the wall decorations was only partially that known as *boiserie*, since it involved the addition to runs of wooden mouldings of enrichments cast in a putty composition. Motifs were generally naturalistic as in the pier glass frames in the green drawing room which were decorated with bullrushes and ivy. So lavishly were the coffered and coved ceilings ornamented and gilded that, unlike the walls, there was almost no plain surface visible. Morant's bill for painting and gilding exceeded £16,000 which was more than that of both plaster contractors combined.[7] By 1841 the house had cost the Sutherlands £270,000, including the purchase of the lease – a figure which today would have to be multiplied about 30 times. By then Sir Charles Barry had overseen completion – B.D. Wyatt's career having ended with the court case, despite his total vindication.

Furniture and pictures were consonant in grandeur with their surroundings in both the regal halls of the *piano nobile* and the family apartments on the ground floor. These sitting rooms, dining rooms and

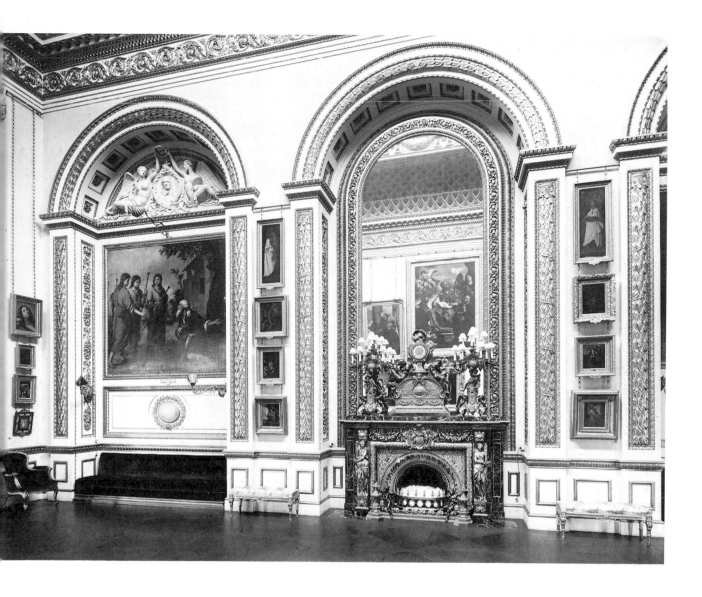

155 *Stafford House. Part of the Orleans Gallery, so called because it contained much of the Duke of Sutherland's collection formerly owned by the Duc d'Orleans. 132 feet long and 32 feet wide, it has been called the most magnificent room in London*

libraries would in most other houses be state apartments. Precision regarding the pictures in these rooms, and even in the house as a whole, is impossible, not only because of the unreliable attributions, but also because of the frequent changes. H. B. Wheatley's list in *London Past and Present* of 1891 differs markedly from Chancellor's descriptions of 1908, but as the latter said in regard to discrepancies between his and another list (a private catalogue of 1898) paintings had been brought from Trentham, another Sutherland home, partly to replace those recently sold at Christie's. The latter had included works by Rubens, Van Dyck and Murillo as well as the English painters Lely, Kneller, Romney and Lawrence. Even then the collection exceeded 300 canvases by such painters as Raphael, Titian, Tintoretto, Velasquez, Rubens, Van Dyck, Watteau and Murillo. Its core was a fourth part of

the Orléans collection brought to England after the French Revolution and divided between the second Duke of Bridgewater and his nephew, Earl Gower, later Marquis of Stafford and Duke of Sutherland.

Such a great house of ceremony was the scene of many balls and receptions starting in 1835, before its completion, and continuing up to a coronation ball for George V and Queen Mary shortly before its sale in 1912. Whig, later Liberal, politicians met there, as well as the leaders of many progressive causes – Garibaldi, Lord Shaftesbury and William Garrison, President of the American Anti-Slavery Society – were fêted in Stafford House. But even that

did not preclude the Tory Disraeli acquiring a familiarity with the place, which he described minutely as 'Crecy House' in his novel *Lothair*. The entertaining which so impressed these famous men depended on the architectural impact of the fine staircase, its columns based on those of the chapel at Versailles, the great state rooms to which it gave access, and the attentions of a large staff. In 1841 Smirke enlarged the attic to provide additional staff accommodation. A glimpse of the time may be obtained from the fact that in 1842 the 54 permanent staff salaries only consumed about £1500 of the Duke's £90,000-a-year income.[8] In 1912 the long Sutherland occupation ended when Sir William Lever, later first Viscount Leverhulme, bought the mansion and renamed it Lancaster House, after his native county. The following year he donated it to the nation to be used for government hospitality and to provide a home for the London Museum. The latter moved to Kensington Palace in 1950 and Lancaster House was refurbished by, among others, Messrs Jacksons. That company found the original boxwood moulds, and the old recipe for the paste of whiting, linseed oil, resin and gum was re-employed to repair the rosette and network decoration in the cove of the gallery ceiling and elsewhere. The house was resplendent once more in time for the coronation banquet of Elizabeth II.

If Stafford House, as it was known through virtually its whole domestic occupation, was famed for a palatial interior which also displayed splendid works of art, *Hertford House* provided a barely adequate setting for a princely picture collection. Maribone Gardens – a good duck-shooting neighbourhood – was developed as Manchester Square in the 1770s. It took its name from George Montagu, fourth Duke of Manchester, who occupied virtually the whole north side. Manchester House was built by Joshua Brown between 1776 and 1780. It was, so the *Critical Review* of 1783 remarked, 'a structure in favour of which very little can be said. It is too small and trifling for a detached and insulated building, and seems besides to be the composition of whim and caprice. It is ornamented without producing any effect either at a near or distant view.'[9] In 1788 the Duke died, and soon afterwards his mansion was leased to the Spanish government for an embassy. An embassy chapel was built by Bonomi. The embassy is recalled in the

name – Spanish Place – of the street to the east of the house.

The ambassador's tenancy lasted only until 1795, the turbulence of the Napoleonic wars perhaps being significant – or perhaps the reason was that the house, though nice, was 'sadly out of the way', as Lord Palmerston opined.[10] In 1797 the lease was taken up by the second Marquis of Hertford. During this period the Prince Regent was a frequent visitor; he sat in the oval drawing room and flirted with the Marchioness.

The second Marquis extended the house by adding two first-floor rooms on the originally single-storey wings either side of the five-bay house. He also built a first-floor conservatory outside the Venetian window in the wide central bay; this involved moving the Doric style portico forward. These changes, as seen in a Wallace Collection archive drawing of 1815, did little to improve a house which was never particularly handsome.

The third Marquis let the house as the French Embassy between 1834 and 1851. Guizot described it in 1840 as 'a large building between a little gravelled court and a damp garden with a handsome ground floor well arranged for official and ceremonial purposes, but bare and inconvenient in the first storey for domestic life'.[11]

Being of loose morals and an artistic bent, Lord Hertford travelled a great deal. He added to the collection already assembled by his predecessors, buying works of art in Paris, where relics of the old régime were still readily available. In 1842 he died in Old Dorchester House, Park Lane. The fourth Marquis was the real collector. His agents scoured Europe for furniture and pictures. For a generation his huge wealth dominated the sale rooms almost like the Getty foundation in later times. His purchases filled three London houses – Hertford House, Piccadilly and St Dunstan's Lodge, Regent's Park – apart from the Manchester Square house. He also maintained two Parisian residences. Indeed he lived chiefly in France and died there, unmarried, in 1870. His illegitimate son and legatee, (Sir) Richard Wallace, wisely decided to remove the works of art from France and the possible depredations of the Commune. He renamed the property Hertford House and commissioned the architect Thomas Ambler to extend and alter the building to house the combined collections.

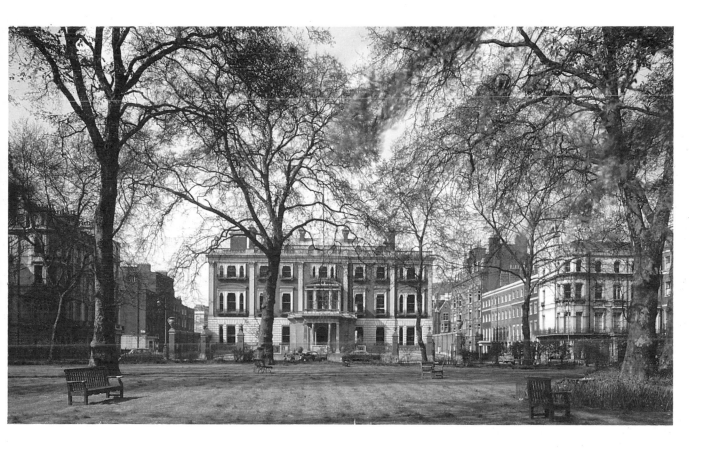

Between 1872 and 1875, Ambler built round three sides of the courtyard with domestic offices, stabling and coach houses at the rear and in the west wing. In the east wing he created an exotic Minton-tiled and part-arcaded smoking room whose chief function was to display paintings by Canaletto and Guardi as well as part of the armour collection. Most of the upper levels on all three sides were occupied by top-lit galleries. Ambler was responsible for the external appearance of Hertford House which has survived. It has very much a French flavour – quite appropriate in that both the fourth Marquis and Sir Richard Wallace lived most of their lives in Paris and are buried in the Père Lachaise cemetery. The east and west parts of the main façade were raised to the general height. Ambler also changed the external finish from stucco to brickwork and modified the conservatory.

Wallace did not change the character of the collection. He added arms, armour, majolica, but only a few paintings. It has a more particular character than any other assemblage of art of international standing. It breathes the air of Arcady and of the civilized sensuality of later eighteenth- and nineteenth-century France, epitomized in Boucher,

156 Hertford House, Manchester Square. It dominates the north side of the square, which was the usual pattern, despite the fact that the private gardens of the mansion faced north. The house is the undistinguished result of a number of changes and additions made to accommodate an ever-growing art collection. The four central Corinthian pilasters were there on the Duke of Manchester's original house of c. 1780

Lancret and Fragonard. The enigmatic smiles of 'The Laughing Cavalier', of 'Nelly O'Brien' and of Rembrandt's 'Titus' and on the faces of the figures in Poussin's 'A Dance to the Music of Time' more than hint at the ephemeral nature of life.

The impermanence of joy is also epitomized in the career of Richard Parkes Bonington. He worked in France and was much admired there. His vigorous, almost impressionistic seascapes influenced later paintings. His work is better represented here than anywhere. He died aged 26 in 1828.

When Lady Wallace bequeathed much of her husband's collection to the British Nation she was fulfilling a wish first expressed by the Marquis of Hertford in 1867, and which her husband had first discussed with a typically ungracious Treasury in the 1880s. The half of the collection remaining in France was finally sold to the dealer Seligman in 1914.

Lady Wallace, who was French, had been unattracted by English civilization and its capital, yet the terms of her bequest ensured that her husband's memory be perpetuated as an adornment of both. The government had to agree to provide a special museum in central London to house a collection which was to remain unaltered and to be called 'The Wallace Collection'. Typically the government now did what it had declined to do 20 years earlier, and bought Hertford House from the estate. The museum was opened in 1900 by the Prince of Wales.

In a competition for London's less attractive surviving mansion buildings *Crewe House* would vie with Hertford House. Both their sites are highly favoured, Hertford facing south over a square, Crewe also facing south but behind a unique private garden, commonly described as an 'oasis' of lawn and trees. Here, behind the plain stucco façade with its unsightly additions, its stripped-down detailing and its over-large windows, are the vestiges of a pleasant mid-Georgian house.

The north side of Curzon Street was quite open in the late 1740s. As can be seen from Rocque's map of the period it consisted, apart from waste land, of the gardens of two mansions then being built. Lord Chesterfield's at the west end faced the park, and a smaller house for Edward Shepherd faced the May Fair chapel on the already more developed south side.

Recent researches[12] show published accounts of the origins of Crewe House to be mistaken. Shepherd did not build an earlier house on the site; he built the core of the present building. It was not for his occupation but a speculation like many of his enterprises; thus he was not living on the site in 1708, nor did he die there in 1747. In fact the Curzon Street house was incomplete at the time of his death which took place in his house in Shepherd Market.

Edward Shepherd (d. 1747) was an architect/builder at a period when the first term was imprecise. His chief aristocratic client was 'Princely' Chandos, for whom he worked at Bridgwater and Bath, after having overseen the completion of the great and shortlived mansions at Canons. He also build two houses for the Duke on the north side of Cavendish Square, where the Chandos town mansion was to have been built. Later he speculated

on his own account, building Shepherd Market in 1735 and at his death was said to be its owner and 'of many other buildings about Mayfair'.[13] He designed in a debased Palladian style, but was one of the first to group together several houses behind a front composed like that of a great palace with a central portico and other large-scale incidents. His most impressive, though incomplete, demonstration was on the north side of Grosvenor Square, where he built Nos. 18–21 in the years 1727–30. Like John Wood in Bath at about the same time, his ground floor was rusticated and upon it he erected an attached portico of six Corinthian columns. But unlike Wood he built in brick and stucco, rather than stone.

Such was the original appearance of the substantial house being built on a comparatively obscure site in Curzon Street at the time of Shepherd's death. An arched and rusticated ground floor supported four Ionic columns attached to the two upper storeys and crowned by a pediment decorated with a cartouche and swags rather like the Grosvenor Square pediment, though smaller.[14] The house was then of five bays, the single ones either side of the centre being wide, but with only one window on each floor above the Venetian windows at ground level. The whole façade was probably stuccoed and painted; the Rate Book of 1747 refers to the 'white house'.[15]

Having been started in 1746, the house was completed by Shepherd's widow in 1748, when she formalized a 999-year lease from Sir Nathaniel Curzon, the ground landlord. Her tenant was a Richard Holmes Esq. In 1753 Elizabeth Shepherd sold the lease to the second Viscount Fane, who then negotiated a new agreement with the Curzons for a site which more than doubled the 60-foot frontage. This achieved, he enlarged the mansion by the addition of two bow-fronted side wings. He died in 1776, his widow stayed on till 1792. She was followed by Lady Reade, for whom in 1813 Sir John Soane probably carried out some minor alterations. His lecture diagram, drawn by R. D. Chantrell, now in the Soane Museum, is labelled 'for Lady Reade's house', and shows a building essentially like that of today.

The chief mutilations to the house were of later periods, chiefly by the Marquis of Crewe and Thomas Tilling Ltd. A tall office wing has been added at the rear, a square porch to the front and,

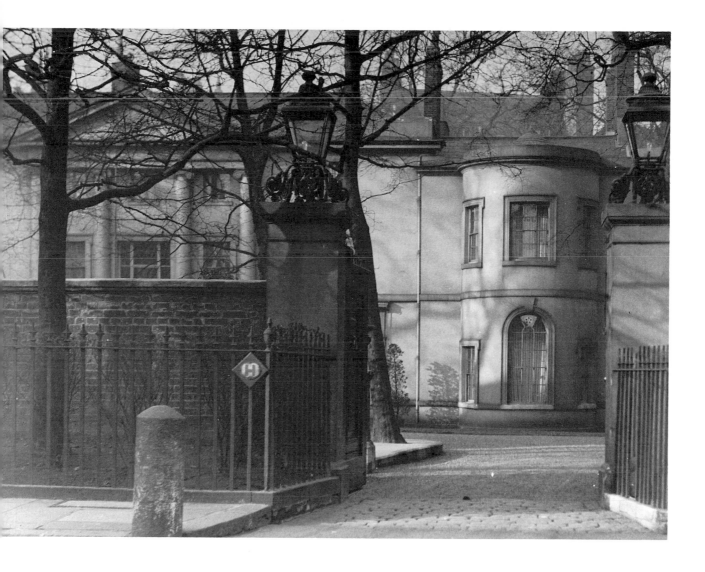

157 *Crewe House, Curzon Street. Built 1748 as a speculation. Mutilated outside and in, its chief importance is that it survives as a detached mansion in Mayfair – though the front wall has gone*

worst of all, the windows have been increased in size and number and the whole robbed of articulation by the removal of ornament. So the pediment is bare and the Venetian windows stripped of the 'Gibbs Surrounds' of alternately small and large blocks which would have complemented the rustication of the centre. Changes to the interior have been even more drastic, if that is possible; now it is essentially of the twentieth century. The east wing, which is the least altered, does contain a boudoir of 1908 with door achitraves probably dating from the original house. The most impressive space is a large drawing room created for the Crewe family by combining two former rooms in the 1930s. Further investigations, perhaps during building works, might bring to light more of the original fabric. Canted walls in the basement suggest that there was once an octagonal staircase above.

The house continued to change hands. In 1818

a long occupation by the Stuart Wortley family began with James Stuart Wortley MP, who was created Baron Wharncliffe in 1826. Wharncliffe House was the name of the house for the remainder of the nineteenth century. A Tory politician of some distinction, being appointed Lord President of the Council in 1841, he was most interesting as the editor of the *Works* of his grandmother, Lady Mary Wortley Montagu. The last of this line to occupy the house, a soldier who was created first Earl of Wharncliffe in 1876, sold it to Earl of Crewe in 1899 for £90,000. The former Robert Milnes, a Liberal politician, he became Marquis of Crewe in 1911. He held many ministerial offices. Crewe

House became a focus of Liberal Party gatherings in the early years of this century. The beautiful second Marchioness, the daughter of the Earl of Rosebery, was a famed hostess. She initiated lavish interior redecorations. At one of her dinner parties Winston Churchill met his future wife. During the First World War the Ministry of Propaganda under Lord Northcliffe was housed here. Frank Kellogg, the American Ambassador, took up residence during Lord Crewe's term as British Ambassador in Paris from 1922–28. Private ownership ceased in 1937 with the occupation of Crewe House by the Thomas Tilling Group. This ended when that conglomerate was taken over by another in 1983. In Summer 1984 the house and adjacent buildings were bought by the Saudi Arabian government for its Embassy, at a price of £37 million.

A mixed, but in part happier fate has befallen another mansion in post-war use as a company headquarters. *Wimborne House*, No. 22 Arlington Street, is now apparently to be called Kent House, so enthusiastic are its owners and recent restorers, Eagle Star Holdings, about the architecture. This alone indicates a welcome revolution in taste since the same company fought hard against the preservation of the building a quarter-century ago. William Kent's responsibility was only recognized in 1959.

The deceptively large site of Wimborne House was also among the most desirable. As the author of the *New Review of London* wrote in 1728 'That side of Arlington Street near the Green Park is one of the most beautiful situations in Europe, for health, convenience and beauty; the front of the street is in the midst of the hurry and splendour of the town; and the back is in the quiet simplicity of the country.'

Most of St James's Fields being already laid out, Charles II granted six acres to the north-east of that estate to Henry Bennet, Earl of Arlington in 1681. The latter was best known as being in the CABAL ministry of 1667; he appears earlier in these pages as the builder of Arlington House, which eventually became Buckingham Palace. If, as is frequently stated, Lord Arlington sold the property almost immediately to a Mr Pym, it is a little mysterious that the streets developed after the granting of a licence to build in 1686 should be called Arlington and Bennet. Whatever the precise ownership, Arlington

Street rapidly became an aristocratic and political address. The Duchess of Cleveland moved there in 1691, when shortage of funds obliged her to leave Cleveland House. Lady Mary Wortley Montagu was another well known resident. Sir Robert Walpole lived there in 1716–32; then he moved into No. 10 Downing Street. On losing office he returned in 1742, albeit to another and smaller house later to be occupied by his son, Horace. So when Henry Pelham bought No. 22 from William Pulteney, Earl of Bath, in 1740, he was among fellow aristocrats and politicians.

Pelham, who was George II's first minister from 1743 to 1754, died a commoner but was related to much of the aristocracy and even distantly by marriage to his predecessor in office, Robert Walpole. His wife was the daughter of the Duke of Rutland, his older brother, Thomas Pelham-Holles, Duke of Newcastle, held office for many years and kept court at his Lincoln's Inn Fields house. He even succeeded Henry Pelham as Prime Minister in 1754.

William Kent was appointed to rebuild the mansion. The site being so deep, the main block was set back behind both a forecourt and an inner courtyard. Passing through the gates in the iron railings the visitor came first to a low, three-bay building of yellow brick with rusticated window surrounds. A central door took him into an entrance hall, and thence a vaulted arcade, which was open to the court on the south side, led him to the house itself. The elevation, partly concealed by this link, comprised a handsome three bays of brickwork with stone dressings and was not unlike No. 44, Berkeley Square. Arched ground-floor windows, lofty pedimented first-floor ones and square – not this time false – chamber-storey windows, lighted the large rooms of a house which was much deeper than Lady Bel's.

There are three principal rooms on the ground and first floors, the two at the rear having bow windows facing the park. The front door, being at the side of the elevation, allowed a large 'dining

158 *Wimborne House, Arlington Street. Here is the second 'great room' Kent designed for this house. The painted ceiling, with its rich Italian renaissance coves and coffers, can be seen reflected in the mirror. The 1902 photograph shows what was then called called the red drawing-room as redecorated for Lord Wimborne*

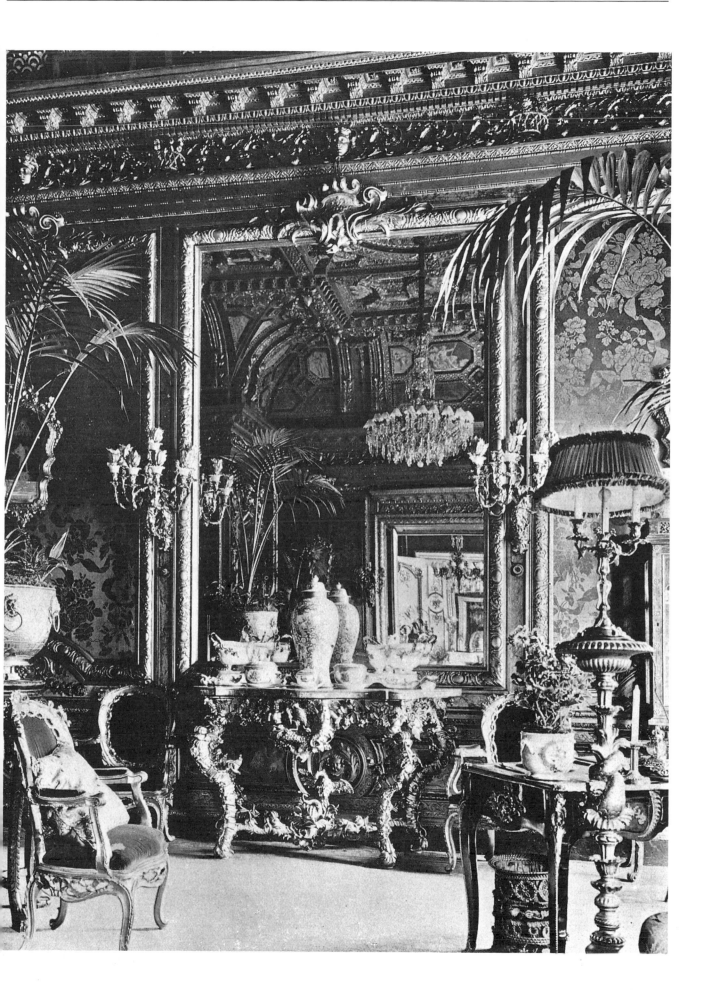

parlour' alongside it. Above this and facing on to the courtyard was the original 'great room', a typical and impressive Kent drawing room in white and gold. At the first floor rear was Mr Pelham's main bedchamber and dressing room. In the centre of the house a staircase hall, with a skylight, a first floor screen of columns and fine plasterwork, had many of the features but little of the subtle drama of the Berkeley Square essay.

Pelham seems to have realized from the beginning that this house would be barely adequate, especially for the levées, and 'cabinets' of a Prime Minister.[16] As early as 1743 he had bought Lady Codrington's house immediately to the south. In 1745 this was demolished and her ladyship moved to No. 18. The courtyard and forebuilding was extended. The combined site now approached half an acre in size, but at first the only new accommodation was another new great room overlooking the park. This was at ground level, but its height extended through much of the first floor to allow for a vaulted, coffered, panelled and gilded ceiling of the Berkeley Square type. With an apsidal bay window and a recessed centre on the opposite wall, the room was larger and had a more complex plan than its predecessor. Nor was it painted by Kent himself, for it was incomplete at his death in 1748; but the grey-white grisaille figures on red and blue panels were very much in his vein. The house was finished by Kent's former assistant, Stephen Wright. This was barely achieved when Henry Pelham died suddenly, having caught a chill while walking in the park just before the general election of 1754.

The house was leased to Earl Gower while William Chambers was building Gower House, Whitehall. Then in 1768 it was let to another Prime Minister, the Duke of Grafton, until 1775. While Pelham's grandson, the Earl of Lincoln, was in residence from 1775-8, Wright repaired and modernized the building. Some heavy friezes and entablatures were replaced in a lighter, more Adamesque mode. Political occupation resumed in 1780-7 in the person of the fourth Duke of Rutland. Briefly in Lord Shelburne's cabinet, he was dispatched by Pitt to Ireland. Then for a decade Lord Eardly was in residence. He was immensely rich and, although an inconsequential politician, was rewarded for his loyalty to Pitt with an Irish peerage. Incorruptible himself, Pitt saw the need to retain loyalties. He

also needed to pack the House of Lords occasionally. At this time a new dining room was added alongside the old one.

In 1798 Lord Camden came to live at No. 22 Arlington Street; he made few significant changes in 40 years. But the seventh Duke of Beaufort was another matter. Beaufort House, as it became known, was transformed. As Marquis of Worcester he had been *aide-de-camp* to Wellington, but having succeeded to the dukedom in 1835, his interests extended well beyond the military. Renowned for his courtly manners and sporting enthusiasms, the Duke was also concerned to redecorate his London house in the latest fashion. His architect was Owen Jones, but the predominant influence seems to have been that of the fresco artist Eduardo Latilla. Of the latter's startlingly bright colouring we can only guess; the character of his designs can be gauged from a surviving photograph of the entrance arcade, which was by then closed in. The styles of the various rooms were eclectic, some being medieval.

The house changed name again in 1853 when the Duke of Hamilton bought it for £60,000. He also transformed its appearance, this time under the direction of the elderly Scottish architect, William Burn. He was renowned as a deviser of plans, an achiever of privacy in the larger and more hierarchic households of the mid nineteenth century. Now the basement, which extended over the whole site, apart from a couple of necessary light wells, contained nearly 40 rooms. Here was hierarchy too, from servant's hall and kitchen up to groom of the chamber's room and down to housemaids' rooms and mangling and brushing rooms. That there was a steward, as well as the usual three principal servants - the butler, housekeeper and cook, each in charge of a department - meant that it was a particularly grand household requiring an overall manager of the finances.[17] The basement, while providing rooms for the principal servants on the garden side, and for the footmen who had to be in earshot of the front door, was separated from the attics where most of the servants slept, by three family floors.

As it happened the Duke of Hamilton and his Duchess, the former Princess Marie of Baden, spent most of their time abroad. Nevertheless Burn made substantial changes to the exterior of Hamilton House as well as to its internal workings. He unified

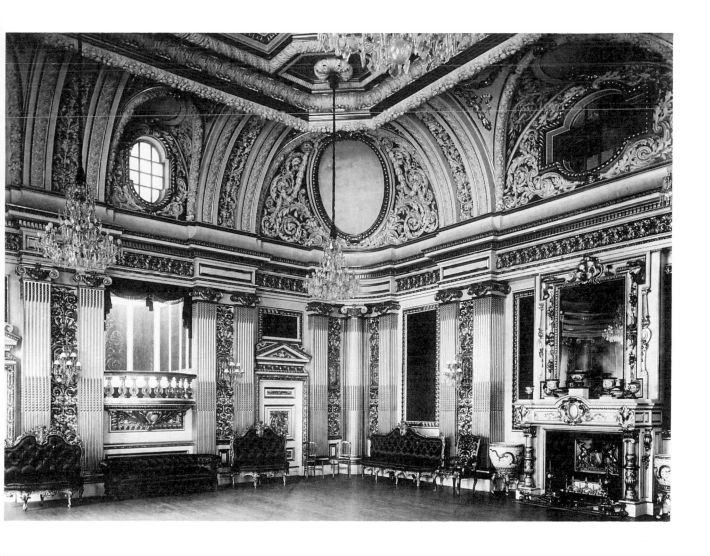

159 *Wimborne House. The ballroom was also used for concerts. It was an addition by George Trollope and Sons for Lord Wimborne in the 1880s*

the main entrance by imposing a *porte-cochère* across the centre of the previously rather dualistic twin façades of the forebuilding. Its Tuscan-columned weight added a more luxurious touch, as did to a smaller degree the iron balconies and enlarged windows on the park front.

The Duke died in 1863. His son sold the house in about 1870, the buyer representing the last family to live there. Sir Ivor Guest's money had come from a Welsh iron works; his mother had been Lady Charlotte Bertie, only daughter of the ninth Earl of Lindsey. He married a daughter of the seventh Duke of Marlborough. He was at various times a Liberal and a Conservative politician. His first contribution to the house was the almost inevitable ballroom. Extremely opulent, with coupled Ionic pilasters supporting a deep entablature beneath a high coved ceiling, it was not unlike a crude version of Kent's second great room. The builders George Trollope and Sons were also responsible for the de-

sign here and elsewhere in the mansion. They swept away all vestiges of Owen Jones work. The interior was French in character: heavy and elaborate, with boiserie panelling filled with French-style furniture, as well as mirrors, paintings, chandeliers, ferns and grasses and tables covered with expensive clutter. Wimborne House was the quintessential late-Victorian palace. Amidst all this were some superb paintings by Hogarth, Van Dyck, Reynolds and Boucher, among others.

Guest was created Baron Wimborne in 1880. At that time there were famously lavish entertainments at the house, especially for the politically and musically distinguished. All four of Lord Wimborne's sons were Liberal politicians; Freddie Guest, the third eldest, was private secretary to his cousin

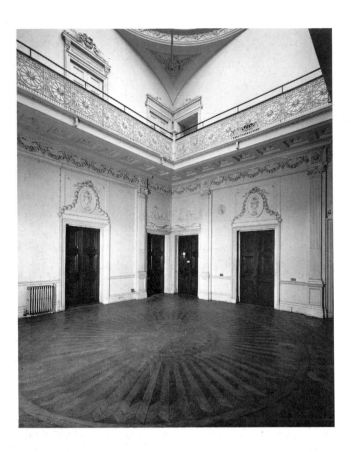

160 *Bath House, Piccadilly. An undistinguished exterior allowed an unmourned demolition in 1960, yet the plasterwork in the central hall was very fine*

Winston Churchill at the Colonial Office in 1921. The first son, Ivor, had succeeded to his father's title in 1914, having been created a peer in his own right in 1910. The family firm had been amalgamated with Keen and Nettlefold interests; the successor company GKN is a multi-national engineering concern capitalized at over five hundred million pounds. During the First World War Lord Wimborne was Viceroy in Ireland, maintaining a vulgar regal pomp even at that time. Nonetheless he continued in the post till 1918, despite being totally baffled by the Easter uprising of 1916 and other troubles. On his return to England he was made a Viscount.

There were some post-war simplifications to both the plan and the appearance of Wimborne House: the conservatory – latterly known as the winter garden – was demolished and the courtyard below it reduced to basement floor level. But the house, with much of the internal clutter removed, was grander

than ever. The basement and ground floor, both occupying almost the whole site, covered an acre of floor space between them. Unusually, the ground floor was the principal one, and by adding a library in front of the ballroom and inserting double doors in the centre of two walls formerly occupied by fireplaces, an *enfilade* of 166 feet through six rooms on the south side of the house stretched most of the way from Arlington Street to the park.

The western culmination of this parade, the great room with its Italian high-renaissance ceiling as interpreted by Kent, was now given a vast French sixteenth-century fireplace and doorcases of similar origin. This effective evocation of the hall of a château was somewhat marred when the visitor glanced through the bay window on to Green Park. Other apartments were variously treated, some in Lousi XVI style. Some, such as Kent's earlier great room on the first-floor front which was converted into Lord Wimborne's bedroom, had much of their Palladian character restored. Even the Victorian provision for guests and servants was inadequate, so extra bedrooms were added at the Arlington Street end of the house. Finally, Wimborne's friend, Sir Edwin Lutyens, designed a weighty classical screen to go in front of the forecourt, although this was not built.

In 1931 Viscount Wimborne was elected President of the new National Liberal party. His house was the setting for receptions on the eve of the State Opening of Parliament analogous to those held by the Tories at Londonderry House. There was another kind of rivalry between the two mansions – in the extravagant grandeur of the chatelaines; Lady Londonderry's diamonds were famed, and Lady Wimborne was known for her expenditure on clothes – once she was shocked that it was 'only' £10,000 a year which she was being accused of spending. In the artistic sphere Wimborne House certainly excelled, its musical evenings being graced by the Waltons and Sitwells.

The second Viscount, on the other hand, spent little time there. In the Second World War most of the place was occupied by the Red Cross. In 1947 it was sold for £250,000. The building was refurbished as offices and used as such from 1950. Demolition was again proposed in 1957, but halted by a 1959 Preservation Order which was largely based on the discovery of Kent's involvement. Almost

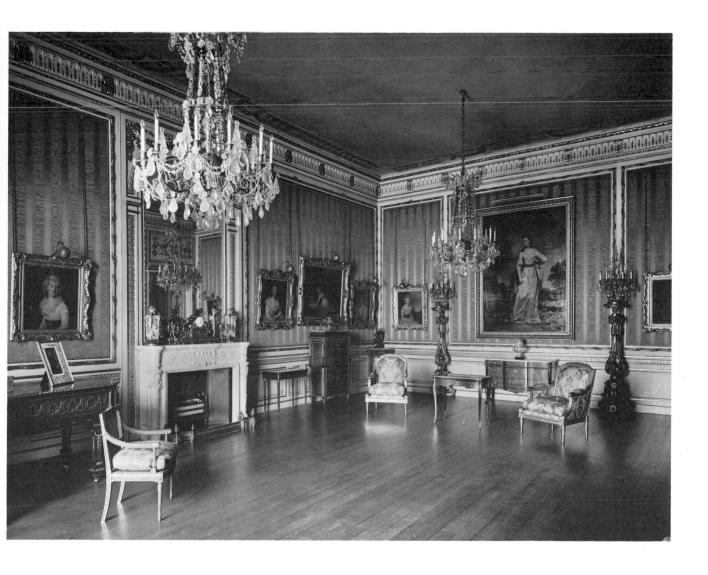

161 *Bath House. The yellow drawing room in 1911; the house was then occupied by Sir Jules Wernher*

endless negotiations with planning authorities re-sulted in permission in 1976 for demolition of all but the original Kent house at the park end of the site. These were then restored to something like their mid eighteenth-century form, while retaining some later features.

Bath House in Piccadilly was not so fortunate. Its original architect, Giacomo Leoni, an almost exact contemporary of Kent, was not distinguished enough for his name to secure a reprieve in 1959. In any case little or nothing of Leoni's house had survived. It had been built in 1735 for William Pulteney, Earl of Bath, from whom Henry Pelham had bought his house in Arlington Street five years later. As a politician Lord Bath was known for his bitter opposition to Robert Walpole's ministry. Horace Walpole, naturally predisposed toward his father, later wrote that grass grows 'just before my Lord Bath's door, whom nobody will visit'.[18] The

detailed appearance of the house built in 1735 is unknown, though some relevant Leoni drawings do exist at Cliveden. It was a Palladian exercise not unlike Queensberry House built by the same archi-tect a dozen years before. Its gardens were much more extensive than those of that mansion, how-ever, stretching almost to Curzon Street and had 'a stone basin of water in the centre'. The general verdict was dismissive; 'the house was in no way remarkable' according to *London Past and Present*.[20]

In 1821 Bath House was rebuilt for the banker, Alexander Baring. His architect, Henry Harrison (*c.* 1785–*c.* 1865) had a considerable practice 'of minor country houses and parsonages . . . he built or altered many town houses in the West End of London', as

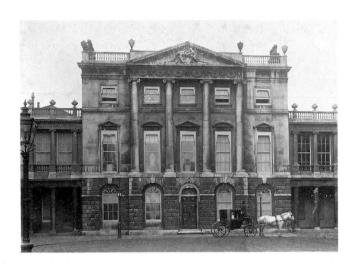

162 *Derby (ex Stratford) House, Stratford Place. In c. 1900 the elevation of this comparatively small house was in its transitional form, with one extra storey added to the colonnaded side-wings*

Mr Colvin tells us; he also mentions 'the rather tame Greek Revival style which he favoured in the 1820s'.[21] Externally unimpressive, it comprised a three-storey yellow-brick box with a bowed centre. Modest height allowed the central hall to extend through the house to a shallow, partly glazed dome. This apartment also had fine plasterwork and here was more than a touch of grandeur. Baring was created Lord Ashburton in 1835; his house was thereafter often known by that name.

Lord Ashburton's was 'a noble collection of works of art, selected with good taste and at great expence'.[22] The list included works by Titian, Giorgione, Veronese, Caracci, Domenichino, Guercino – these latter two perhaps being more highly regarded then than now – Velasquez, Murillo, Rubens, Van Dyck, Rembrandt, Metzu, Jan Steen, Ostade, Cuyp, Rysdael, Hobbema, Holbein, De Hooch – and those are just some of the attributions Wheatley regarded as firm. The Leonardo de Vinci and Correggio he was less sure about. Two of the most celebrated were Ruben's 'Wolf Hunt' of 1612 and Rembrandt's 'Lieven von Coppenol'. The word 'noble' was not misapplied.

A detached Piccadilly mansion, facing Green Park, was attractive whatever its architectural inadequacies. In 1900 it was purchased by Sir Julius Wernher, the financier. Extensive remodelling of the principal rooms was carried out in the *Dix-*

huitième style. After the Second World War the house was neglected and was replaced in 1960 by a commercial building designed by Lewis, Solomon, Kaye and Partners with their usual flair and sensitivity.

If the survival of a Piccadilly mansion was unlikely in 1960, one in Oxford Street would have had even greater odds against it. But it was then that *Stratford House* found salvation in new owners. This building encapsulates most of the themes discussed in these pages. Situated near good hunting country north west of London, it was for many years the property of the City Corporation. At the head of an important water supply conduit, the City acquired pasture land called Conduit Mead, where it was determined in September 1565 to make 'a good hansom room ... for the receipt of the Lord Mayor and their Company at the time of their yearly visitation and for the hansom dressing of their meat'.[23] Having decayed, this building was demolished in 1736. The site continued to graze cattle until 1771, then a petition to Common Council from the Hon. Edward Stratford sought a building lease to develop a small square. This having been granted he was able to name his mansion on the north side of Aldeborough House, on succeeding to his father's title in 1778. The Irish earldom was one of several created the preceding year.

The second Earl's architect was Richard Edwin (d. 1778) a former pupil of Matthew Brettingham Junior. Edwin was in his early twenties, so, not surprisingly, the design owed a lot to the leader of architectural fashion, Robert Adam. A 'longitudinal elevation' showed at the Academy in 1774 resembled Adam's recent development in Portland Place. Some of the three-storey houses had attics. They were completed piecemeal. The western range, being partly over the old river, was not finished until 1793, long after Edwin's early death in 1778. Only then were the gates installed between the lion-topped sentry boxes, which ensured a degree of privacy.

Aldeborough House itself was of five bays which survive, although later enlarged. A strong, rusticated and arched ground storey supports a portico of four attached Ionic columns in front of two storeys of plain ashlar. This centre block remains largely unaltered, but the side wings were originally only single-storey, fronted by loggias of four Tuscan columns each side, and surmounted by an entabla-

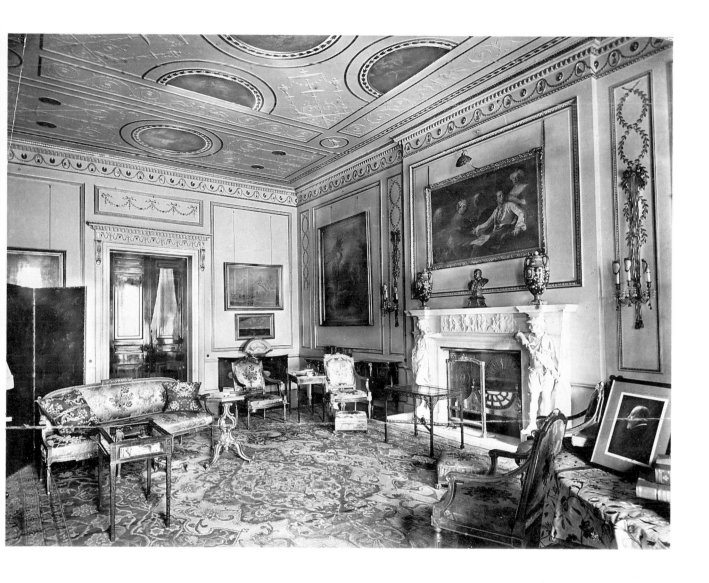

163 *Derby House. The drawing room had pretty Adam-style decorations and a vigorously carved chimneypiece*

ture with triglyphs, a balustrade and urns. It was altogether an elegant composition.

The building work was financed by the inheritance of the Earl's wife, who was a Herbert, related to the Earls of Pembroke. She outlived her husband. After her death the house was let to the first Earl Talbot, and after his death in 1793 to a series of aristocratic tenants. Lord Aldeborough, who had moved to No. 12 Stratford Place, did not return to the mansion despite a second marriage. Indeed, although there were five more earls after his death in 1801, 'they seem to have become steadily poorer and more Irish'.[24] By the time the peerage died out in 1875, Stratford House had long passed out of the family.

Nineteenth-century tenants were very distinguished considering the modest size of what was usually still called Stratford House: they included the sixth Duke of St Albans and Prince Esterhazy

among others. Until the 1890s accommodation was limited to the four principal rooms grouped round the staircase well on each floor. There was some service accommodation in the west wing and stabling in the east, as well as the attic and basement. A typically cool and classical entrance hall, with marble floor and small niches for sculpture, led to the staircase. To the right of the front was the fine dining room and at the rear was a library and ante-room. On the first floor was the main drawing room, also used as a ballroom, another drawing room and behind them two principal bedrooms. Other bedrooms were on the second floor. It was Walter Murray MP, the last of several minor political figures to live in the house in the nineteenth

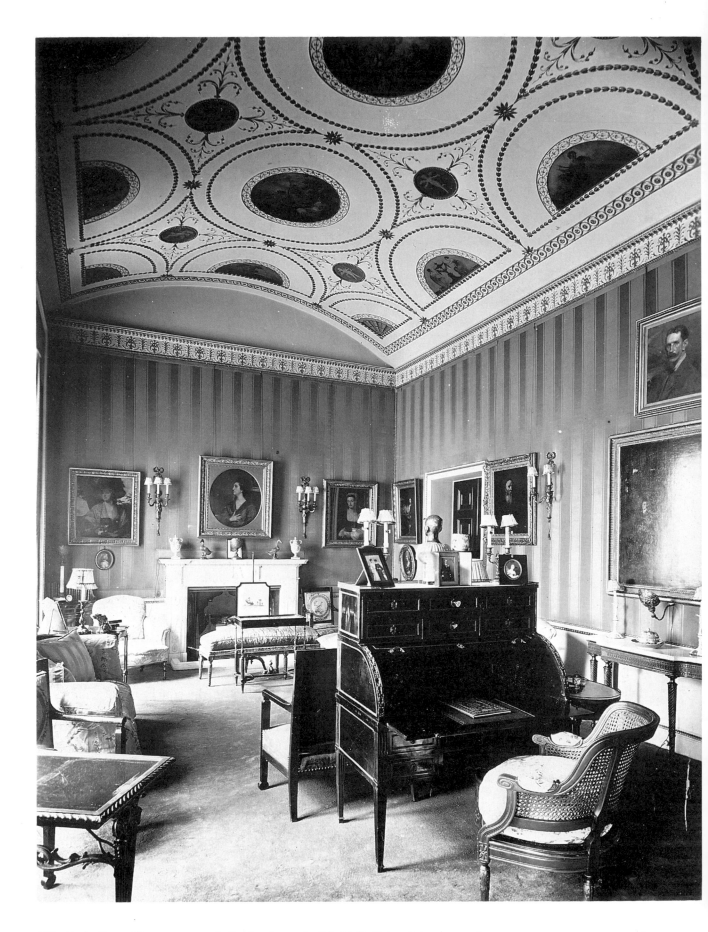

164 *Derby House. The green room on the first floor is now the Oriental Club's 'small drawing room'*

century, who increased the accommodation by adding an extra floor to the side wings.

In 1902 the owner was Sir Edward Colebrooke. He was so wealthy and so well connected that a peerage had to be created for him in 1906. But two years later he sold to one of the 'oldest families', in the person of the seventeenth Earl of Derby. Now the house was to reach its greatest extent. A state dining room, with the ballroom over, was built on the site of the redundant stables. Genuine Adam chimney pieces and other fixtures including ceiling paintings from 'The Oaks' at Epsom, were imported from previous Derby Houses. The main staircase was rebuilt in an inexplicable *beaux arts* style, though with ironwork incorporating the Stanley coat of arms in the supremely fine workmanship of that period. The smart architects, Romaine-Walker and Besant, created the main south façade as it is seen today, a perfectly sensible extension of the main block to replace the demolished wings. Their style for the new dining room and ballroom was less sure, the former in a washed-out Adam, the latter seeking a Roman grandeur with coupled marble columns and a barrel-vaulted ceiling with painted panels. The ballroom was probably the last such in London.

Newly enlarged, Derby House now also reached its social zenith. At a coronation ball in 1911, Lady Derby's guest list included eight Imperial Highnesses, 32 Royal Highnesses and only one mister, the American Ambassador. The political role of the house is highlighted by an event described by Mr Forrest. 'On Tuesday 5 December 1916, Lloyd George, Bonar Law and Edward Carson breakfasted at Derby House; later in the day Lloyd George, followed by Lord Derby, resigned from the Cabinet and Mr Asquith's fate was sealed.'[25] After being War Secretary, Lord Derby went to France as ambassador in 1918–20.

All this time, indeed up to 1930, the freehold of the house was held by the City Corporation. Lord Derby bought it then but the days of private ownership were numbered. The last ball was held in 1939. He offered the house to Christie's in the war and sold it to Hutchinsons afterwards. During 1949–50 Mr Hutchinson's 'National Gallery of British Sports and Pastimes' displayed a selection of

165 *Derby House. Perhaps the last ballroom built on to a London town house; the Earl of Derby opted for a species of Roman grandeur in 1908*

his 3000 paintings on those subjects. With his death in 1950 the venture collapsed and his company finally sold the house in 1955. After six years' occupation as offices, Stratford House, as it was again known, was sold to the Oriental Club.

Works carried out in 1962 were sensitive to the older parts, but not at all to the Edwardian ballroom, into which were inserted two floors of bedrooms. The finest apartments in the house remain the two first-floor drawing rooms. The smaller is, as Lord Derby said, the prettiest room: amidst the beautiful plasterwork of its barrel-vaulted ceiling are paintings recently identified as being by Biaggio Rebecca.

A clubhouse in a *cul-de-sac* off Oxford Street is an inauspicious setting for the conclusion of an account of London's mansions. In the environs of St James's Palace and Green Park it is still possible to imagine a capital dominated by noblemen's houses. In the early summer of 1985 there was a reminder of such times; the heir to the throne attended a lavish ball at Spencer House to celebrate the majority of the Earl's son. But it was a little magical and unreal – like Horace Walpole's vision of the Burlington House colonnade having appeared overnight – for the next morning Spencer House was handed back to its office tenants.

Glossary

ACANTHUS Plant with scalloped leaves which, conventionally treated, form the lower part of a Corinthian capital.
AMPHORA pl. -ae An ancient two-handled vase or wine vessel.
ANTHEMION (or -ium) pl. -ia A honeysuckle, palmette, or other formalized flower-like ornament in cornices, etc.
ARABESQUE Fanciful decoration, flowing and linear depiction of flowers, vases, animals etc.
ARCHITRAVE Beam, or lowest part of entablature, or moulded frame to a door or window.
ASHLAR Smooth-faced masonry with square edges and regular courses.

BAROQUE Late Renaissance style with boldly modelled elements. *c.* 1660–*c.* 1725 in England.
BUCRANIUM pl. -ia. Ox skull decoration, usually on a frieze.

CARTOUCHE Tablet with ornate frame, often inscribed.
CARYATID Whole female figure used as column or support.
COFFERS Sunk panels in ceiling, vaults or domes.
CONSOLE Curved bracket, often supporting upper member of cornice.
CUPOLA Small polygonal or circular domed turret, usually on roof

DADO Decorative surface on lower part of wall.
DENTIL Tooth-like blocks, often forming band in Ionic or Corinthian cornices.

ENTABLATURE The complete horizontal member over a column, comprising architrave, frieze and cornice.

FLUTING Vertical channelling on column shaft.
FRIEZE Middle division of entablature.

GROTESQUE Ornament, similar to Arabesque.

LUNETTE Semi-circular window or opening, in tympanum or in wall under vault or dome.

METOPE Space between Doric triglyphs.
MODILLION Small bracket, usually repeated in line below cornice.

ORDER Column with base, shaft, capital and entablature. Greek orders: Doric has no base, a fluted shaft and plain capital; Ionic is lighter, has base, fluting and a capital with volutes; Corinthian is also fluted, capital has small volutes but is chiefly composed of eight acanthus stalks. The Romans added a Tuscan order, similar to Doric but has plain entablature and shaft, and Composite, which combines large volutes of Ionic with acanthus decoration of Corinthian, has either plain or fluted shaft.

ORIEL Window bay corbelled out from wall.

PALLADIAN Architecture following ideas and practice of Andrea Palladio (1508–80).
PATERA pl. -ae Small, round, dish-like ornament on frieze or bas-relief, occasionally oval.
PEDIMENT Low pitched ornamental gable in classical and Renaissance architecture, usually triangular when over portico, can be segmental (i.e. curve which is part of a circle) when on a smaller scale and placed over a door or window. Broken pediment is where the sloping members are interrupted, often to allow a sculptural motif to break upwards at the centre.
PENDENTIVE Concave triangular spandrel under dome.
PIANO NOBILE Principle storey of a palace-type house, containing chief apartments, normally at first floor level.
PILASTER Shallow pier projecting only about one sixth of its breadth from the wall, of same design of the order with which it is used.
PORTE COCHÈRE Porch large enough to admit coaches.

RENDERING Plaster or stucco applied to outside wall.
ROCOCO (Fr. *rocaille* = rock-work). Late phase of baroque (*c.* 1720–60) in which rock-like forms and other profuse and irregular ornament with scrolls, shells etc are used.
RUSTICATION Stonework with recessed joints – sometimes horizontal ones only – often with rough surface to blocks.

SCAGLIOLA Surface material for columns, walls etc., comprised of cement and colouring to imitate marble.
SOFFIT Underside of arch, window lintel etc.
SPANDREL Space between shoulder of arch and surrounding rectangular moulding or framework, or between shoulders of adjoining arches.
STUCCO Plasterwork.

TERMS (terminal figure) Upper part of human figure developing out of a pier or pilaster which tapers towards its base.
TRIGLYPHS Blocks with vertical grooves (usually three) separating metopes in Doric frieze.
TYMPANUM Space between lintel of doorway and the arch above it.

VENETIAN WINDOW Window with three openings, the central one arched and wider than those on the outside.
VERMICULATED STONEWORK Rusticated masonry with surface texture like worm holes.
VOLUTE Scroll or spiral forming major part of Ionic capital.

Select Bibliography

SOURCE REFERENCES

Published in London, unless stated otherwise

Barker, Felix & Jackson, Peter, *London, 2000 Years of a City & its People*, Macmillan, 1974

Beard, Geoffrey, *The Work of Robert Adam*, Bartholomew, 1978

Blakiston, Georgiana, *Woburn and the Russells*, Constable, 1980

Campbell, Colen, *Vitruvius Britannicus*, published in three volumes by subscription in 1715, 1717 and 1725. A 1972 reprint by Benjamin Blom has an additional index volume by Paul Breman, with commentaries by John Harris etc.

Cannadine, David, The Landowner as Millionaire: the finances of the Dukes of Devonshire c. 1800–c. 1926, *Agriculture History Review*, 1977

Chancellor, E. Beresford, *Devonshire House, Piccadilly*, published by Devonshire House Ltd., 1925

Chancellor, E. Beresford, *The Private Palaces of London*, Kegan Paul, 1908

Charlton, John, *Marlborough House*, Department of the Environment, 2nd ed. 1978

Colby, Reginald, '11, Grosvenor Square', *Country Life*, 27 July 1961

Colvin, Howard, (ed.) *History of the King's Works*, vol V, HMSO, 1976

Colvin, Howard, *Biographical Dictionary of British Architects, 1600–1840*, John Murray, 1978

Cornforth, John, *English Interiors 1790–1848 — The Quest for Comfort*, Barrie & Jenkins, 1978

Cornforth, John, 'Devonshire House', *Country Life*, 13 & 20 November 1961

'Grosvenor House', *Country Life*, 15 November 1973

'Stafford House Revisited', *Country Life*, 7 & 14 November 1968

Crook, J. Mordaunt, *The Greek Revival*, Country Life Books, 1968

Draper, Marie, 'Monmouth House', *Country Life*, 12 September 1963

Duchess of Devonshire, *Chatsworth*, illustrated guide, 1983

The House, A Portrait of Chatsworth, Macmillan, 1982

Dunlop, Ian, 'First Home of the British Museum', (Montagu House), *Country Life*, 14 September 1951

Evelyn, John, *Diaries*, various editions

Feiling, Keith, *A History of England*, Macmillan, 1952

Fiennes, Celia, *Journeys 1685–c. 1712*, illustrated edition by Christopher Morris, Macdonald, 1982

Fletcher, Sir Bannister, *A History of Architecture*, Athlone Press, 18th ed. 1975

Girouard, Mark, *Robert Smythson & the Elizabethan Country House*, Yale, 1983

Girouard, Mark, '44, Berkeley Square', *Country Life*, 27 December 1962

Greater London Council, *Survey of London*, vols I–XLI, 1900–1983

Harris, John, *Sir William Chambers*, Zwemmer, 1970

Harris, John, and others, *The King's Arcadia*, Arts Council, 1973

Hobhouse, Hermoine, *Lost London*, Macmillan, 1971

Hussey, Christopher, *The Story of Ely House, 37 Dover Street*, Country Life Books, 1953

Hussey, Christopher, 'Dorchester House', *RIBA Journal*, August/September 1954

Jervis, Simon & Tomlin, Maurice, *Apsley House, Wellington Museum*, Victoria & Albert Museum, 1984

Lees-Milne, James, *Earls of Creation*, Hamish Hamilton, 1962

Montgomery-Hyde, H. *Londonderry House & Its Pictures*, Cresset Press, 1937

Murphy, Sophia, *The Duchess of Devonshire's Ball*, Sidgwick & Jackson, 1984

Needham, Raymond & Webster, Alexander, *Somerset House Past and Present*, Fisher Unwin, 1905

Oswald, Arthur, 'Londonderry House', *Country Life*, 10 July 1937

Owsley, David & Rieder, William, *The Glass Drawing Room from Northumberland House*, Victoria & Albert Museum, 1974

Pepys, Samuel, *Diaries*, various editions

Pevsner, Nikolaus, *The Buildings of England: London, Volume One*, third edition revised by Bridget Cherry, 1973. Also *Northamptonshire*, revised Cherry, Penguin, 1973

Pevsner, Nikolaus, 'Old Somerset House', *Architectural Review*, September, 1954

Prockter, Adrian & Taylor, Robert, *The A to Z of Elizabethan London*, London Topographical Society, 1979

Ralph, James, *A Critical Review of the Public Buildings, Statues and Ornaments in and about London and Westminster*, 1734, also enlarged edition, 1783

Robinson, John Martin, *The Wyatts*, Oxford, 1979

Schofield, John, *The Building of London*, Colonnade (British Museum), 1984

Somerville, Robert, *The Savoy, Manor, Hospital, Chapel*, Duchy of Lancaster, 1960

Stow, John, *A Survey of London*, edition by William J. Thoms, Chatto & Windus 1876

Stroud, Dorothy, *George Dance, Architect*, Faber & Faber, 1971

Stroud, Dorothy, *Sir John Soane, Architect*, Faber & Faber, 1984

Summerson, Sir John, *Architecture in Britain 1530–1830*, Pelican, 7th ed., 1983

Summerson, Sir John, *Georgian London*, Pleiades, 1945

Summerson, Sir John, *Inigo Jones*, Penguin, 1966

Summerson, Sir John, and others, *Great British Architects*, Architectural Association, 1981

Thompson, Nicholas, and others, *A House in Town*, Batsford, 1984

Thomson, Gladys Scott, *The Russells in Bloomsbury*, Jonathan Cape, 1940

Walford, Edward, *Old and New London*, Cassell, six volume edition, 1890

Wallace Collection, Trustees of, *General Guide*, 1982

Weinreb, Ben & Hibbert, Christopher, *The London Encyclopaedia*, Macmillan, 1983

Wheatley, Henry B, *Round about Piccadilly and Pall Mall*, Smith, Elder, 1870

Wheatley, Henry B, *London Past and Present*, John Murray, 1891

Whinney, Margaret, *Home House*, Country Life Books, 1969

Whiffen, Marcus, Bridgewater House, St James's, *Country Life*, 13 May 1949

Notes

There are frequent references to a number of standard works, especially in the Notes. These are detailed in the Bibliography; below are indicated the abbreviations used in the Notes.

EBC: Chancellor, E. Beresford, *The Private Palaces of London*
Colvin: Colvin, Howard, *A Biographical Dictionary of British Architects*
Pevsner BE Lon I: Pevsner, Nikolaus, *The Buildings of England, London, Volume One*
Ralph: Ralph, James, *A Critical Review . . . of London and Westminster*
Schofield: Schofield, John, *The Building of London*

Stow: Stow, John, *A Survey of London* (*1603 edition*). Also Strype's 1720 edition of Stow, referred to as Strype (volume & book, eg B IV)
Sum A in B: Summerson, Sir John, *Architecture in Britain* (seventh edition 1979)
Sum GL: Summerson, Sir John, *Georgian London*
SL IX: *Survey of London*, Volumes I (1900) to XLI (1983)
Old and New London vol: Walford, Edward, *Old and New London* (in six volumes)
Wheatley Lon I: Wheatley, Henry B. *London Past and Present* (in three volumes)
Weinreb: Weinreb, Ben & Hibbert, Christopher, *The London Encyclopaedia*

CHAPTER I

1 Wheatley, Lon I p.542.
2 Wheatley, Lon III p.537, letter in Lamb MSS vol. VIII No. 936.
3 Colvin, p.336.
4 Sir Balthazar Gerbier, *A Brief Discourse concerning the Three Principles of Magnificent Building* London, 1662 (Colvin p.336).
5 Bishop Goodman's *Memoirs* (quoted EBC p.45).
6 Peacham, *Compleat Gentleman*, ed. 1661, p.108 (Wheatley, Lon III p.538).
7 Sum. A in B, p.151.
8 Evelyn, *Diary*, 27 Nov. 1655.
9 H. Colvin (editor), *The History of the King's Works*, vol. I, p.213.
10 Schofield, p.98.
11 Schofield, p.140. This is often called Paulet House after Sir William Paulet, Lord Treasurer in 1540; the Marquis's father was the original post-Reformation owner.
12 Schofield, p.140. But Pevsner (BE Lon I p.50) says Lord Cobham.
13 According to a Poll Tax of that date (Pevsner BE Lon I, p.36).
14 Sum A in B, p.99.
15 Pevsner, BE Lon I, p.35.
16 ibid, p.52 - although unique in England, London's population growth was comparable with other European ports such as Antwerp.
17 Pevsner, BE Lon I, p.55.
18 Schofield, p.110.
19 ibid, p.81.
20 Wheatley, Lon I, p.441.
21 Stow, p.89.
22 ibid, p.127.
23 Howell, *Londinopolis*, 1657, p.342.

24 Seymour, *Survey of London*, 1736, p.771.
25 Stow, p.167.
26 Norden's *Middlesex*, (Harl MSS 570. Quoted Wheatley, Lon I p.343).
27 John Harris *et al*, *King's Arcadia*, p.106. Jones entrance and 'pergola' was built in 1618, destroyed 1628. RIBA Drawings Catalogue, Inigo Jones and John Webb No. 13.
28 Wheatley, Lon III, p.353.
29 Strype B IV, p.120.
30 Strype B VI, p.93.
31 Colvin, p.455.
32 Ralph, p.82.
33 Sum A in B, p.84.
34 Colvin, p.873.
35 Walpole to Sir Horace Mann 5 May 1757, *Letters of Horace Walpole* ed. Mrs Paget Toynbee, Oxford 1903-5, vol IV, pp.52-3.
36 S L XVIII, p.16. There still appears to be a shortage of proof of Mylne's involvement at Northumberland House, despite Chancellor and A.T. Bolton references.
37 Walpole, *Letters*, op cit vol. IX p.87.
38 David Owsley and William Rieder *The Glass Drawing Room from Northumberland House*, V & A, 1974, p.6.
39 E. Beresford Chancellor, *Annals of the Strand*, London 1912, p.270.
40 Ralph, 1734 edition (demolished before 1783 edition).
41 Stow.
42 Keith Feiling, *A History of England*, Macmillan, 1952, p.370.
43 Weinreb, p.795. Summerson mentions two other craftsmen from Nonsuch:

William Cure and Giles Gering, the 'molde-maker', A in B, p.46.
44 Strype, B IV, p.105.
45 Wheatley, Lon I, p.73.
46 Duc de Sully, quoted by Pennant, reproduced in Old and New Lon, vol. III, p.74.
47 Sir Isaac Walton, *Life of Donne*, 1824, p.18.
48 ibid, p.99.
49 Colvin, p.905.
50 Wheatley, Lon I, p.472.
51 Lord Herbert of Cherbury, *Autobiography*, p.52.
52 Cal of State Papers, 1611-18, p.458, (Wheatley, Lon I p.515).
53 The last bishop (Dolben) deserted this unfashionable area in 1633. Remnants of the Tudor house were finally demolished in 1828.
54 Weinreb, p.259.
55 Howell, *Letters*, ed. 1737, p. 119 (Wheatley, Lon II, p.12).
56 Dodsley, *London and its Environs Described*, (6 vols) 1761, vol. II, p.273.

CHAPTER II

1 H.B. Wheatley, *Round About Piccadilly...*, Smith, Elder, 1870, p.1.
2 Weinreb, p.458.
3 Weinreb, p.202.
4 Keith Feiling, *History of England*, Macmillan, 1952, p.449.
5 Weinreb, p.181.
6 Wheatley, Lon II, p.587.
7 Mark Girouard, *Robert Smythson and the Elizabethan Country House*, Yale, London, 1983, p.247.
8 Wheatley, Lon II, p.587.
9 Girouard loc cit.

10 Wheatley, Lon I, p.85.
11 Sum. A in B, p.103.
12 *An Account of the Conduct of the Dowager Duchess of Marlborough, from her first coming to Court to the year 1710*: by the Duchess, but 'put in order' by Nathaniel Hooke, 1742, p.147.
13 In unpublished *Notes on Newcastle House*, courtesy of Messrs Farrar.
14 W. Coxe, *Memoires of Sir Robert Walpole*, vol. III, p.299.
15 Sir Robert Hawkins, *Life of Johnson*, p.192, (quoted Wheatley, Lon II, p.588 and elsewhere).
16 Pevsner, BE Lon I, p.369.
17 Sum. A in B, p.165.
18 Hatton, *New View of London*, 1708.
19 Jonathan Swift, letter to Mrs Dingley, 26 Jan 1713.
20 Horace Walpole, *Letters* (to Lord Hertford), vol. IV, p.247.
21 Marie P.G. Draper, 'The Great Houses in Soho Square' *Country Life* CXXXIV, p.592.
22 Sum. A in B, pp.290–291.
23 ibid.
24 J.T. Smith, *Life of Nollekens*, ed. Edmund Gosse, 1895, pp.53–55.
25 Evelyn, Letter to Lord Cornbury (Clarendon's son), 20 Jan 1666.
26 Sum. A in B, p.155.
27 EBC, p.67.
28 Sum. A in B, p.155.
29 Quoted, EBC, p.72.
30 Pepys, *Diary*, 21 Sept 1674.
31 See also Colvin pp. 804, 904.
32 J. Macky, *Journey Through England*, 1722, vol. I, p.194.
33 Duke of Buckingham's *Works*, 1729, Letter to Duke of Shrewsbury.
34 Ralph, p.180.
35 Pevsner, BE. Lon I, p.476.

1 Alexander Pope, *Moral Essays*, Essay on Taste, 1732.
2 Ralph, Preface, ix–x.
3 Colen Campbell, Introduction to *Vitruvius Britannicus*, vol. I, 1715.
4 Ralph, Introduction, xxx.
5 John Harris, Introduction to the Index Volume of 1972 reprint of *Vitruvius Britannicus*, by Benjamin Blom.
6 Horace Walpole, *Letters* (to Montagu), 18 May 1748.
7 Rev. Thomas Herring, in a letter from York, 1743 (Burlington's Assembly Rooms had not long been completed there).
8 James Lees Milne, *Earls of Creation*, Hamish Hamilton, 1962, p.140.
9 J. Macky, *Journey Through England*, vol 1, p.196.
10 Ralph, p.182.
11 John Charlton, *Marlborough House*, Department of the Environment, 2nd ed. 1978.
12 For full discussion of design responsibility see S L, vol. XXXII, p.391.
13 Colvin, p.258.
14 Lord Burlington, quoted in S L XXXII, p.398.
15 Sum. A in B, p.335.
16 Horace Walpole, *Anecdotes of Painting*.
17 Ralph, p.192.

18 This begs the question of areas of responsibility for design work at Marble Hill between Campbell, Lord Herbert and Roger Morris.
19 Colvin, p.128.
20 S I. XXXII, p.460.
21 Ralph, p.194.
22 S L XXXII, p.460.
23 J.B. Papworth, *The Public Buildings of London*, 1825 vol. I, pp.80–2.
24 Ralph, p.184.
25 RIBA Burlington/Devonshire Collection, vol XVII, No. 11.
26 H.B. Wheatley, *Round About Piccadilly* ... Smith Elder, 1870, p.77.
27 Horace Walpole, Letter to George Montagu, 18 May 1748.
28 James Lees Milne, *Earls of Creation*, Hamish Hamilton 1962, p.157.
29 Wheatley, ibid, p.205.
30 EBC, p.220.
31 Earl of Chesterfield, *Letters*, to Bristowe, 13 August 1747.
32 Chesterfield, ibid, 17 Sept 1747.
33 EBC, p.212.
34 Author unknown, possibly James 'Athenian' Stuart, *Critical Observations on the Buildings and Improvements of London*, 1771.
35 H.B. Wheatley, *Round About Piccadilly* ... Smith Elder 1870, preface ix.
36 Colvin, p.136.
37 Mrs Delaney, *Autobiography and Correspondence*, ed. Mary Granville. 1st series, vol. III, p.409.
38 Horace Walpole, *Letters*, vol. II, ed. 1903, p.396.
39 William Farrington, Letter to his sisters, 18 Feb 1756, reproduced in full as Appendix A, pp.48–9 by Desmond Fitz-Gerald, *The Norfolk House Music Room*, Victoria & Albert Museum, 1973.
40 Elizabeth, Lady Holland, *Letters to her Son 1821–41*, ed. Earl of Ilchester, London 1946, pp.228–9.
41 Pevsner, BE, Lon I, p.647.
42 Sum. A in B, p.365.
43 Woolfe and Gandon, *Vitruvius Britannicus* vol. IV, 1767.
44 Drawing in Collection of Greater Council, (plate 252b S L XXX).
45 Sum. A in B, p.365.
46 Arthur Young, *A Six Week's Tour through the Southern Counties of England and Wales*, 2nd ed. 1769.
47 Such a scheme of decorations was not a Vardy invention, c.f. design for King's bedchamber at Greenwich, engraved by Vardy, published in his *Some Designs of Mr Inigo Jones and Mr William Kent*. The origins are in Italian villa architecture, even in Roman classical work.
48 S L XXX, p.528.
49 EBC, p.345.
50 SL XXX, p.528.

CHAPTER IV

1 Sir John Summerson, *Georgian London*, Pleiades Books, 1945, p.9.
2 A.S. Turbeville, *The House of Lords in the Age of Reason*, Faber and Faber, 1958, Appendix VI.

3 This does not include peers of Ireland, of whom Pitt alone created 77. See Keith Feiling, *A History of England*, Macmillan, 1952, p.726.
4 Margaret Whinney, *Home House, No 20 Portman Square*, Country Life Books 1969, p.53.
5 Weinreb, p.480.
6 S L XXIX, p.142.
7 Sum. A in B, p.417.
8 *Works in Architecture of R and J Adam*, 1773.
9 Ralph, p.191.
10 Dorothy Stroud, *George Dance Architect, 1741–1825*, Faber and Faber, 1971.
11 Fitzmaurice, *Life of Shelburne*, vol. I p.311, (EBC p.280).
12 Ticknor, *Diary*, 28 March 1838 (EBC, p.288).
13 Ticknor, ibid, 2 April 1838.
14 Soane Museum, Adam Drawings, vol. XI, No. 83.
15 Pevsner, BE, Lon I, p.559.
16 S L XXIX, p.164.
17 Sir John Summerson, *Georgian London*, Pleiades Books, 1945, p.126.
18 Sum. loc cit.
19 J.W. Oliver, *Life of William Beckford*, OUP, 1932.
20 Christopher Hussey and Arthur Oswald, *Home House, No 20 Portman Square*, Country Life Books, 1934 p.18.
21 *The Works in Architecture of R and J Adam*, part I, vol IIA, 1779.
22 Fanny Burney, quoted by EBC, p.332.
23 Sum. A in B, p.468.
24 Summerson, Georgian London, p.125.

CHAPTER V

1 Gladys Scott Thomson, *The Russells in Bloomsbury 1669–1771*, Jonathan Cape, 1940, p.158.
2 Georgiana Blakiston, *Woburn and the Russells*, Constable, 1980, p.96.
3 Scott Thomson, op cit, p.163.
4 Blakiston, op cit, p.153.
5 Dobie, *History of Bloomsbury*, 1834, p.176.
6 Colvin, p.428.
7 ibid.
8 Evelyn, quoted by Ian Dunlop in 'First Home for the British Museum', *Country Life*, 14 Sept 1951.
9 Ellis's *Letters*, 2nd series, vol. IV, p.89, (quoted Wheatley, Lon I, p.556).
10 Pevsner/Cherry, Buildings of England, *Northamptonshire*, Penguin, 2nd edition, 1973, p.110.
11 Celia Fiennes wrote in the account of her journeys (1685–c. 1712) '... one roome in the middle of the building is of a surpriseing height curiously painted and very large, ...' and, elsewhere, of 'the large roome in Montague House (soe remarkable for fine painting) I have been in it and when the doores are shutt its so well suited in the walls you cannot tell where to find the doore if a stranger, ...' *The Illustrated Journeys of Celia Fiennes, 1685–c.1712*, edited by Christopher Morris, Macdonald, London, 1982, pp.191 & 224.
12 Dunlop, op cit.

13 Ralph, p.195.
14 Evelyn, *Diary*, 1672 (quoted Weinreb, p.451).
15 S L XXIX, p.119.
16 ibid, p.119.
16 ibid, p.121.
17 J. Macky, *A Journey Through England*, 1722, vol. I, p.199.
18 *The Daily Journal*, 6 Jan 1727, (quoted Wheatley, Lon I, p.516).
19 Evelyn, *Diary*, 12 June, 1684.
20 Summerson, *Georgian London*, p.100.
21 Quoted by Mark Girouard in '44 Berkeley Square, London', *Country Life*, 27 Dec 1962, p.1651.
22 Girouard, loc cit.
23 EBC, p.100.
24 *Old and New London*, vol. iv, p.445.
25 Ralph, p.172.
26 *Old and New London*, vol. iv, p.446.
27 The story of the loss of the lease in a card game between the third Earl Harcourt and the Duke of Portland in 1825, though probably based on fact, may not have been so dramatic as it sounds. The lease was nearing surrender in any case. It is retold in Weinreb, p.364.
28 Sum. A in B, p.388.
29 Colvin, p.69.
30 Weinreb, p.364, but not corroborated by Colvin.
31 EBC, p.103.
32 Weinreb, p.364.
33 Colvin, p.891.
34 Strype B, IV, p.120.
35 Wheatley, Lon II, p.187.
36 Colvin, p.606; professional status was not clarified for a further half century.
37 Christopher Hussey, 'No 12, North Audley Street', *Country Life*, 15 Nov 1962, p.1215.
38 Proved by recent research at the Public Record Office by the GLC Survey of London team.
39 Pevsner, BE Lon I, p.603.
40 ibid, p.619.
41 ibid, p.656.
42 S L XL, p.69.
43 ibid, p.277.
44 loc cit.
45 Grosvenor Estate Board Minutes no. 301, 1909.
46 Pevsner, BE Lon I, p.616.
47 Grosvenor Estate, Surveyor's Report.

CHAPTER VI

1 Design drawings are in a Burlington sketch book loaned to the RIBA drawings collection by the Duke of Rutland.
2 Horace Walpole to Sir Horace Mann, *Letters*, vol. II, p.155, No. 160.
3 Wheatley, Lon III, p.162.
4 EBC, p.145.
5 S L XXIX, p. 369.
6 EBC, p.119.
7 Historical Manuscripts Commission, MSS of the Earl of Denbigh part V, 1911, p.241.
8 ibid (quoted in S L XXIX, p.360).
9 S L XXIX, p.360.
10 Old and New Lon, vol. IV p.129.
11 Ralph, p.184.

12 John Cornforth, 'Devonshire House, London', *Country Life*, 13 Nov. and 20 Nov. 1980, pp.1750–1758 and 1894–1897.
13 EBC, p.238.
14 Anonymous poem, quoted in H.B. Wheatley, *Round About Piccadilly . . .*, p.99.
15 Prince Puckler-Muskau, quoted by Cornforth, op cit.
16 EBC, p.241.
17 This and much other information was kindly provided by the Chatsworth archivist and librarian, Peter Day and Michael Pearman.
18 J. Macky, *The History of the Present State of the British Isles*, 1743, vol. II, p.134.
19 Sum. A in B, p.577, Notes Ch 26 (10).
20 H.B. Wheatley, *Round About Piccadilly . . .*, p.277.
21 Paine worked for Lord Melbourne at his country home, Brocket Hall. Chimneypieces and some other features were eventually removed to Renishaw Hall in 1803. See Colvin p. 609, and S L XXXII p.384.
22 Ralph p.192.
23 John Harris, *Sir William Chambers*, Zwemmer, 1970, p.70.
24 Harris, loc cit.
25 ibid, p. 227.
26 *Old and New London*, vol. IV, p.285.
27 Dodsley, *London and its Environs. Described*, 1761.
28 Ralph, p.183.
29 H.B. Wheatley, *Round About Piccadilly...* p.32.
30 Chancellor, however, says that the house was built for the 'notorious Lord Barrymore'. EBC, p.121.
31 *Old and New London*, vol. IV, p.285.
32 Disraeli, quoted by H. Montgomery Hyde in *Londonderry House and its Pictures*, Cresset, 1937.
33 Wheatley, Lon I, p.320.
34 Colvin, p.640.
35 Lady Williams-Wynn, quoted in S L XL, p.287.

CHAPTER VII

1 Gladys Scott Thomson, *The Russells in Bloomsbury, 1669–1771*, Jonathan Cape, 1940, p.168.
2 *Old and New Lon*, vol. IV, p.370.
3 David Cannadine, 'The Landowner as Millionaire: The Finances of the Dukes of Devonshire', c. 1800–c. 1926, *The Agricultural History Review*, Vol. 25, 1977, p.77.
4 loc cit.
5 Strype, B VI, p.66.
6 Wheatley, Lon I p.545.
7 S L XL, p.242.
8 *Country Life*, Nov. 15, 1973.
9 ibid.
10 Ralph, p.183.
11 Or for £40,000 in 1816 according to J.M. Robinson, *The Wyatts*, OUP, 1979, p.105.
12 J. Bamford and the Duke of Wellington (eds) *The Journal of Mrs Arbuthnot* 1950, pp.355–6 (quoted Robinson, ibid, p.106).

13 loc cit.
14 Pevsner, BE Lon I, p.515.
15 S L XXX, p.499.
16 EBC, p.193.
17 S L XIII, p.214.
18 Colvin, p.160.
19 EBC, p.303.
20 EBC, p.250.

CHAPTER VIII

1 Sum. A in B, p.509.
2 John Martin Robinson, *The Wyatts*, OUP 1979, p.111.
3 John Cornforth, 'Stafford House Revisited', *Country Life*, 14 Nov 1968, pp.1257–61.
4 Robinson, loc cit.
5 Pevsner, BE, Lon I, p.512.
6 Cornforth, ibid.
7 loc cit.
8 loc cit.
9 Ralph p.174.
10 Wheatley, Lon II, p.461.
11 Quoted in *The Wallace Collection: General Guide*, The Trustees, 1982, p.13.
12 Some of the points summarized here remain to be proved, if and when an examination of the fabric of the house takes place during refurbishment, but they are based on more recent and reliable research by the GLC officers than is reported in any account hitherto published.
13 Colvin, p.731.
14 The houses have been demolished, but are illustrated in T Malton's *Picturesque Tour*, of 1792 – and elsewhere.
15 According to Mr Belcher of the GLC, the portico was probably similar to that on No. 17 Bruton Street, completed to Shepherd's designs in 1748.
16 Charles II's close advisors had waited upon him in a small room beyond his state bedchamber, called a 'cabinet'. Hence the 'King's Cabinet Council' and eventually the 'cabinet' as in British and US governments, c.f. *A House in Town* by Nicholas Thomson *et al*, p.110.
17 These details, in common with much other information on this house are derived from *A House in Town*.
18 Horace Walpole, *Correspondence*, 1840, vol. II, p.123.
19 H.B. Wheatley, *Round About Piccadilly*, p.31.
20 Wheatley, Lon I, p.123.
21 Colvin, p.392.
22 Wheatley, Lon I, p.124.
23 Order in Common Council, quoted by Denys Forrest, *The Oriental*, Batsford, 1968, p.158.
24 ibid, p.173.
25 ibid, p.190–1.

Index

Figures in **bold** refer to the detailed discussion of a particular topic